AMERICAN STYLE

© 2004 Assouline Publishing, Inc.

Assouline Publishing, Inc.
601 West 26th Street
18th floor
New York, NY 10001
USA
Tel.: 212 989-6810 Fax: 212 647-0005
www.assouline.com

ISBN: 2 84323 608 8

All rights reserved.

Color separation: Gravor (Switzerland)
Printing: Editoriale Lloyd S.r.l (Italy)

Introduction by Harold Koda

AMERICAN STYLE

KELLY KILLOREN BENSIMON

ASSOULINE

My mother and twin brother.

I was going to tell you stories about growing up in the Midwest wearing purple Converse, cutting my hair "bilevel," racing sailboats, living in polo shirts, and hiding under the racks at Saks Fifth Avenue in Chicago with my twin brother and my older sister while my mother tried on designer clothes. But I realized that this book should not be a reflection of my own experience, but rather a reflection of our country and the people who have pioneered their own style. I have been proud to discover that American culture has had such a strong influence on the world's stage, but surprised that it does not get the credit it deserves.

American Style is an exploration of America through its fashion designers, celebrity icons, and social history. The timeline outlines some of the wonders and hardships that have generated changes in the way we look and live.

If I had my way, this book would have 293 million pages—one for each person that makes up our national character. Since this is impossible, I have selected images that highlight the major contributors to "American Style"—and even some that may be a surprise.

From the voluptuous and "sporty" new look of the Gibson Girl at the turn of the century to the '90s grunge of Marc Jacobs, American Style has always had a transformative effect. Gilbert Adrian designed gowns that made actresses into starlets. After World War II, with the awakening of American sportswear, designers leveled the field of fashion by allowing every woman access to beautiful clothes. Katharine Hepburn believed that a woman could not do what she needed to do while wearing stockings; Mary Tyler Moore knew that housewives could not do what they needed to do while wearing dresses. These icons used fashion to reflect not only the changing ideas of designers, but also the social changes within the country.

And no one will ever forget how movie stars like James Dean and Marlon Brando showed us what teenage angst looked like: silent, brooding, and sexy. They took the motorcycle jacket off the bike and paired it with a white T-shirt and jeans, creating a uniform for nonconformity. In the same way, the 1950s beatniks and the '90s grunge musicians took lumberjack shirts out of the

forest and into the alternative scene. And in the 21ˢᵗ century, rappers took basketball gear off the court and onto the streets.

With the dawn of rock and roll and the gradual disintegration of the American family, this nonconformity was brought to a boiling point with the assassination of President Kennedy. And issues such as civil rights and women's rights, as well as the antiwar movement, added fuel to the fire. America was ready to let down its hair , and the "hippie" fashions reflected these ideals.

In 1973, fashion maven and public relations guru Eleanor Lambert organized designers Bill Blass, Calvin Klein, Anne Klein, Oscar de la Renta, Stephen Burrows, and Halston to take part in a fashion show supporting the restoration of the palace at Versailles. It was at this show that Europeans realized what "American Style" really was: simple, chic, sporty, and according to Hubert de Givenchy, "cool."

We have explored new territories, walked on the moon, and created the ultimate super-hero. We changed acting forever, made stars on the red carpet, and created new genres of music. We have gone from petticoats to low-riders and silent films to Technicolor DVDs, and brought designers from the drafting table to the spotlight. Through the power of the media, we have made sports sexy and glamour tangible.

I have spent many years being told that there is no "American Style." But in fact American Style is *every* style. It is all-encompassing, from California coal miners to New York socialites, athletes to actresses, urban trends to cowboy hats.

As Americans, we can say what we want and be whoever we want; all we have to do is be true to ourselves. Now that we understand how important our freedom has been to us, it will be most interesting to see who will be the next style icons and how they will influence our future. This book is for you, America: I am so proud to be a part of your family.

KELLY KILLOREN BENSIMON

INTRODUCTION

American Style, like the country itself, is an amalgamation of diverse sensibilities. A wide assortment of aesthetic impulses have animated our history, each evolving into distinctive regional and vernacular tags—Southern Californian beach bunnies, northeastern WASPs, Harlem hip-hoppers, Western cowboys, *Sex in the City* urbanites. They flourish in an ideological context inflected by the country's fundamental principle of *e pluribus unum*: "from many one." Indeed, "from many one" is the paradox of American Style (as it is of all of American culture), a unified entity that can only be defined by the array of its expression.

The various manifestations of American Style include contrasting and conflicting attitudes and approaches. These contradictions are rooted in the long-held American practice of simultaneously advocating the new—often comprised of oppositional social and cultural values—while continuing to endorse traditional strategies of self-expression that stem from the country's Western European roots. American Style may therefore simultaneously embody a fondness for nostalgic evocations of an idealized past, as well as a preference for the "next big thing." Thus, Ralph Lauren's leisured narratives of "establishment" style are as much of a contemporary cultural influence as the larger-than-life "bling-bling" street style of an MTV video.

It is precisely this discordance of wildly contrastive modes of expression that infuses American Style with its free-wheeling vivacity. American Style is where the reserved propriety of Mainbocher, purveyor of unimpeachable elegance, coexists with the uninhibited theatrical fantasies of Bob Mackie; where the "zoot suit" of inner-city dandies is as iconic as the Brooks Brothers business suit, emblem of the social, political, and economic establishment; where Native Americans are as lively a romantic ideal as their cowboy counterparts; where the adventurer's machismo of Ernest Hemingway squares with the street suavity of Sean "P. Diddy" Combs; where the transformative artifice of Madonna "vogues" against the classic sportive naturalism of C.Z. Guest; where the airborne virtuosity of skateboarders arcs as elegantly as the footwork of a white-tied Fred Astaire; where lithe Charlie's Angels provoke the same libidinous meditations as the voluptuous girls of *Baywatch*; and where Joan Crawford shares the limelight with Li'l Kim, and Frank Sinatra with Elvis. If there's one common element in these various

embodiments of American Style, it is a clarified sense of self, of individual identities cultivated in a climate of free expression, where rules exist, but only as a menu of options.

Until the end of the 19ᵗʰ century, "American Style" would have appeared to most cultivated Europeans as an oxymoron. The common American reputation abroad was that of a people more enthralled with work and industry than civility and beauty, a people for whom style was subordinate to substance. American Style for much of its history has been an upwardly percolating phenomenon, a response to the realities of its democratic social system and the attendant cultural authority wielded by its citizenry. This directly contrasts with the conventions of Europeans, for whom style was disseminated in the opposite direction, an elitist enterprise of "trickle-down." To the stylesetters of the Old World, a society in which the privileged classes attempt to be egalitarian by "dressing down" would seem to preclude the refinement of any serious form of personal allure.

This difference in attitude was reflected in George Washington's decision to dress plainly, without exceptional distinction. As costume historian Caroline Milbank has noted, his decision was symbolic: "homegrown, homespun, and home-sewn clothes" projected the self-sufficiency and independence aspired to by the post-Revolutionary. Washington's ensembles were in direct and deliberate contrast with the rich apparel associated with the aristocratic sensibilities of a monarchial hierarchy. Simplicity of dress was Washington's sartorial declaration of independence from the thrall of Old World autocracies. That the early Puritan founders, as well as the Amish and Quakers, also abhorred any ostentatious dress further inscribed simplicity as a recurring component of American Style. Surprisingly, the puritanical aversion to ostentation and the Yankee pragmatism that once seemed to limit any possibility of stylish expression in this country have encouraged the development of America's greatest—and most intrinsically American—fashion contribution: sportswear. The mass-manufactured functionalism of Claire McCardell or the utopianism of Rudi Gernreich by their nature question the very character of high fashion, by looking to vernacular forms rather than Paris "originals." McCardell was inspired by—among other things—the utility of laborers' uniforms, and Gernreich by the freedom of movement of dancers' practice clothes.

Sportswear is all about dressing in interchangeable separates, introducing elements of activewear into leisure and formal attire and elements of workmen's clothes and men's apparel into womenswear. With its emphasis on function, American sportswear—supported by a ready-to-wear manufacturing and marketing infrastructure unrivaled in the world—introduced new ideas of comfort and ease of care. The growing informality of the American Way of Life, first

popularly embraced in the indulgent environment of the West Coast, has continued to be reflected in the country's increasingly casual attire. In this, as in other areas of fashion change, innovation is predicated on an evolving social reality, with America initiating the global shift.

The growing authority and recognition of a distinctive American Style coincided with the dawn of the 20th century. Unencumbered by the calcified values of the old social order, America was by the end of the 19th century poised to incorporate the encroaching changes of the new century in its behavior and dress. Revolutionary transformations in society and culture registered in this country earlier and more broadly than in Europe, a phenomenon supported by the fact that America was spared the extensive devastation of the two World Wars and the subsequent struggles of reconstruction experienced abroad.

Nowhere was the emerging modernity of American Style more clearly expressed than in the Gibson Girl, the imaginary protagonist of the sweetly tart social narratives of illustrator Charles Dana Gibson. The Gibson Girl was a representation of a new social phenomenon: the All-American Beauty, independent and strong willed, athletic and slightly reckless, and above all, classically beautiful, though perhaps more Athena than Venus in the line of her nose and the strength of her jaw. She was, in spirit, Katharine Hepburn *avant la lettre*, representing a proto-feminist ideal. Fashion, at that point defined by the designers in Paris, would only acknowledge an indigenous American Style decades later, when Jean Patou—who, as much as Coco Chanel, was responsible for inventing the *sportif* and modernist wardrobe of the 20th century woman—selected six American girls to model for him in 1925. His American mannequins caused an uproar in France. He had chosen them, according to Milbank, not only for the media sensation he knew they would inspire, but also for their "long-legged natural strides." To Patou, his tall, slender American beauties represented nothing less than a "new breed." The Gibson Girl, their antecedent, was as much a reflection and response to changing social realities as she was a fashion icon.

It is in the 20th century, when this country established its political and economic hegemony in the world, that manifestations of American Style, which might formerly have been dismissed as quotidian, rude, or provincial—blue jeans and sneakers, for example—took on an international allure and authority. Likewise, it is in the period after the Second World War that the American Way of Life, and the global interest in American popular culture, has yielded so many new and influential styles from minority cultures and urban neighborhoods. Not surprisingly, the prime mechanisms for eroding and penetrating any provincial barriers and national boundaries have been film, television, and, increasingly, music video.

Indeed, from the start, Hollywood films were responsible for disseminating seductive images of American glamour to the rest of the world. By creating on-screen personae for studio stars, Hollywood films established a template of style obsessively followed by the public. While narratives provided the basis for costuming each star through the nuances of hair, makeup, and wardrobe, had to clearly define his or her celebrated image. Just as important as the images of the stars dressed for their movie roles was their depiction in "off the set" in fan magazines. Shown lounging poolside or serving drinks on a patio, they transmitted to the rest of the country and the world the leisurely pursuits of the Southern California lifestyle. In a country with an intransigently democratic ideology, a carefully cultivated and stylish elite was invented for the dreams and aspirations of a national and international following.

With the weakening of the studio's control over the lives of its contracted players, the ability of Hollywood to create personalities with iconic impact eroded. The influence of cinematic stars was eventually shared, and soon superceded, by their colleagues in the music and sports worlds. As early as the late 1910s and early 1920s, musicians of popular and vernacular styles projected a riveting aura of cool. A louche reputation and a casual disregard for establishment niceties contributed an edgy credibility not only to early jazz performers, but also to all the rock and rollers, rappers, and hip hop entrepreneurs who followed.

More recently, sports heroes, especially those who have introduced personalized nuances to their on-the-court and on-the-field dress, have been emulated by an enthusiastic public. While celebrity endorsements have a long history, at no other time have so many been compensated so well to promote all the services and accoutrements of contemporary life. Interestingly, apparel sporting team logos, once the Average Joe's weekend dress, has become the most ubiquitous export of American Style, at least in the inflated proportions of XXL jerseys and precariously suspended baggy jeans. Music videos, with hip-hop and rap performers who use streetwear to enhance their credibility, have become the international transmitters of the once anti-fashion fashion.

The cultivation of outsider status as a style strategy is not restricted to the music industry. As a subcultural *modus operandi*, self-definition achieved through a distinction from the majority, and a repudiation of mainstream sensibilities, can be seen in the zoot suit phenomenon of the late 1930s, the Beats of the 1940s and '50s, and the hippies in the 1960s. The zoot suit was a style that originated in urban black and Chicano communities and, like the contemporary vogue for hip-hop clothing, began as the style of a marginalized underclass. Beats and hippies, on the other hand, were often individuals of middle-class origins who sought to repudiate the conventions

of their upbringing, in effect creating their own cultural marginalization. Therefore, whether as stemming from a neighborhood gang or an informal social clique, American Style is as much the prerogative of subcultures as it is of the majority.

The variety that characterizes American Style, it might be argued, has always been a response to the cultural, political, and economic realities of the social experiment that is democracy, and a consequence of the power of the egalitarian body politic. But the diversity of its expression is amplified by an American confidence in the future—a belief that the new is almost invariably progressive. This attitude facilitates the adaptation of novel and inventive forms, even when they are in opposition to prevailing tastes. At the same time, this country's extraordinary opportunities for social mobility are coincident with the freedom to shift at will from one social role, celebrity identification, romantic narrative, or political statement to another. American Style's multiplicity of paradigms encourages such slippage of roles and experimentation with identity if only as a weekend road warrior on his "hog" or a suburban girl cruising the mall in her "banjee girl" outfit. The land of opportunity holds the possibility of constant self-invention, for American Style has always been as much about a plethora of choices as it is about the freedom to choose. Like a map of the country with each state a distinct entity defined as pink, blue, yellow, or green, but contributing to the overall identity of the larger federation, American Style is a sum of colorful parts.

HAROLD KODA

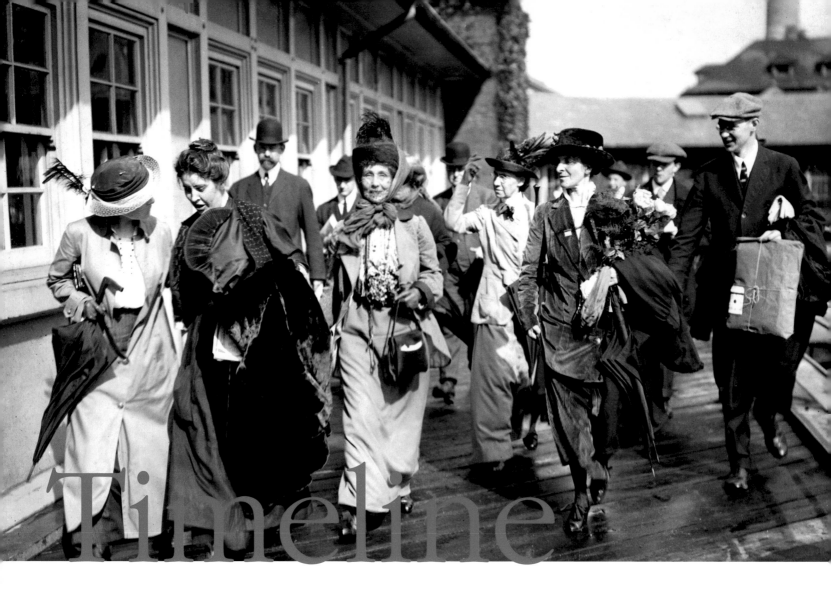

Timeline

19TH CENTURY

1809: Dolley Madison serves as First Lady between 1809 and 1817, and is renowned for her sense of style.

1848: First women's rights convention is held in Seneca Falls, NY, the brainchild of Elizabeth Cady Stanton.

1867: *Harper's Bazaar* is founded.

1886: Coca Cola, invented by Dr. John Pemberton of Atlanta, GA, adds historical effervescence to the beverage industry.

20TH CENTURY

1900: Eastman Kodak's Brownie camera is first sold, for one dollar.

1902: The Chicago Coliseum opens a public roller skating rink. Over 7,000 people attend the opening night.

1906: Madame C.J. Walker opens her first commercial venture in Denver, CO, manufacturing and distributing hair care products. She goes on to become one of the leading African-American business-women of the early 20th century.

1913: The Armory Show in New York City introduces Post-Impressionism and Cubism to the United States. The Woolworth Building opens in New York City.

TWENTIES

1920: American women gain the right to vote.

1921: Margaret Gorman is the first Miss America.

1922: Emily Post publishes *Etiquette in Society, in Business, in Politics, and at Home.*

1830: *Godey's Lady's Book* enjoys immense popularity and becomes the leading fashion and women's interest publication, paving the way for periodicals like *Ladies Home Journal.*

The Declaration of Sentiments and Resolutions is adopted, based on the Declaration of Independence, declaring that "all men and women are created equal."

1876: Alexander Graham Bell patents what he called the "electrical speech machine" and what we now call the telephone. Mark Twain publishes *Tom Sawyer.*

1892: *Vogue* magazine is founded.

1893: The Sears & Roebuck catalogue is introduced.

1907: Neiman Marcus, specializing in ready-to-wear clothing, is founded by Herbert Marcus, his sister, Carrie Marcus Neiman, and her husband, Al Neiman, in Dallas, TX.

1908: Bakelite jewelry is invented by Leo Baekeland.

1909: The first meeting of the Bohemian Club, an elite male secret society, in Bohemian Grove outside of San Francisco.

1914: Dancer Irene Castle bobs her hair starting a craze.

1917: Converse's "Chuck Taylor" canvas basketball shoe is born.

1919: Prohibition begins (ends 1933).

1924: Cecil B. DeMille releases *The Ten Commandments. Time* magazine begins publication.

1925: F. Scott Fitzgerald publishes *The Great Gatsby.*

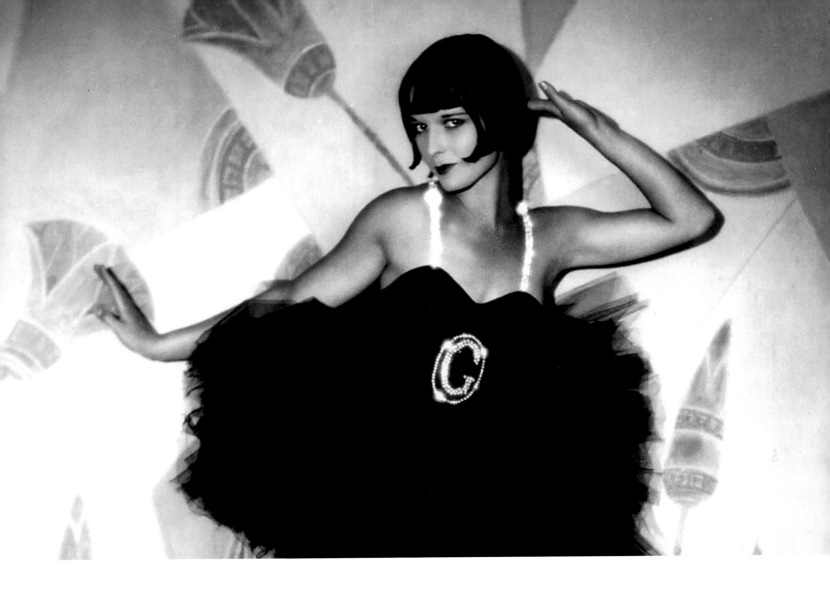

THIRTIES

FORTIES

FIFTIES

1927: *The Jazz Singer* with Al Jolson becomes the first "talkie." Charles A. Lindbergh flies the Spirit of St. Louis non-stop from New York to Paris, in 33.5 hours. Josephine Baker takes Paris by storm. Disney releases the first cartoon starring Mickey Mouse.

1931: The Empire State Building opens.

1933: *King Kong* opens, causing a sensation. President Franklin D. Roosevelt introduces the New Deal.

1937: *Mademoiselle* magazine begins publication. Roma Whitney, 17, is selected as the first "Breck Girl" because of her all-American hair and smile. She is made the official face of Breck, and a registered trademark, in 1951.

1939: The film version of *Gone With the Wind* wins the Academy Award for Best Picture. Nylon stockings first appear.

1941: America joins World War II after Pearl Harbor.

1943: Rodger's and Hammerstein's *Oklahoma!* begins a five-year, 2,248-con-secutive-performance run on Broadway. Zoot suit race riots erupt in Los Angeles.

1947: The Polaroid Land camera is introduced. Christian Dior unveils his "New Look."

1949: Pro-Keds are born.

1950: The "letterman" sweater is popular.

1951: Color television is introduced.

1952: Jack O'Neill designs the first neoprene wetsuits. Ray-Ban introduces Wayfarer sunglasses. Mr. Potato-head is patented.

1929: Black Thursday at the NYSE begins the Great Depression, which lasts until 1939.

1932: Dashiell Hammet releases the first of his Thin Man detective books. Amelia Earhart is the first woman to fly solo across the Atlantic.

1936: The penny loafer is created by GH Bass. Union Pacific engineers create the first chairlift in Sun Valley, CA. *Gone with the Wind* wins the Pulitzer Prize for Best Novel. Cole Porter's "It's De-Lovely" is a hit.

1938: Tupperware introduces a new method of food storage.

1939-1945: World War II

1945: Aaron Copland's "Appalachian Spring" composed for a Martha Graham ballet, wins the Pulitzer Prize for music.

1950-1953: Korean War

1957: The Soviet Union launches the Sputnik I satellite. Jack Kerouac's *On The Road* is published. The number of female voters equals that of male voters for first time. Everready produces the first AA batteries.

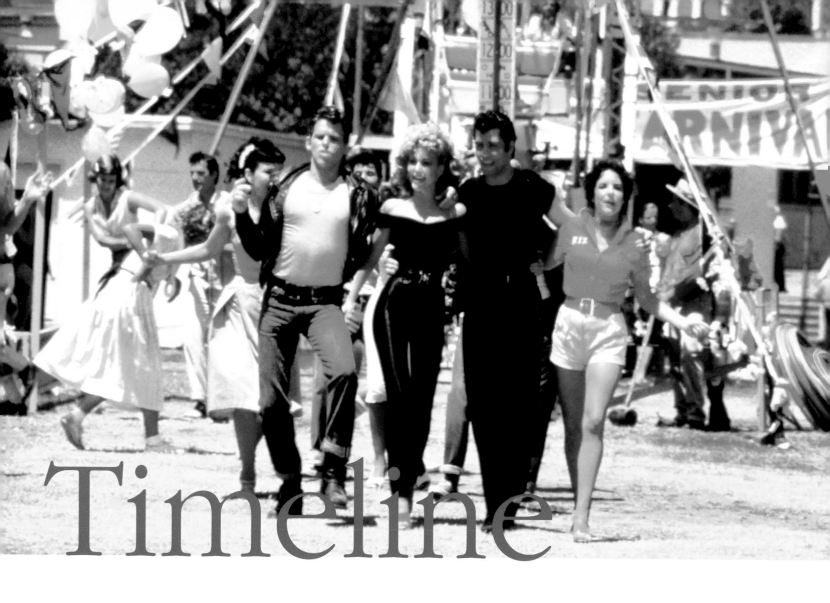

Timeline

SIXTIES

1958: The Hula Hoop is invented by Richard Knen and Arthur "Spud" Melon.

1959: The new home of the Guggenheim Museum, designed by Frank Llyod Wright, opens in New York City.

1961: John F. Kennedy is inaugurated. He does not wear a hat while wife, Jackie, wears a pillbox hat by Halston. Audrey Hepburn stars in *Breakfast at Tiffany's*, wearing clothes designed by Givenchy and styled by Edith Head.

1962: John Glenn is the first American to orbit the earth. Cuban missile crisis.

1963: President Kennedy is assassinated in Dallas. Andy Warhol, Robert Rauschenberg, and Jasper Johns participate in the Guggenheim.

1964: The Beatles perform on *The Ed Sullivan Show*, during their first tour of the U.S. The Civil Rights Act is passed, prohibiting discrimination on the basis of sex, race, religion, or national origin.

1967: There is a surge in peace demonstrations and civil disobedience against American participation in the Vietnam War. The film *Bonnie and Clyde* inspires "gangster chic" style.

1969: Apollo 11 lands on the moon. Neil Armstrong makes "One small step for man, one giant leap for mankind." Phil Knight designs and creates a high-performance running shoe—the "Nike dynasty" begins.

SEVENTIES

1970: Student protesters are killed at Kent State, OH. Ali McGraw becomes a star in *Love Story*.

1973: Abortion becomes legal in the United States after the Supreme Court decision *Roe v. Wade*.

1960: The FDA approves the first birth control pill in the United States.

The Berlin Wall is erected. President John F. Kennedy establishes the Peace Corps.

Museum's Pop Art exhibition, featuring renderings of soup cans, comic strip-style silk screens, and inflatable sculpture. Betty Friedan publishes *The Feminine Mystique*.

Ford Motor Company revolutionizes the automotive industry with the introduction of the Mustang. "Baby Love," by the Supremes, tops the chart.

1968: Calvin Klein establishes his fashion empire. Robert Kennedy is assassinated. Martin Luther King is assassinated. Tom Wolfe's *The Electric Kool-Aid Acid Test* is published.

The Gap opens its first store in San Francisco, CA.

1971: *Jesus Christ Superstar* debuts on Broadway.

1972: Ralph Lauren launches his eponymous label. The Watergate break-in takes place. *The Godfather* is released.

Fashion show to benefit the restoration of Versailles featured American designers Bill Blass, Anne Klein, Oscar de la Renta, Halston, and Stephen Burrows, who show Europe what "cool" looks like.

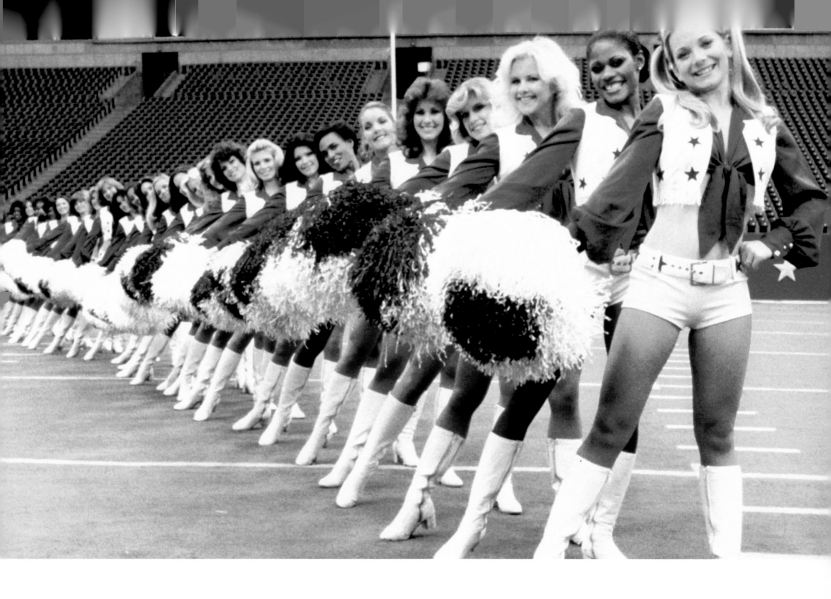

EIGHTIES

NINETIES 21ST CENTURY

1974: President
Richard M. Nixon
resigns over the
Watergate scandal.
The oil crisis leads to
a gasoline shortage.

1975: The Fall of
Saigon marks the end
of the Vietnam War.

1977: *Saturday Night
Fever* popularizes
disco.

1978: The Love Canal,
in Niagara Falls, New
York, becomes one
of the biggest environ-
mental tragedies.

1981: Sandra Day
O'Connor becomes the
first woman appointed
to the U.S. Supreme
Court.
Sally K. Ride becomes
the first American
woman in space.
Banana Republic
opens, selling safari
surplus clothing.

1983: *Flashdance*
launches a fad for off-
the-shoulder tops.
Sony revolutionizes
music listening with
the Walkman.
The first case of AIDS
is discovered.
On August 1, MTV
airs for the first time.

1985: Hachette
Filipacchi launches
American *ELLE*.
Donna Karan's brand
is established.
Actor Rock Hudson
dies from AIDS-related
causes.

1987: Iran-Contra
hearings are held.
Tom Wolfe's *Bonfire
of the Vanities* is
published.

1991: Collapse of
the Soviet Union.
Nirvana releases
"Smells like Teen
Spirit."
Anna Sui holds her
first runway show.

2000: Cell phones
are widespread.

2001: Attack on the
World Trade Center
and the Pentagon.

2004: Designer
Stephen Sprouse
dies at 50.
The corner of East 2nd
Street and the Bowery,
near CBGBs,
is renamed "Joey
Ramone Place"
after the lead singer
of the punk band
the Ramones.

1976: Punk rock hits
the Roxy nightclub
in London's Covent
Garden when Billy Idol
performs for the
first time with
Generation X.
Charlie's Angels begins
its first TV season.

1979: Designer jeans
become popular.
Iran hostage crisis.
Three Mile Island
nuclear meltdown.

1982: Moonies, follow-
ers of the Reverend
Sun Myung Moon,
hold a mass wedding
in Madison Square
Garden.
Sony and Philips
jointly develop
the compact disc.

1984: Apple releases
the Mac computer.
Tommy Hilfiger starts
his own label.
Madonna releases
Like A Virgin.

1989: Fall of the
Berlin Wall.
Baywatch becomes
a phenomenon
portraying "typical"
California lifeguards.

1992: The World Wide
Web becomes available
to the general public.

1999: Y2K Millennium
Countdown

2002: Japanese artist
Takashi Murakami is
chosen by Marc Jacobs
at Louis Vuitton to
design a series of bags.
Knock-offs are seen
from New York
to Tokyo.
Bill Blass dies at 80.

Designer Isaac Mizrahi
teams up with Target
to create a line of fun,
affordable clothing for
the average American
woman.

C

CANVAS SHOE

With its lightweight canvas upper and thick sole made of vulcanized crepe rubber, the canvas shoe was initially favored by tennis champions. But its sleek shape soon moved it off the courts and into everyday leisure-time activities, evolving into the ultimate '50s shoe.

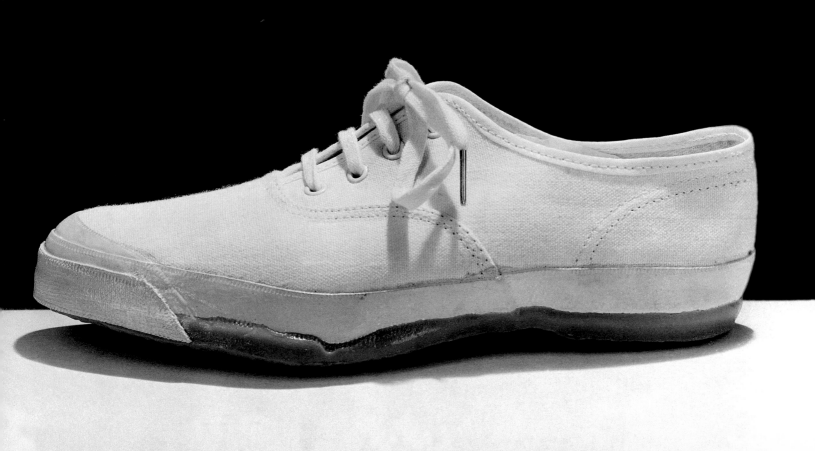

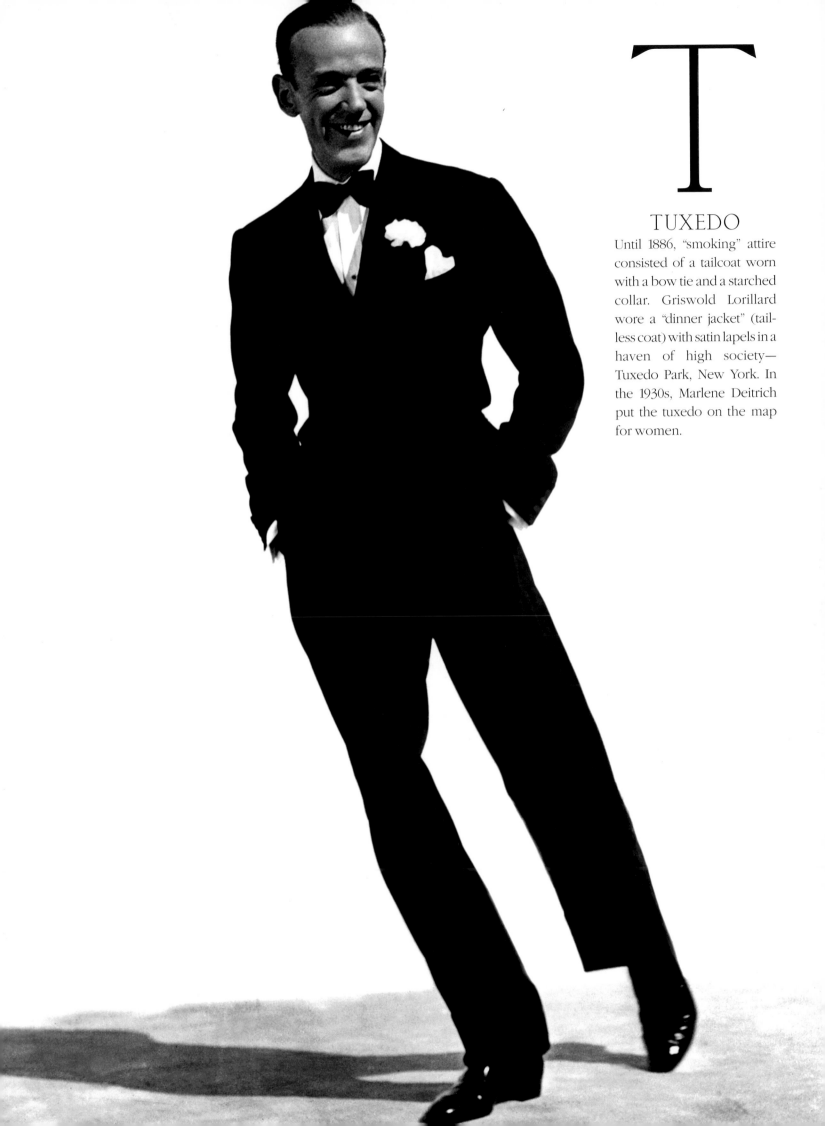

T

TUXEDO

Until 1886, "smoking" attire consisted of a tailcoat worn with a bow tie and a starched collar. Griswold Lorillard wore a "dinner jacket" (tailless coat) with satin lapels in a haven of high society—Tuxedo Park, New York. In the 1930s, Marlene Deitrich put the tuxedo on the map for women.

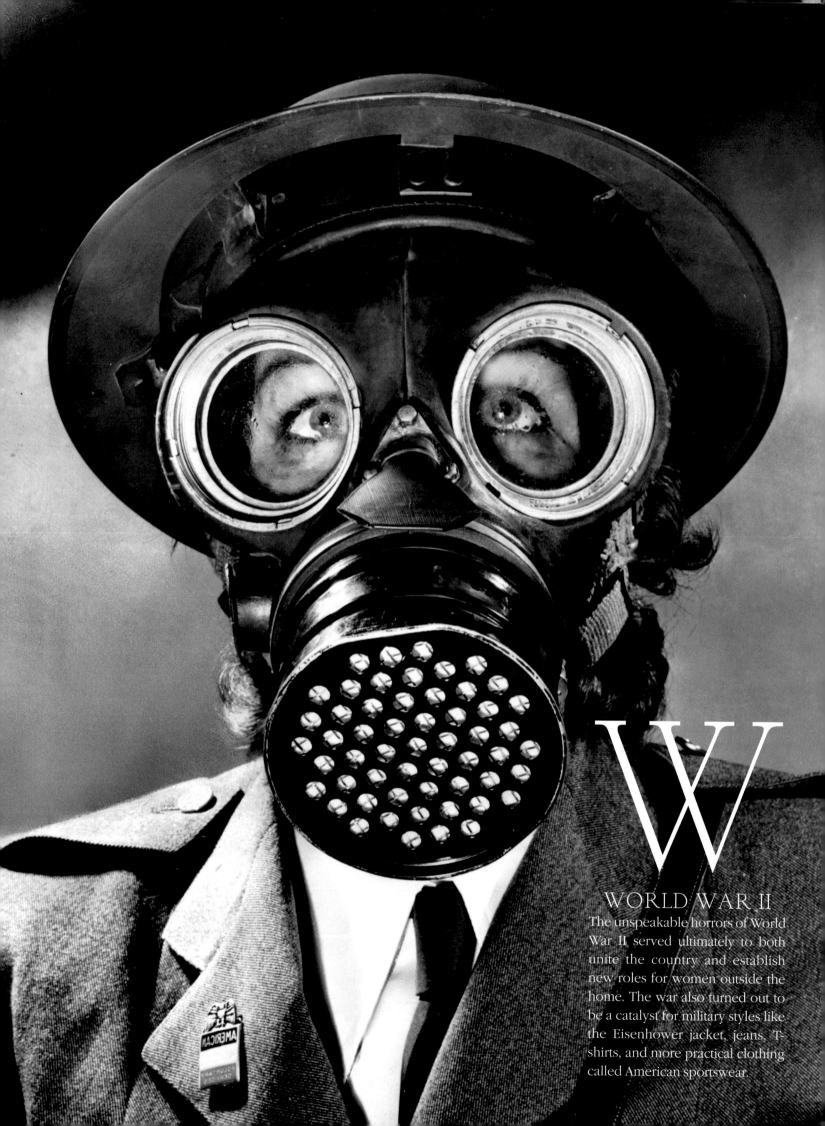

W

WORLD WAR II

The unspeakable horrors of World War II served ultimately to both unite the country and establish new roles for women outside the home. The war also turned out to be a catalyst for military styles like the Eisenhower jacket, jeans, T-shirts, and more practical clothing called American sportswear.

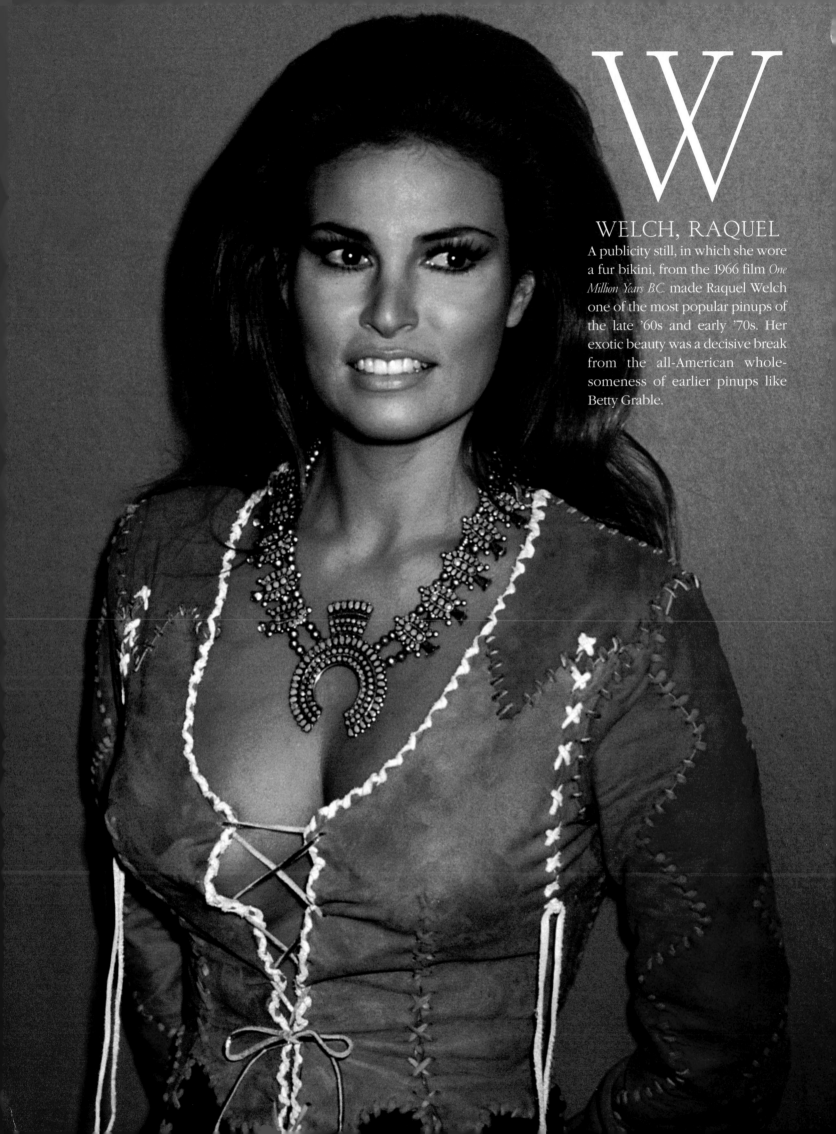

W

WELCH, RAQUEL

A publicity still, in which she wore a fur bikini, from the 1966 film *One Million Years B.C.* made Raquel Welch one of the most popular pinups of the late '60s and early '70s. Her exotic beauty was a decisive break from the all-American wholesomeness of earlier pinups like Betty Grable.

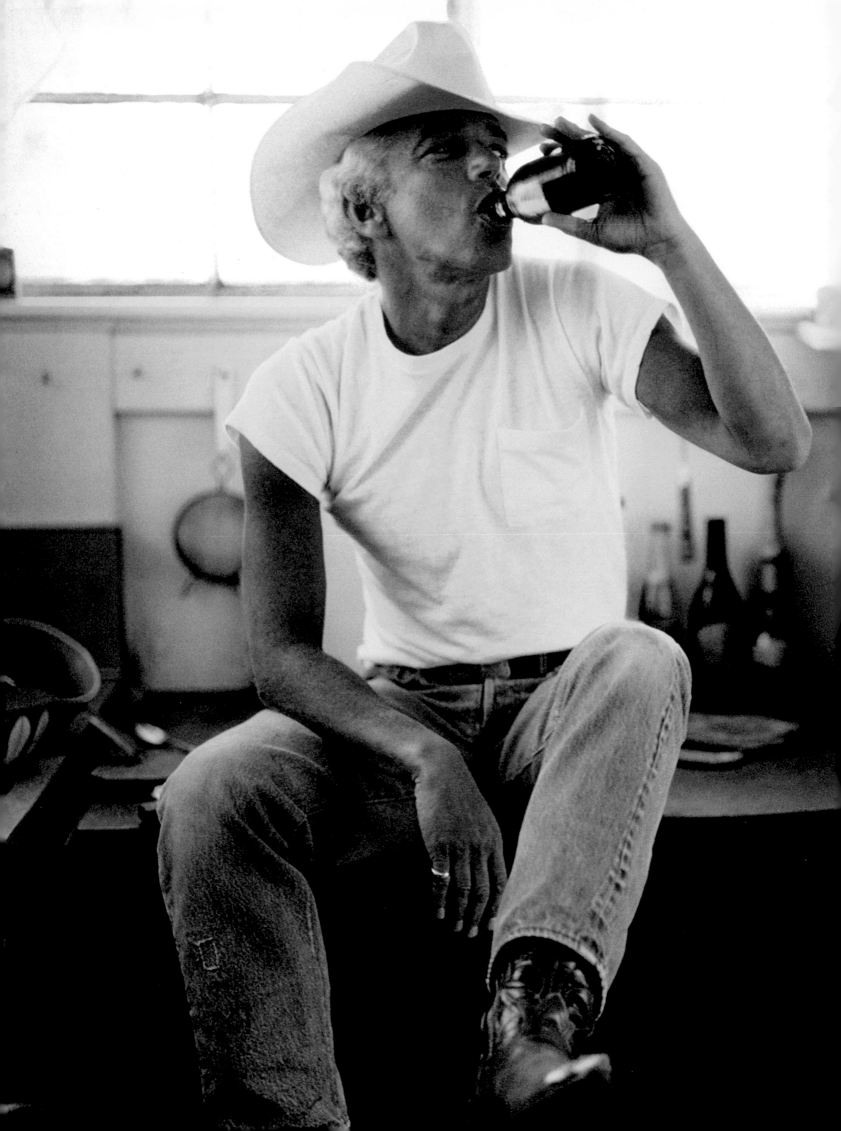

L
LAUREN, RALPH

Ralph Lauren began by making striped ties and ended up creating a uniform that invokes Old World charm. His all-American label has become a rite of passage for men and women throughout the world.

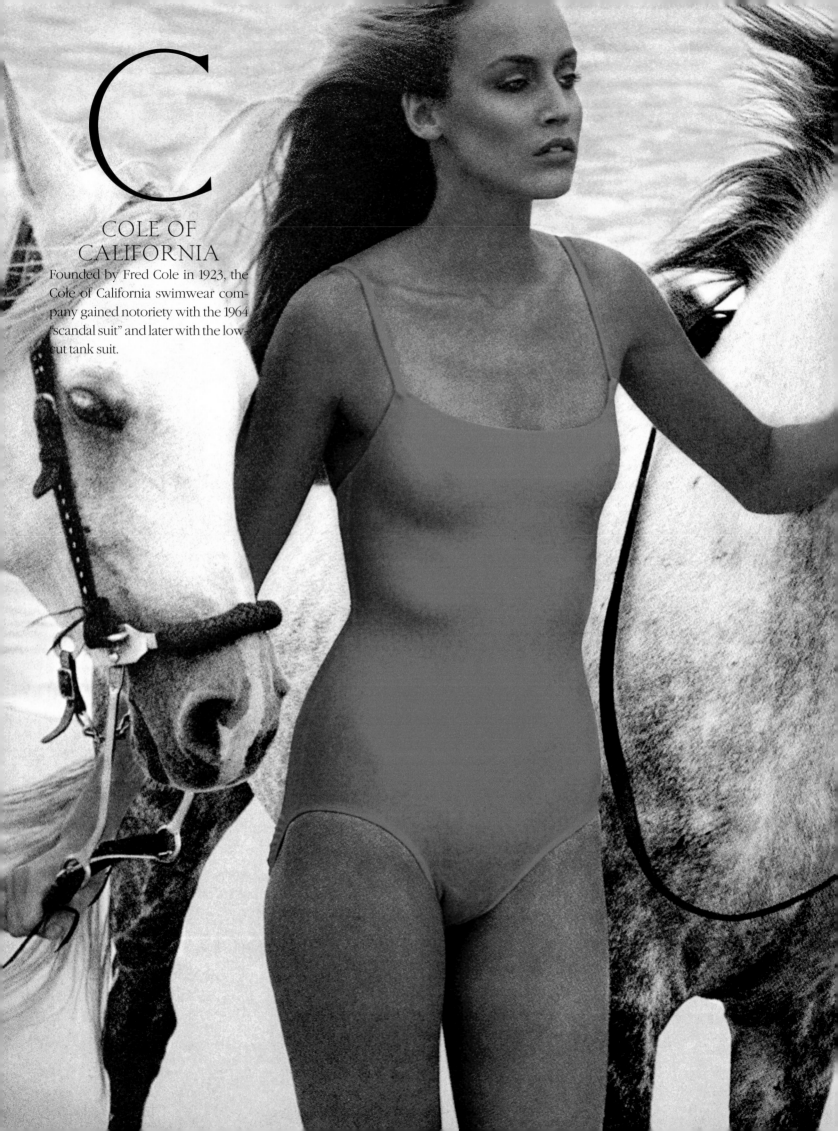

C

COLE OF CALIFORNIA

Founded by Fred Cole in 1923, the Cole of California swimwear company gained notoriety with the 1964 "scandal suit" and later with the low-cut tank suit.

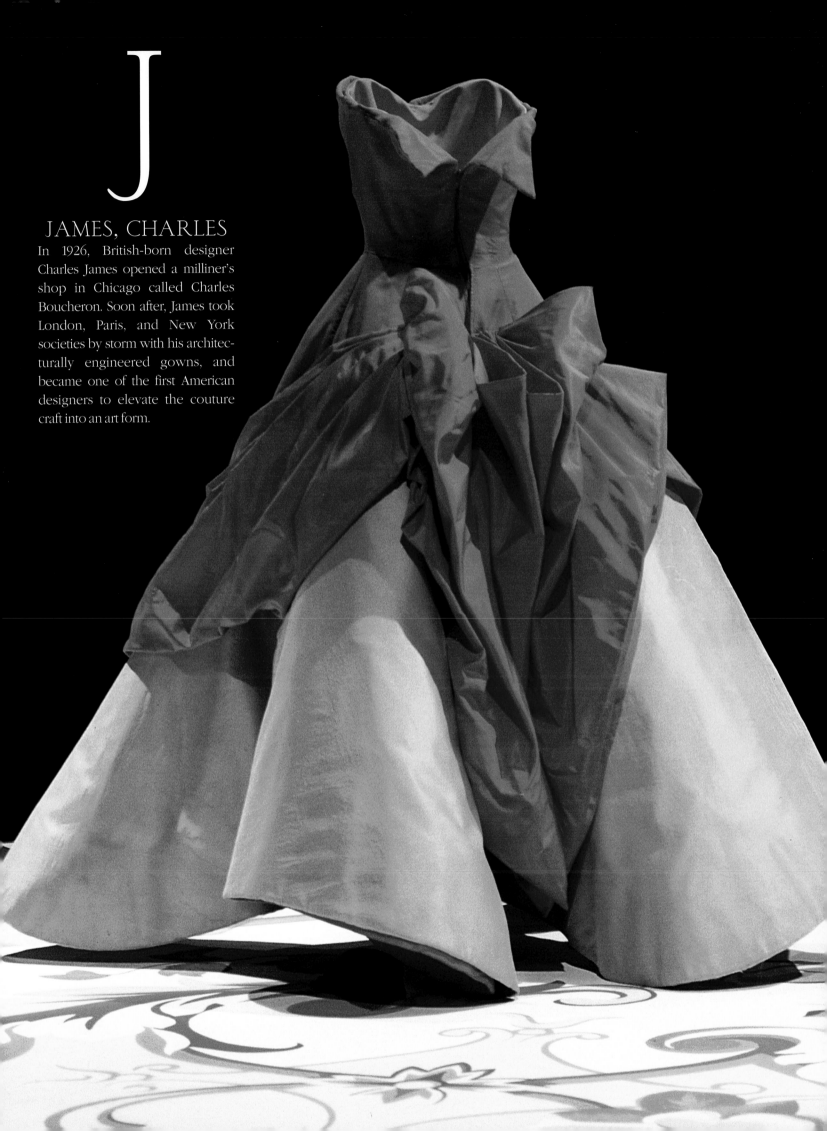

J

JAMES, CHARLES

In 1926, British-born designer Charles James opened a milliner's shop in Chicago called Charles Boucheron. Soon after, James took London, Paris, and New York societies by storm with his architecturally engineered gowns, and became one of the first American designers to elevate the couture craft into an art form.

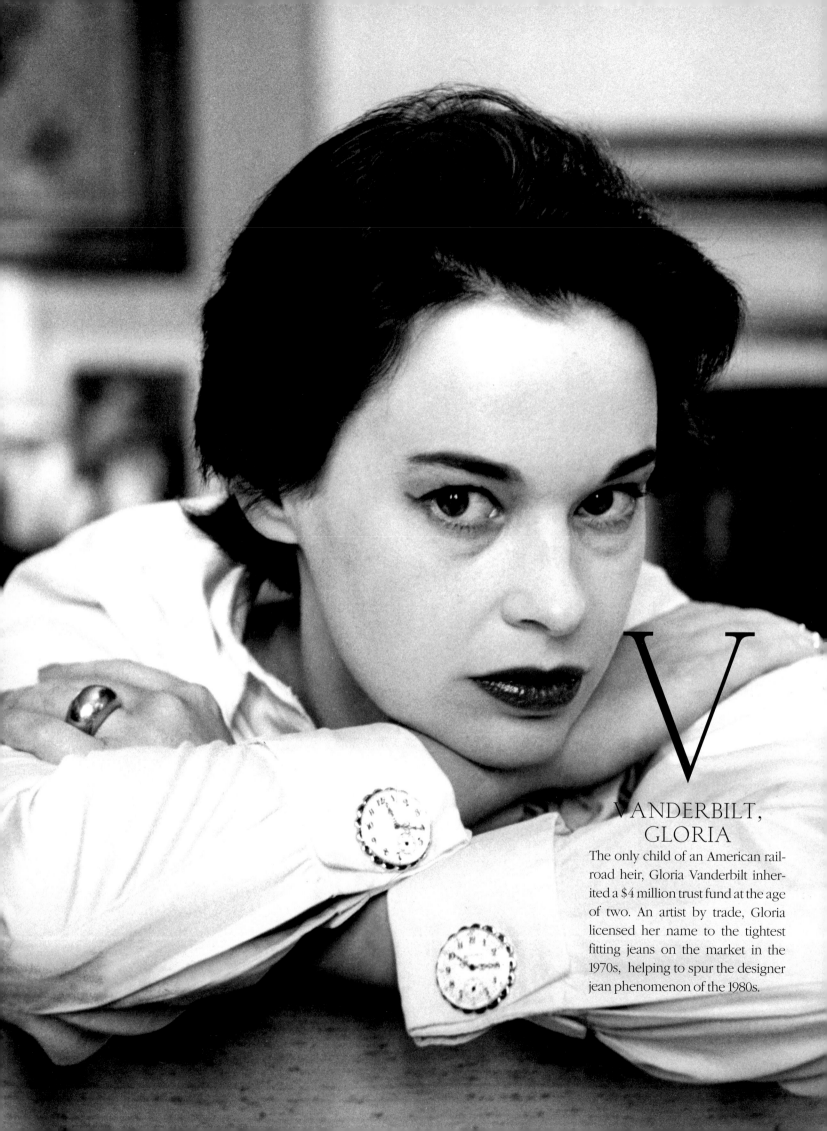

V

VANDERBILT, GLORIA

The only child of an American railroad heir, Gloria Vanderbilt inherited a $4 million trust fund at the age of two. An artist by trade, Gloria licensed her name to the tightest fitting jeans on the market in the 1970s, helping to spur the designer jean phenomenon of the 1980s.

S

STEINEM, GLORIA

Gloria Steinem wrote a *A Bunny's Tale*, which deflated the Playboy bunny myth, cofounded *New York* magazine, and founded *Ms* magazine. Her most powerful achievement was to empower women with the idea that they had choices.

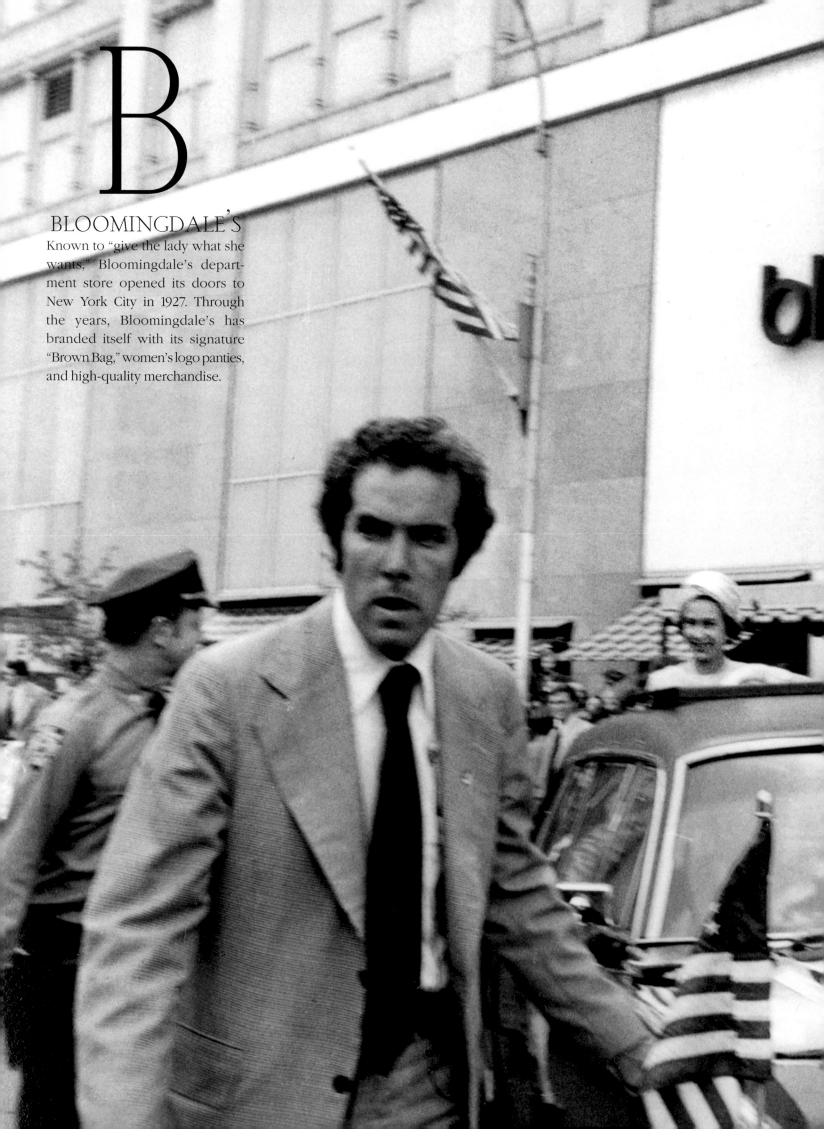

B

BLOOMINGDALE'S

Known to "give the lady what she wants," Bloomingdale's department store opened its doors to New York City in 1927. Through the years, Bloomingdale's has branded itself with its signature "Brown Bag," women's logo panties, and high-quality merchandise.

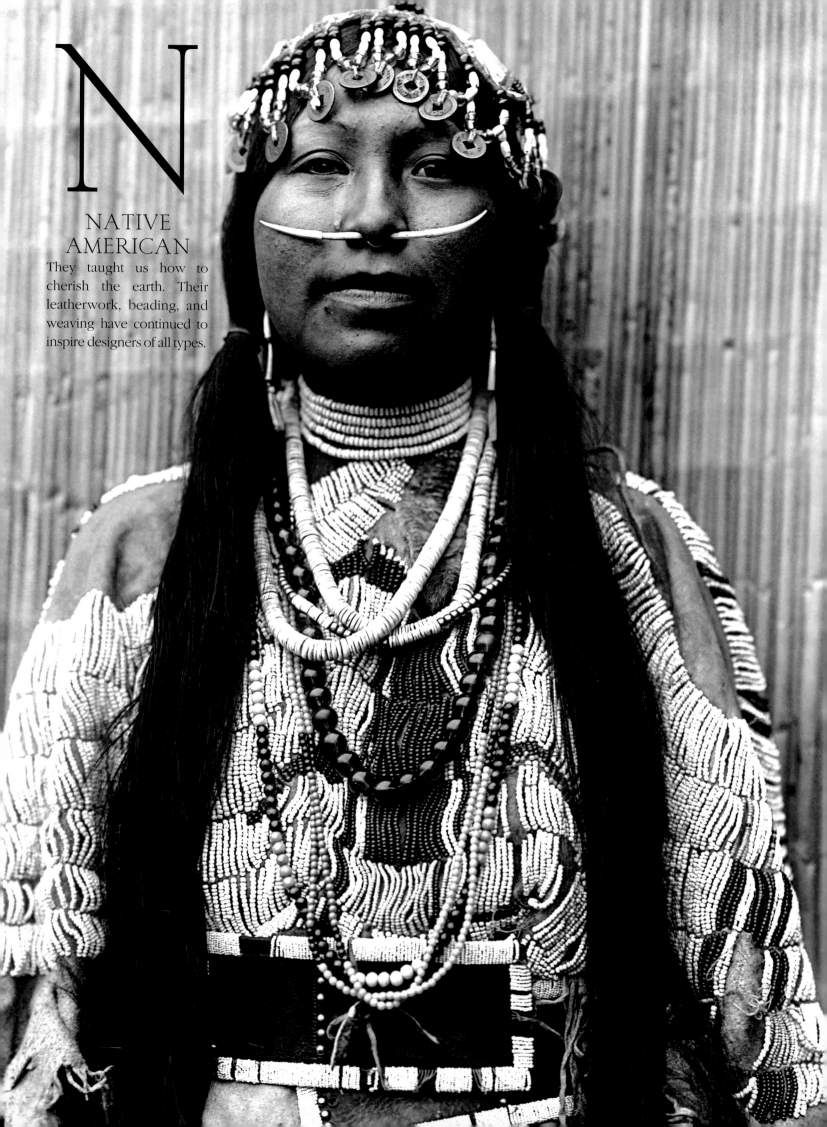

N

NATIVE AMERICAN

They taught us how to cherish the earth. Their leatherwork, beading, and weaving have continued to inspire designers of all types.

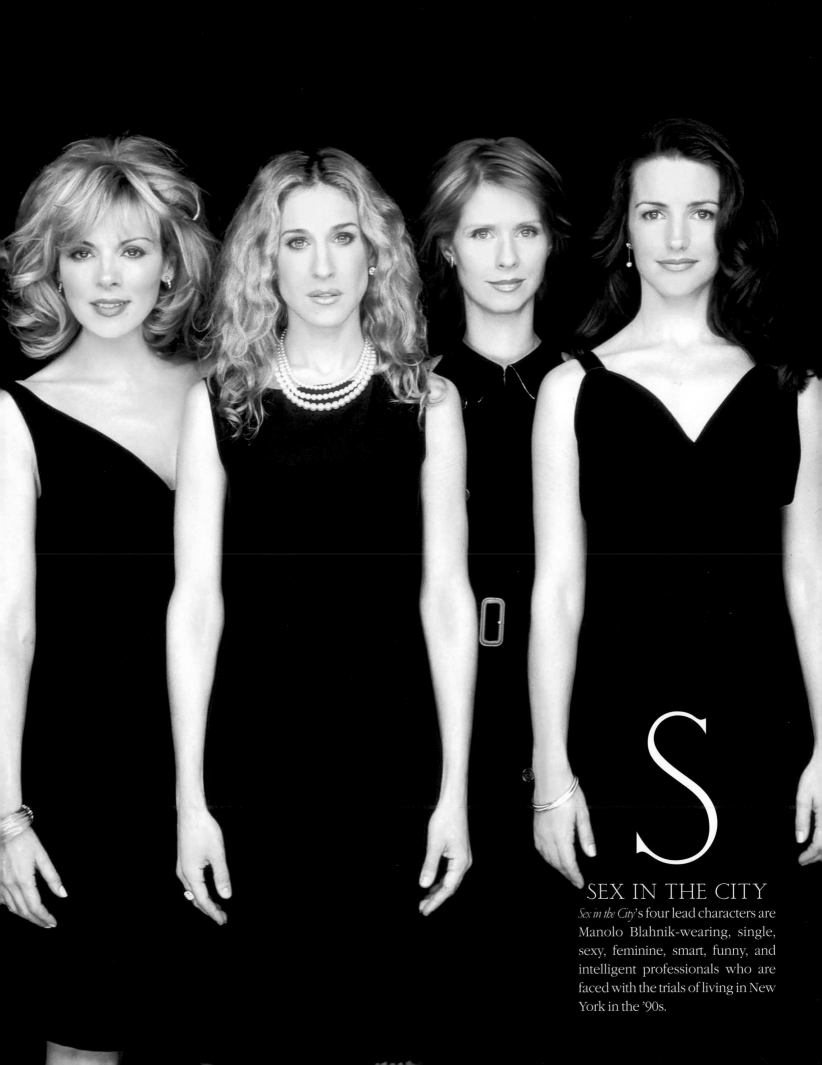

S

SEX IN THE CITY

Sex in the City's four lead characters are Manolo Blahnik-wearing, single, sexy, feminine, smart, funny, and intelligent professionals who are faced with the trials of living in New York in the '90s.

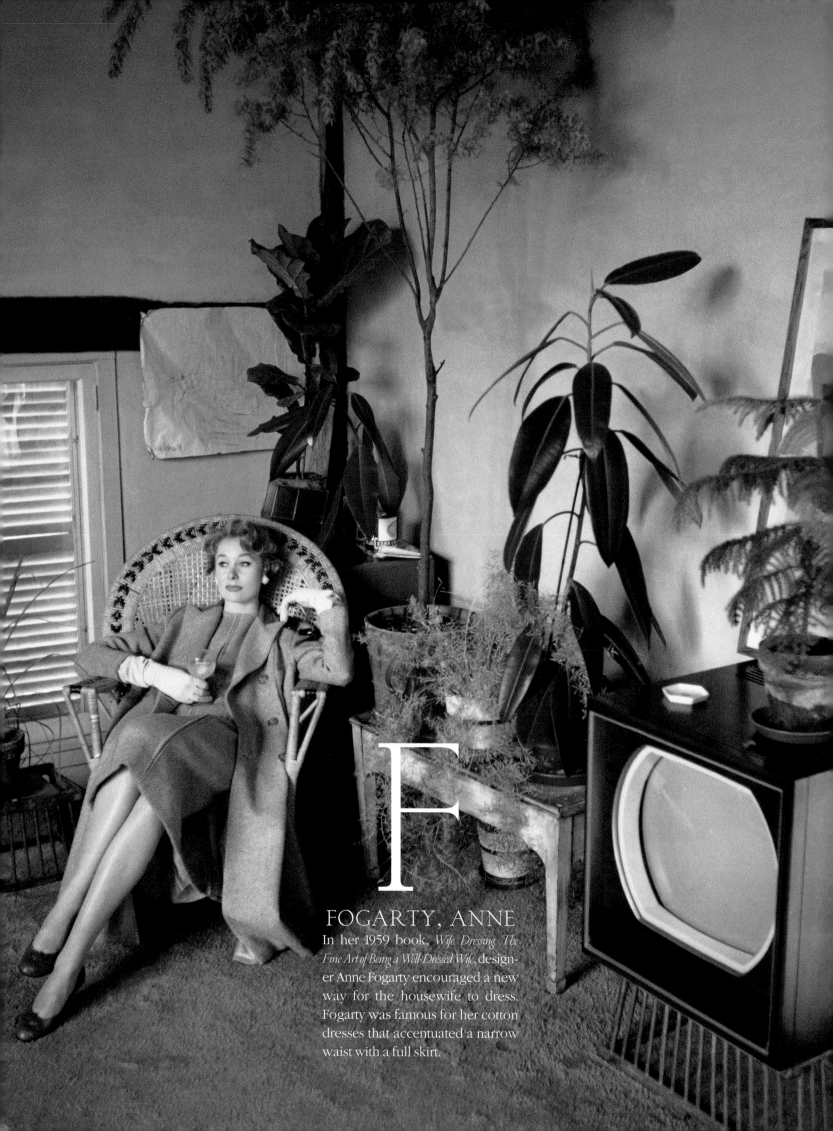

F

FOGARTY, ANNE

In her 1959 book, *Wife Dressing The Fine Art of Being a Well-Dressed Wife*, designer Anne Fogarty encouraged a new way for the housewife to dress. Fogarty was famous for her cotton dresses that accentuated a narrow waist with a full skirt.

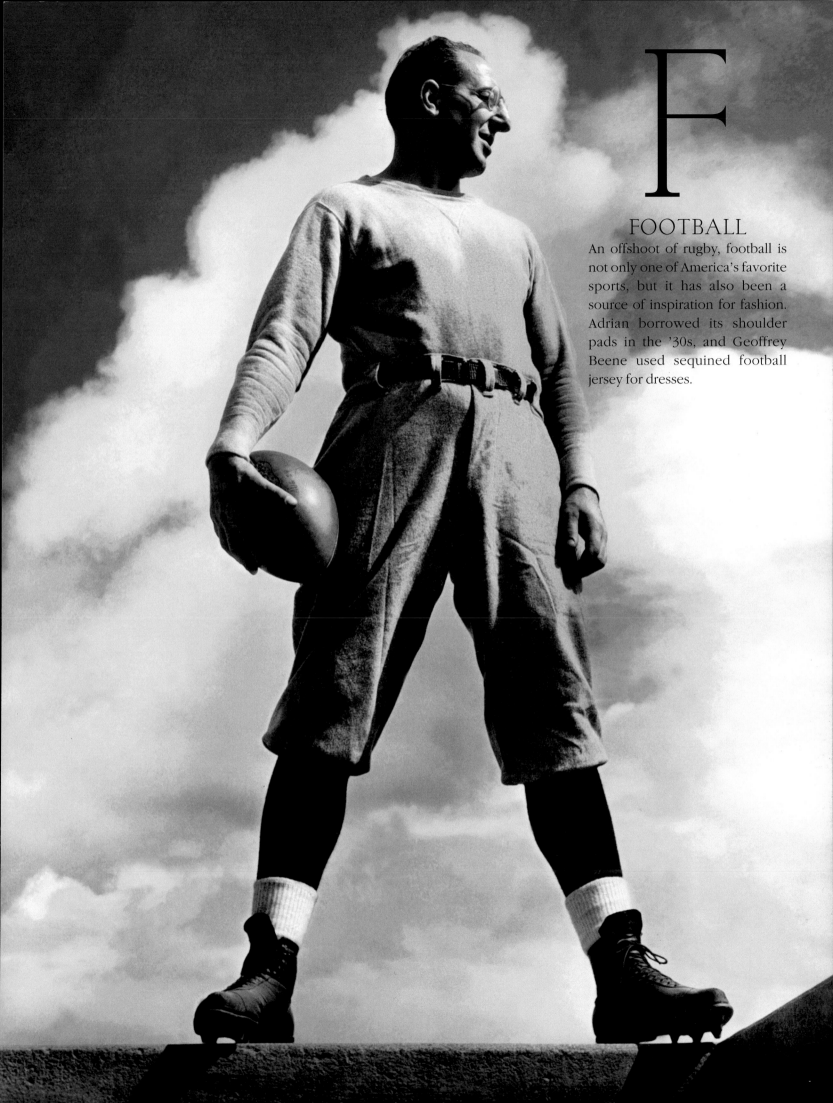

F

FOOTBALL

An offshoot of rugby, football is not only one of America's favorite sports, but it has also been a source of inspiration for fashion. Adrian borrowed its shoulder pads in the '30s, and Geoffrey Beene used sequined football jersey for dresses.

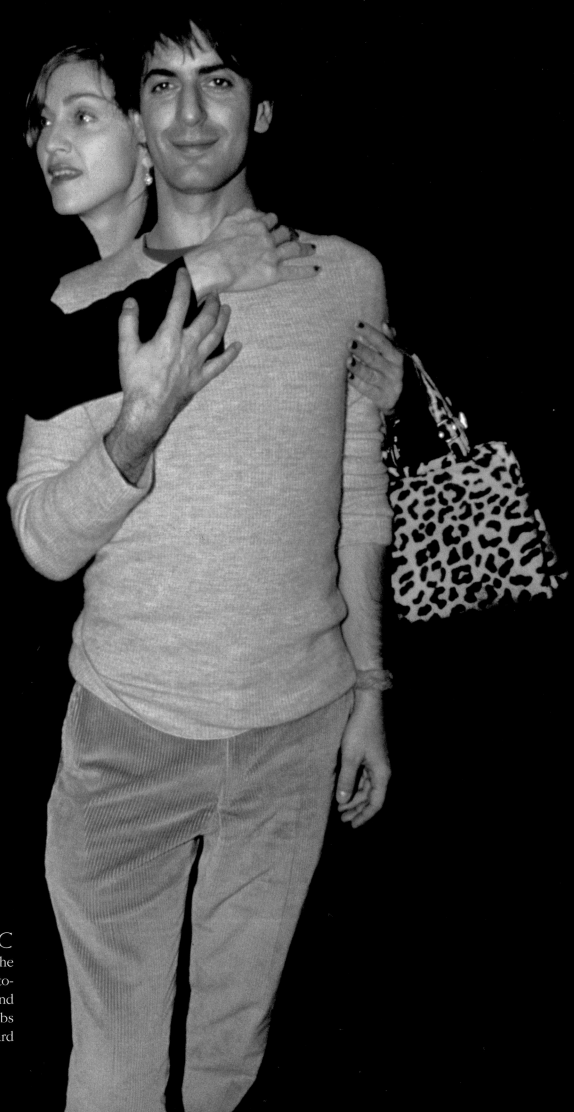

J

JACOBS, MARC

Inspired by music from the Mudd Club and the photographs of Jürgen Teller and David Sims, Marc Jacobs finds beauty in the awkward and imperfect.

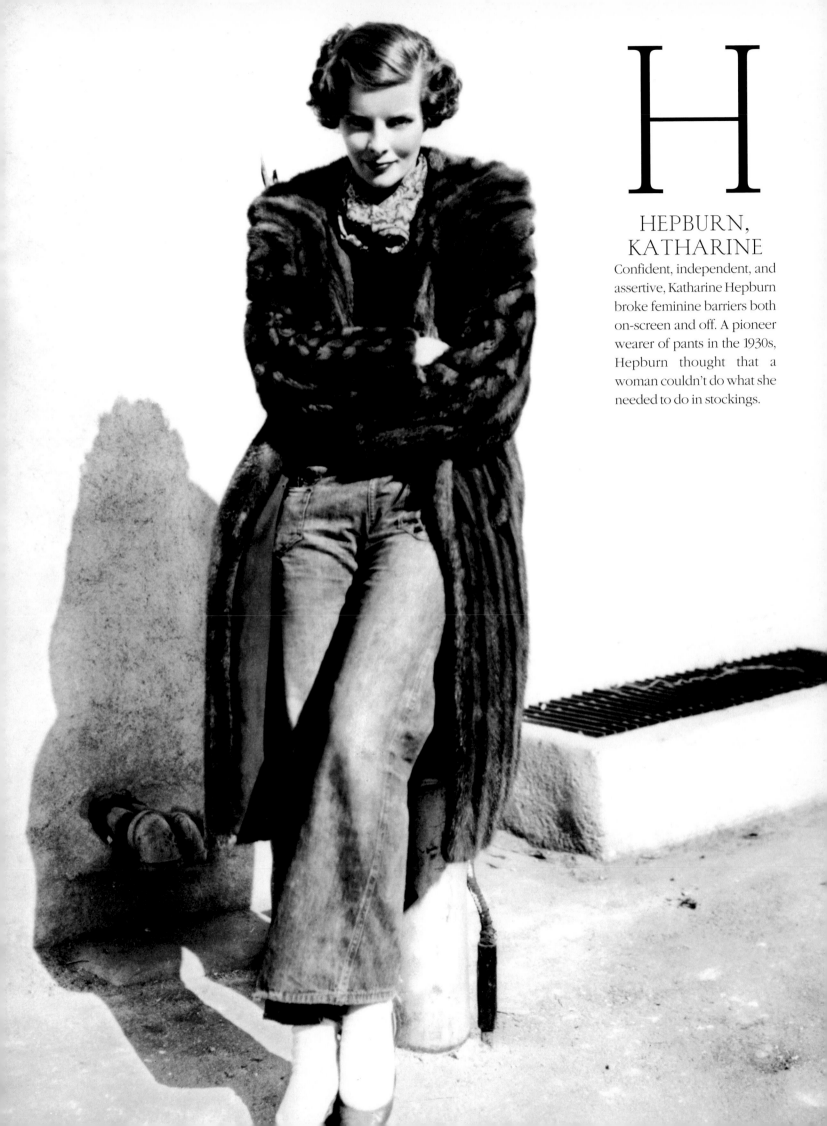

H

HEPBURN, KATHARINE

Confident, independent, and assertive, Katharine Hepburn broke feminine barriers both on-screen and off. A pioneer wearer of pants in the 1930s, Hepburn thought that a woman couldn't do what she needed to do in stockings.

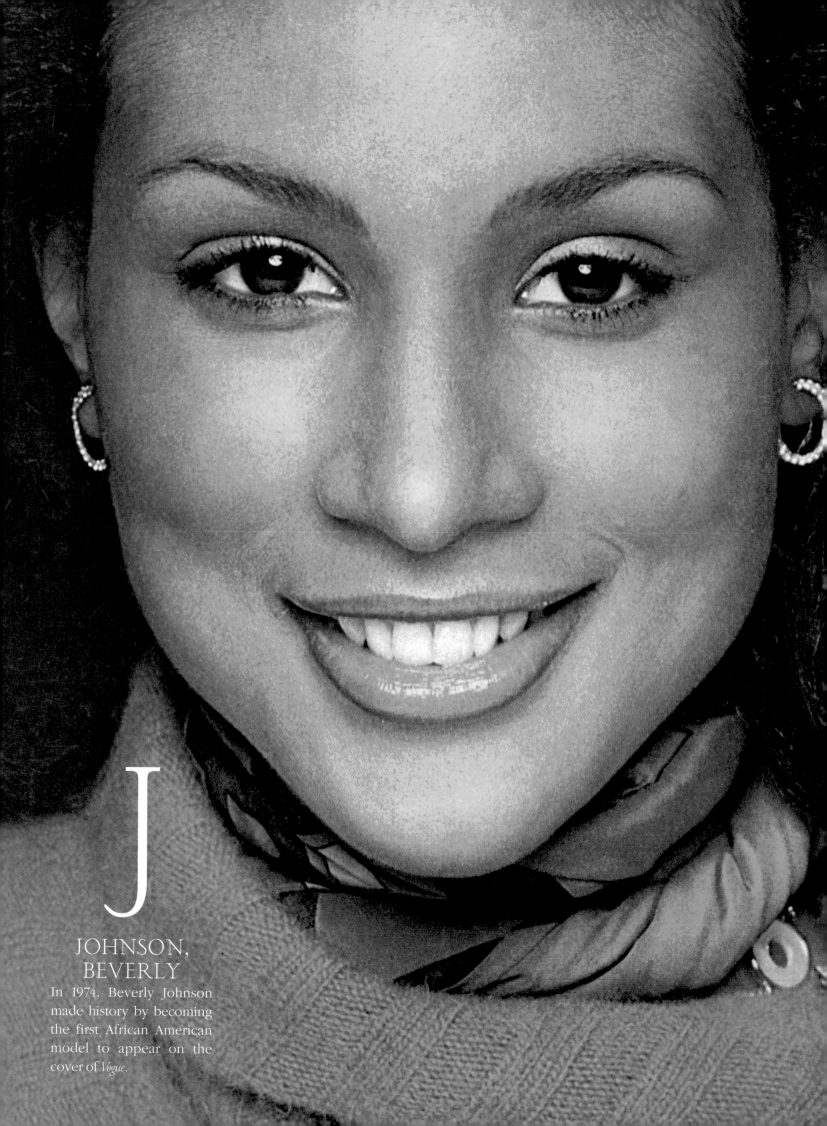

J

JOHNSON, BEVERLY

In 1974, Beverly Johnson made history by becoming the first African American model to appear on the cover of *Vogue*.

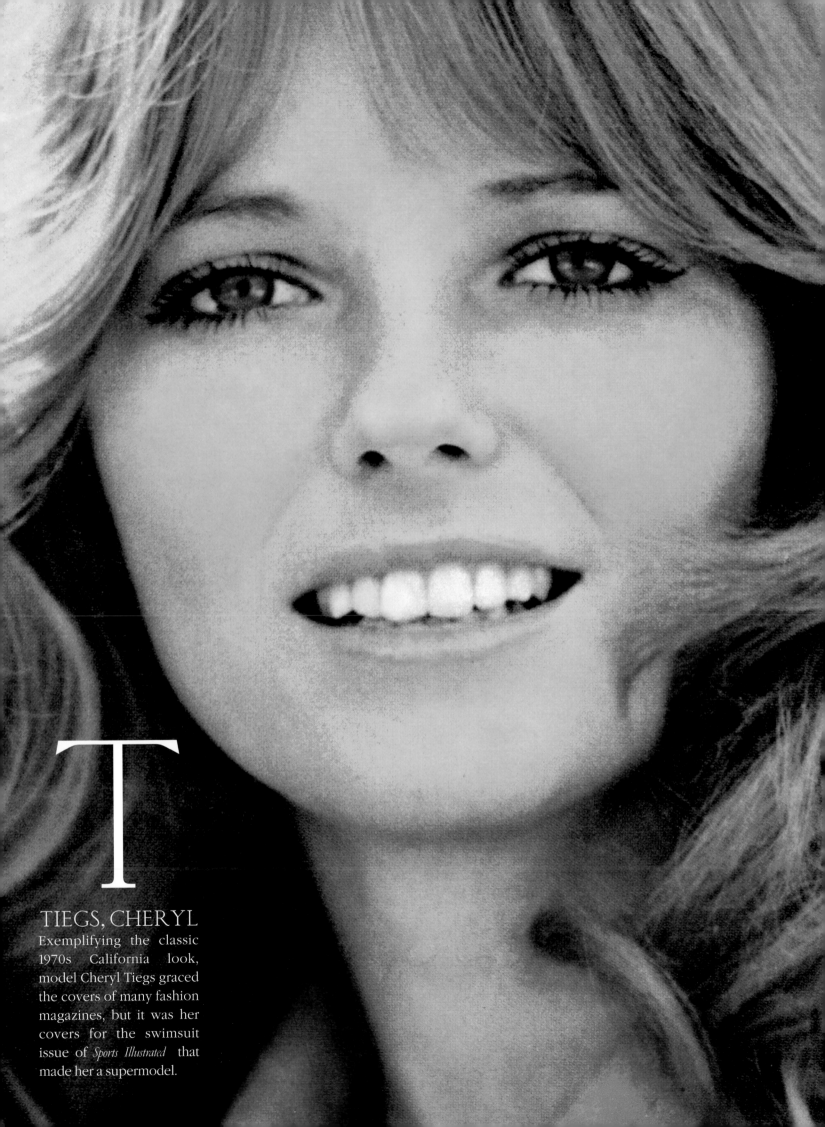

T

TIEGS, CHERYL

Exemplifying the classic 1970s California look, model Cheryl Tiegs graced the covers of many fashion magazines, but it was her covers for the swimsuit issue of *Sports Illustrated* that made her a supermodel.

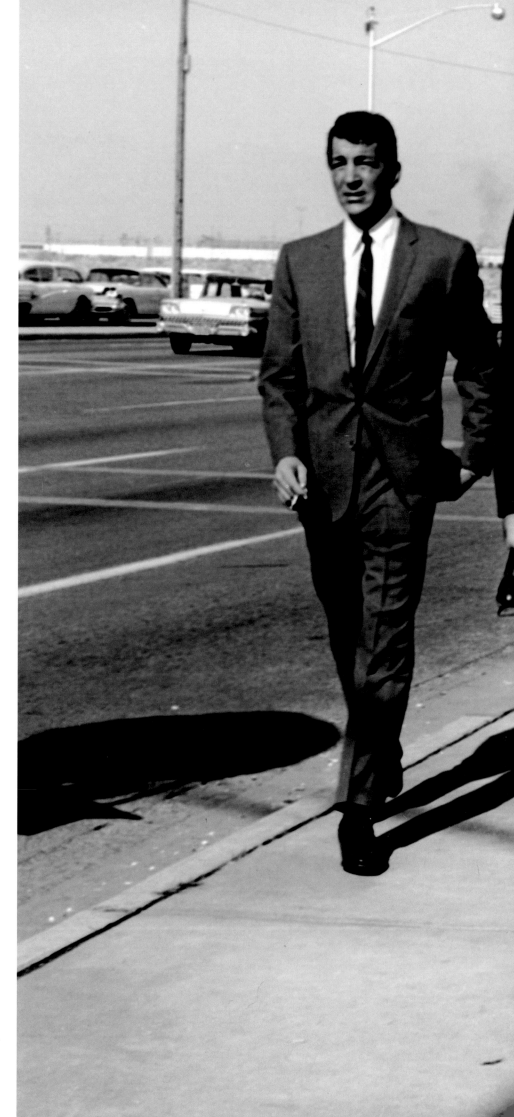

R

THE RAT PACK

Dubbed "the Rat Pack" by Lauren Bacall after she saw them recovering from a five-day rampage in Las Vegas, this slick quintet—Frank Sinatra, Dean Martin, Sammy Davis, Jr., Peter Lawford, and Joey Bishop—were the original stars of the 1960 movie *Ocean's Eleven*.

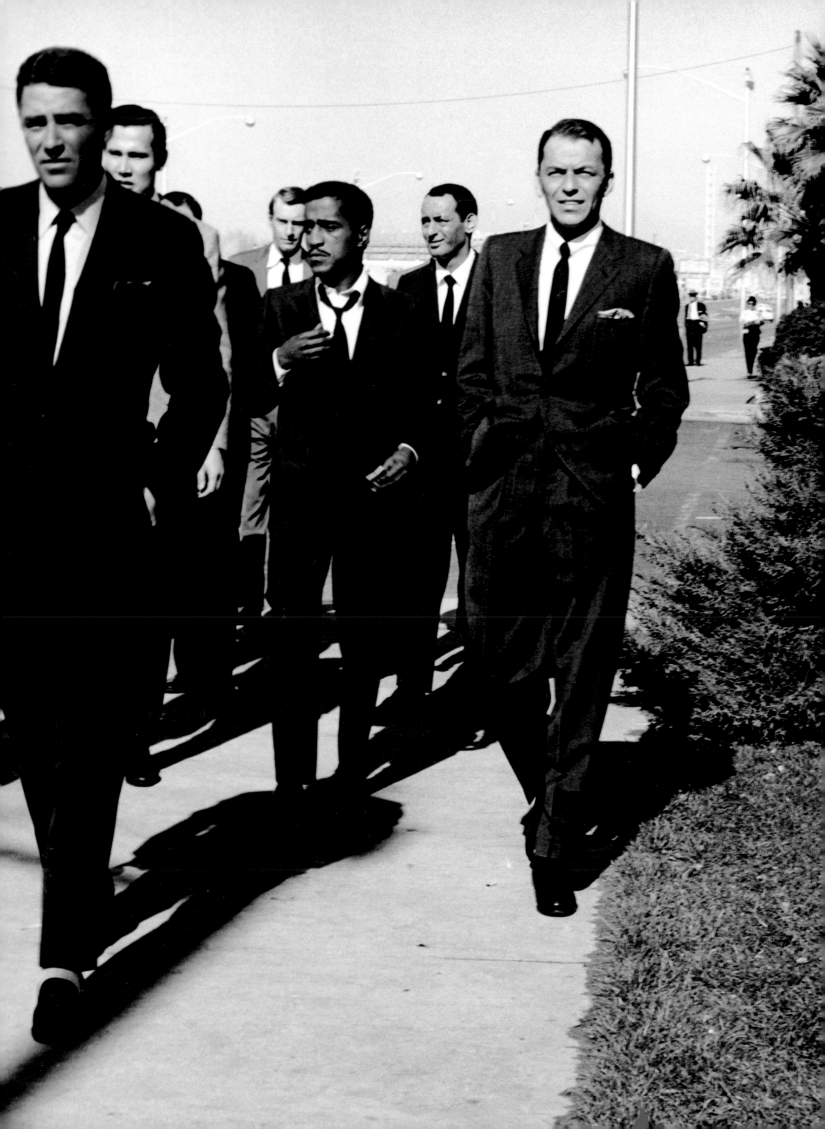

B

BARNEYS NEW YORK

In the 1980s, Barneys New York transformed itself from a traditional men's department store into a venue for cutting-edge fashion designers like Azzédine Alaïa, Miuccia Prada, Proenza Schouler, and Marc Jacobs.

R

ROSIE THE RIVETER

After the attack on Pearl Harbor on December 7, 1941, the nation beckoned for women to fill the void in the workforce left by the men leaving for war. Rosie the Riveter was the image of the "Everywoman" who had taken to the factories and assembly lines.

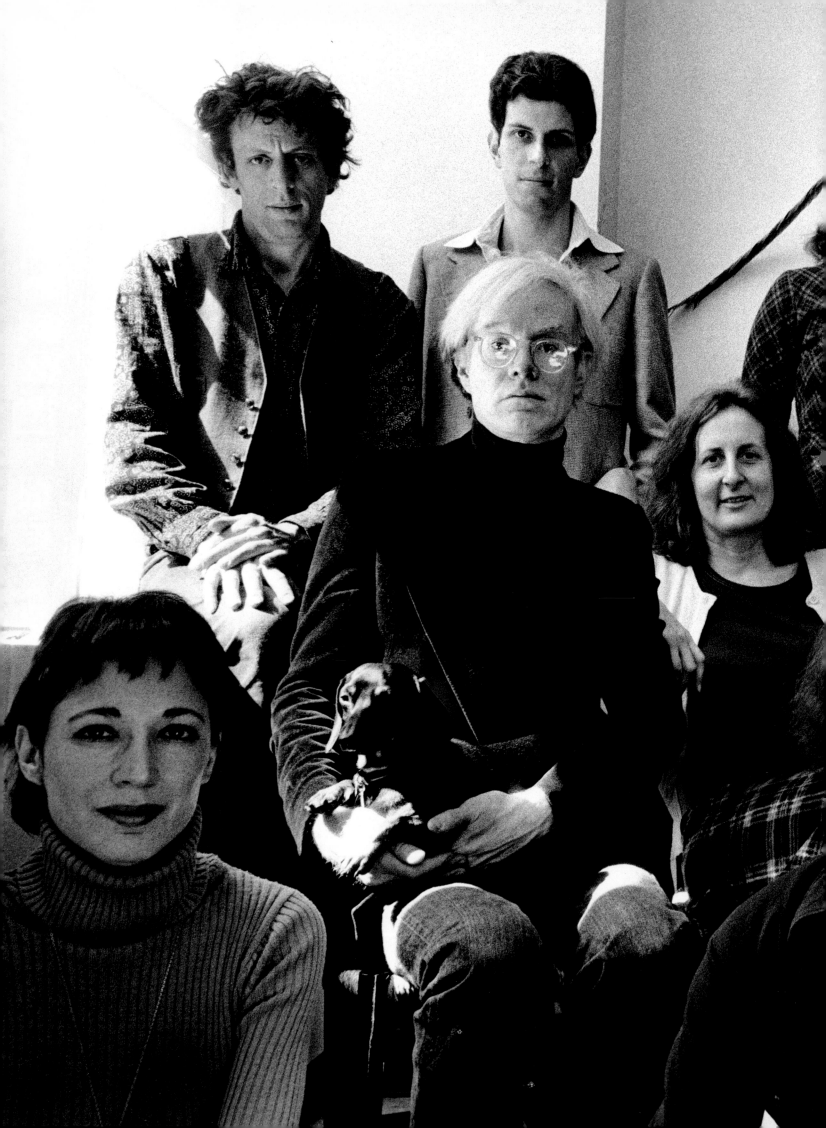

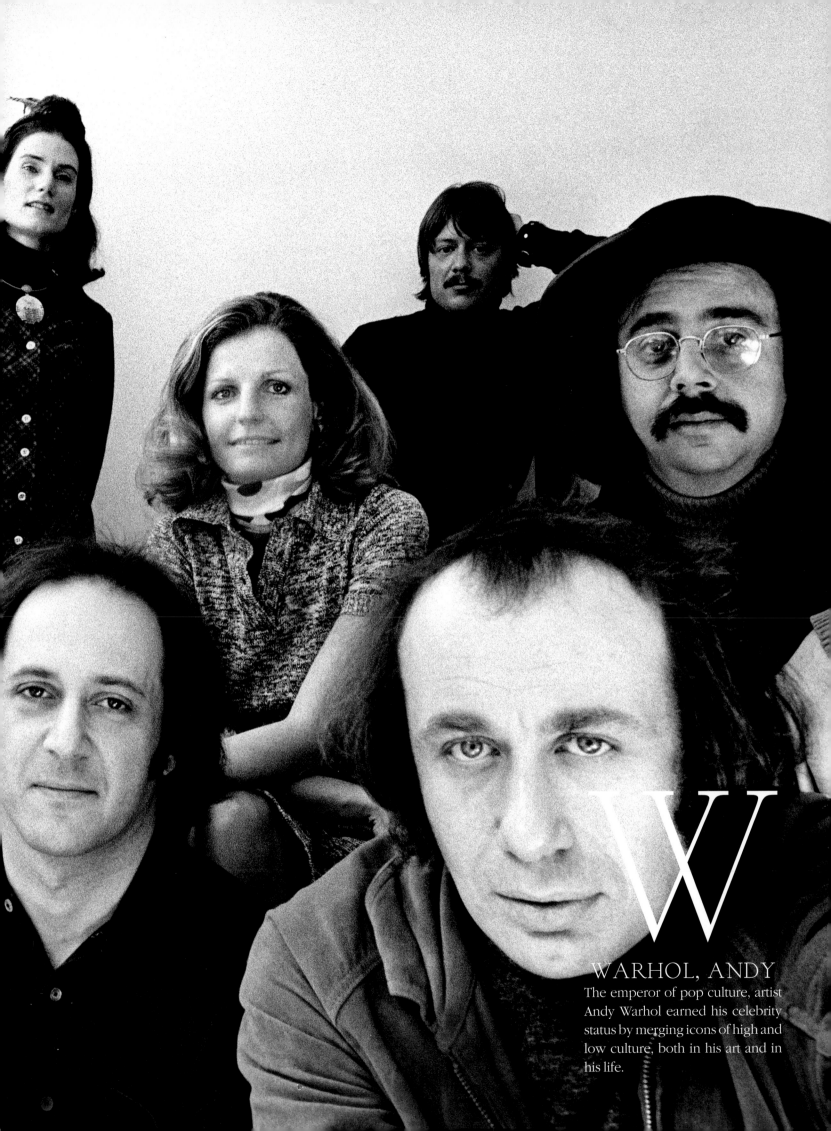

W

WARHOL, ANDY

The emperor of pop culture, artist Andy Warhol earned his celebrity status by merging icons of high and low culture, both in his art and in his life.

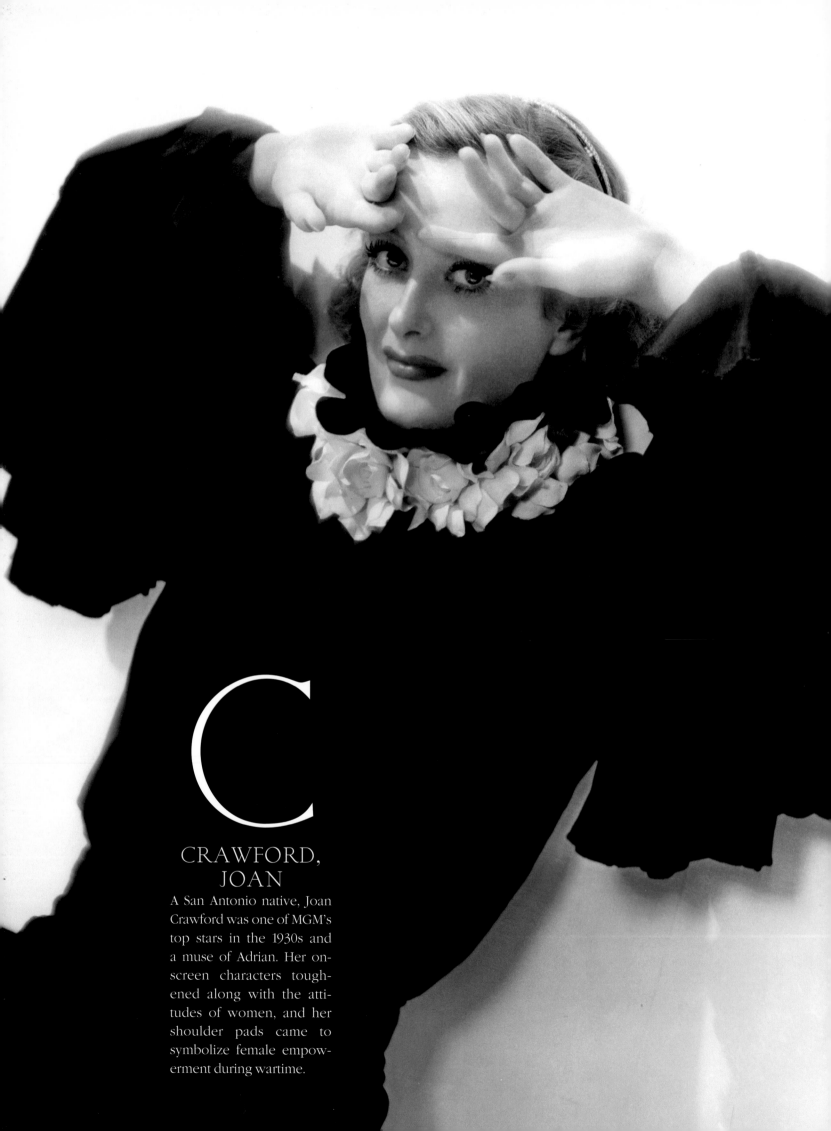

C

CRAWFORD, JOAN

A San Antonio native, Joan Crawford was one of MGM's top stars in the 1930s and a muse of Adrian. Her on-screen characters toughened along with the attitudes of women, and her shoulder pads came to symbolize female empowerment during wartime.

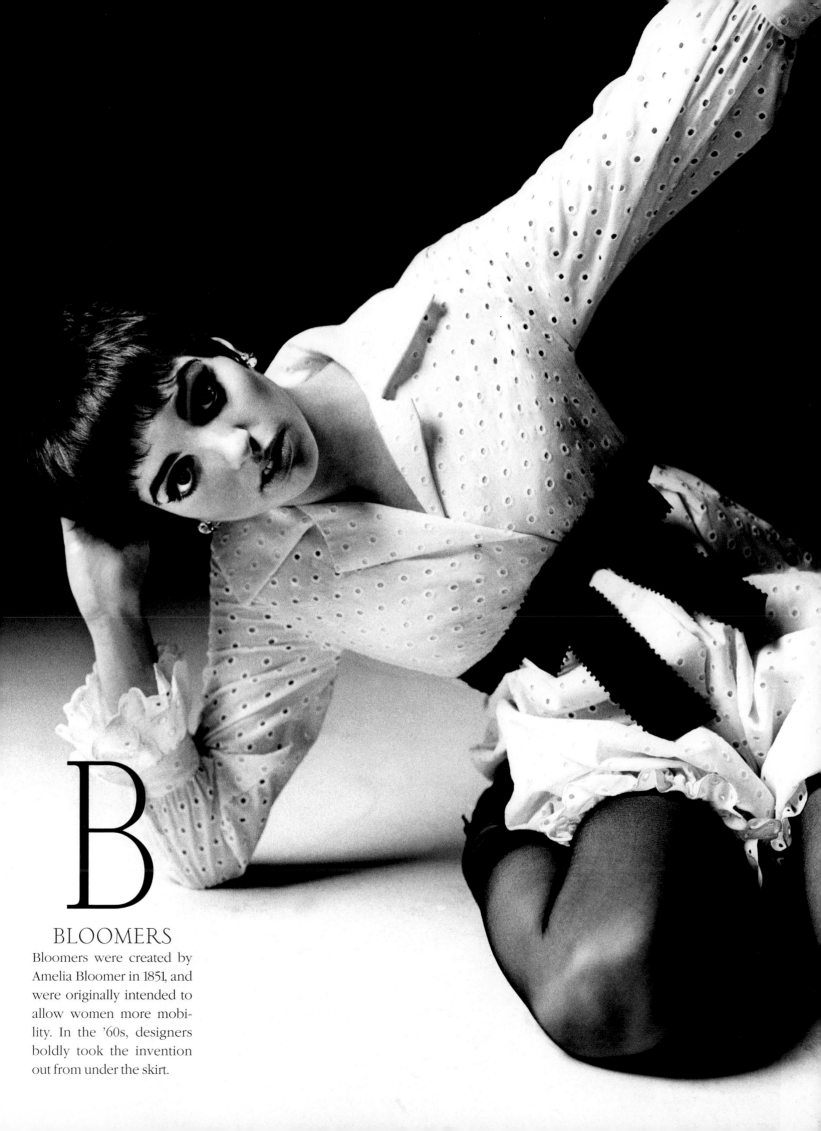

B

BLOOMERS

Bloomers were created by Amelia Bloomer in 1851, and were originally intended to allow women more mobility. In the '60s, designers boldly took the invention out from under the skirt.

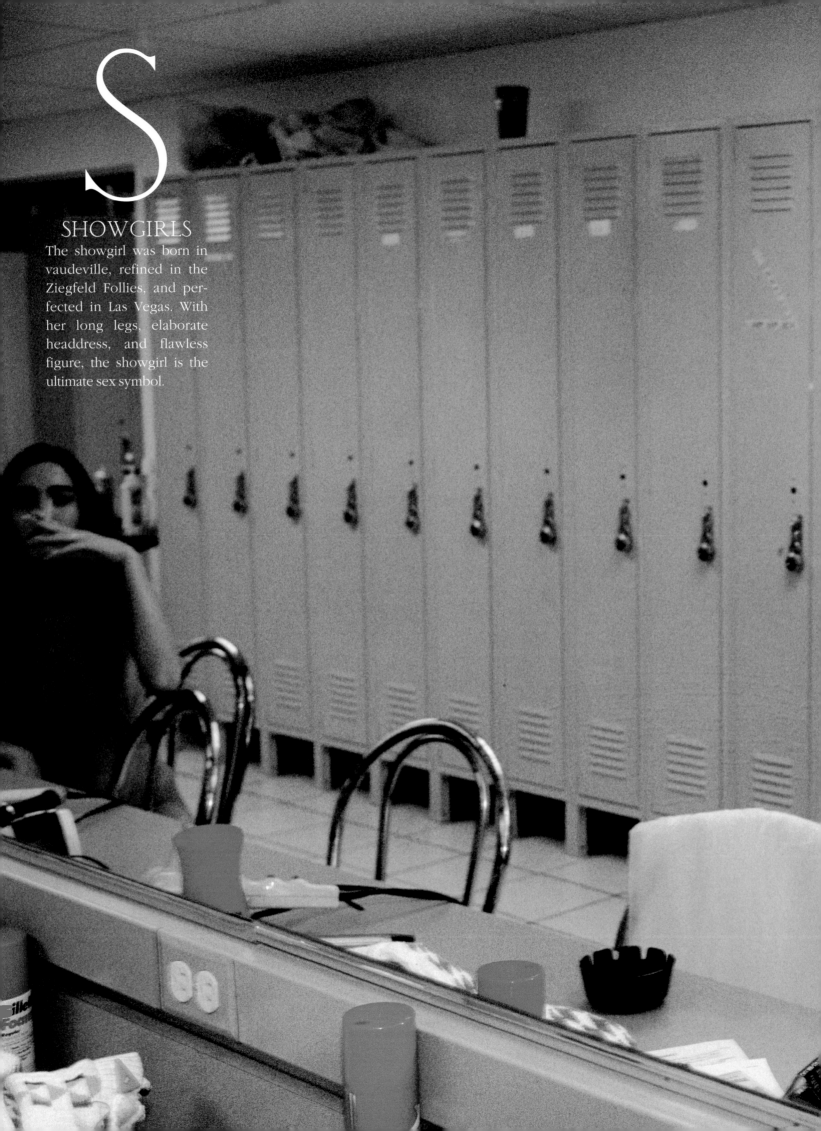

S

SHOWGIRLS

The showgirl was born in vaudeville, refined in the Ziegfeld Follies, and perfected in Las Vegas. With her long legs, elaborate headdress, and flawless figure, the showgirl is the ultimate sex symbol.

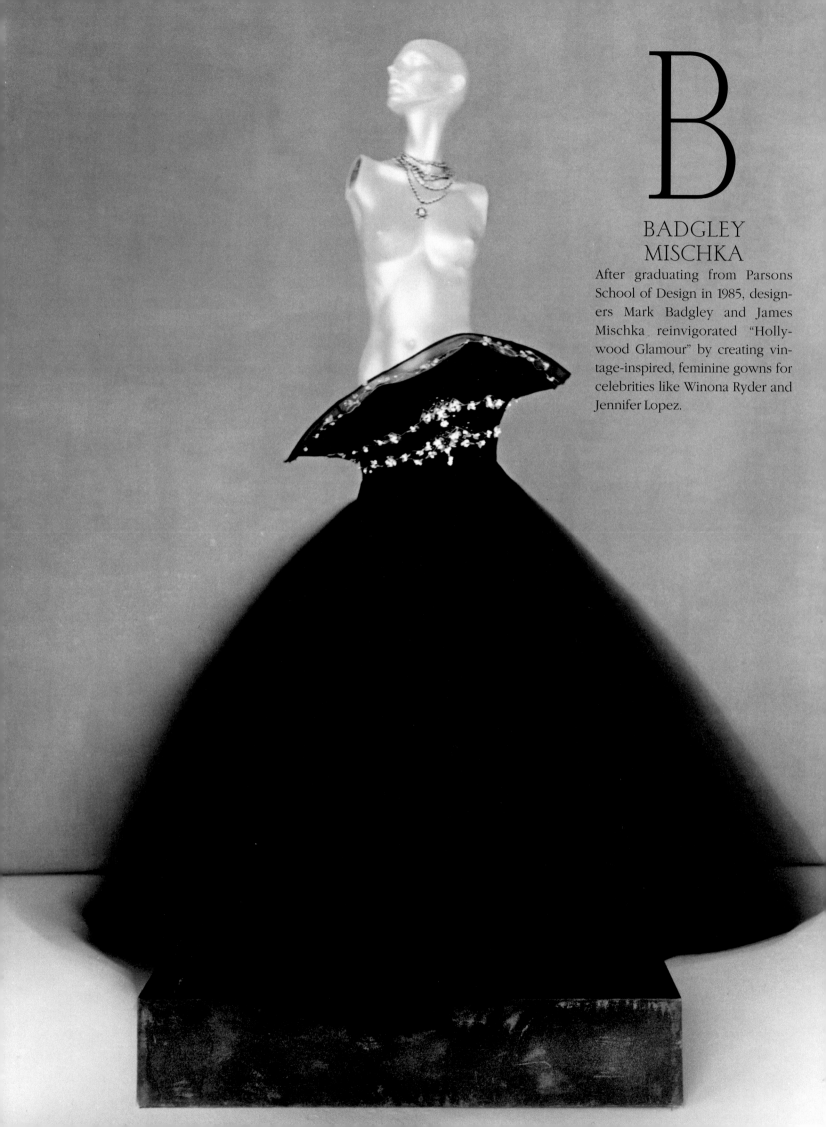

B

BADGLEY
MISCHKA

After graduating from Parsons School of Design in 1985, designers Mark Badgley and James Mischka reinvigorated "Hollywood Glamour" by creating vintage-inspired, feminine gowns for celebrities like Winona Ryder and Jennifer Lopez.

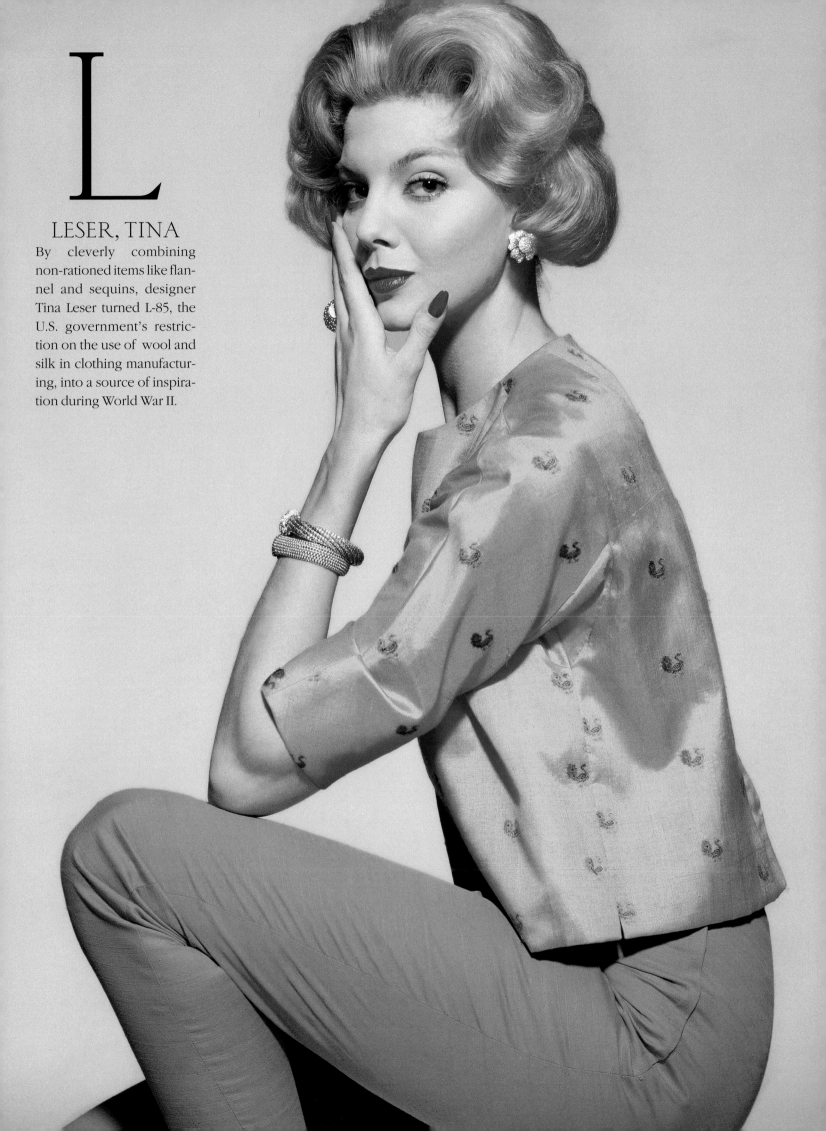

L

LESER, TINA

By cleverly combining non-rationed items like flannel and sequins, designer Tina Leser turned L-85, the U.S. government's restriction on the use of wool and silk in clothing manufacturing, into a source of inspiration during World War II.

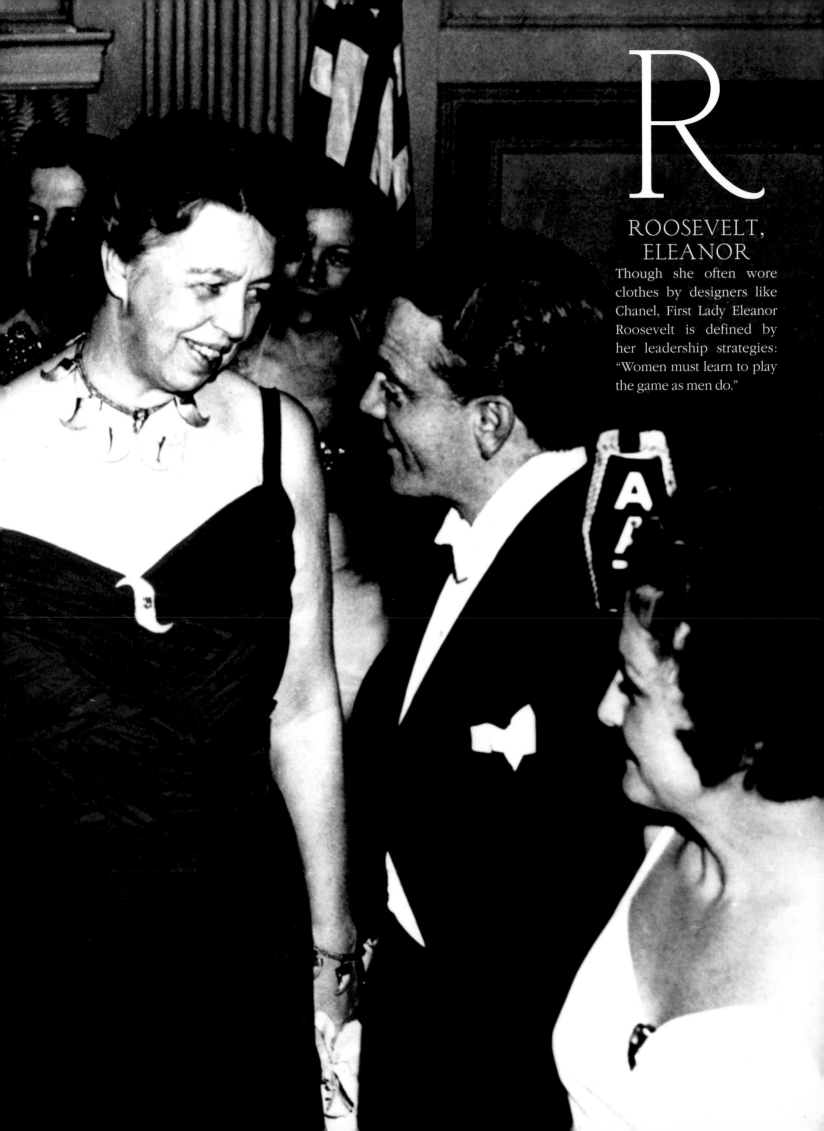

R

ROOSEVELT, ELEANOR

Though she often wore clothes by designers like Chanel, First Lady Eleanor Roosevelt is defined by her leadership strategies: "Women must learn to play the game as men do."

L&T

LORD & TAYLOR

Samuel Lord and George Washington Taylor founded the New York department store Lord & Taylor in 1826. In the 1930s and '40s, Lord & Taylor became known for their advertising illustrations as much as for their support of young designers.

How to succeed in Palm Beach (or Acapulco or Eleuthera or Estoril) without really trying

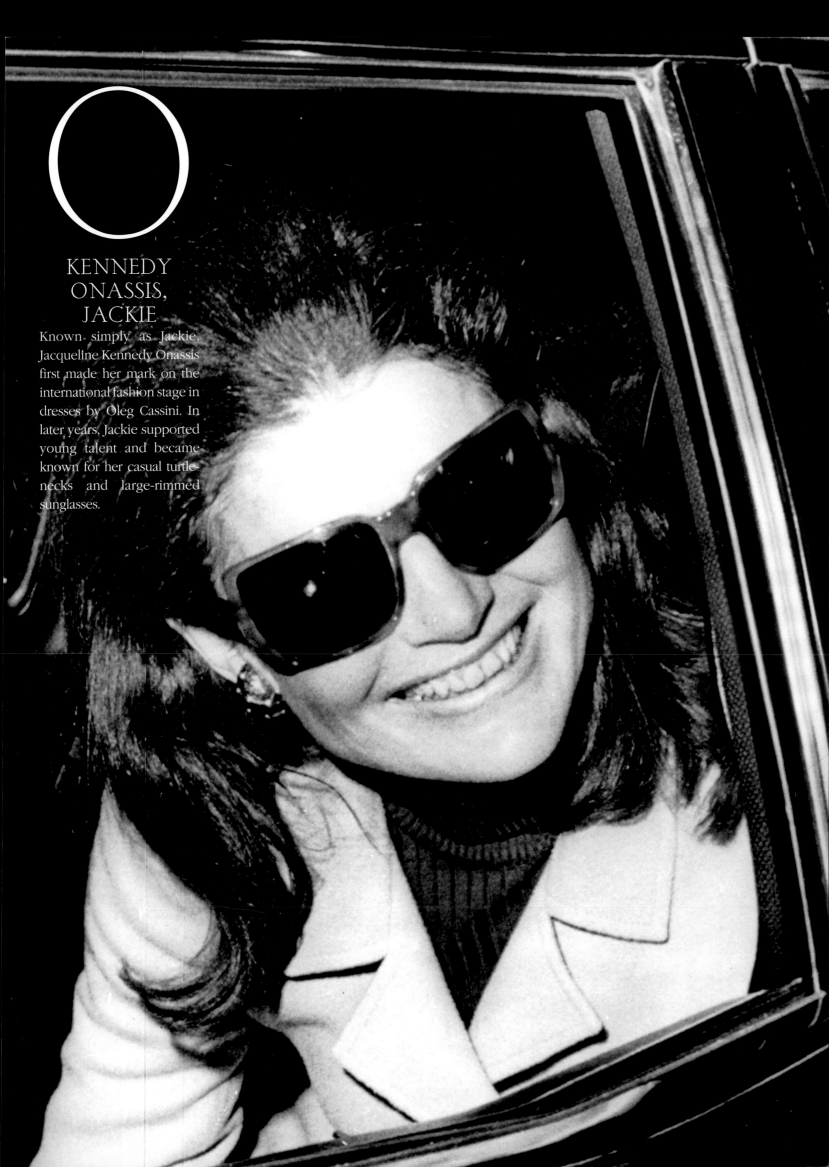

O

KENNEDY ONASSIS, JACKIE

Known simply as Jackie, Jacqueline Kennedy Onassis first made her mark on the international fashion stage in dresses by Oleg Cassini. In later years, Jackie supported young talent and became known for her casual turtle-necks and large-rimmed sunglasses.

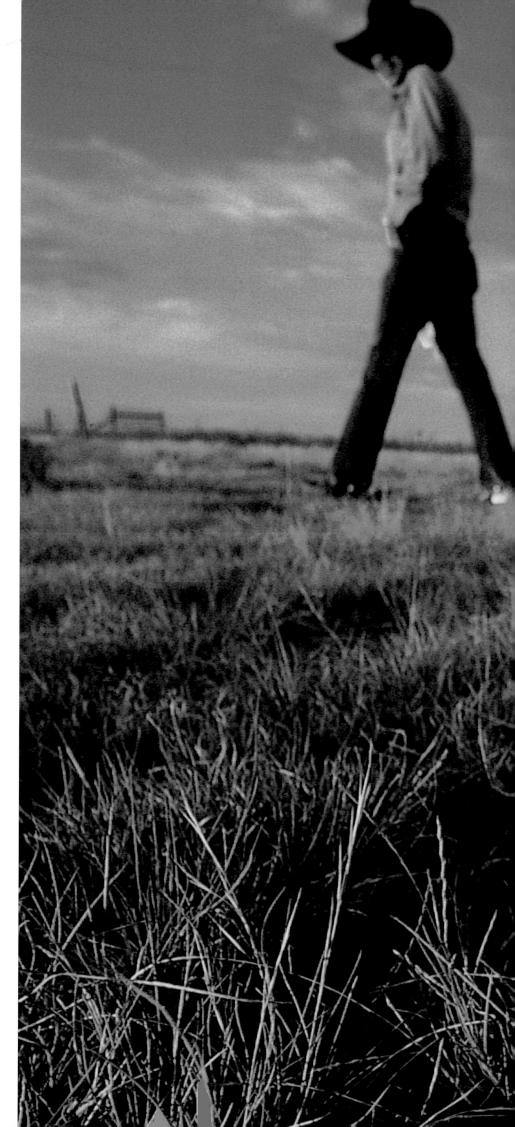

C

COWBOY

More than just Wranglers, boots, and hats, the cowboy constitutes a way of life. Either as a hero in a white hat or as a down-home country boy, the cowboy has come to symbolize American freedom.

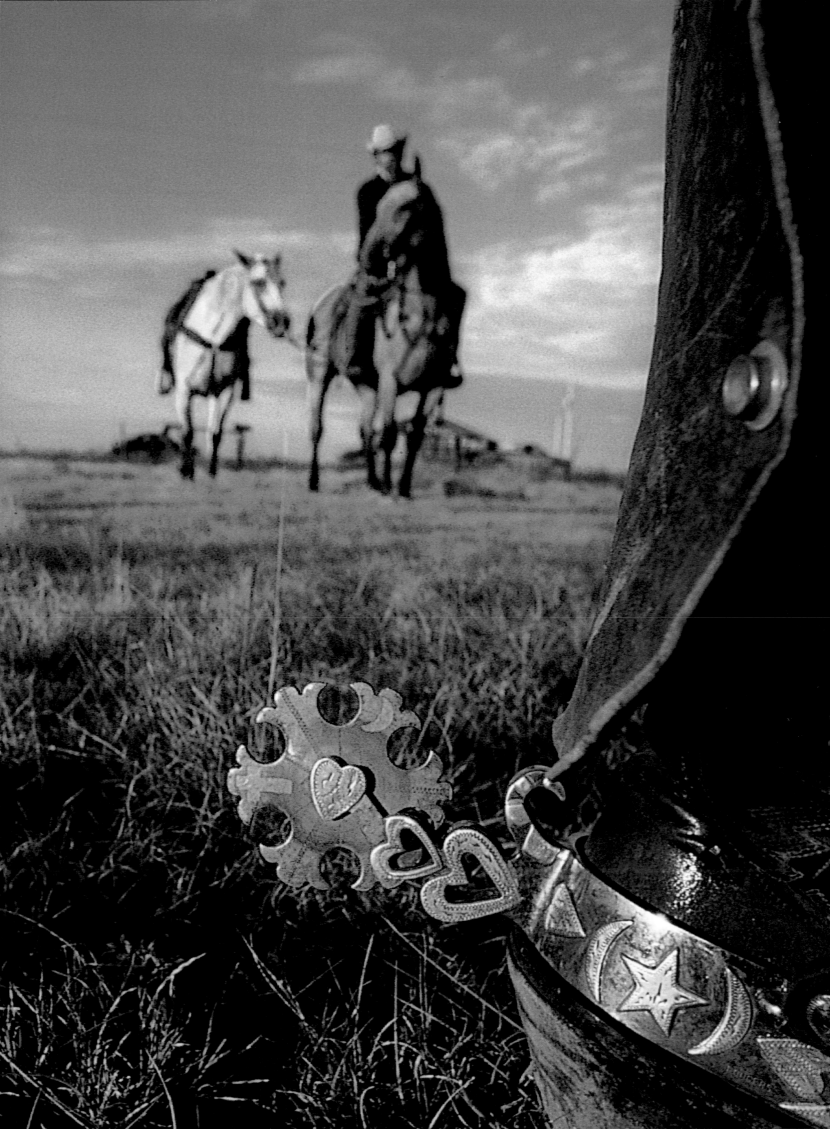

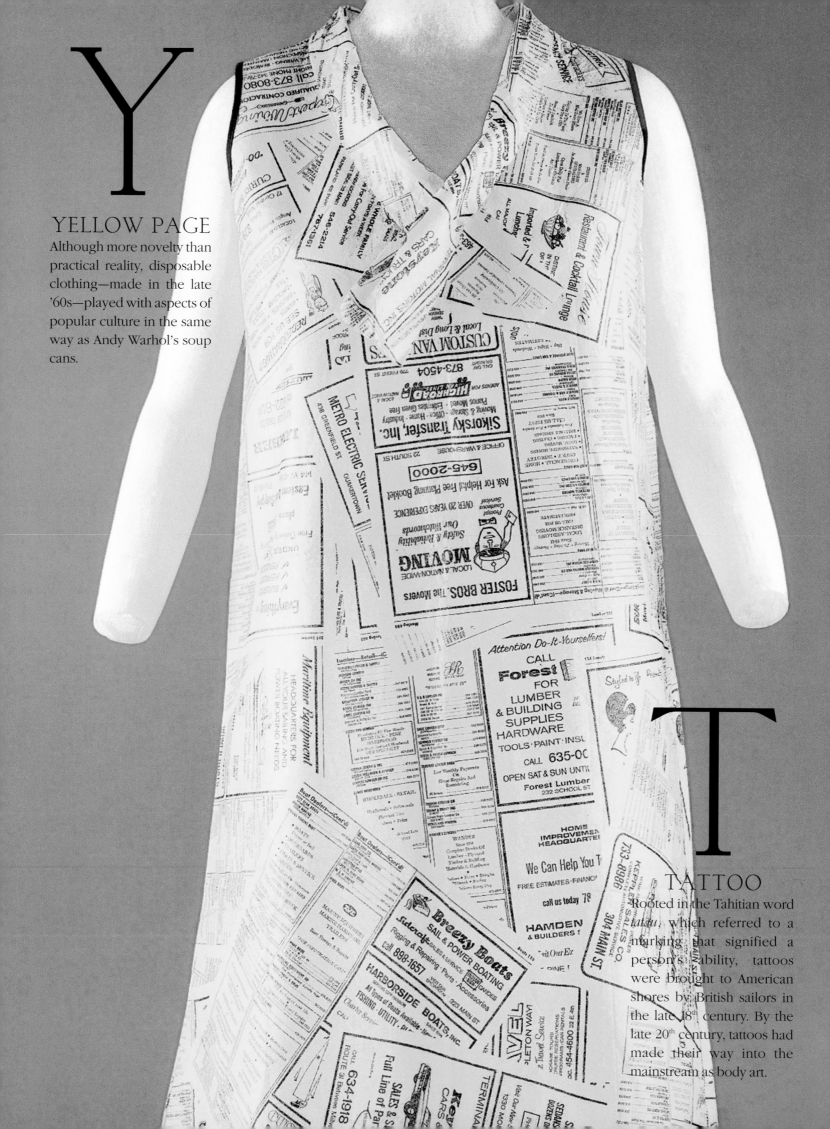

Y

YELLOW PAGE

Although more novelty than practical reality, disposable clothing—made in the late '60s—played with aspects of popular culture in the same way as Andy Warhol's soup cans.

T

TATTOO

Rooted in the Tahitian word *tatau*, which referred to a marking that signified a person's ability, tattoos were brought to American shores by British sailors in the late 18th century. By the late 20th century, tattoos had made their way into the mainstream as body art.

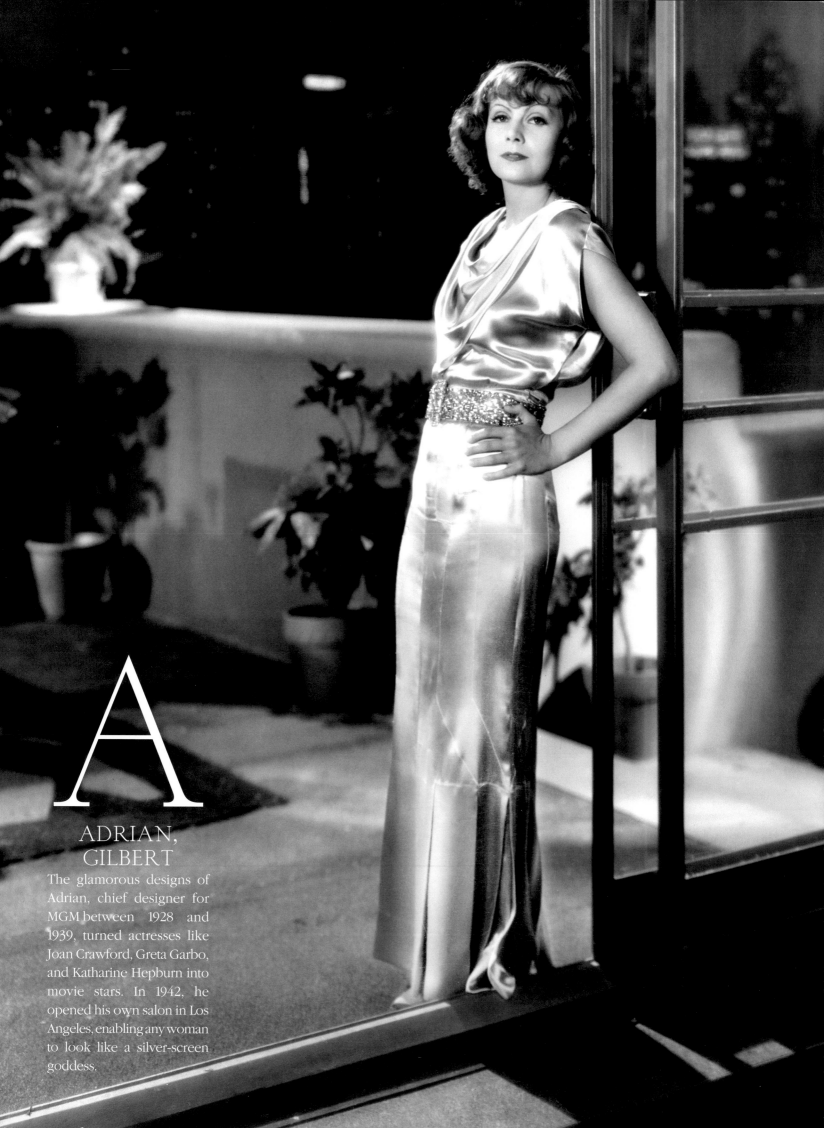

A
ADRIAN, GILBERT

The glamorous designs of Adrian, chief designer for MGM between 1928 and 1939, turned actresses like Joan Crawford, Greta Garbo, and Katharine Hepburn into movie stars. In 1942, he opened his own salon in Los Angeles, enabling any woman to look like a silver-screen goddess.

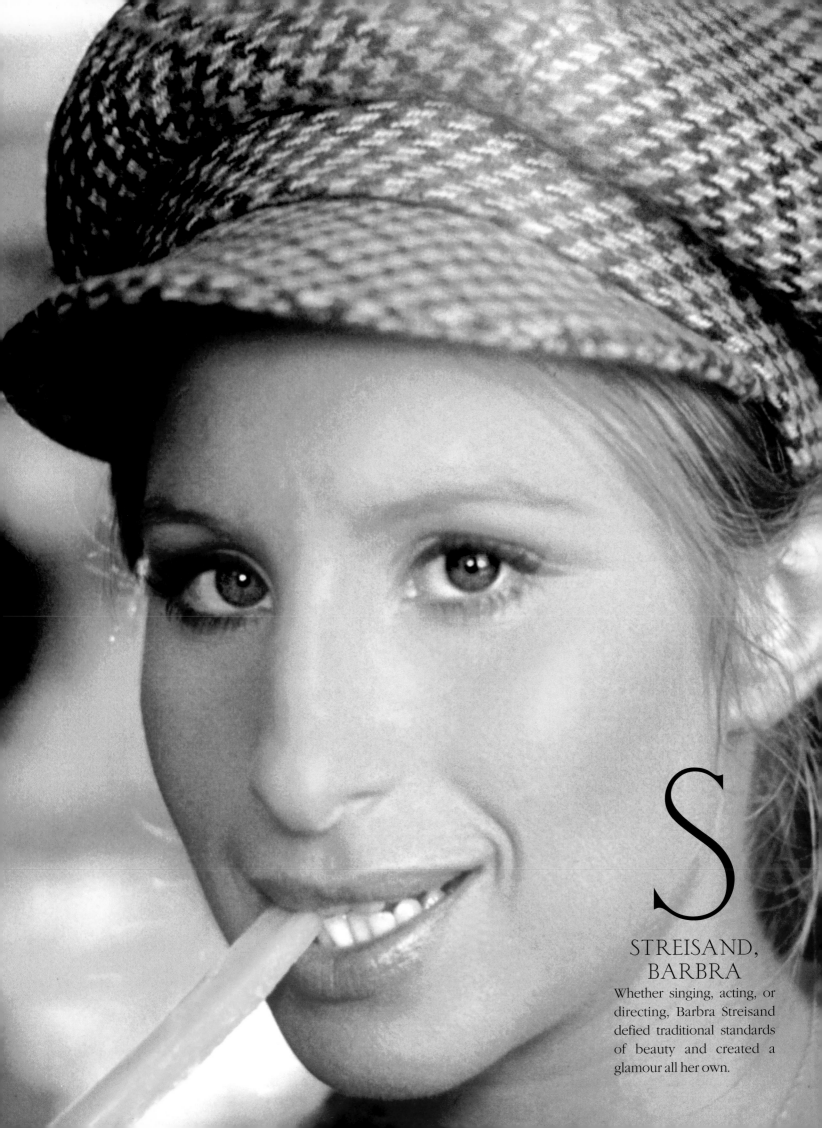

S

STREISAND, BARBRA

Whether singing, acting, or directing, Barbra Streisand defied traditional standards of beauty and created a glamour all her own.

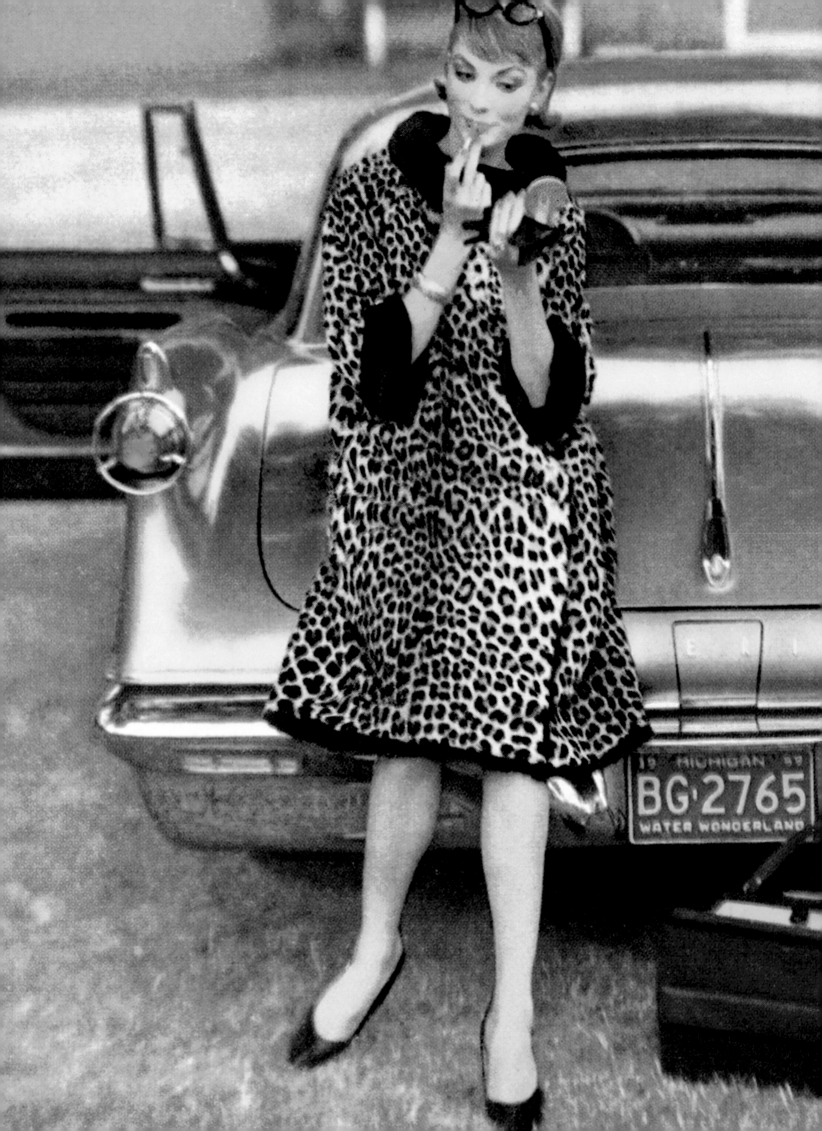

A
AUTOMOBILE

Ever since Henry Ford introduced the Model T in 1908, cars and their designs have played a central role in the American way of life. From '40s roadsters to '50s pink Cadillacs to '80s DeLoreans, the style of a car has evoked the spirit of its time.

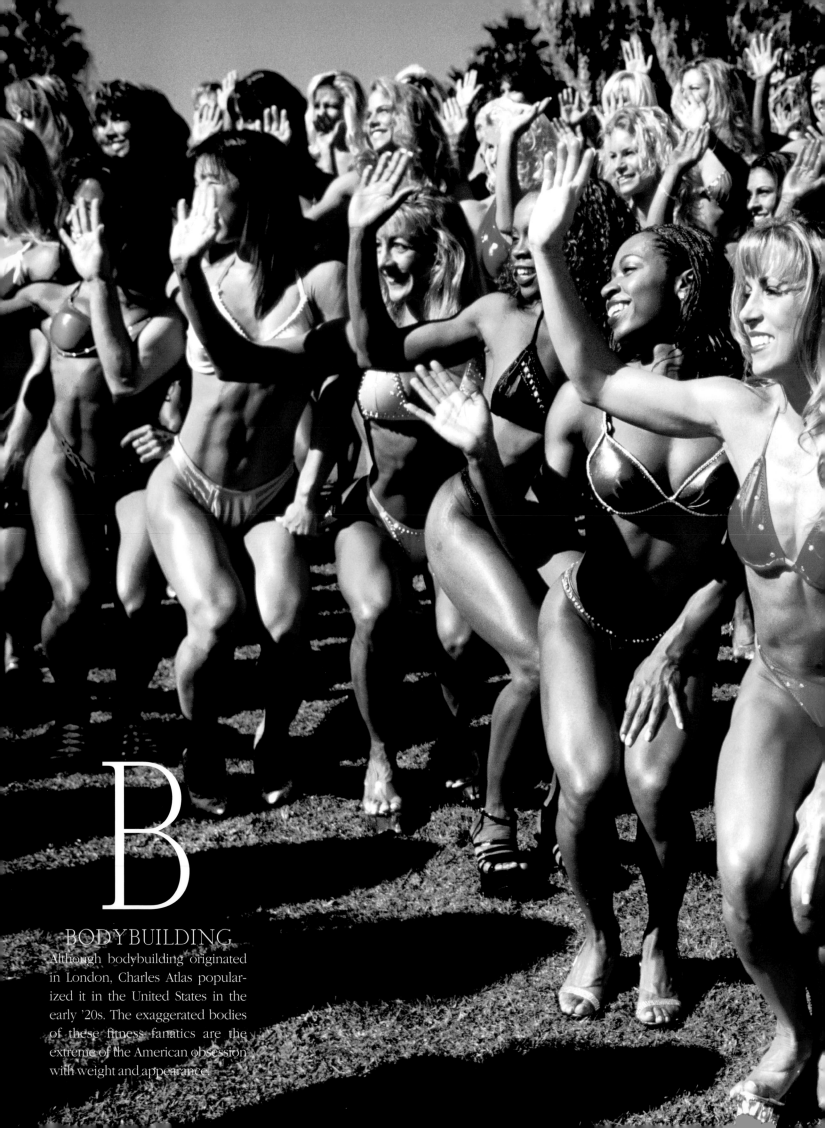

B
BODYBUILDING
Although bodybuilding originated in London, Charles Atlas popularized it in the United States in the early '20s. The exaggerated bodies of these fitness fanatics are the extreme of the American obsession with weight and appearance.

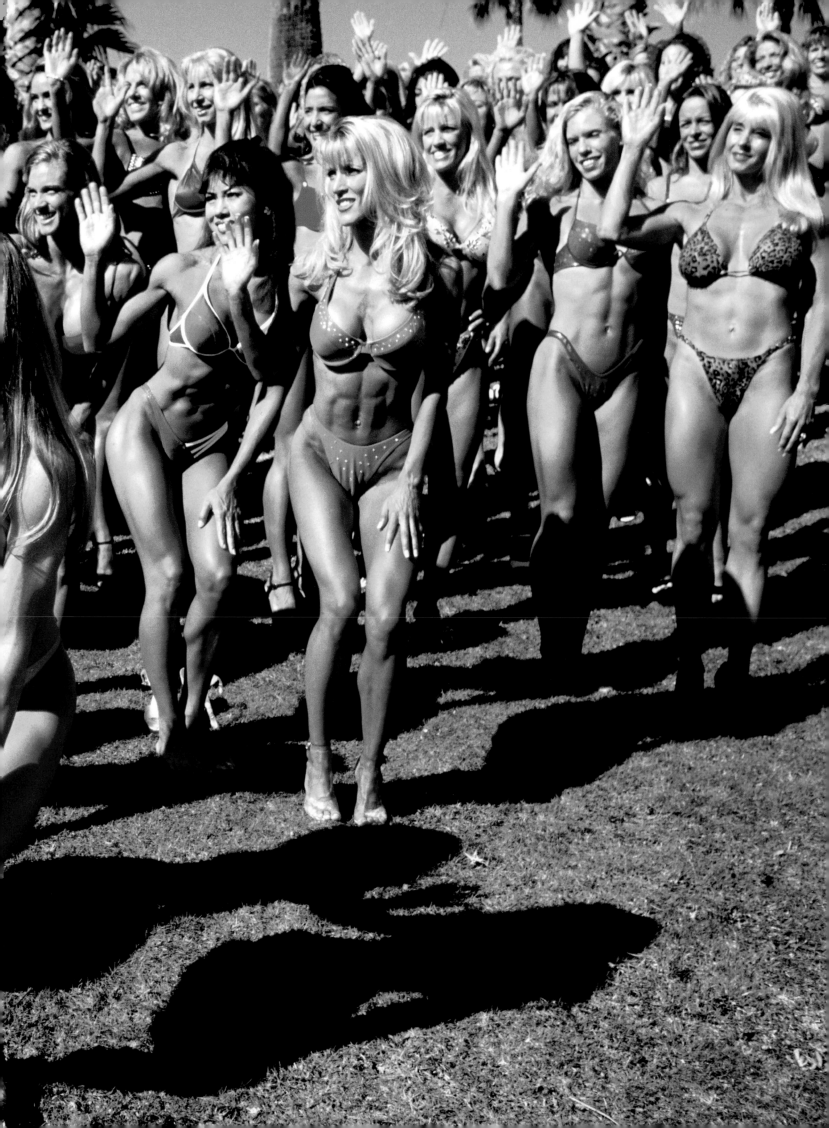

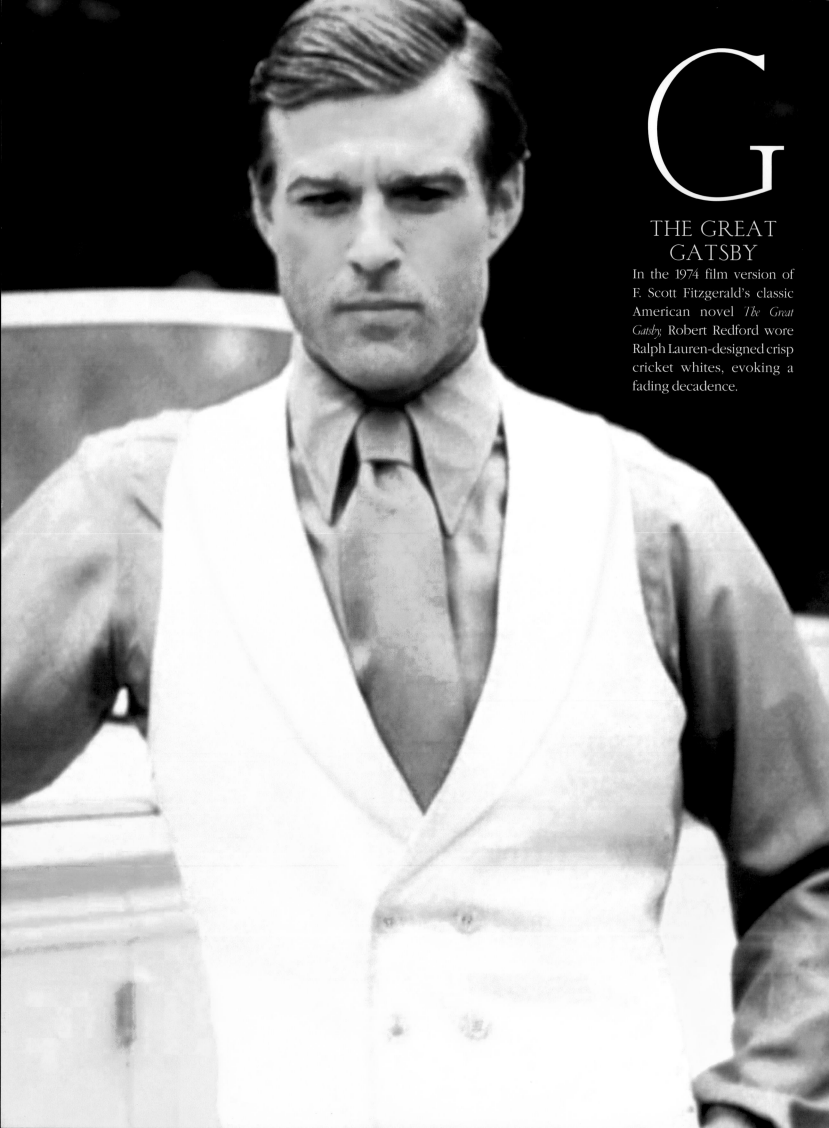

G
THE GREAT GATSBY

In the 1974 film version of F. Scott Fitzgerald's classic American novel *The Great Gatsby,* Robert Redford wore Ralph Lauren-designed crisp cricket whites, evoking a fading decadence.

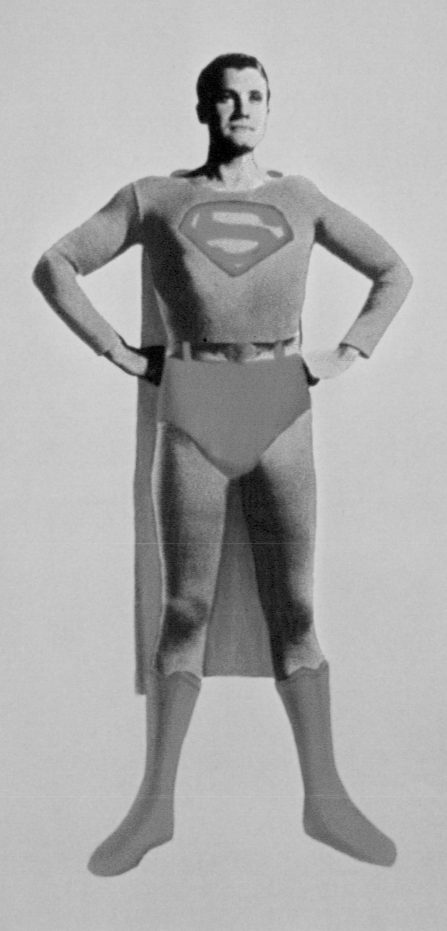

S

SUPERMAN

The symbol of truth, justice, and the American way, Superman is the prototypical superhero. Created in the 1940s as a comic strip idol, Superman empowered many young men and women to fight for what they believe in.

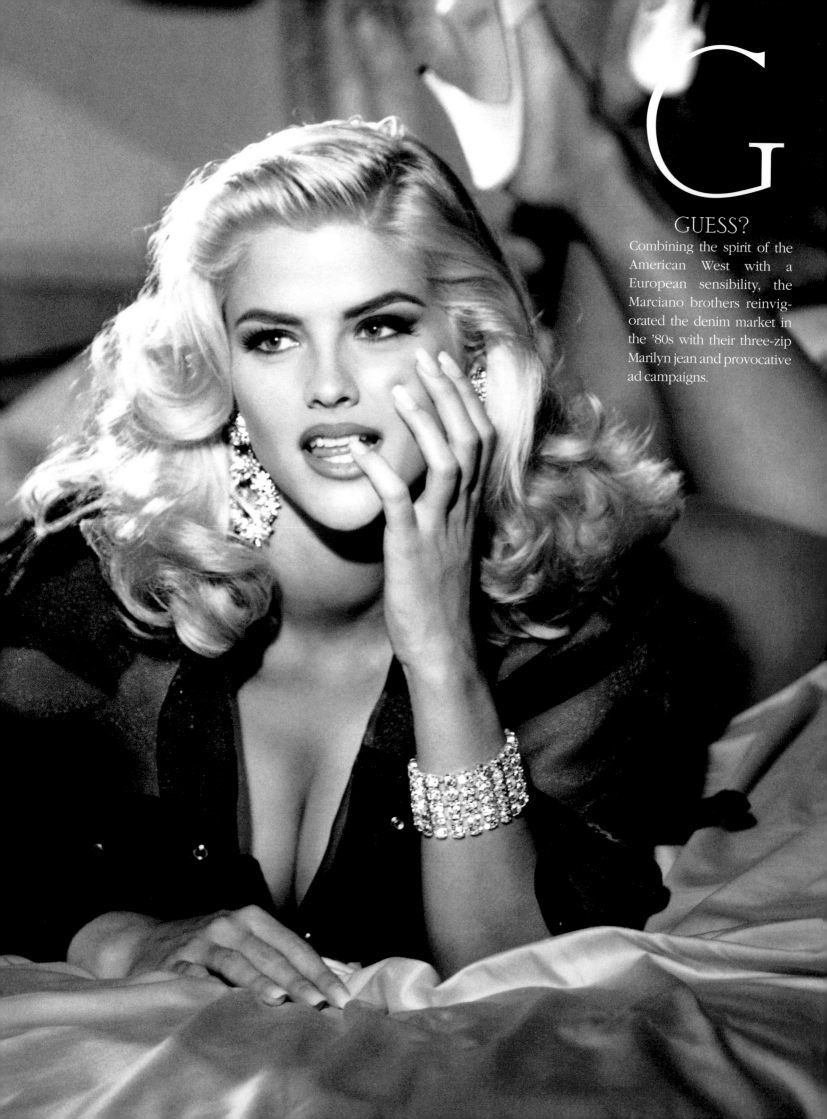

G

GUESS?

Combining the spirit of the American West with a European sensibility, the Marciano brothers reinvigorated the denim market in the '80s with their three-zip Marilyn jean and provocative ad campaigns.

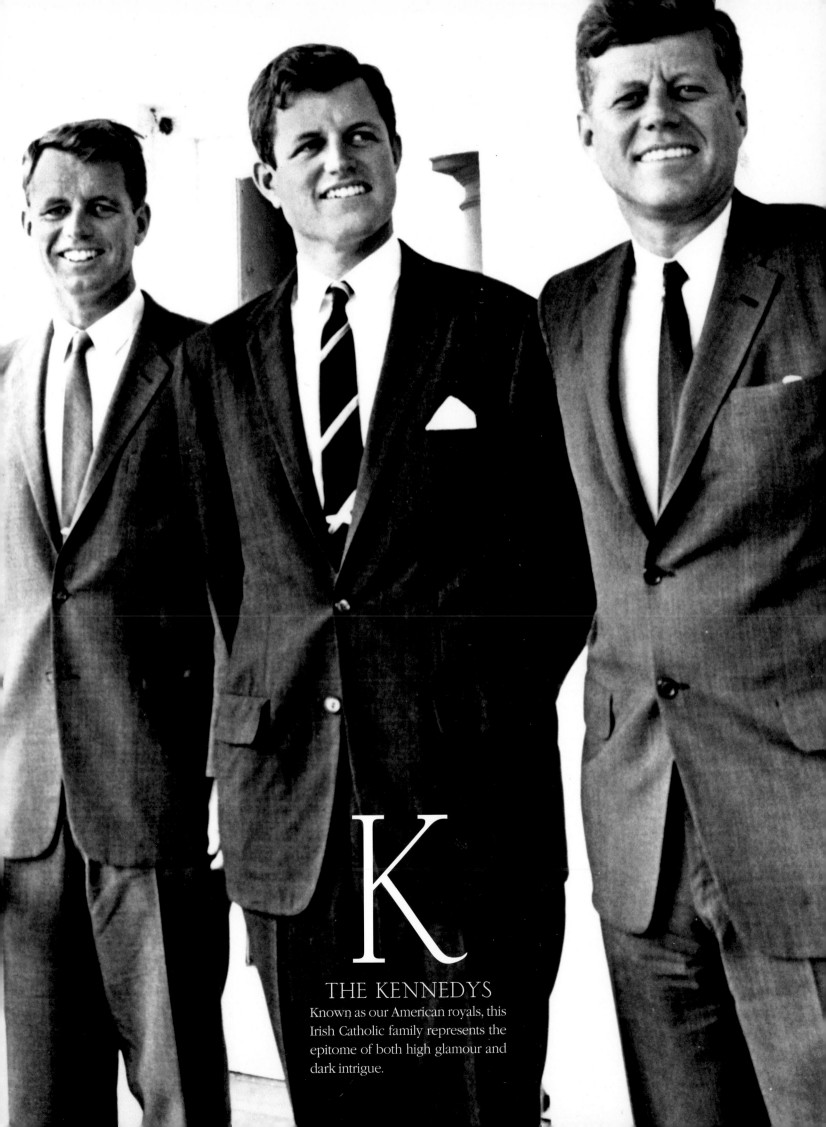

K

THE KENNEDYS

Known as our American royals, this Irish Catholic family represents the epitome of both high glamour and dark intrigue.

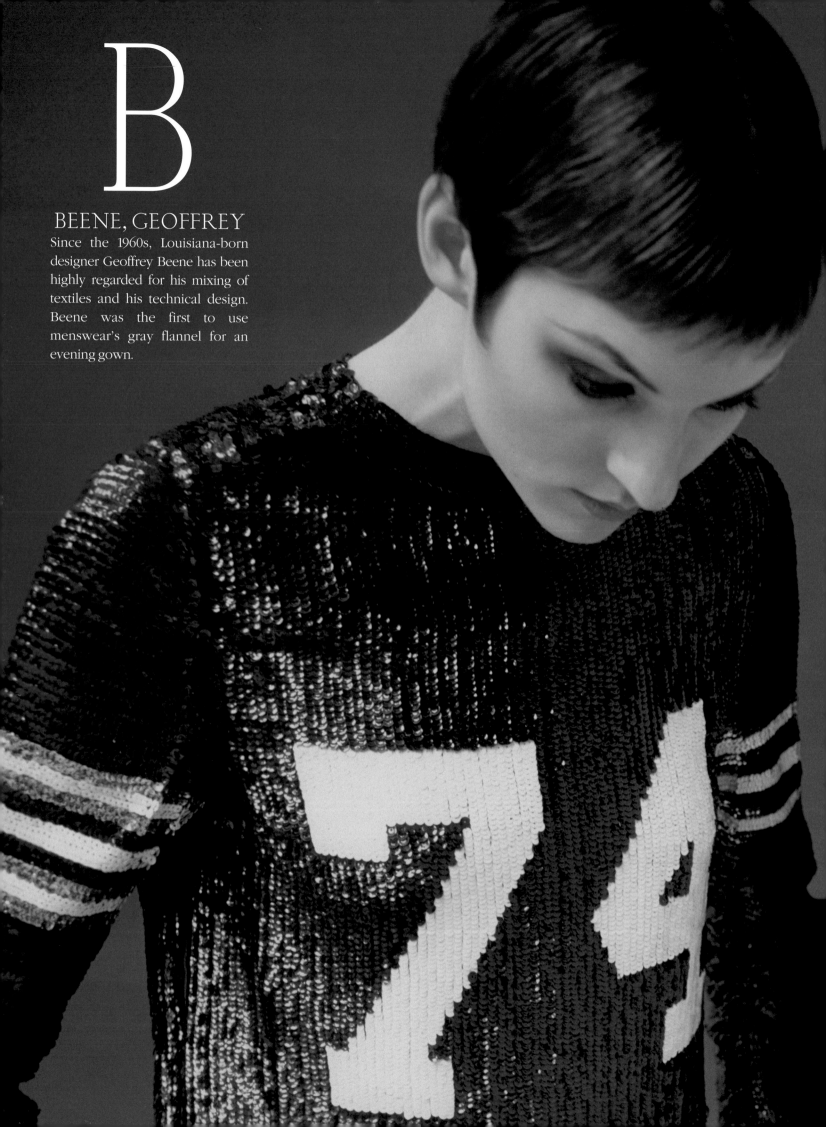

B

BEENE, GEOFFREY

Since the 1960s, Louisiana-born designer Geoffrey Beene has been highly regarded for his mixing of textiles and his technical design. Beene was the first to use menswear's gray flannel for an evening gown.

S

DI SANT'ANGELO, GIORGIO

A trained architect and industrial designer, Giorgio di Sant'Angelo was known in the 1970s for his draped gypsy clothes and Indian-inspired styles, which contrasted with what women of the day were wearing: "stiff boxes with zippers up the back as dresses."

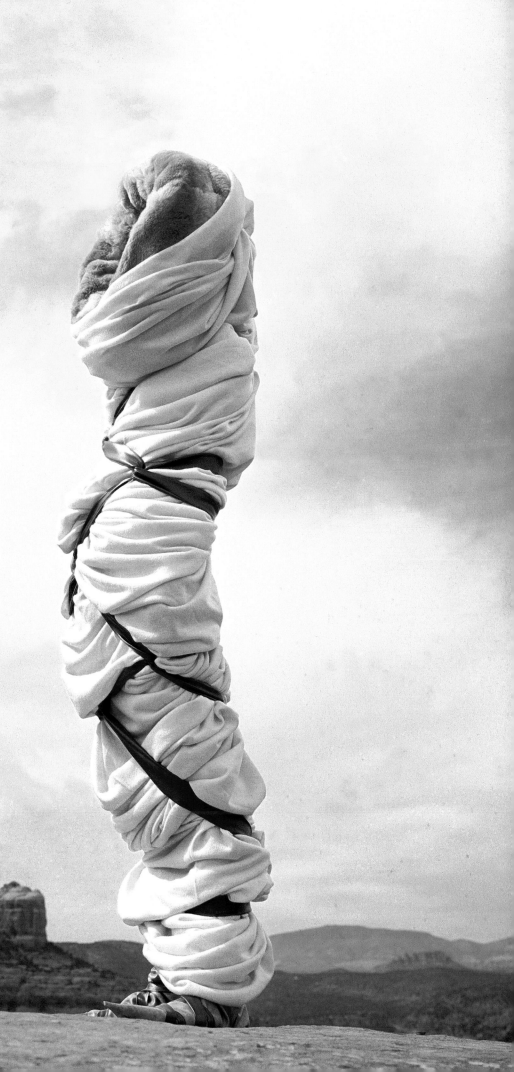

L

LEVINE, HERBERT & BETH

From the '40s to the '70s, husband-and-wife design team Herbert and Beth approached shoe-making as an art form. Their inventive designs used transparent vinyl (with Lucite for heels) and newspaper, and included all-in-one stretch pants/boots.

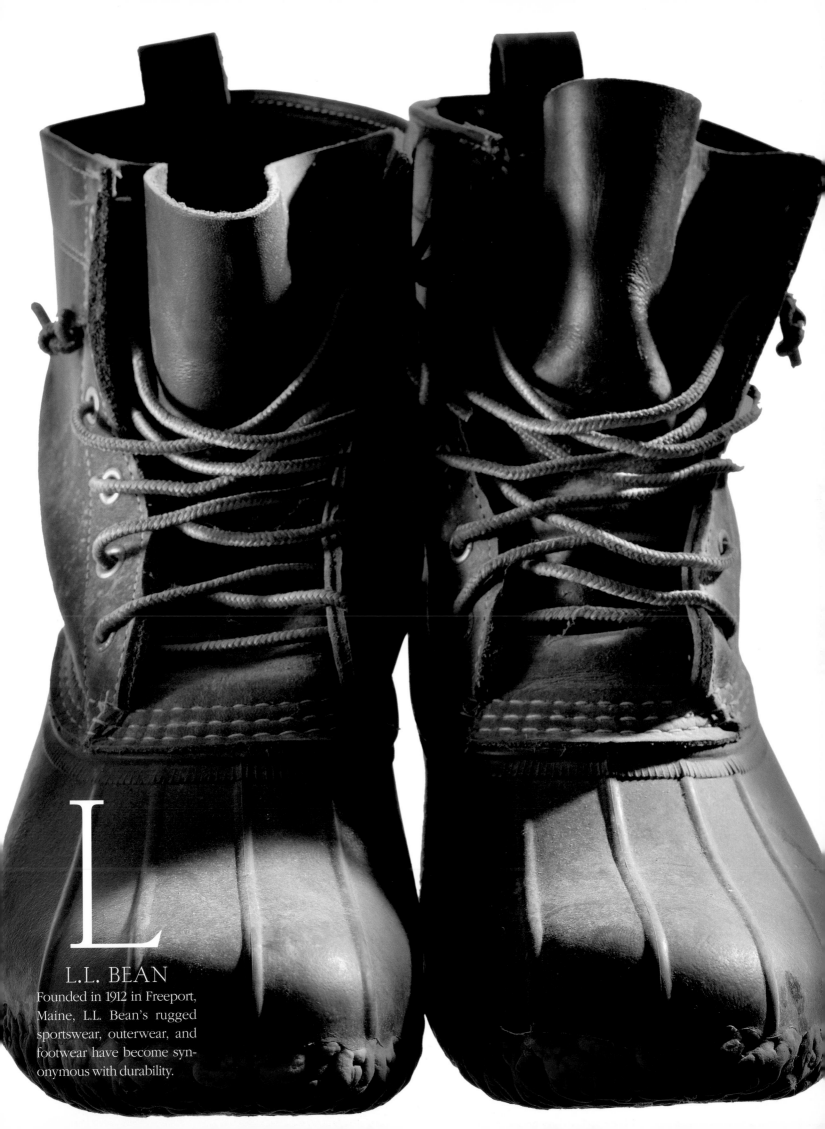

L

L.L. BEAN

Founded in 1912 in Freeport, Maine, L.L. Bean's rugged sportswear, outerwear, and footwear have become synonymous with durability.

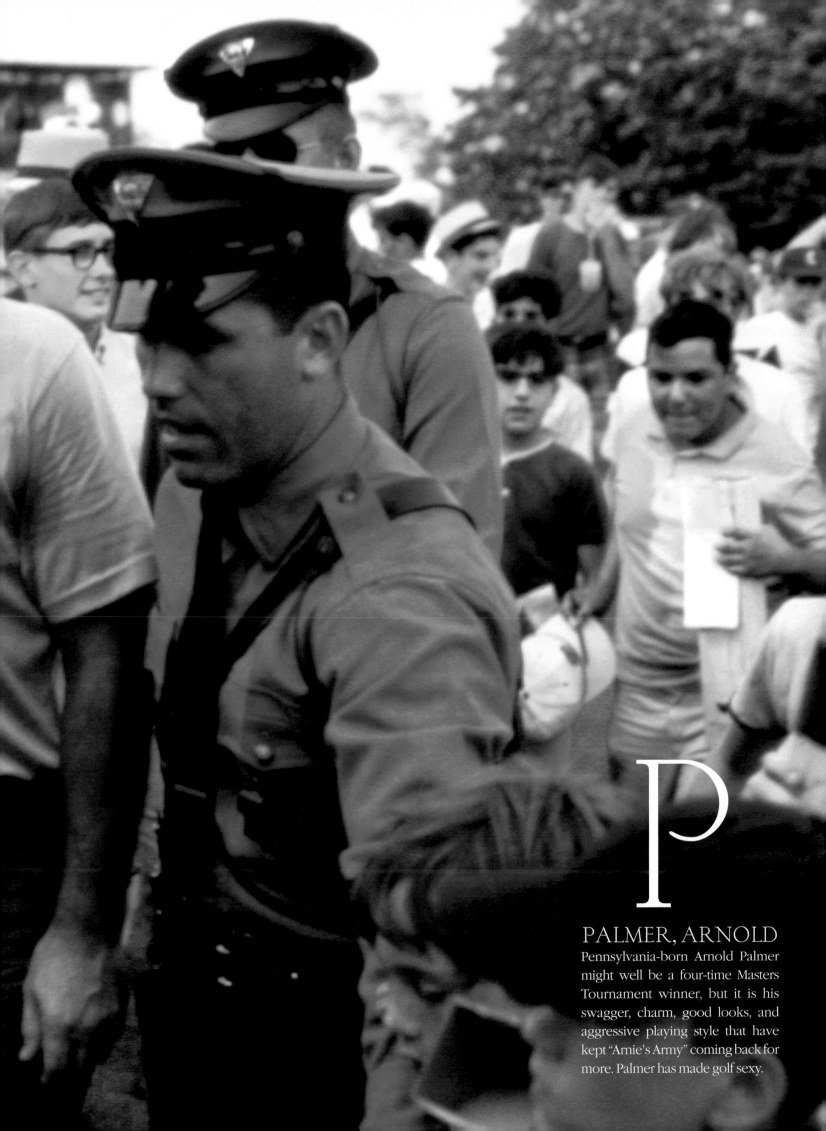

P

PALMER, ARNOLD

Pennsylvania-born Arnold Palmer might well be a four-time Masters Tournament winner, but it is his swagger, charm, good looks, and aggressive playing style that have kept "Arnie's Army" coming back for more. Palmer has made golf sexy.

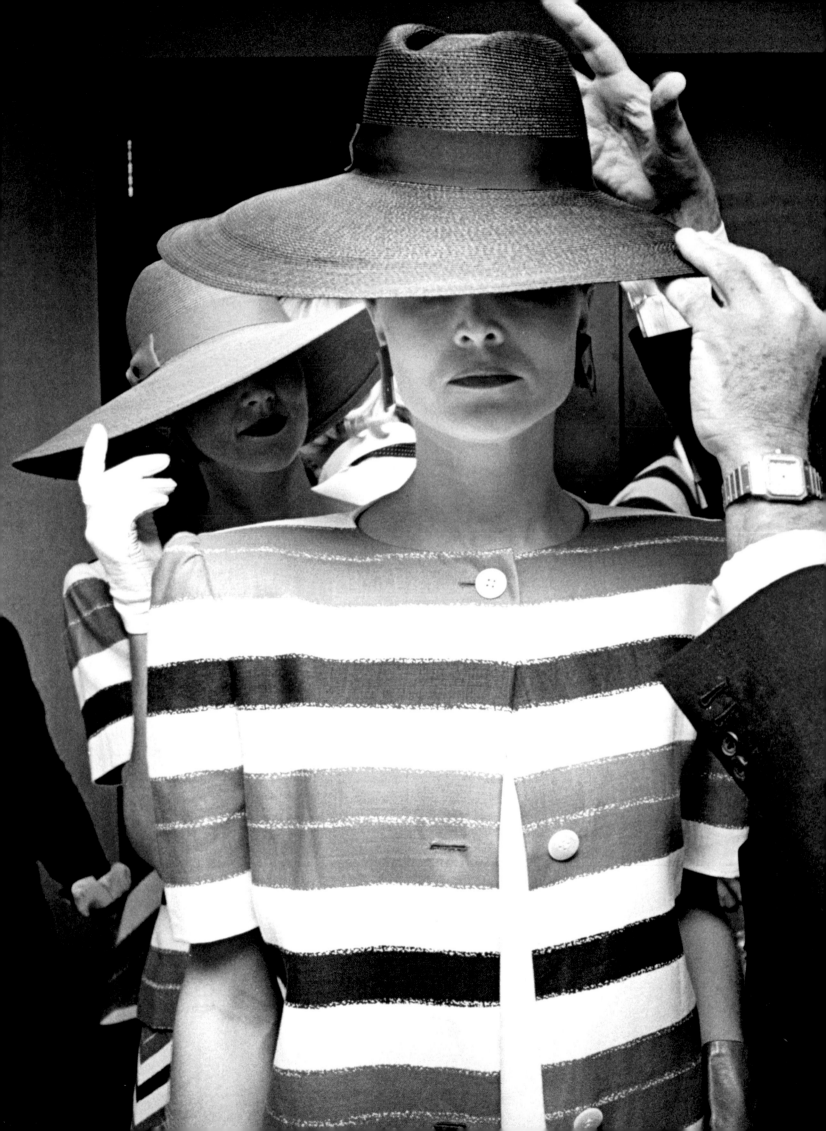

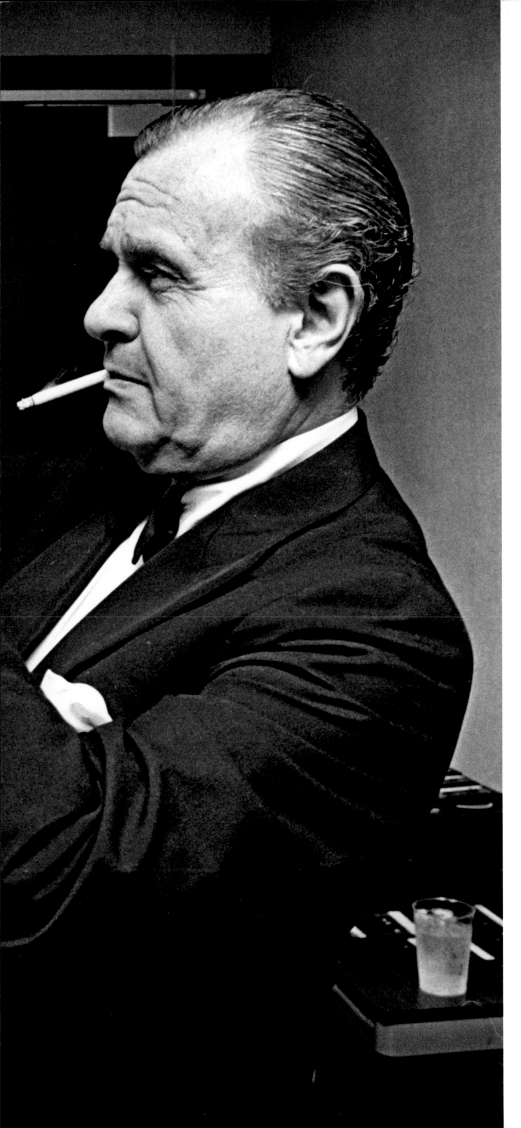

B

BLASS, BILL

Since the 1960s, the name of this Fort Wayne, Indiana, native has epitomized luxuriously innovative designs and New York City's "uptown cool."

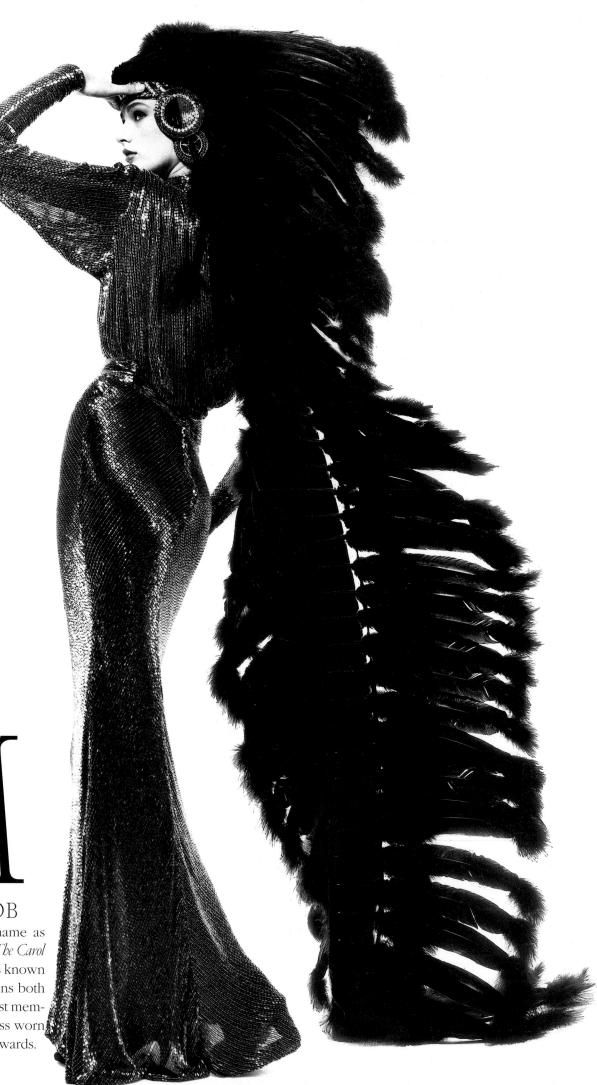

M

MACKIE, BOB

Becoming a household name as the costume designer for *The Carol Burnett Show*, Bob Mackie is known for his extravagant creations both on-screen and off. The most memorable: the spiderweb dress worn by Cher to the Academy Awards.

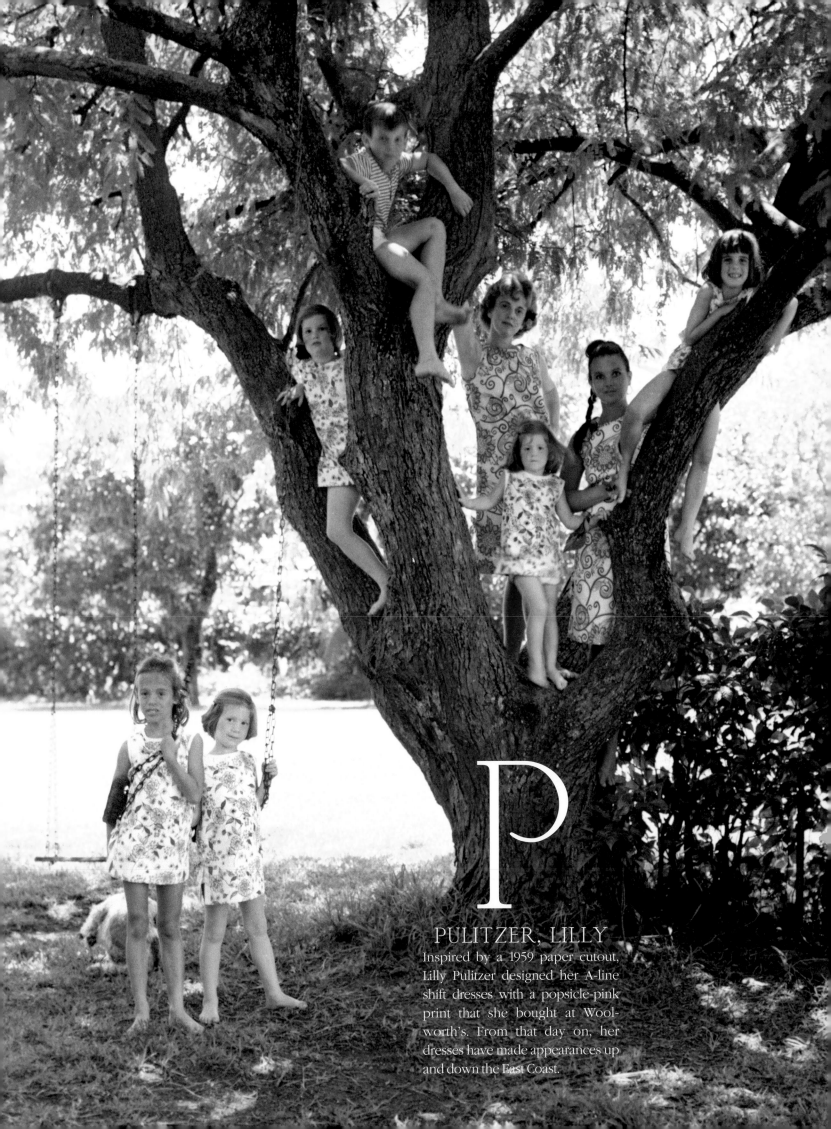

PULITZER, LILLY

Inspired by a 1959 paper cutout, Lilly Pulitzer designed her A-line shift dresses with a popsicle-pink print that she bought at Woolworth's. From that day on, her dresses have made appearances up and down the East Coast.

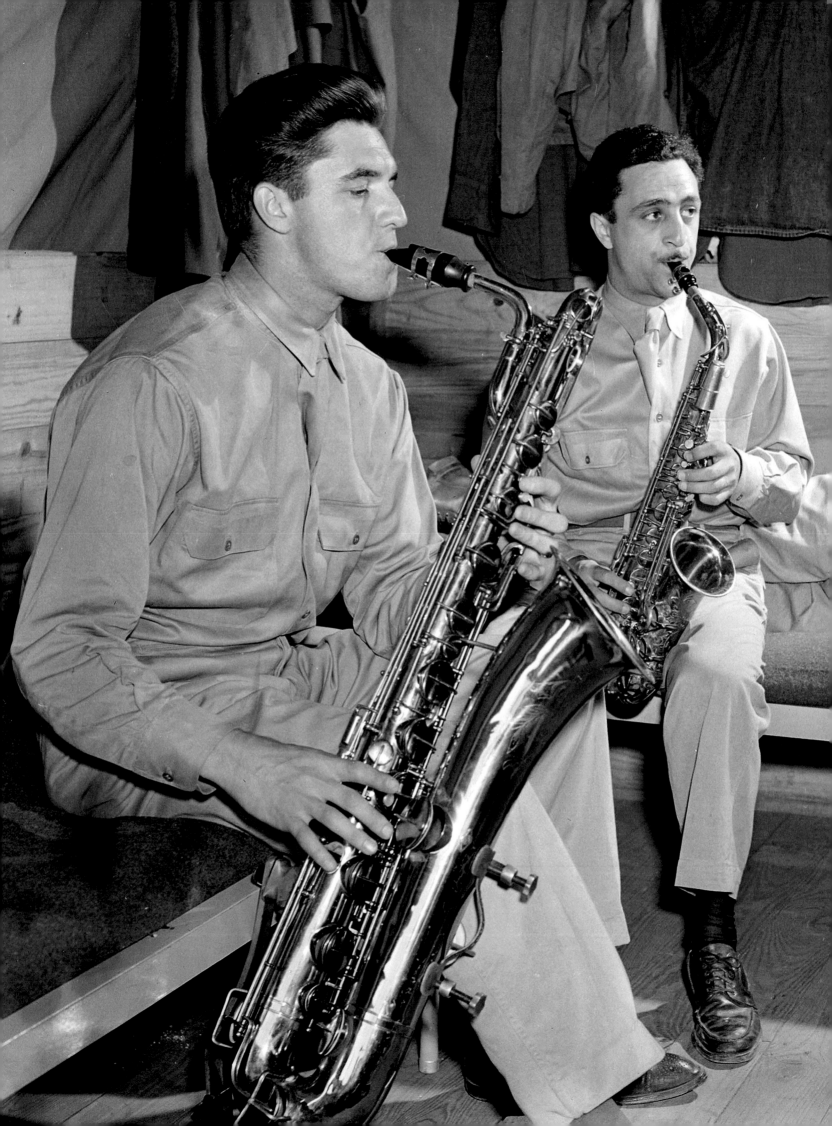

K

KHAKIS

First introduced in 1845 by the British in India, khakis were created by officers who soaked white uniforms in coffee, curry, and mud for camouflage. In 1942, Brooks Brothers started carrying khakis, permanently securing their place as an American staple.

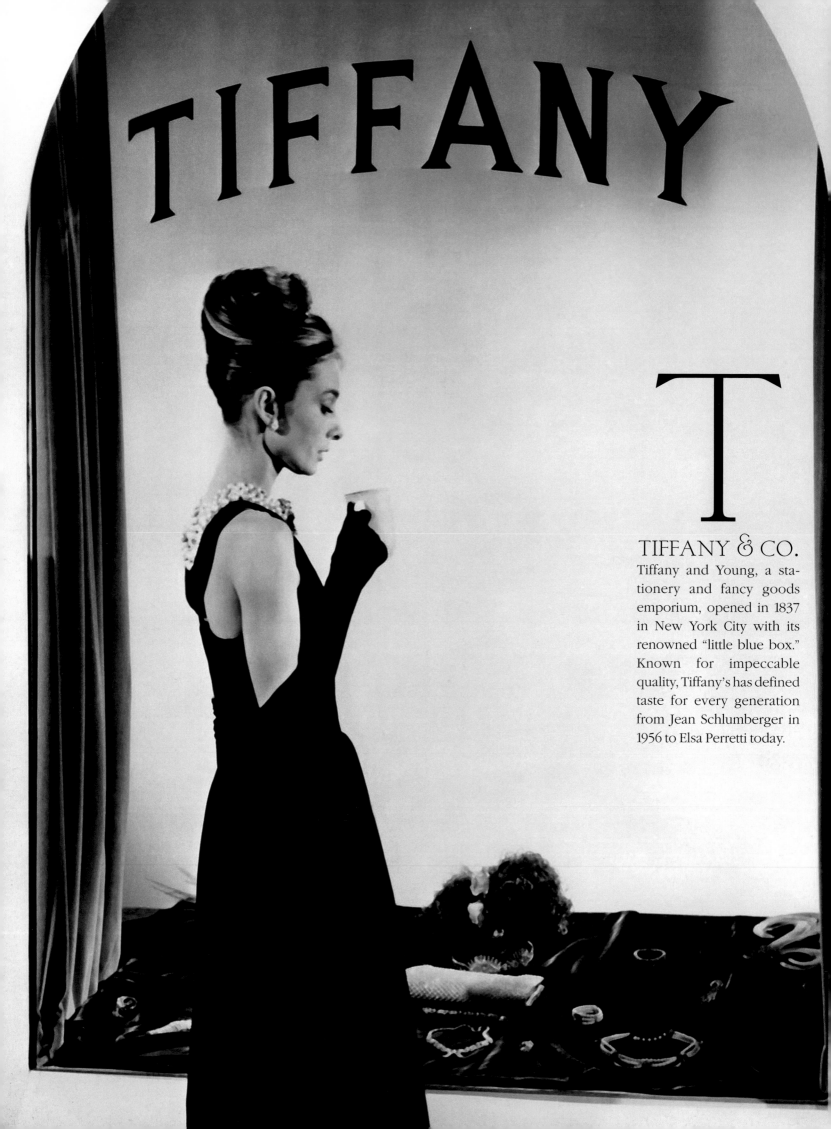

TIFFANY

T

TIFFANY & CO.

Tiffany and Young, a stationery and fancy goods emporium, opened in 1837 in New York City with its renowned "little blue box." Known for impeccable quality, Tiffany's has defined taste for every generation from Jean Schlumberger in 1956 to Elsa Perretti today.

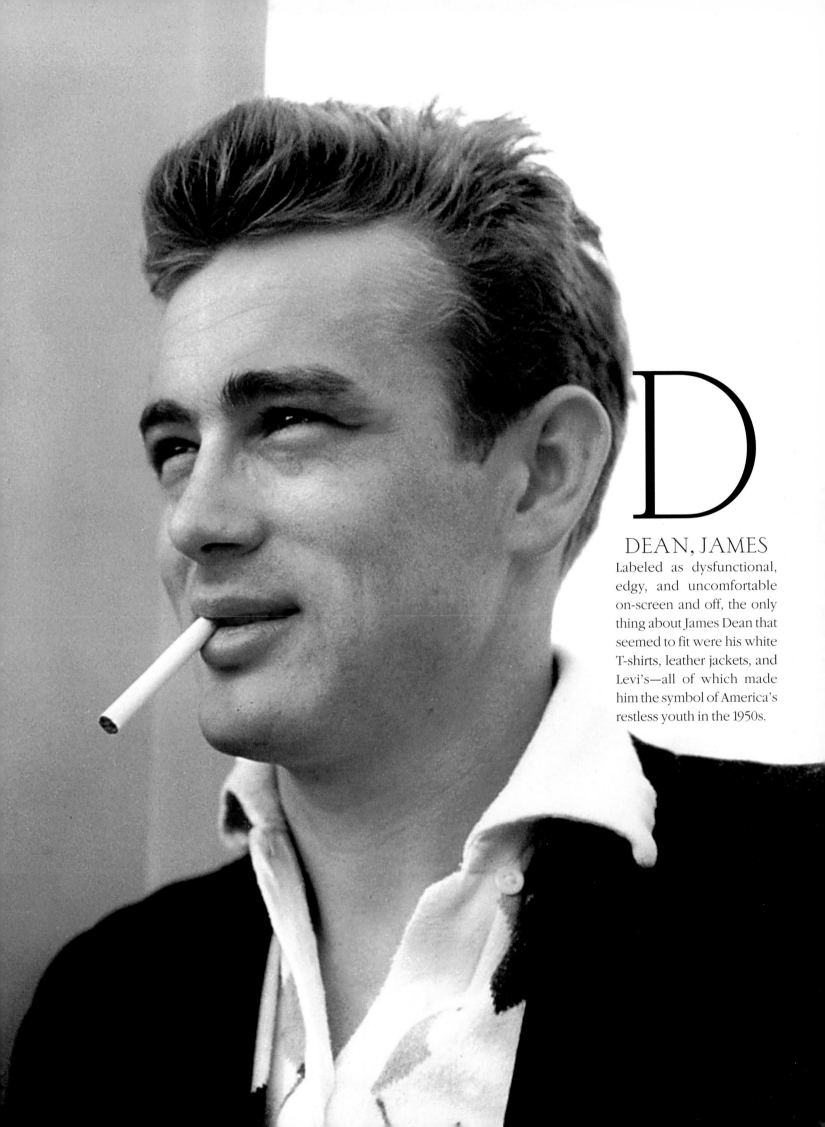

D

DEAN, JAMES

Labeled as dysfunctional, edgy, and uncomfortable on-screen and off, the only thing about James Dean that seemed to fit were his white T-shirts, leather jackets, and Levi's—all of which made him the symbol of America's restless youth in the 1950s.

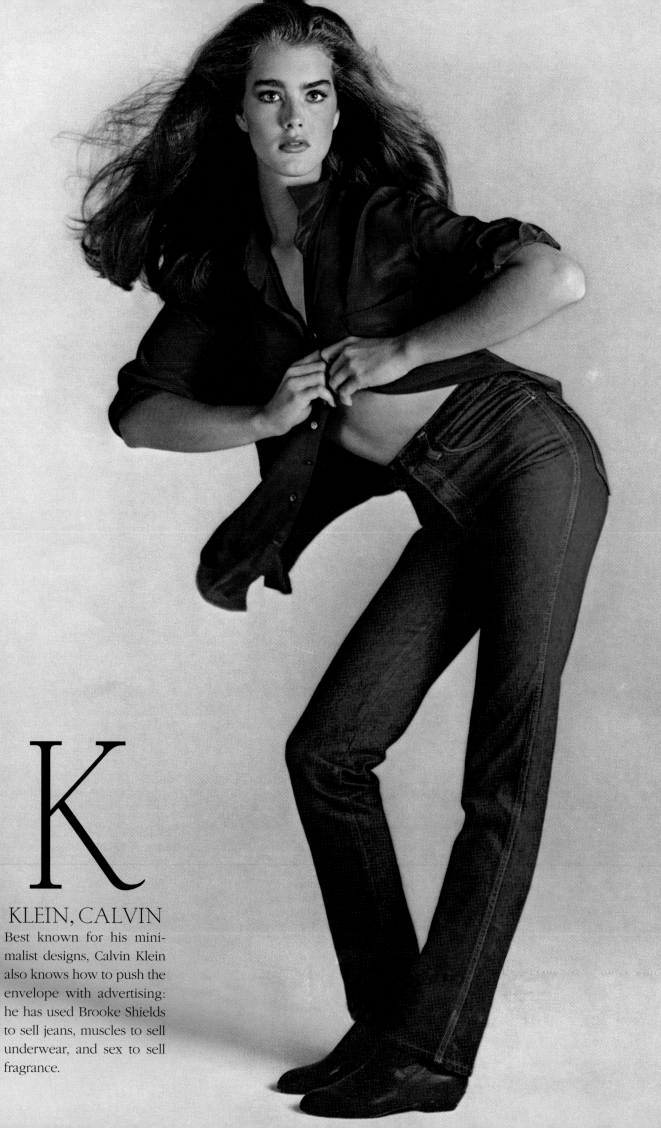

K

KLEIN, CALVIN

Best known for his mini-
malist designs, Calvin Klein
also knows how to push the
envelope with advertising:
he has used Brooke Shields
to sell jeans, muscles to sell
underwear, and sex to sell
fragrance.

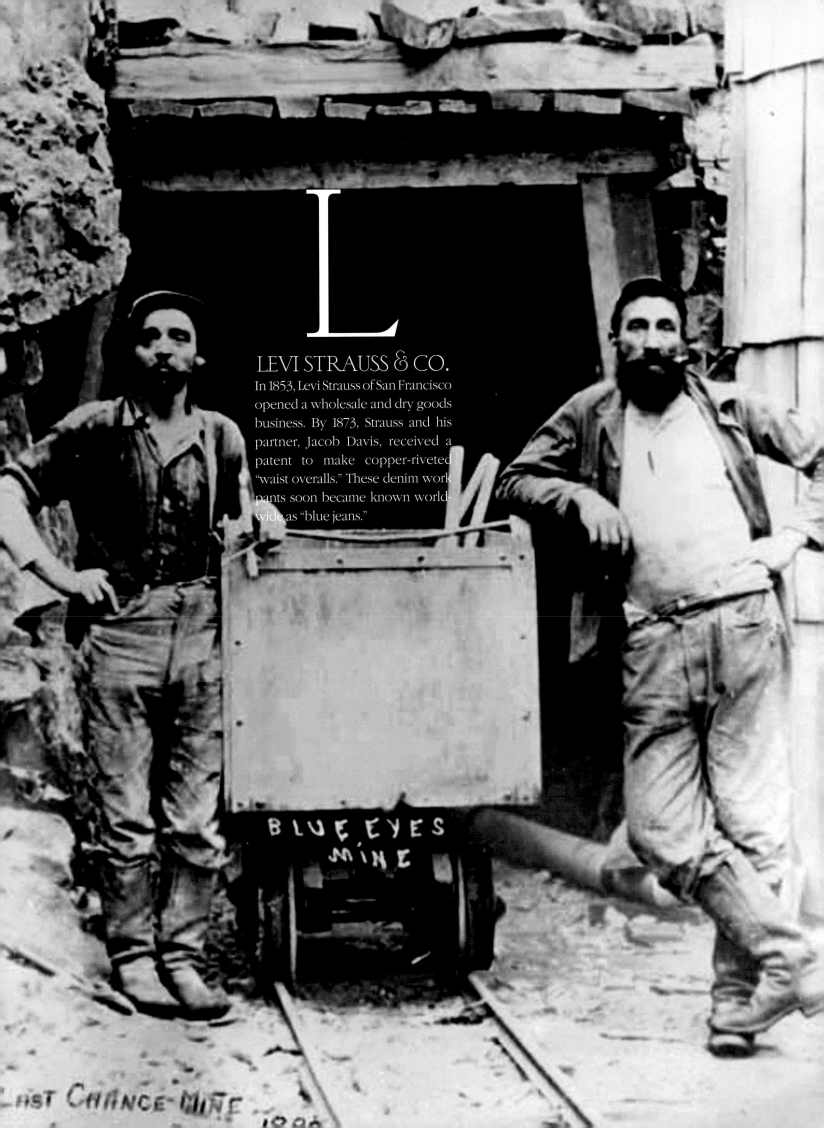

L

LEVI STRAUSS & CO.

In 1853, Levi Strauss of San Francisco opened a wholesale and dry goods business. By 1873, Strauss and his partner, Jacob Davis, received a patent to make copper-riveted "waist overalls." These denim work pants soon became known worldwide as "blue jeans."

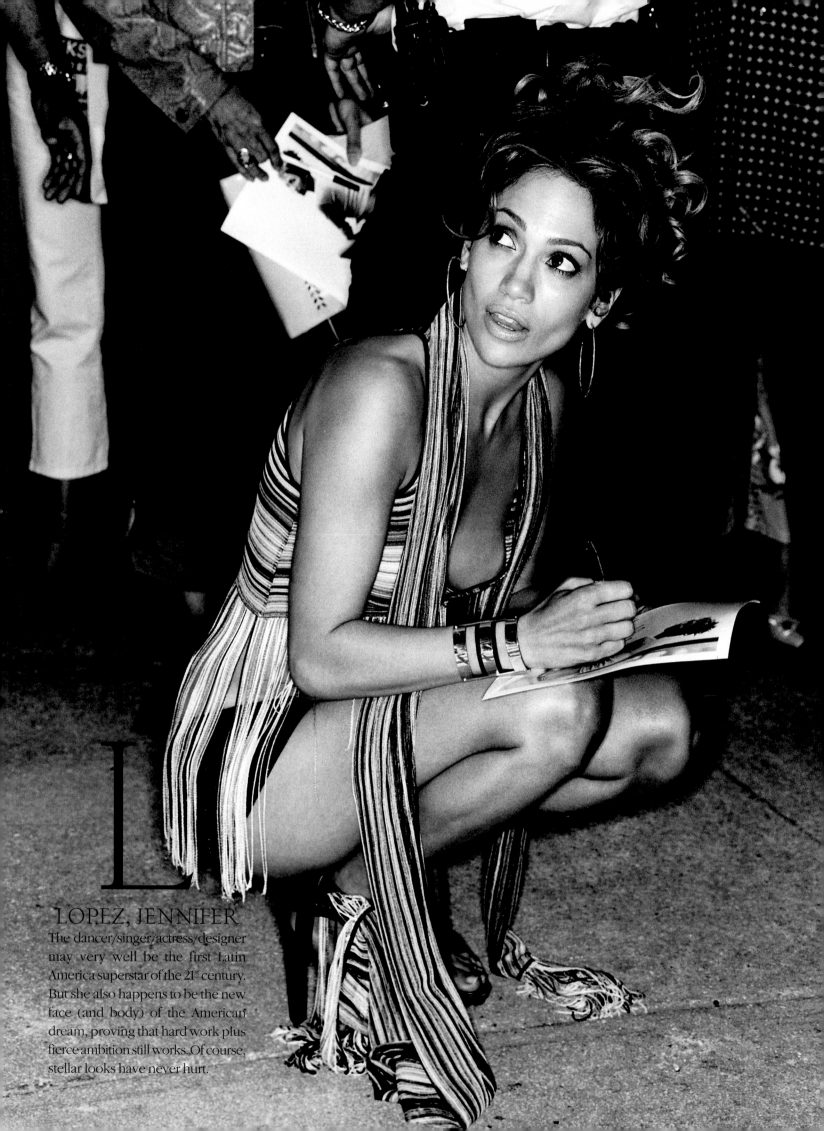

L
LOPEZ, JENNIFER

The dancer/singer/actress/designer may very well be the first Latin America superstar of the 21st century. But she also happens to be the new face (and body) of the American dream, proving that hard work plus fierce ambition still works. Of course, stellar looks have never hurt.

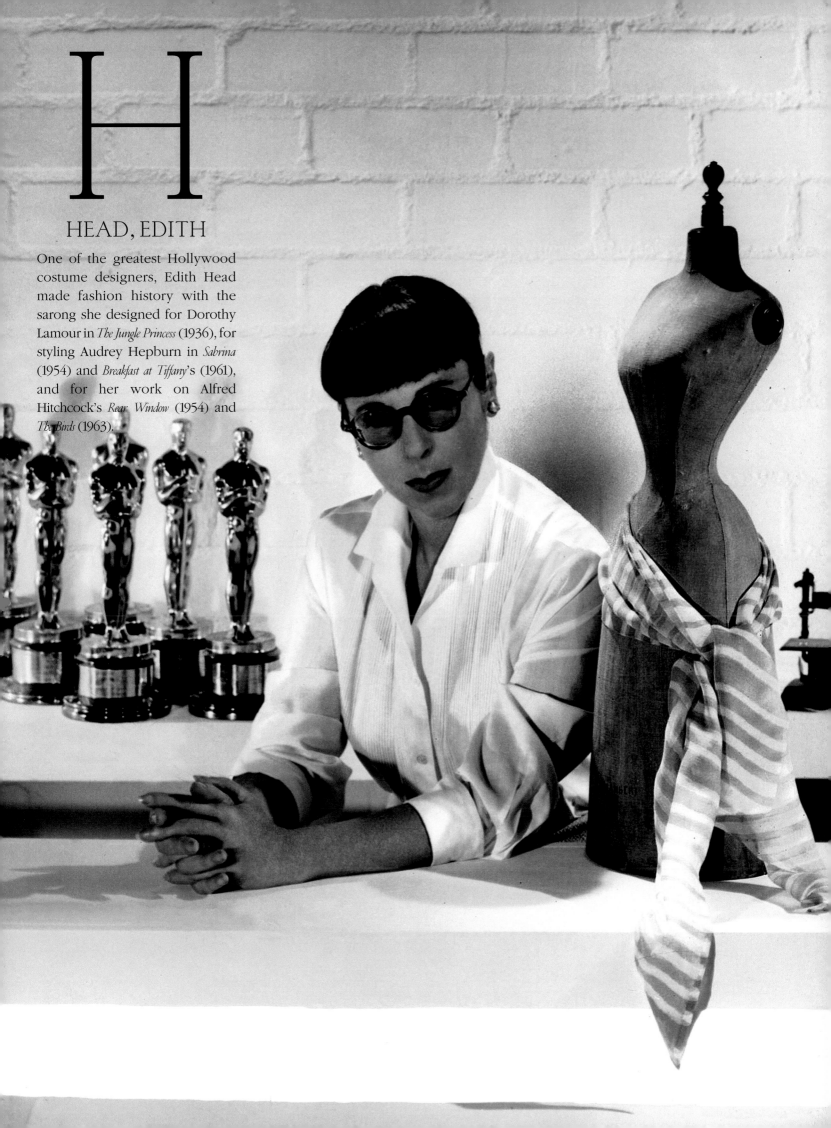

H

HEAD, EDITH

One of the greatest Hollywood costume designers, Edith Head made fashion history with the sarong she designed for Dorothy Lamour in *The Jungle Princess* (1936), for styling Audrey Hepburn in *Sabrina* (1954) and *Breakfast at Tiffany*'s (1961), and for her work on Alfred Hitchcock's *Rear Window* (1954) and *The Birds* (1963).

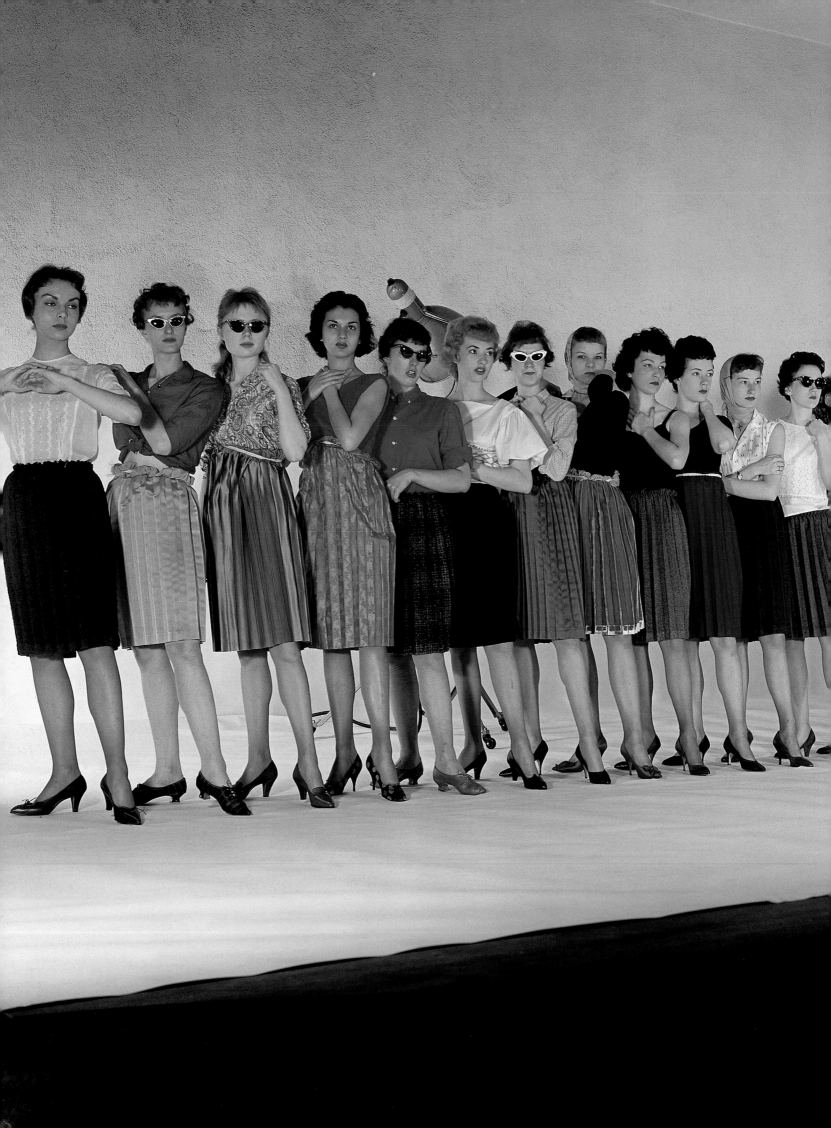

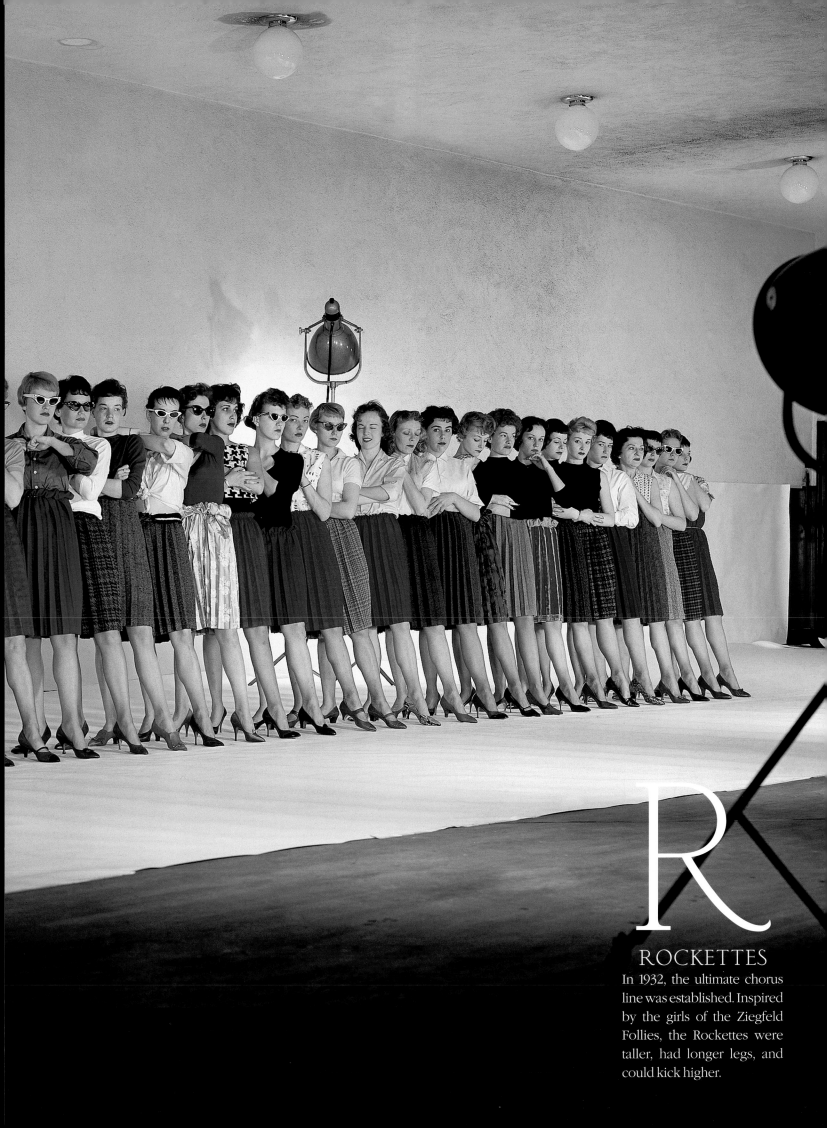

R

ROCKETTES

In 1932, the ultimate chorus line was established. Inspired by the girls of the Ziegfeld Follies, the Rockettes were taller, had longer legs, and could kick higher.

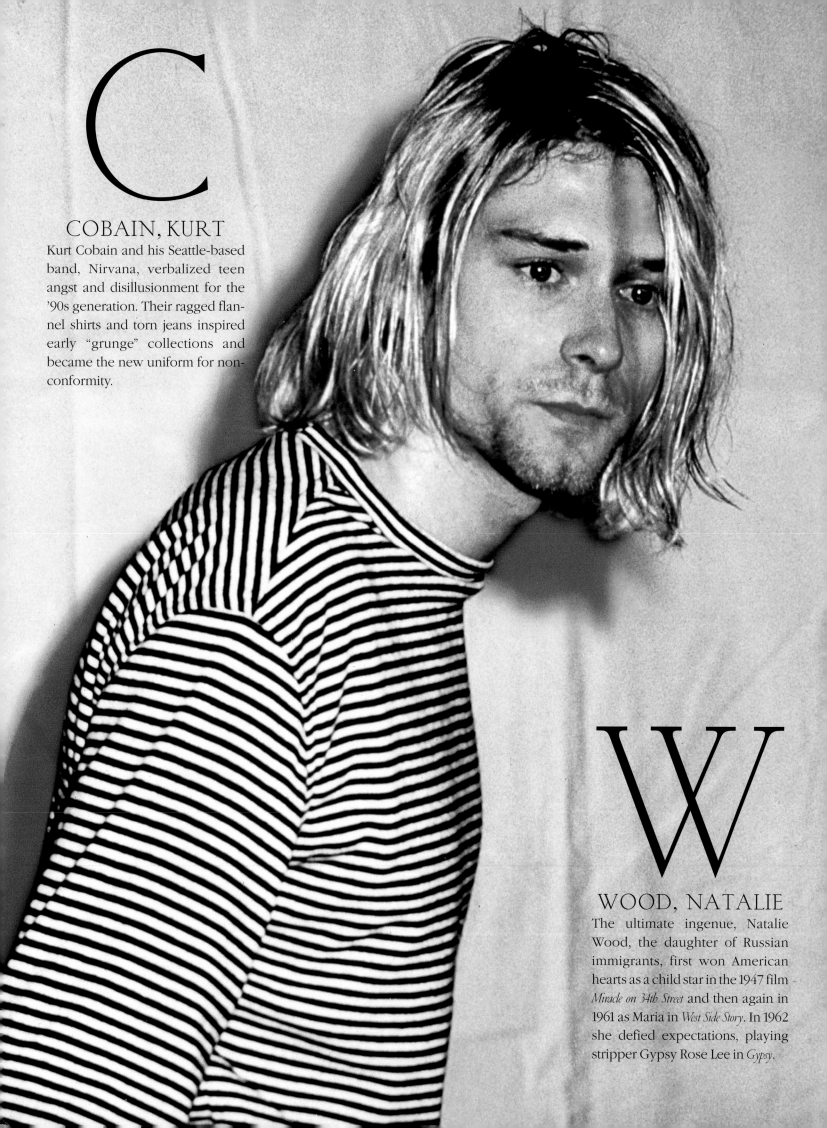

C

COBAIN, KURT

Kurt Cobain and his Seattle-based band, Nirvana, verbalized teen angst and disillusionment for the '90s generation. Their ragged flannel shirts and torn jeans inspired early "grunge" collections and became the new uniform for non-conformity.

W

WOOD, NATALIE

The ultimate ingenue, Natalie Wood, the daughter of Russian immigrants, first won American hearts as a child star in the 1947 film *Miracle on 34th Street* and then again in 1961 as Maria in *West Side Story*. In 1962 she defied expectations, playing stripper Gypsy Rose Lee in *Gypsy*.

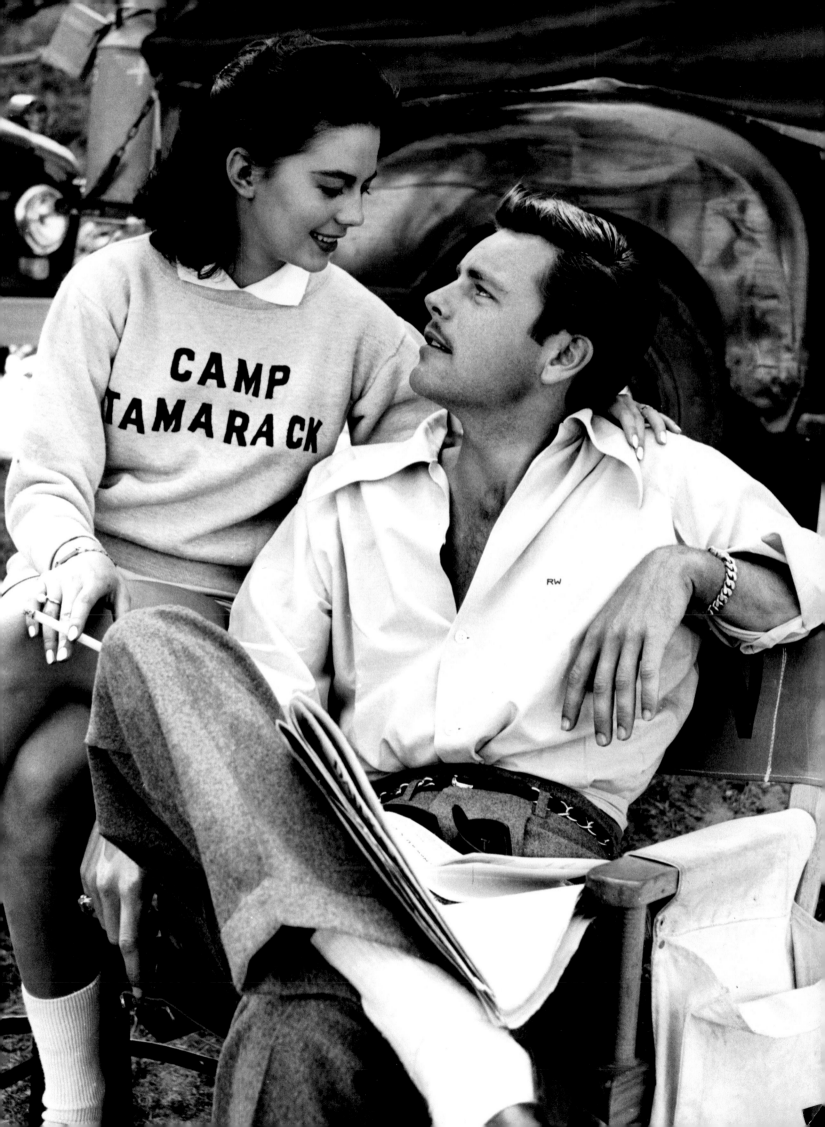

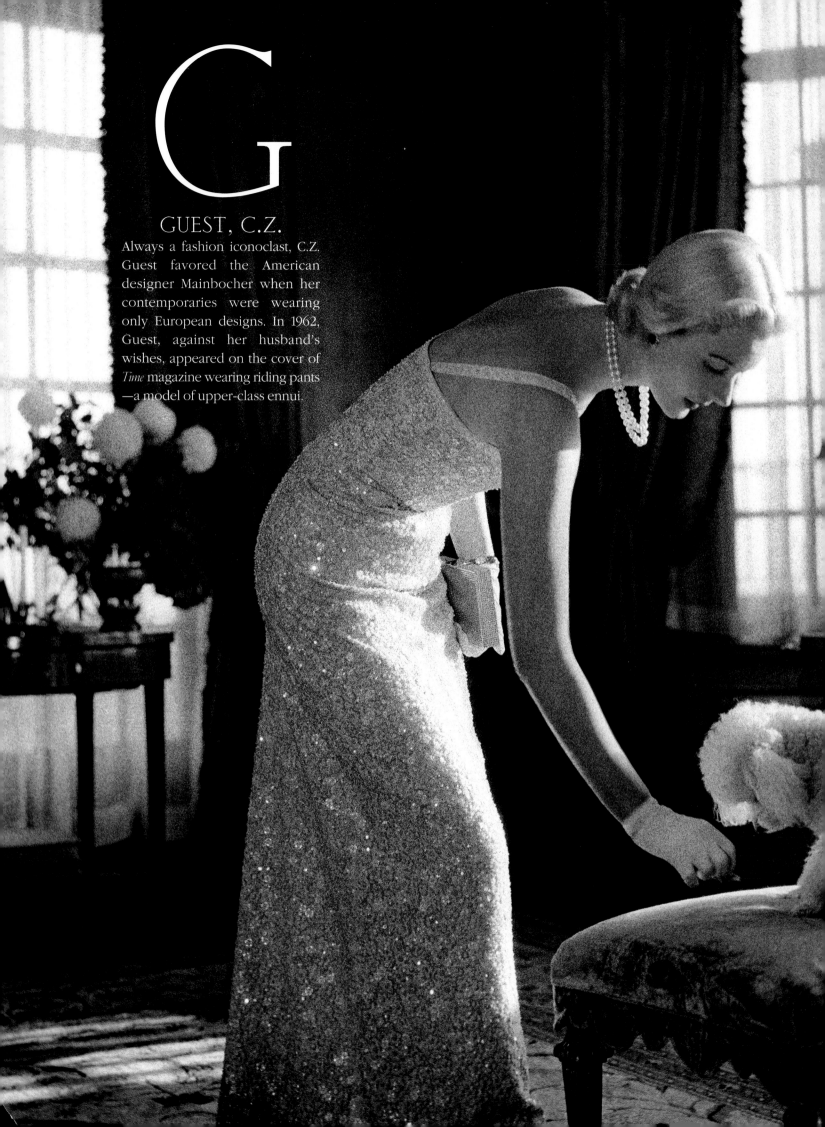

G

GUEST, C.Z.

Always a fashion iconoclast, C.Z. Guest favored the American designer Mainbocher when her contemporaries were wearing only European designs. In 1962, Guest, against her husband's wishes, appeared on the cover of *Time* magazine wearing riding pants —a model of upper-class ennui.

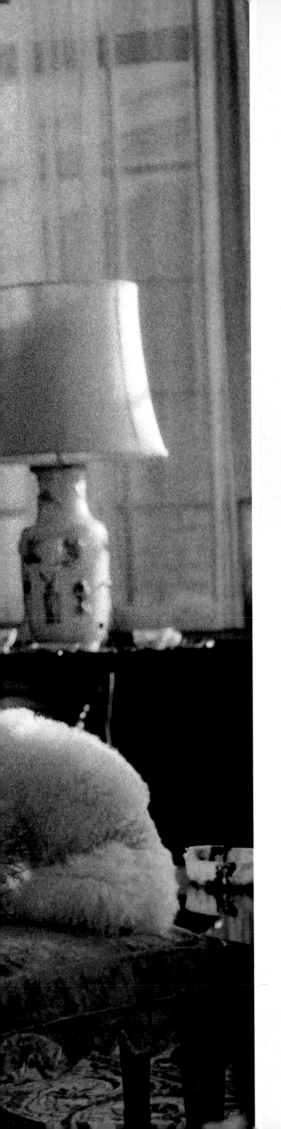

U

UNIFORMS

Uniforms have always been of interest to designers. Mainbocher designed uniforms for the WAVES and the American Girl Scouts; Hattie Carnegie for the Women's Army Corps; and Halston for Braniff and the Girl Scouts.

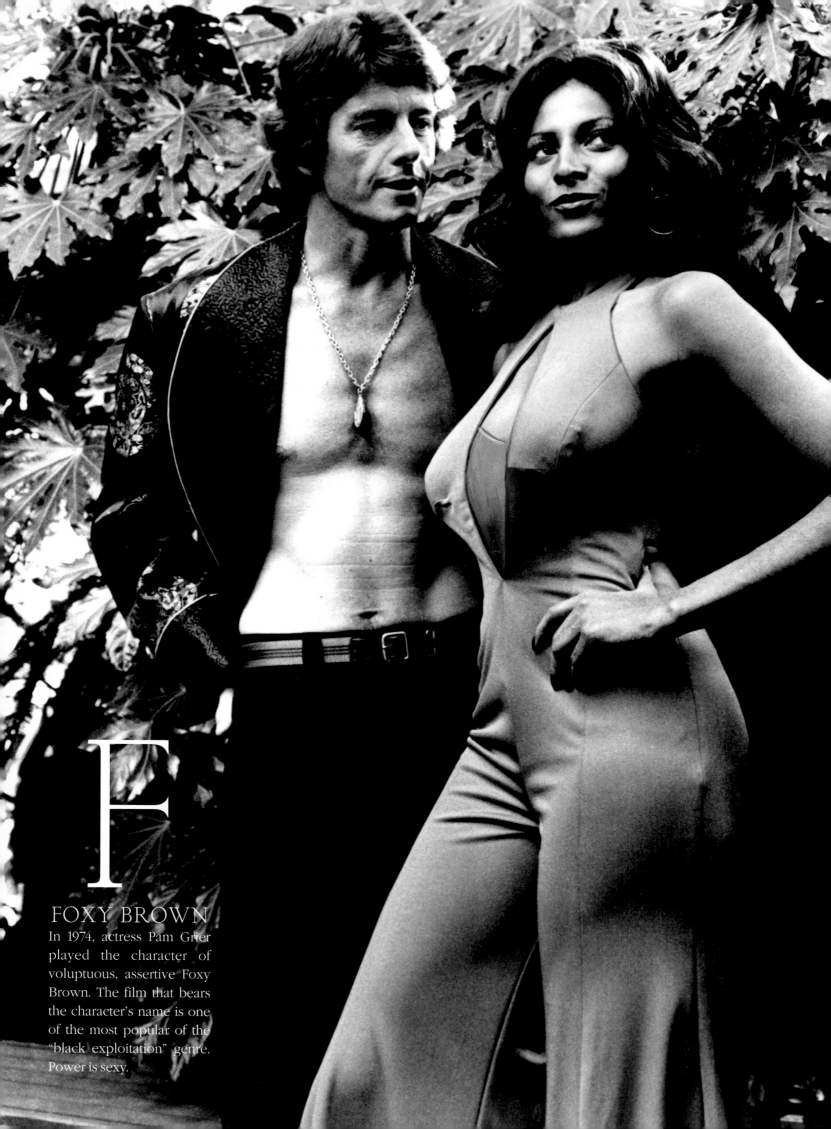

F

FOXY BROWN

In 1974, actress Pam Grier played the character of voluptuous, assertive Foxy Brown. The film that bears the character's name is one of the most popular of the "black exploitation" genre. Power is sexy.

GQ
GENTLEMEN'S QUARTERLY

THE MANY FACES OF YOU

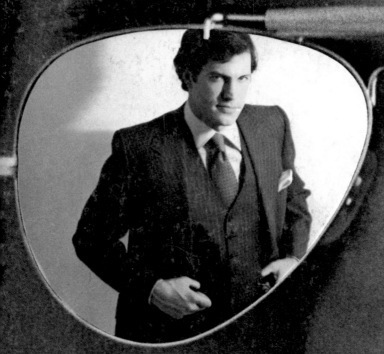

THE ULTIMATE FASHION GUIDE FOR MEN

ALL YOU'LL EVER NEED TO KNOW TO LOOK AND FEEL YOUR BEST

GQ

GENTLEMEN'S QUARTERLY

Founded in 1921, the ultimate men's fashion magazine was updated in 1983 with "Mr. GQ" as the moniker—which quickly became part of the lexicon denoting a man of style.

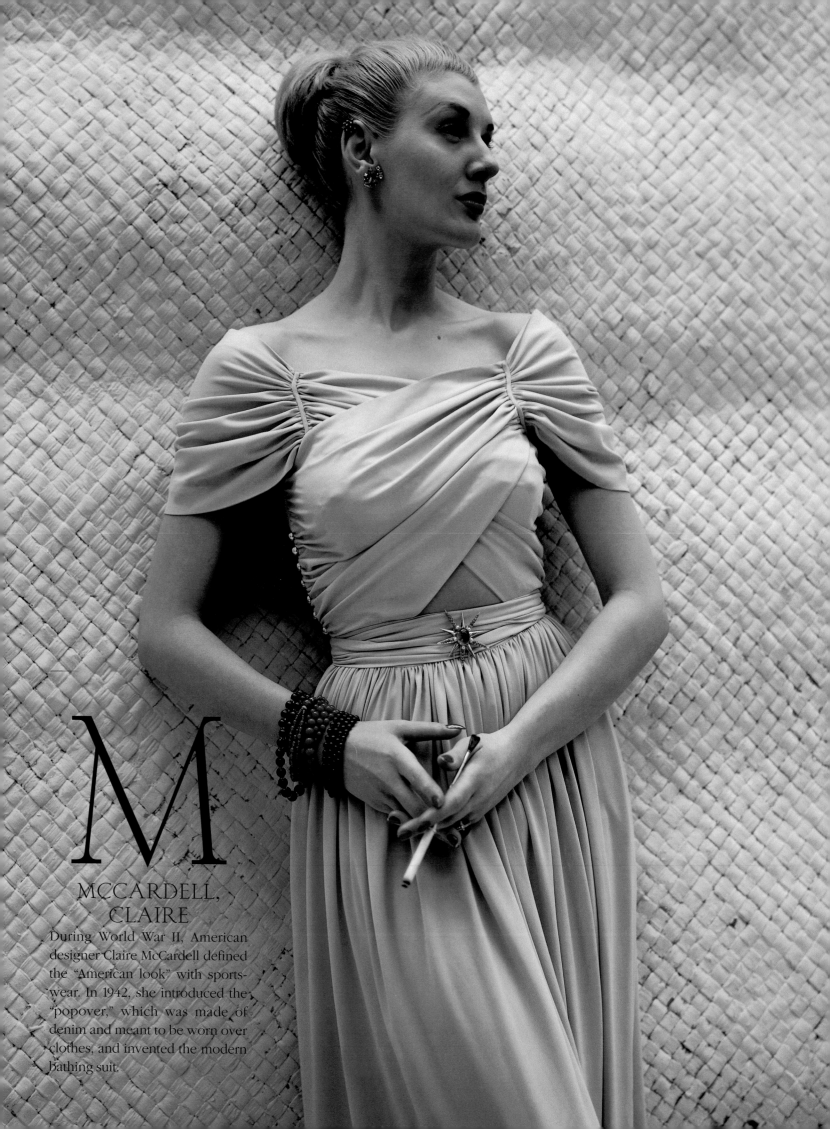

M

MCCARDELL, CLAIRE

During World War II, American designer Claire McCardell defined the "American look" with sportswear. In 1942, she introduced the "popover," which was made of denim and meant to be worn over clothes, and invented the modern bathing suit.

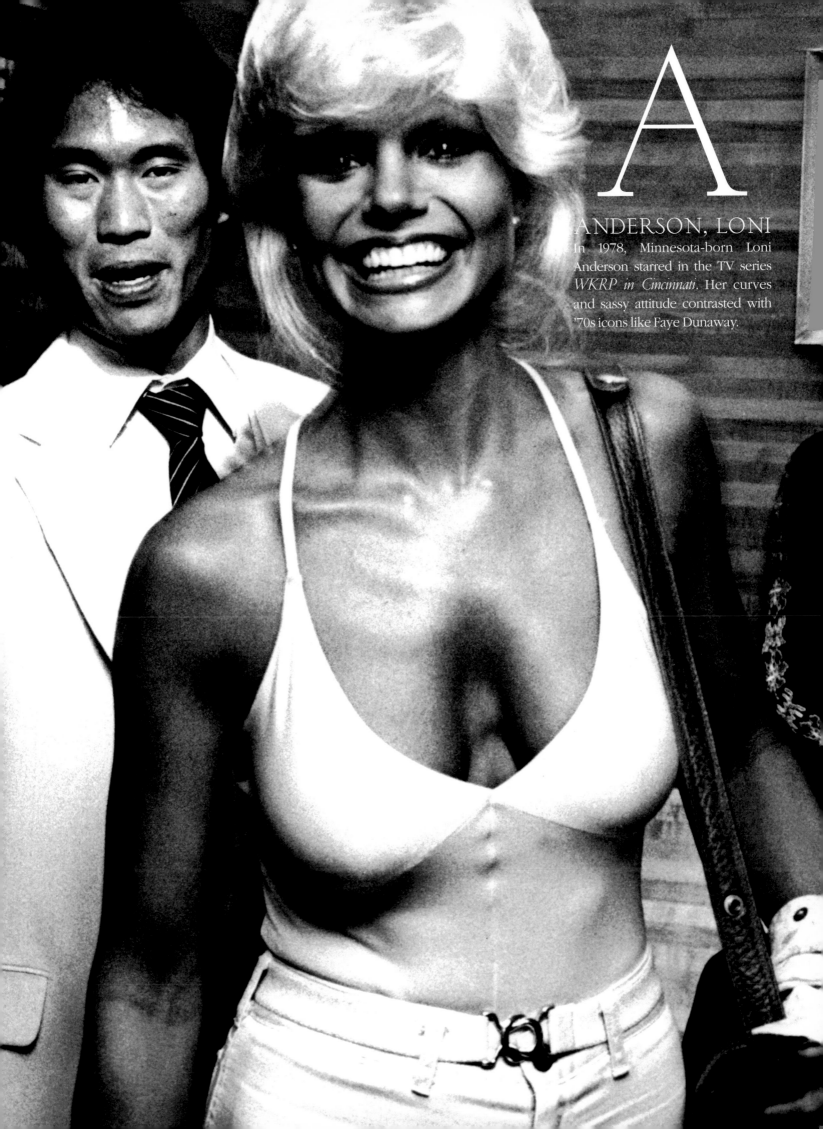

A

ANDERSON, LONI

In 1978, Minnesota-born Loni Anderson starred in the TV series *WKRP in Cincinnati*. Her curves and sassy attitude contrasted with '70s icons like Faye Dunaway.

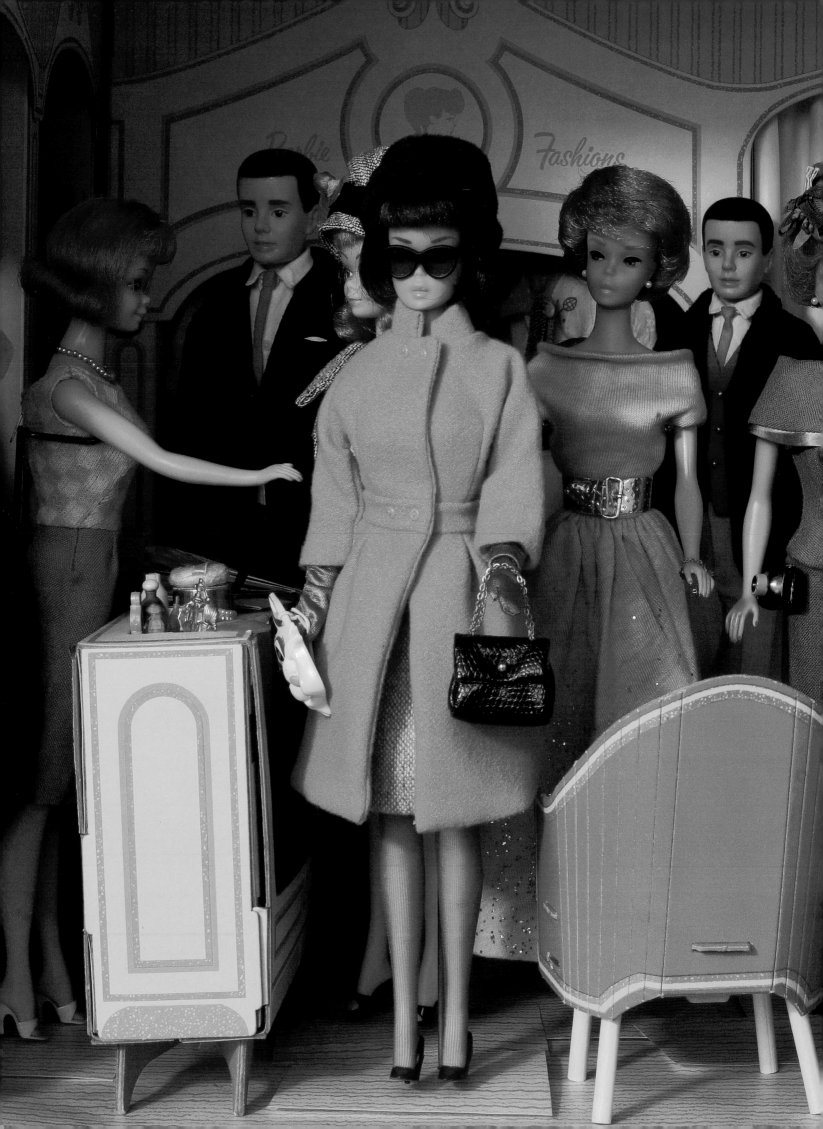

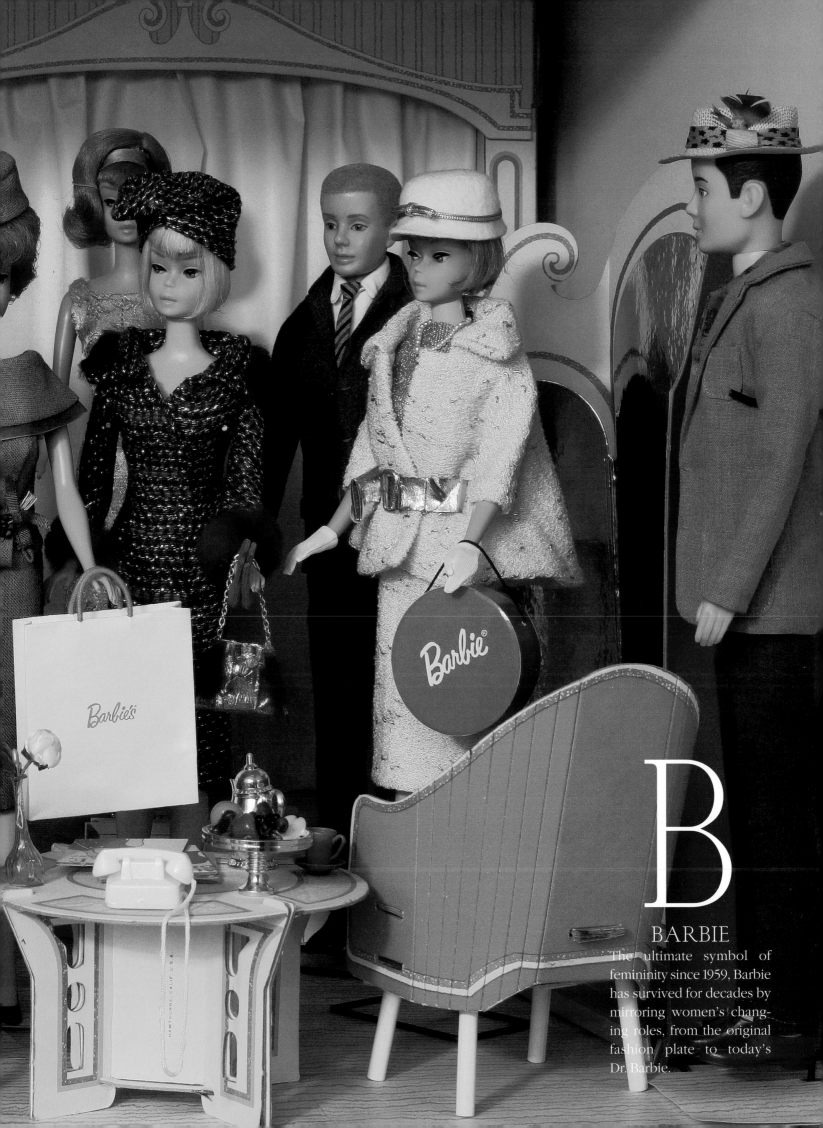

B

BARBIE

The ultimate symbol of femininity since 1959, Barbie has survived for decades by mirroring women's changing roles, from the original fashion plate to today's Dr. Barbie.

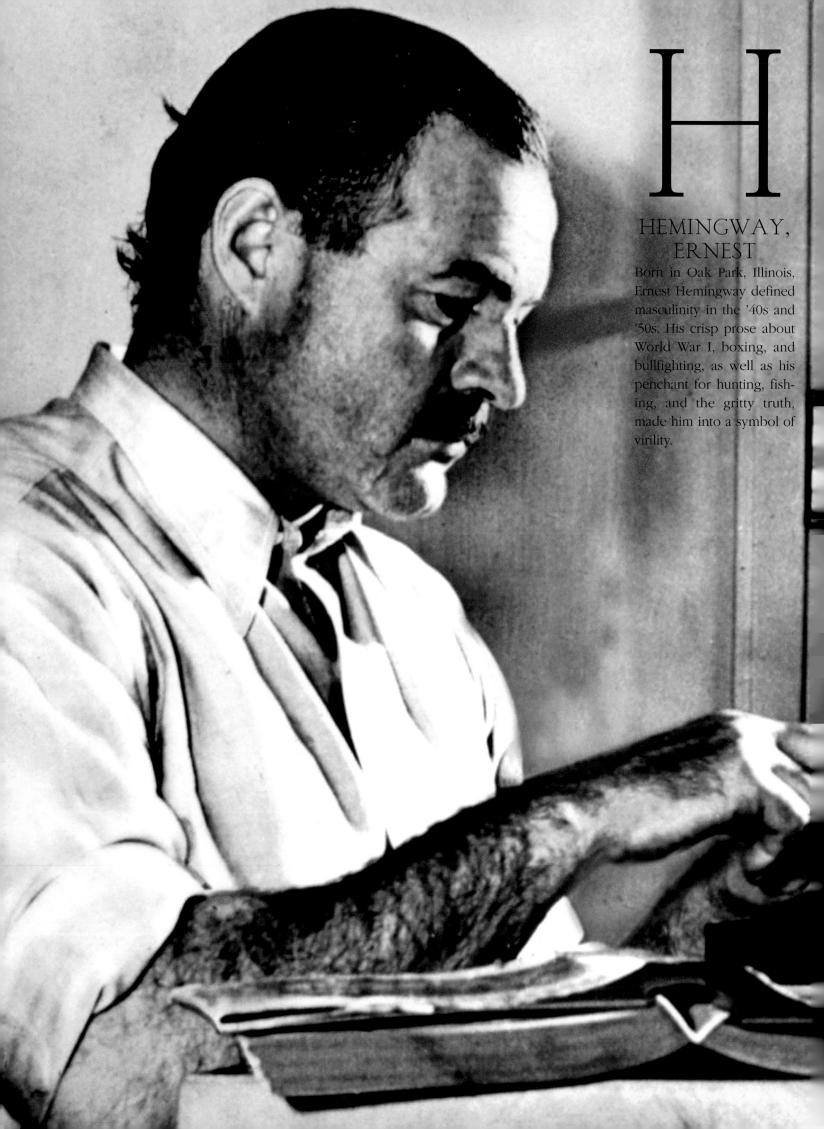

H

HEMINGWAY, ERNEST

Born in Oak Park, Illinois, Ernest Hemingway defined masculinity in the '40s and '50s. His crisp prose about World War I, boxing, and bullfighting, as well as his penchant for hunting, fishing, and the gritty truth, made him into a symbol of virility.

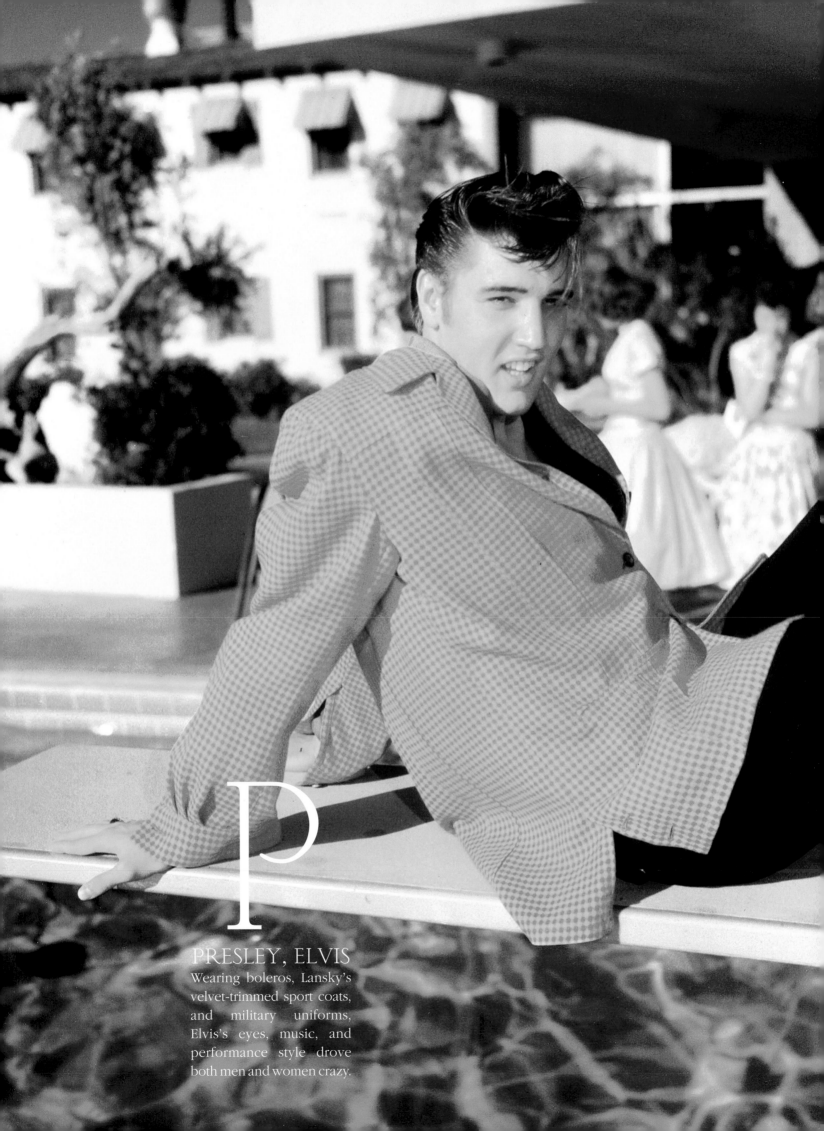

PRESLEY, ELVIS

Wearing boleros, Lansky's velvet-trimmed sport coats, and military uniforms, Elvis's eyes, music, and performance style drove both men and women crazy.

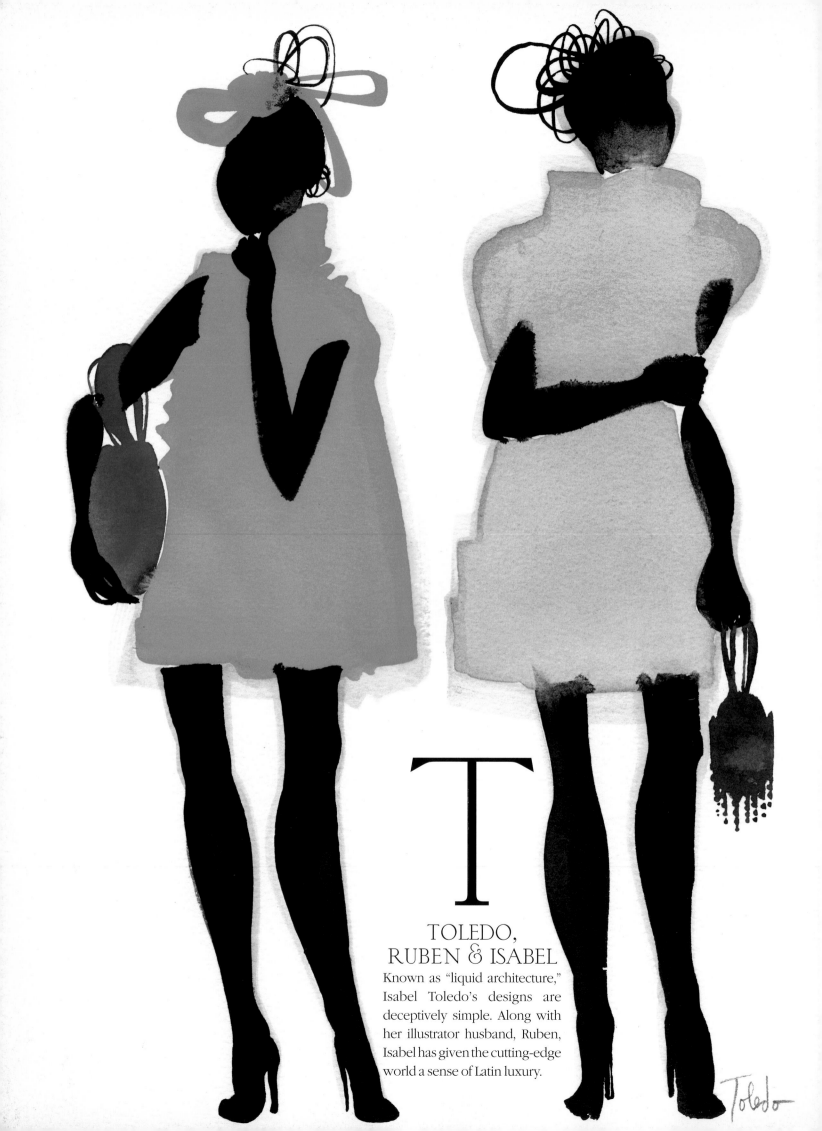

T

TOLEDO, RUBEN & ISABEL

Known as "liquid architecture," Isabel Toledo's designs are deceptively simple. Along with her illustrator husband, Ruben, Isabel has given the cutting-edge world a sense of Latin luxury.

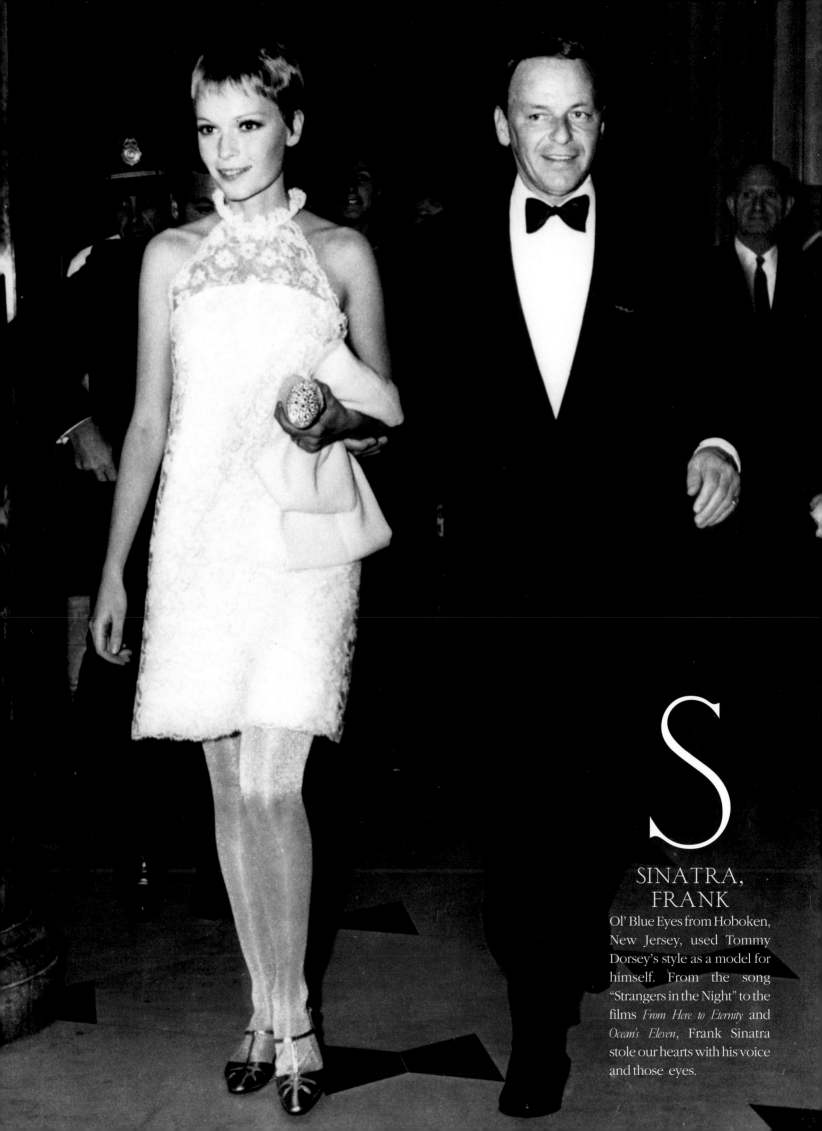

S

SINATRA, FRANK

Ol' Blue Eyes from Hoboken, New Jersey, used Tommy Dorsey's style as a model for himself. From the song "Strangers in the Night" to the films *From Here to Eternity* and *Ocean's Eleven*, Frank Sinatra stole our hearts with his voice and those eyes.

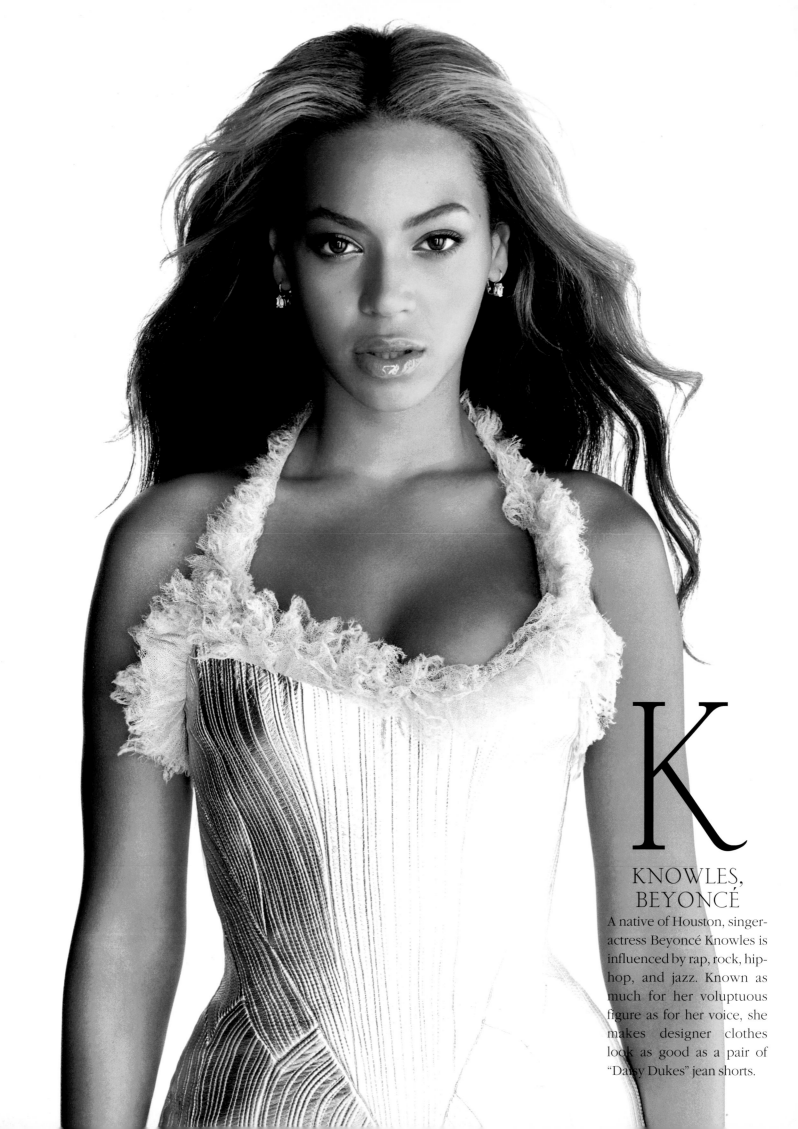

K

KNOWLES, BEYONCÉ

A native of Houston, singer-actress Beyoncé Knowles is influenced by rap, rock, hip-hop, and jazz. Known as much for her voluptuous figure as for her voice, she makes designer clothes look as good as a pair of "Daisy Dukes" jean shorts.

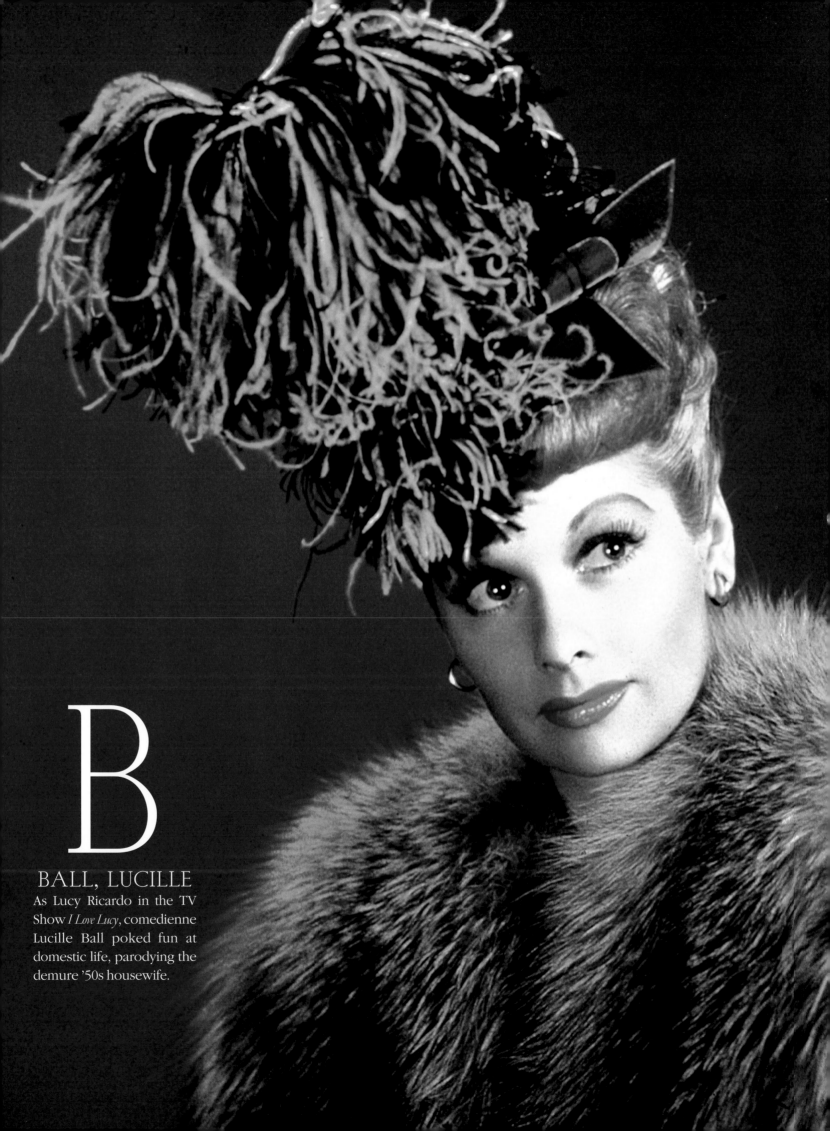

B

BALL, LUCILLE

As Lucy Ricardo in the TV Show *I Love Lucy*, comedienne Lucille Ball poked fun at domestic life, parodying the demure '50s housewife.

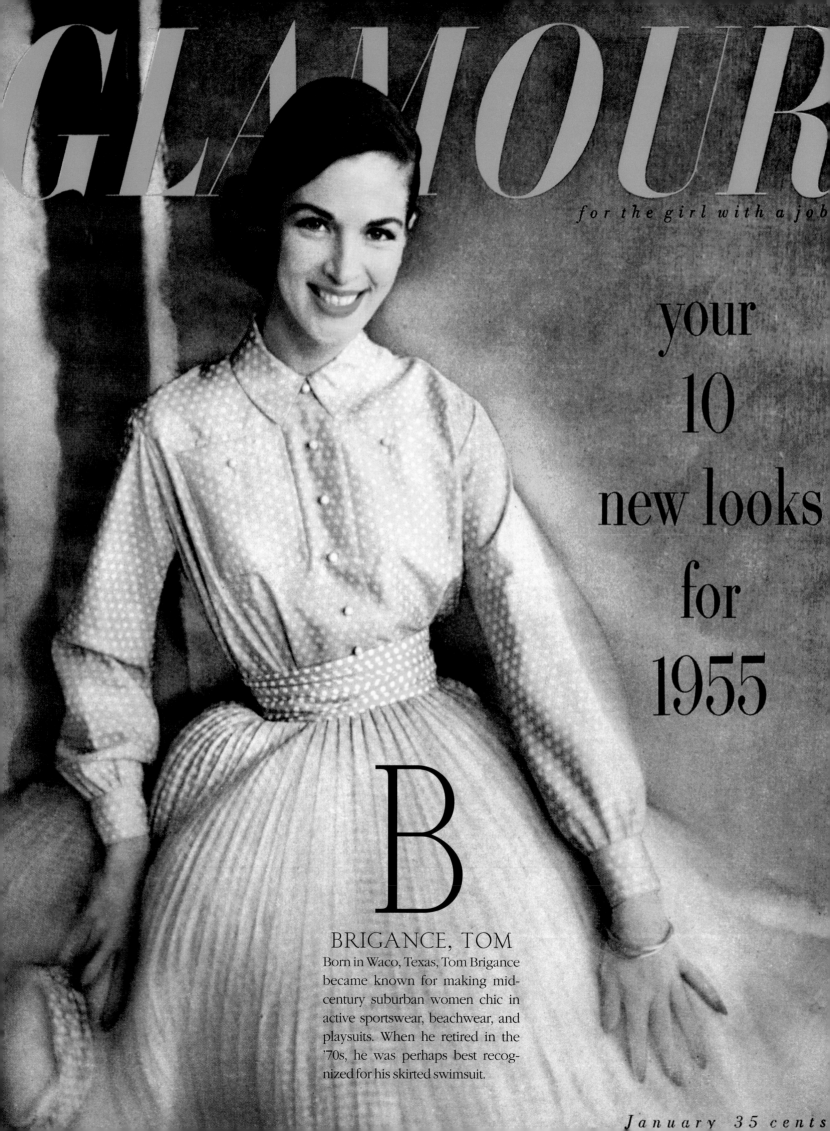

GLAMOUR

for the girl with a job

your 10 new looks for 1955

B

BRIGANCE, TOM

Born in Waco, Texas, Tom Brigance became known for making mid-century suburban women chic in active sportswear, beachwear, and playsuits. When he retired in the '70s, he was perhaps best recognized for his skirted swimsuit.

January 35 cents

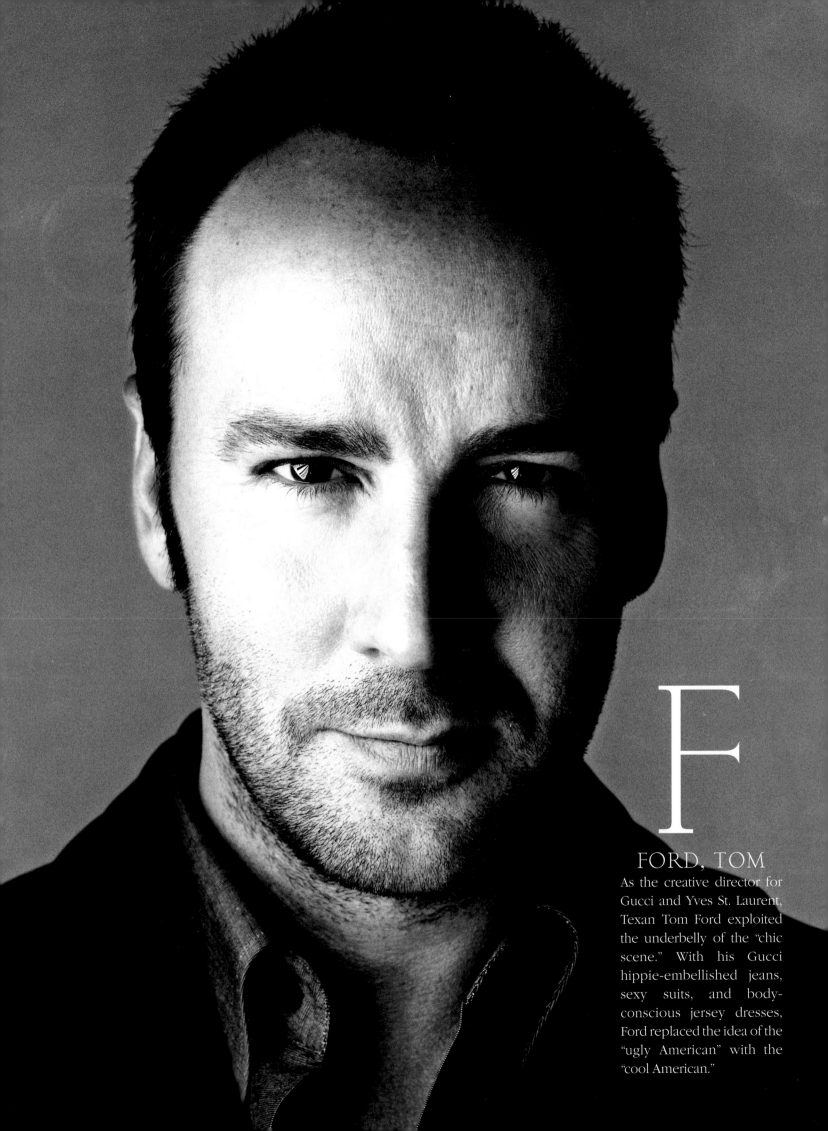

F

FORD, TOM

As the creative director for Gucci and Yves St. Laurent, Texan Tom Ford exploited the underbelly of the "chic scene." With his Gucci hippie-embellished jeans, sexy suits, and body-conscious jersey dresses, Ford replaced the idea of the "ugly American" with the "cool American."

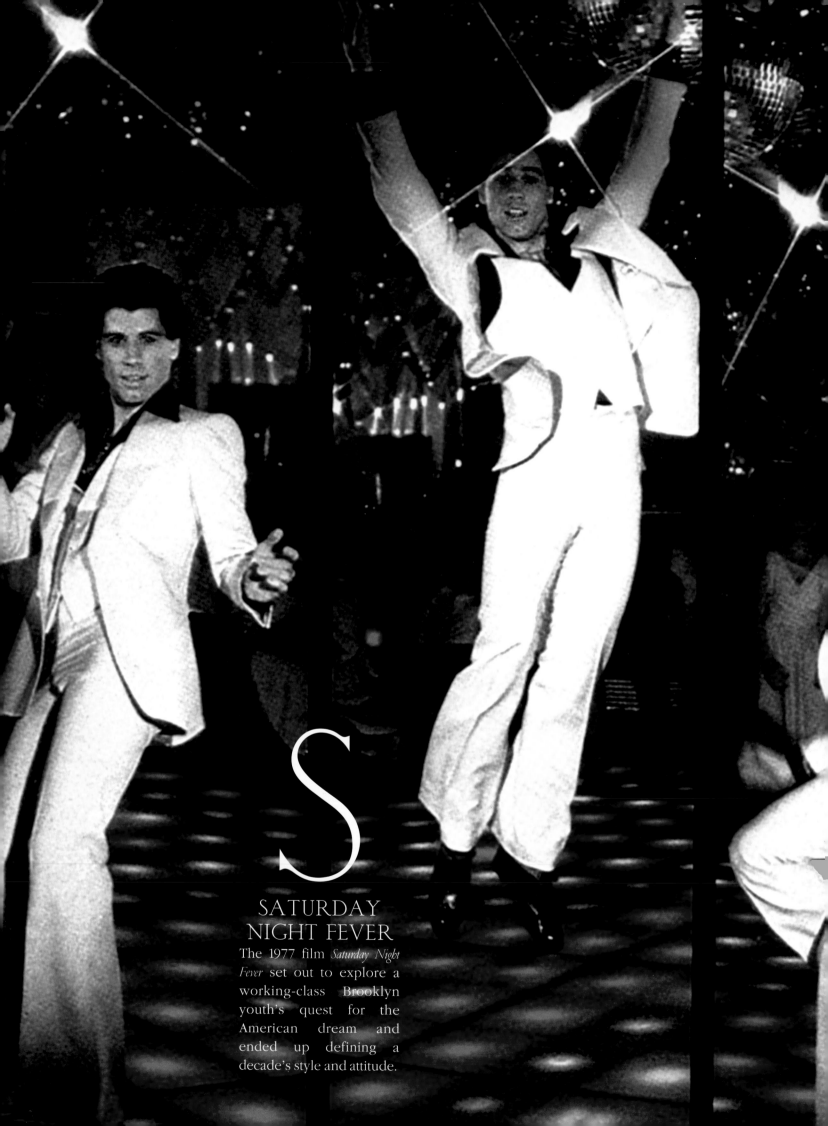

S

SATURDAY NIGHT FEVER

The 1977 film *Saturday Night Fever* set out to explore a working-class Brooklyn youth's quest for the American dream and ended up defining a decade's style and attitude.

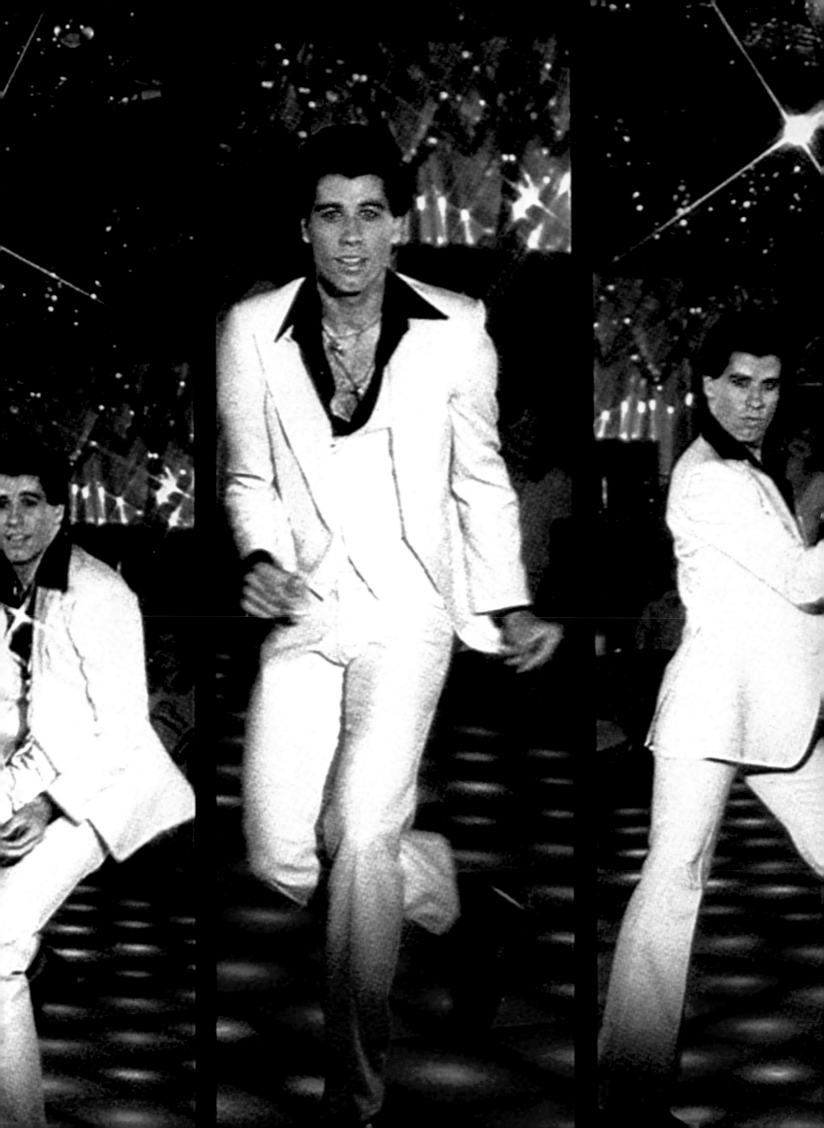

K

KARAN, DONNA

New Yorker Donna Karan knows women's bodies. From cashmere bodysuits to pin-striped power suits, Donna Karan has fundamentally changed the way women now dress: sexy and empowered.

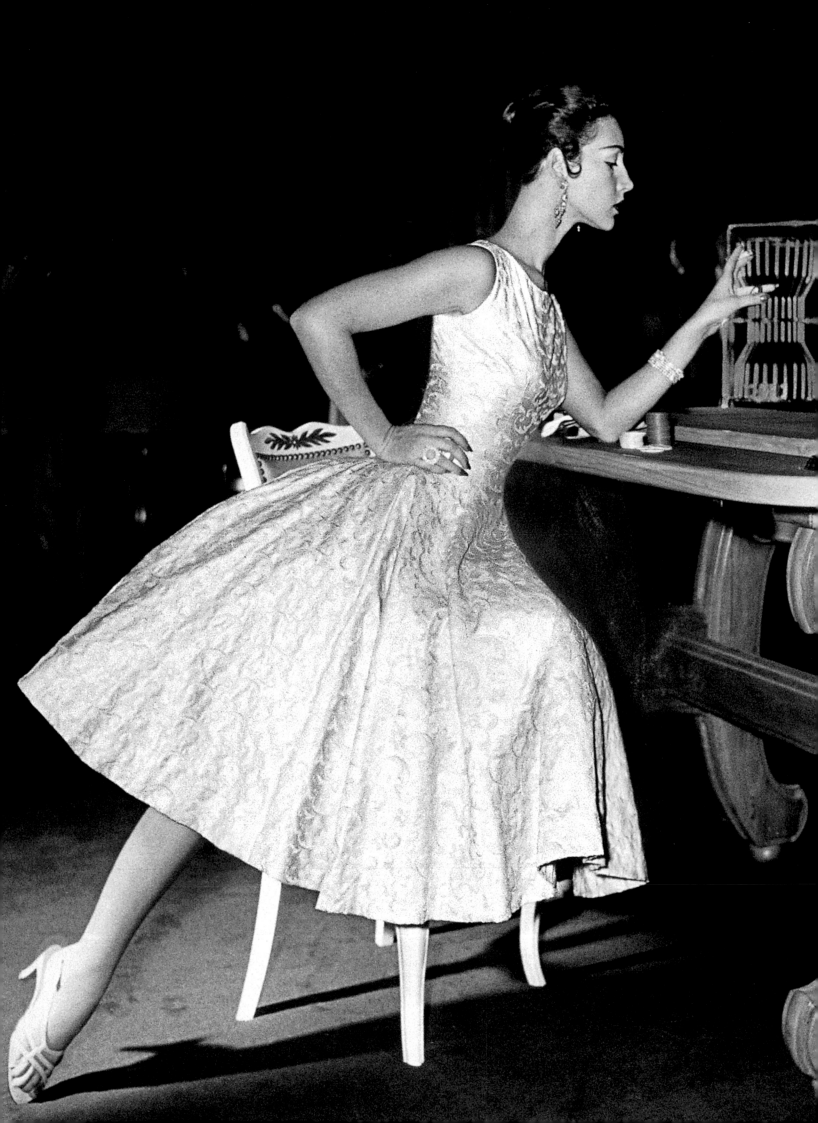

V

VOGUE PATTERNS

Introduced in 1913, Vogue Patterns democratized fashion by simplifying haute couture designs for women to make in their homes.

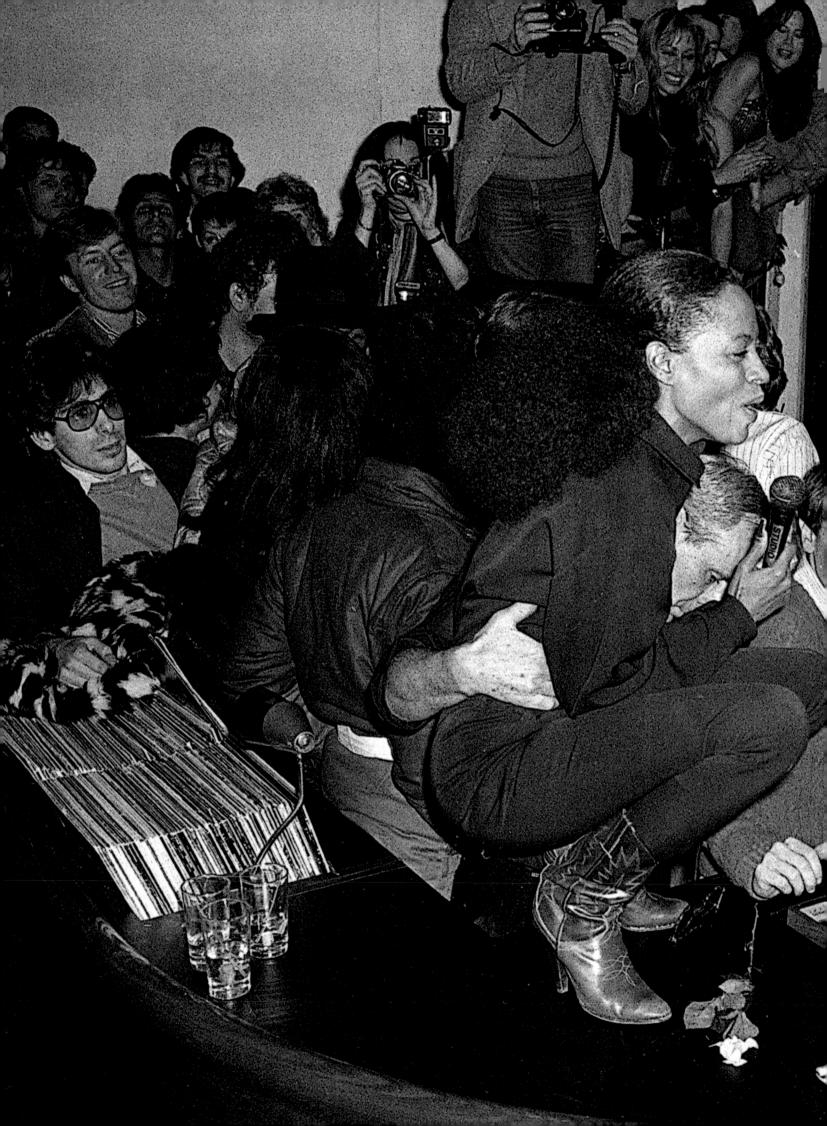

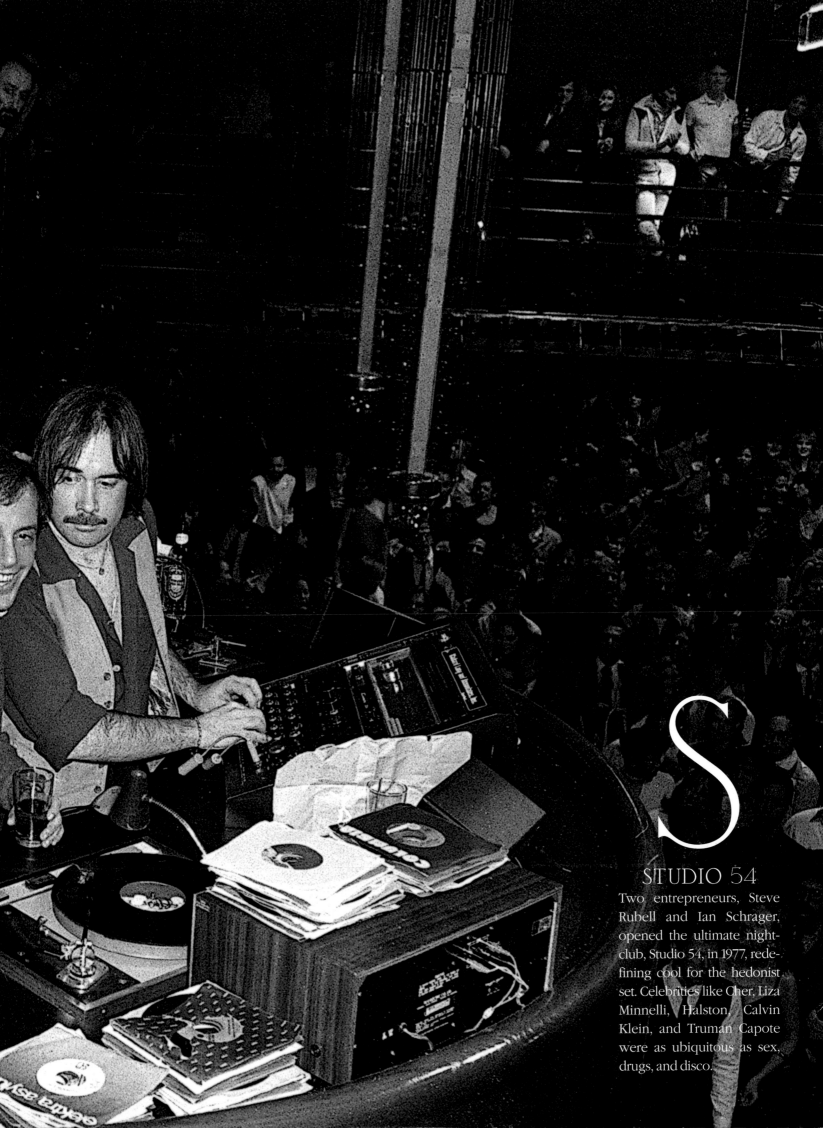

S

STUDIO 54

Two entrepreneurs, Steve Rubell and Ian Schrager, opened the ultimate nightclub, Studio 54, in 1977, redefining cool for the hedonist set. Celebrities like Cher, Liza Minnelli, Halston, Calvin Klein, and Truman Capote were as ubiquitous as sex, drugs, and disco.

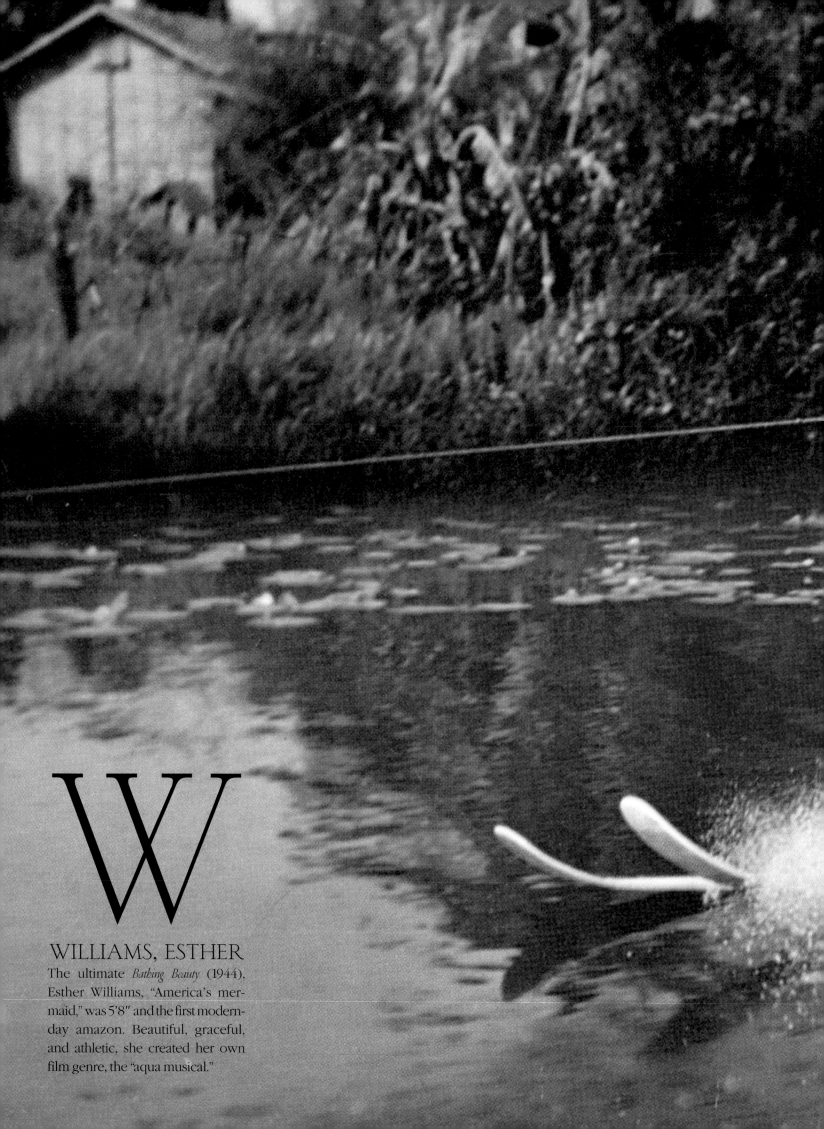

W

WILLIAMS, ESTHER

The ultimate *Bathing Beauty* (1944), Esther Williams, "America's mermaid," was 5'8" and the first modern-day amazon. Beautiful, graceful, and athletic, she created her own film genre, the "aqua musical."

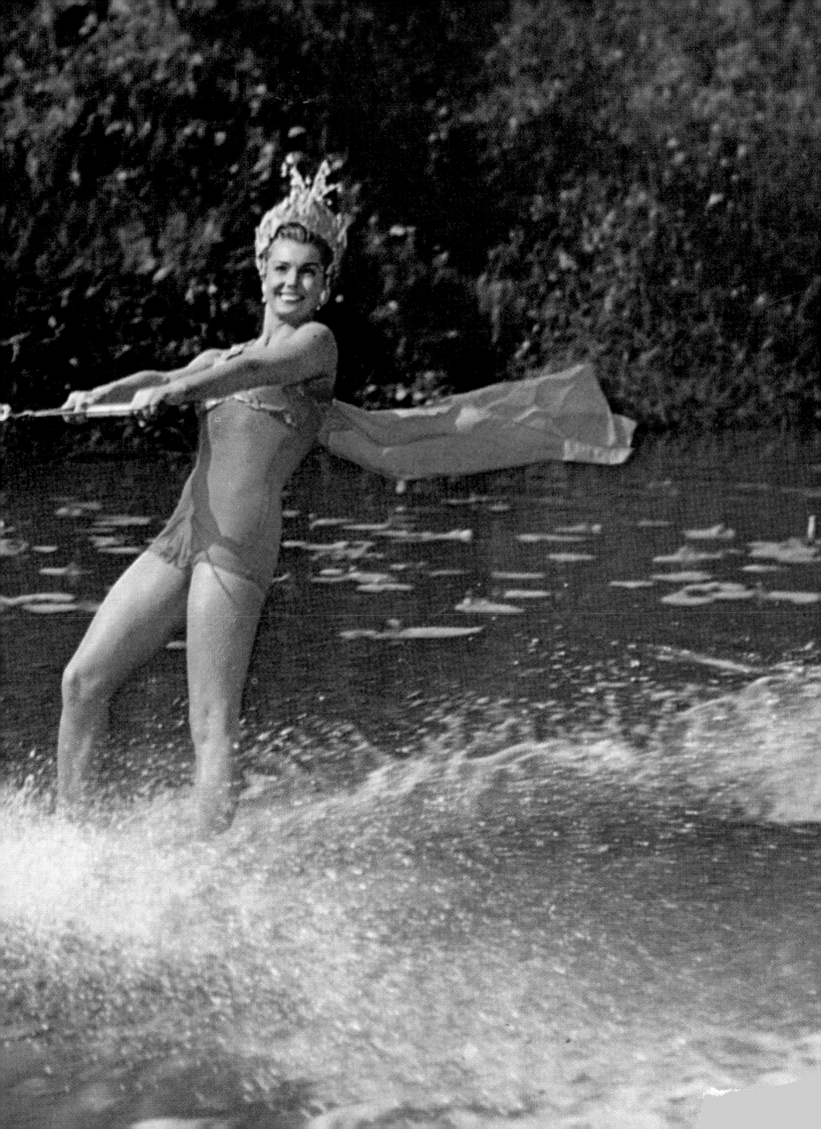

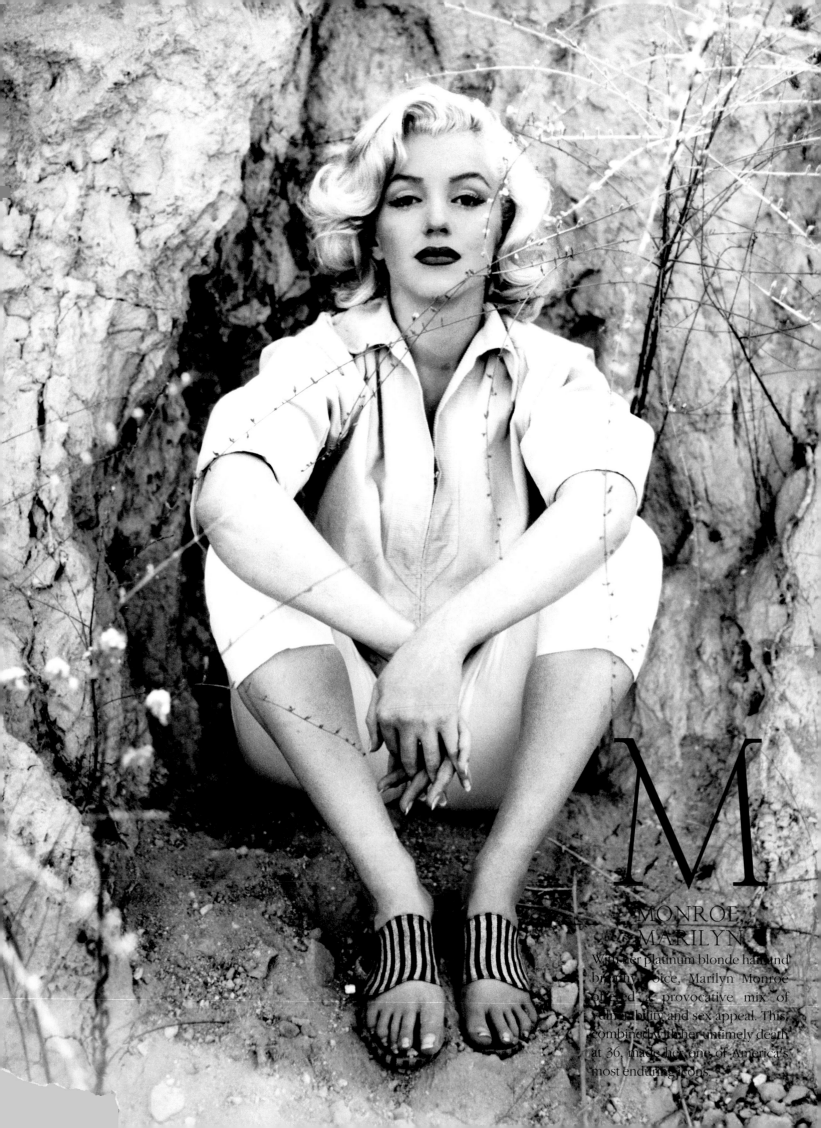

M

MONROE, MARILYN

With her platinum blonde hair and breathy voice, Marilyn Monroe offered a provocative mix of vulnerability and sex appeal. This, combined with her untimely death at 36, made her one of America's most enduring icons.

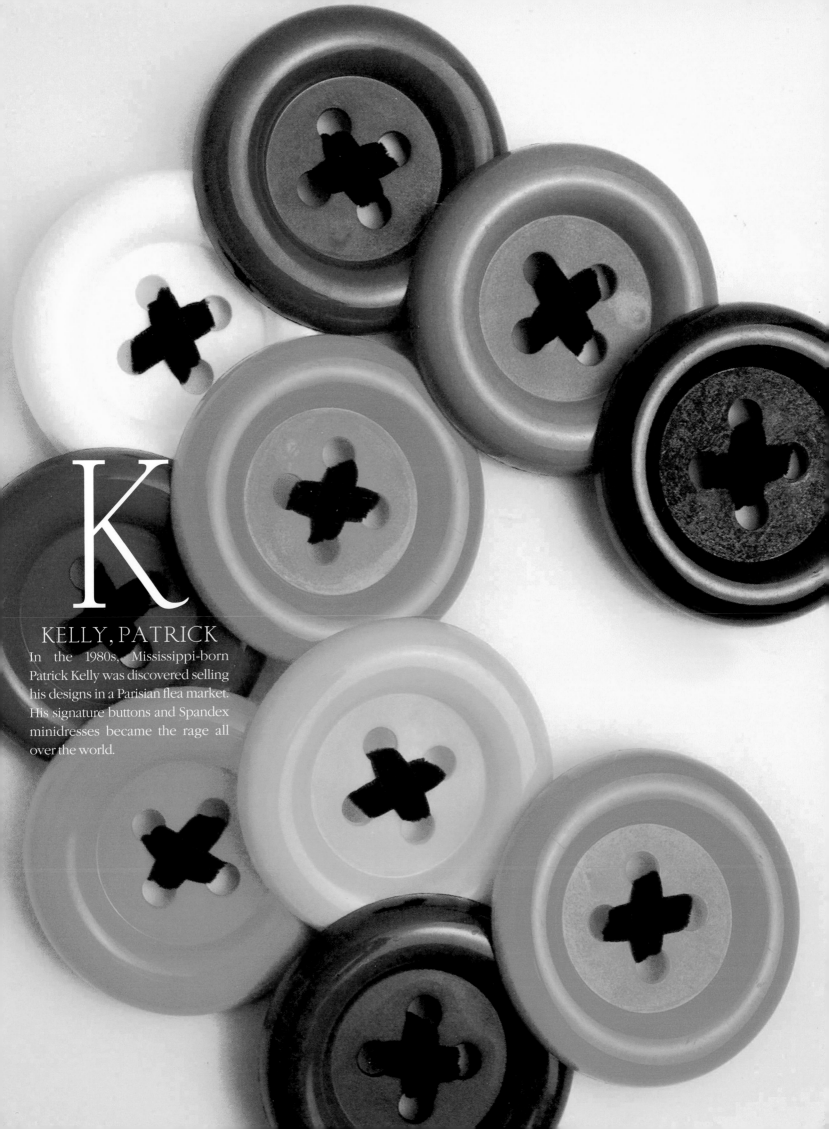

K

KELLY, PATRICK

In the 1980s, Mississippi-born Patrick Kelly was discovered selling his designs in a Parisian flea market. His signature buttons and Spandex minidresses became the rage all over the world.

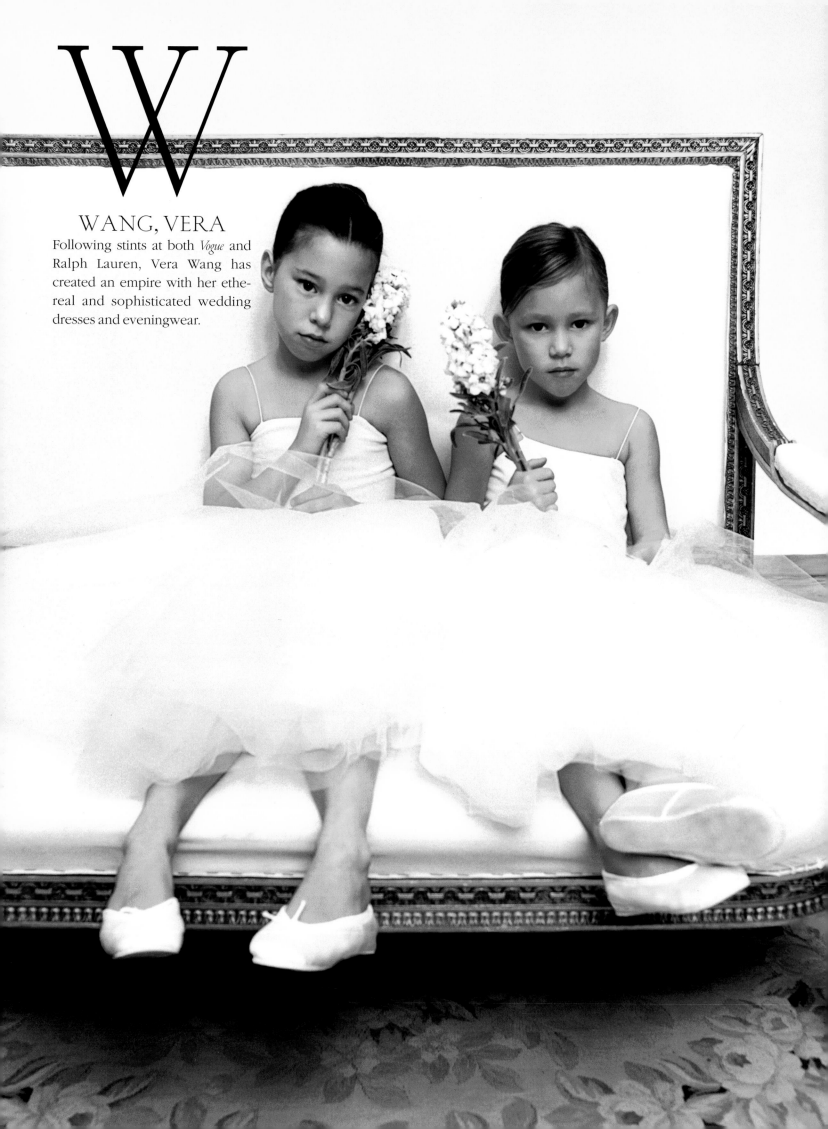

W

WANG, VERA

Following stints at both *Vogue* and Ralph Lauren, Vera Wang has created an empire with her ethereal and sophisticated wedding dresses and eveningwear.

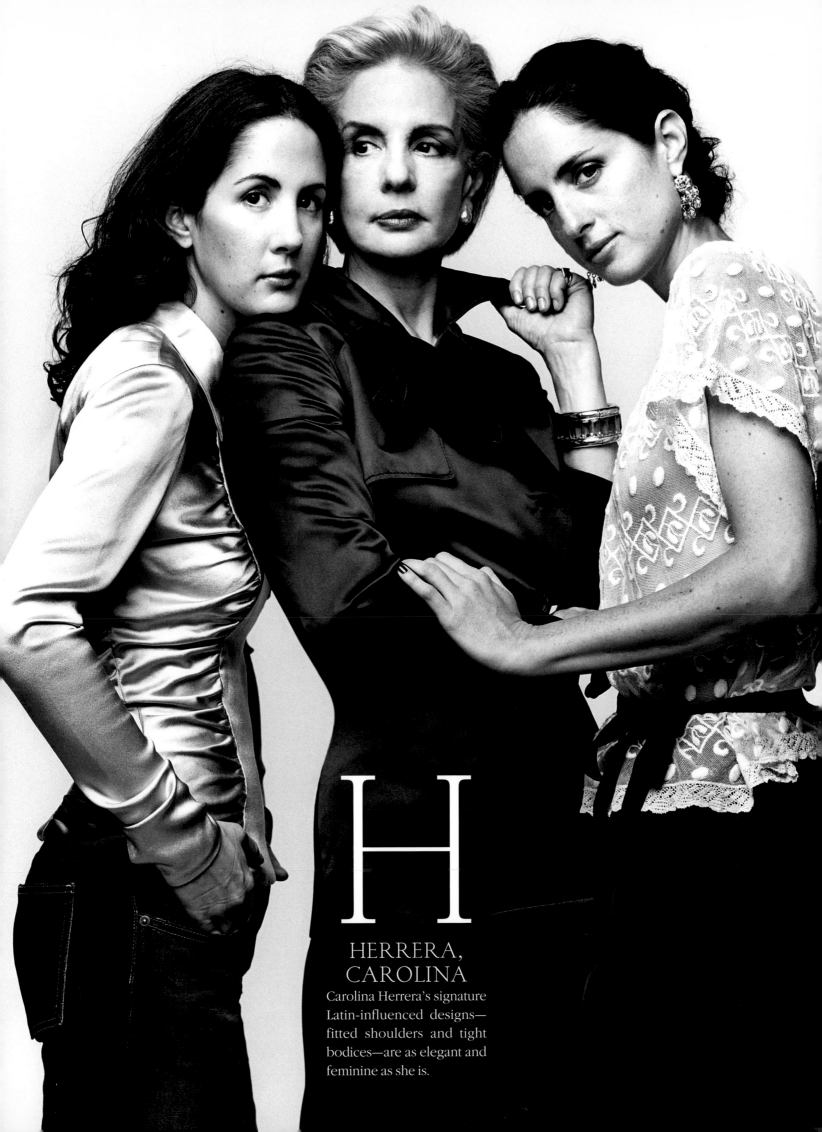

H
HERRERA, CAROLINA

Carolina Herrera's signature
Latin-influenced designs—
fitted shoulders and tight
bodices—are as elegant and
feminine as she is.

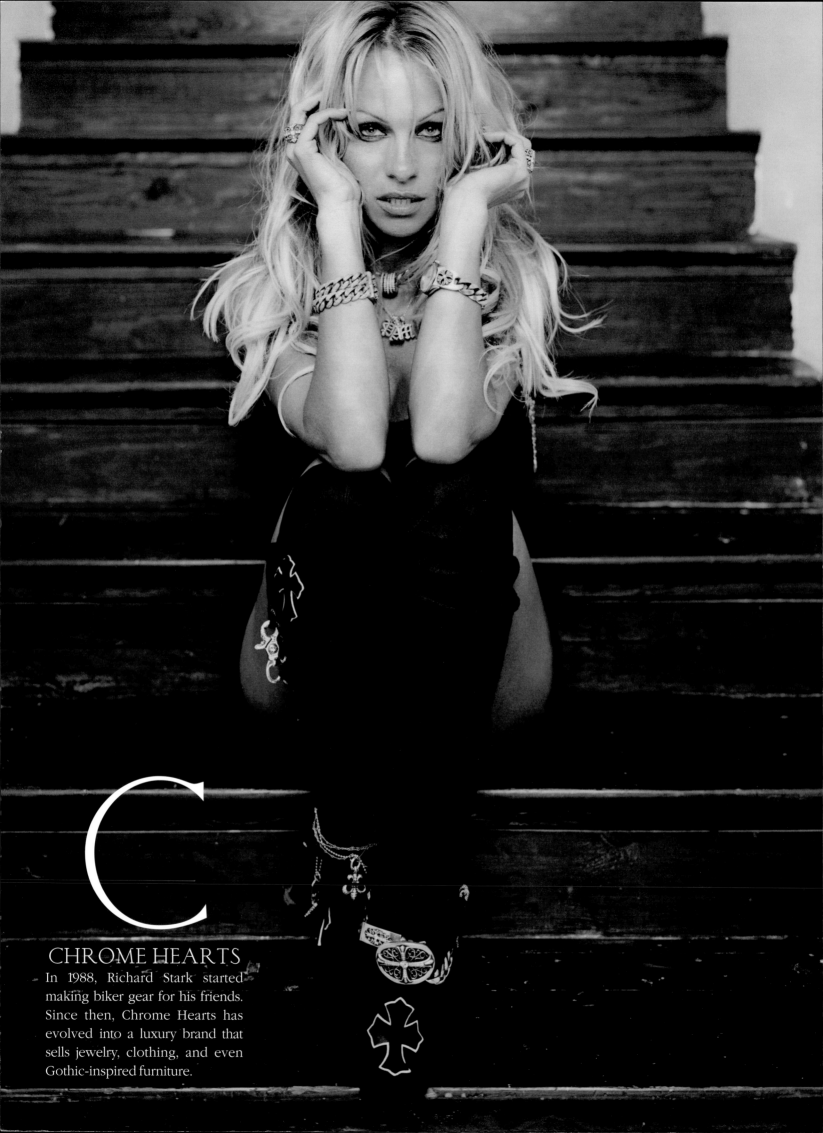

C

CHROME HEARTS

In 1988, Richard Stark started making biker gear for his friends. Since then, Chrome Hearts has evolved into a luxury brand that sells jewelry, clothing, and even Gothic-inspired furniture.

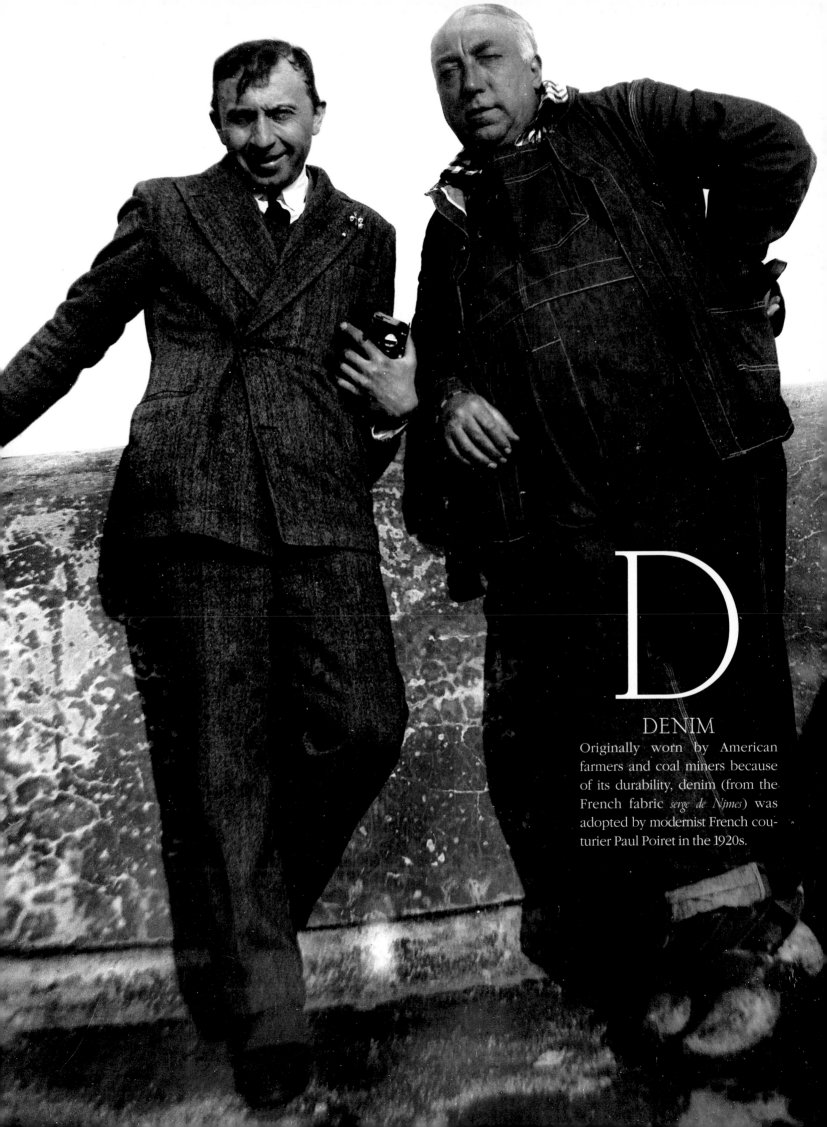

D

DENIM

Originally worn by American farmers and coal miners because of its durability, denim (from the French fabric *serge de Nîmes*) was adopted by modernist French couturier Paul Poiret in the 1920s.

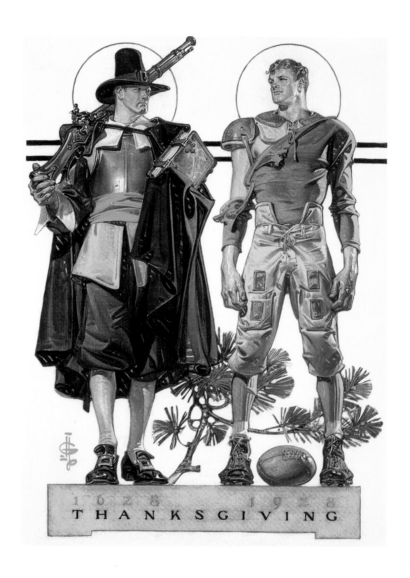

T

THANKSGIVING

What started as a shared feast between Native Americans and settlers has evolved into the most important American tradition. The order of the day is a standard trilogy: family, food, and football.

A

ARROW COLLAR

The story goes that in 1820 Mrs. Montague of Clue H. Peabody & Co. shirtmakers simply snipped off the collar of her blacksmith husband's shirt, and created the first detachable collar. Arrow perfected the concept in the early 20th century.

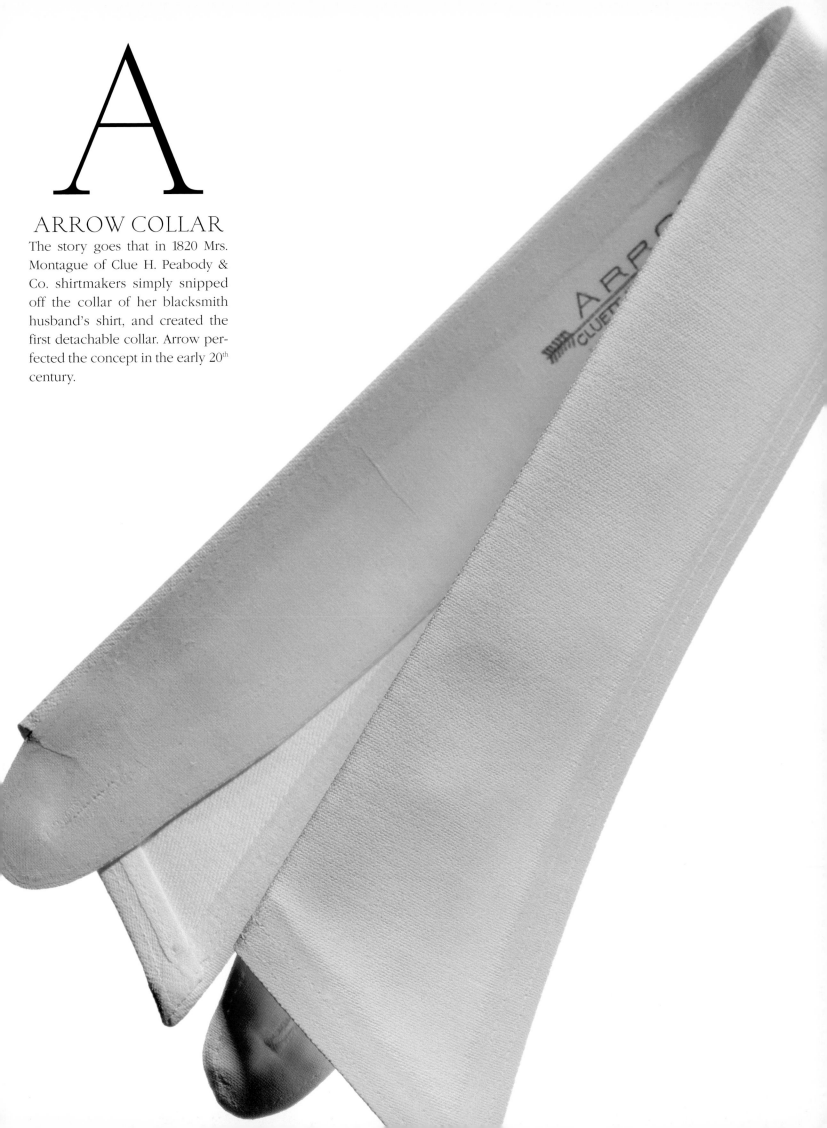

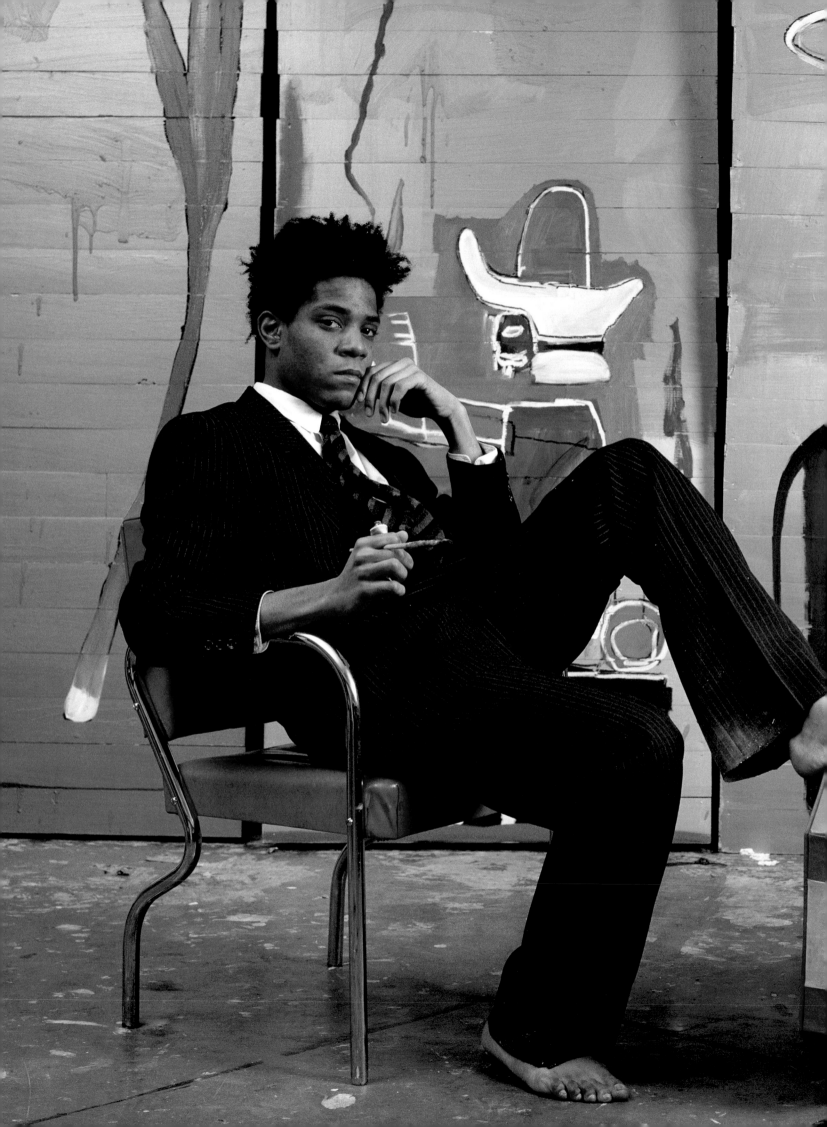

B

BASQUIAT, JEAN-MICHEL

Brooklyn-raised '80s art darling Jean-Michel Basquiat shook the art world with his street-inspired graffiti paintings and his friendship with artist-voyeur Andy Warhol. Basquiat's disheveled "dandy style" pin-striped suits, tie, and dreadlocks made him unique among his '80s counterparts.

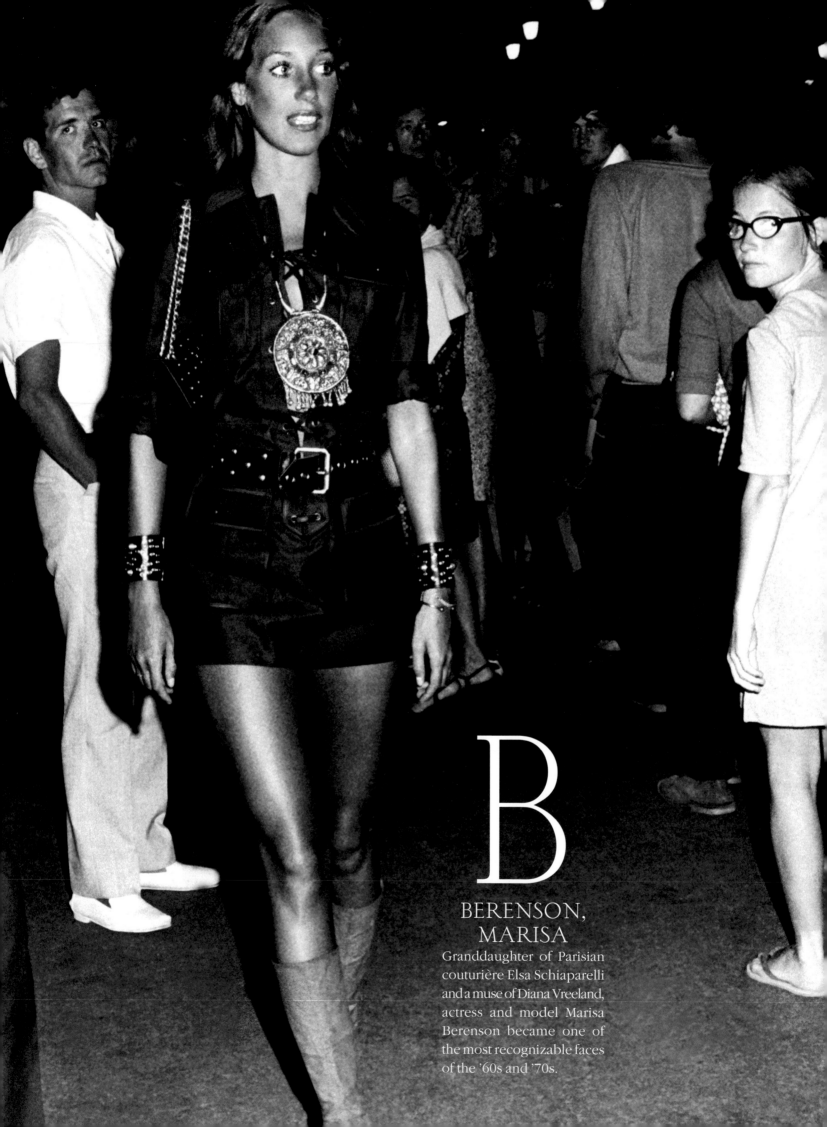

B

BERENSON, MARISA

Granddaughter of Parisian couturière Elsa Schiaparelli and a muse of Diana Vreeland, actress and model Marisa Berenson became one of the most recognizable faces of the '60s and '70s.

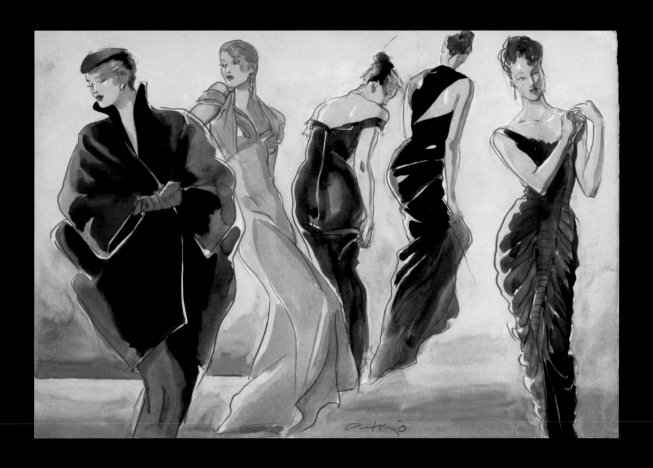

L

LOPEZ, ANTONIO

Antonio Lopez, a Puerto Rican-born fashion illustrator known by his first name, was celebrated in the '70s and '80s for his evocative "street" illustrations and "instamatics" for designers like Charles James and Karl Lagerfeld.

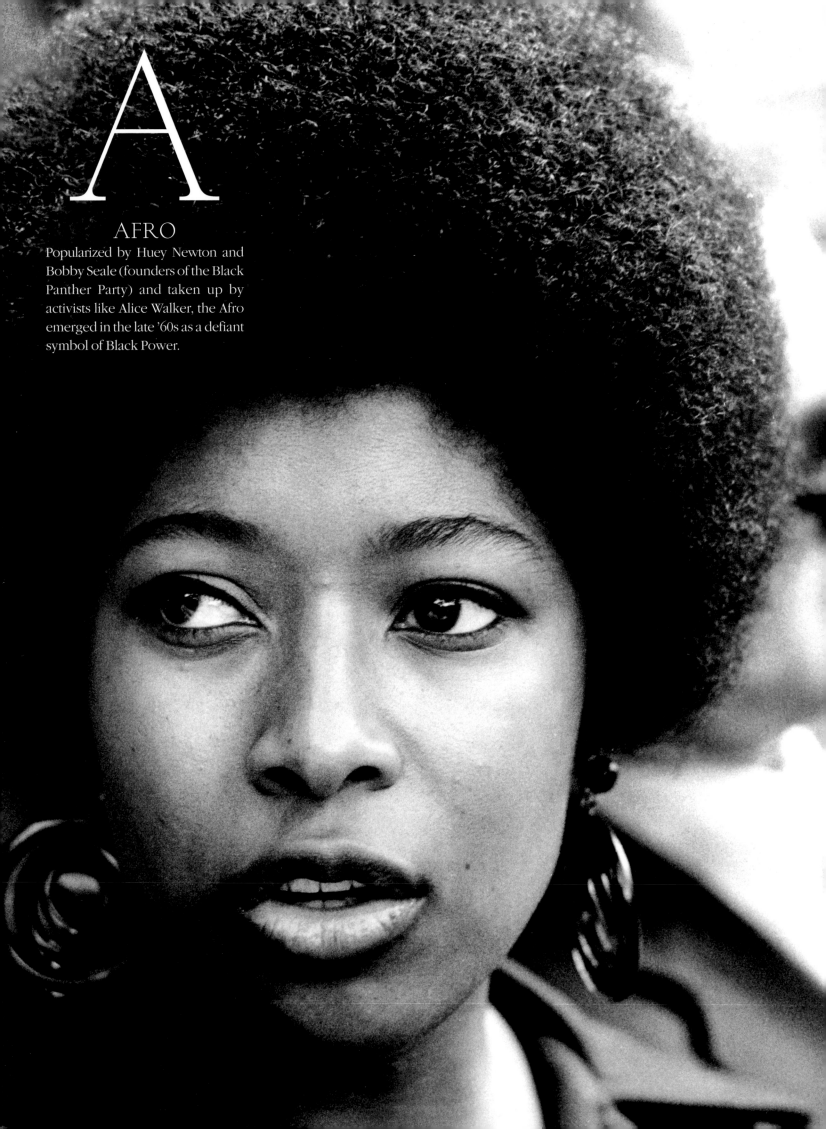

A

AFRO

Popularized by Huey Newton and Bobby Seale (founders of the Black Panther Party) and taken up by activists like Alice Walker, the Afro emerged in the late '60s as a defiant symbol of Black Power.

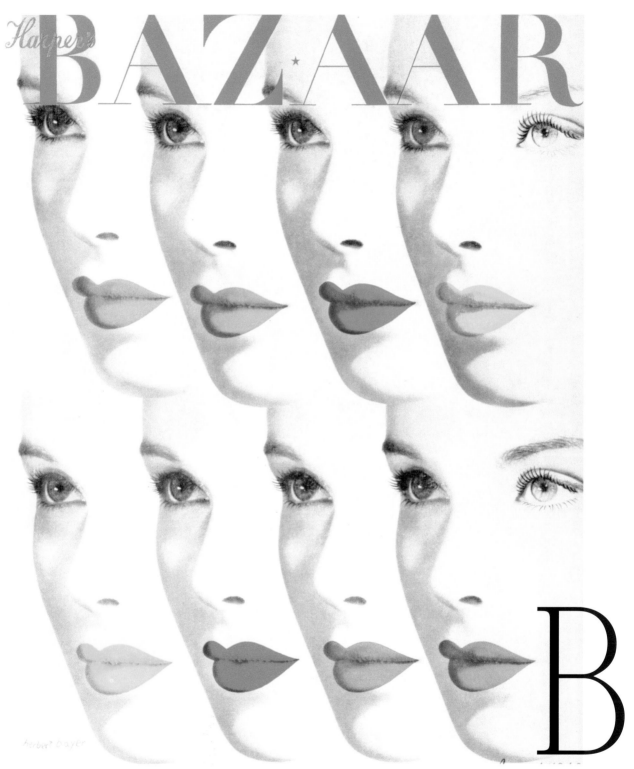

B

BRODOVITCH, ALEXEY

As art director for *Harper's Bazaar* from 1934 to 1950, the Russian-born Alexey Brodovitch was known for creating legendary images—molding text into the shape of a woman, changing and enlarging fonts, and fusing art with fashion.

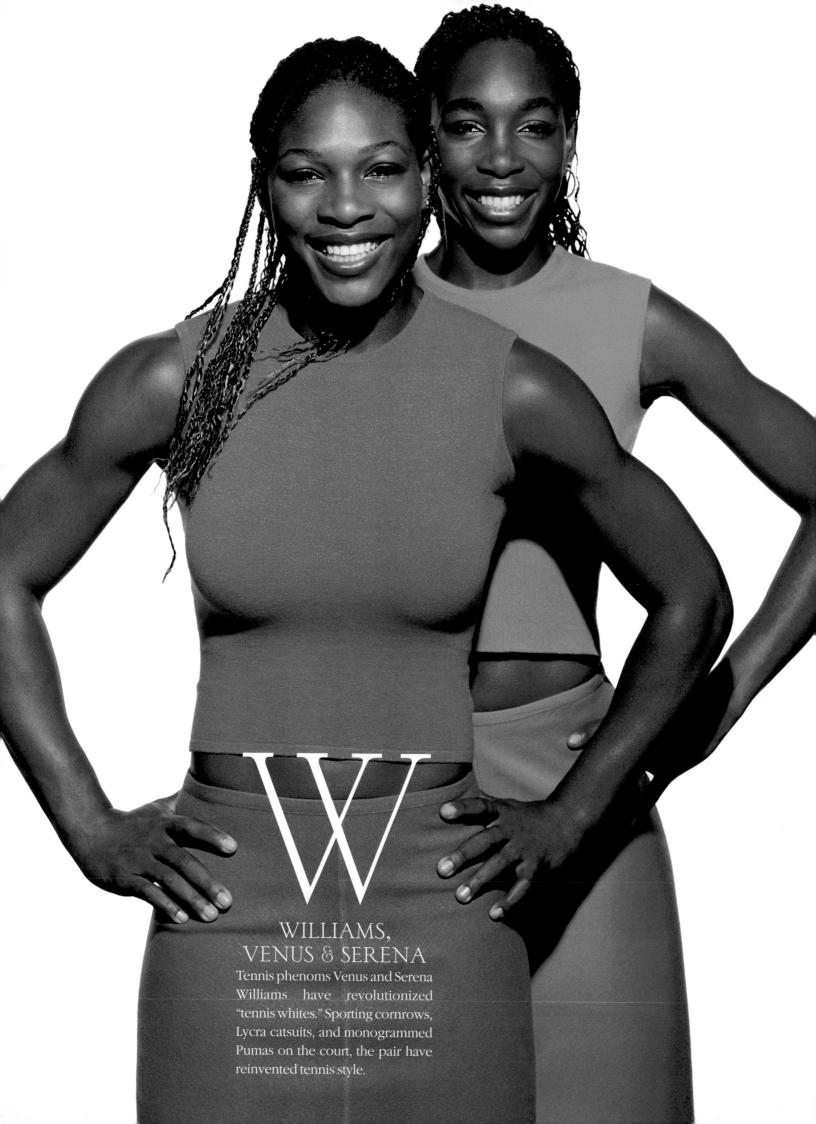

W

WILLIAMS, VENUS & SERENA

Tennis phenoms Venus and Serena Williams have revolutionized "tennis whites." Sporting cornrows, Lycra catsuits, and monogrammed Pumas on the court, the pair have reinvented tennis style.

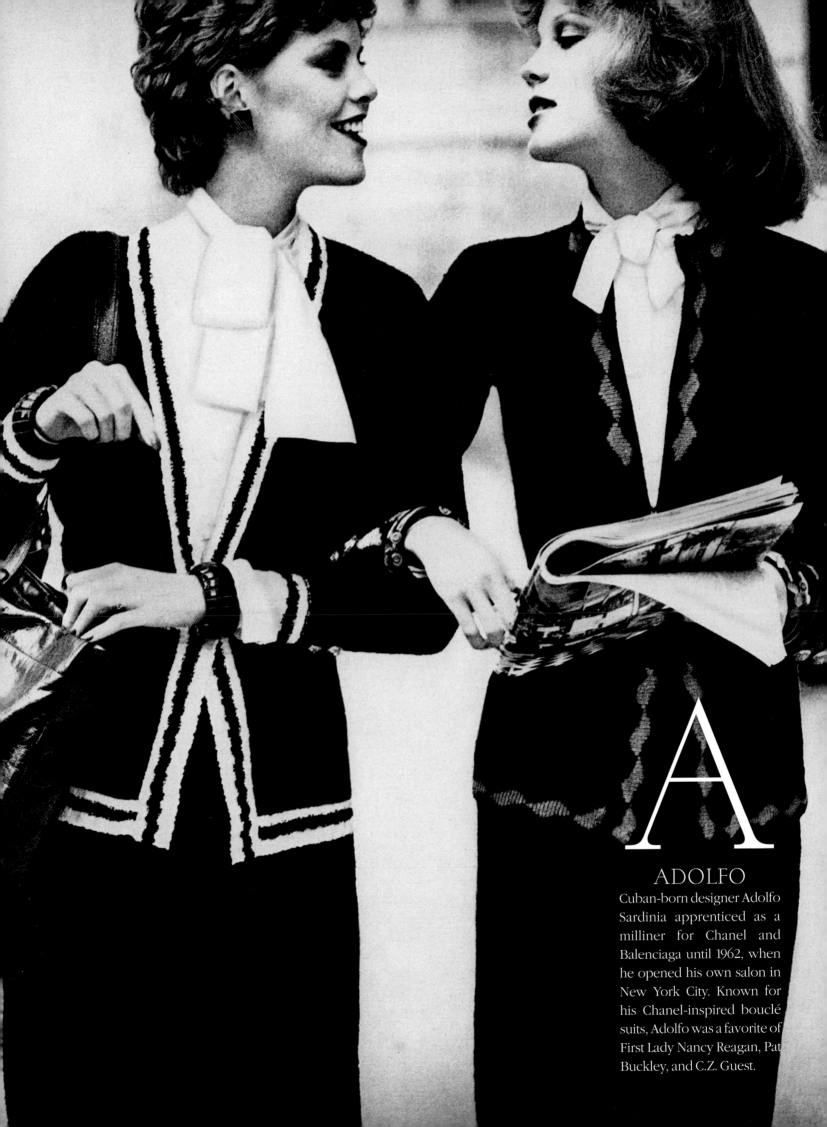

A

ADOLFO

Cuban-born designer Adolfo Sardinia apprenticed as a milliner for Chanel and Balenciaga until 1962, when he opened his own salon in New York City. Known for his Chanel-inspired bouclé suits, Adolfo was a favorite of First Lady Nancy Reagan, Pat Buckley, and C.Z. Guest.

B
BEATNIKS
The beatniks sparked far more than a literary revolution. The expressive youth culture of the '40s and '50s also kindled performance art and the wearing of a new uniform: black and leggings.

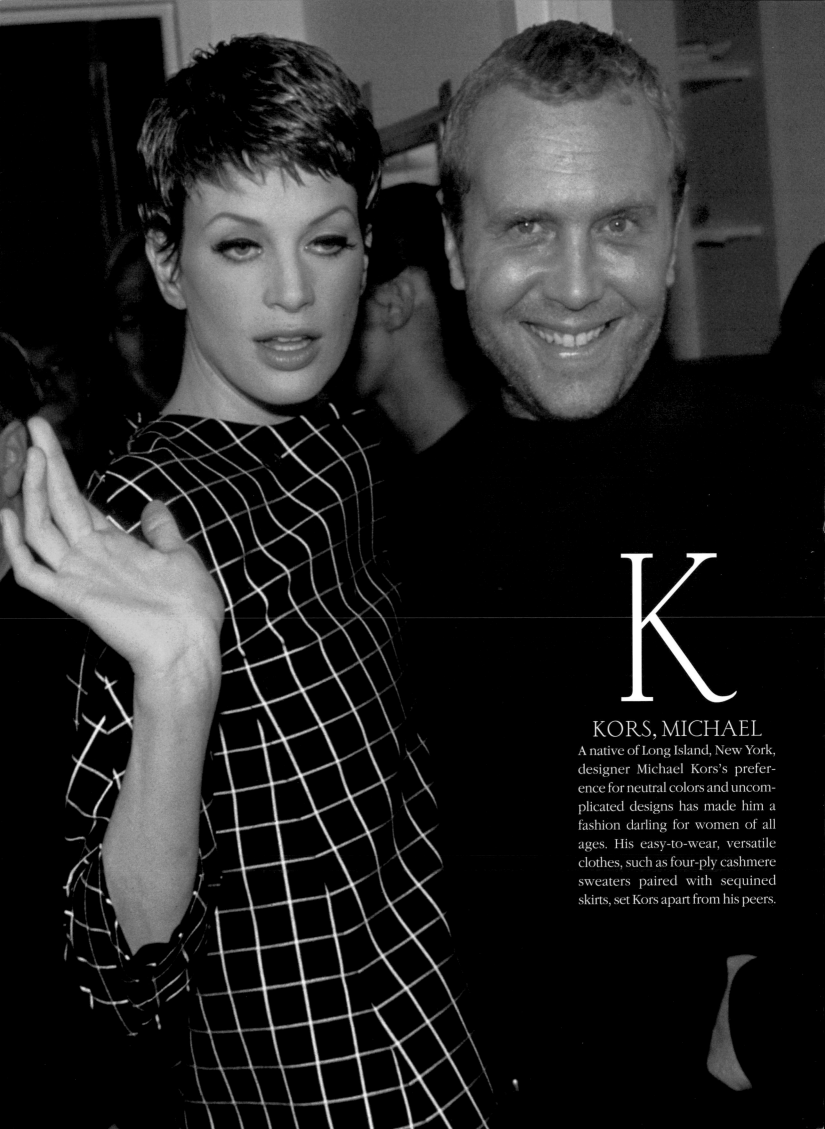

K

KORS, MICHAEL

A native of Long Island, New York, designer Michael Kors's preference for neutral colors and uncomplicated designs has made him a fashion darling for women of all ages. His easy-to-wear, versatile clothes, such as four-ply cashmere sweaters paired with sequined skirts, set Kors apart from his peers.

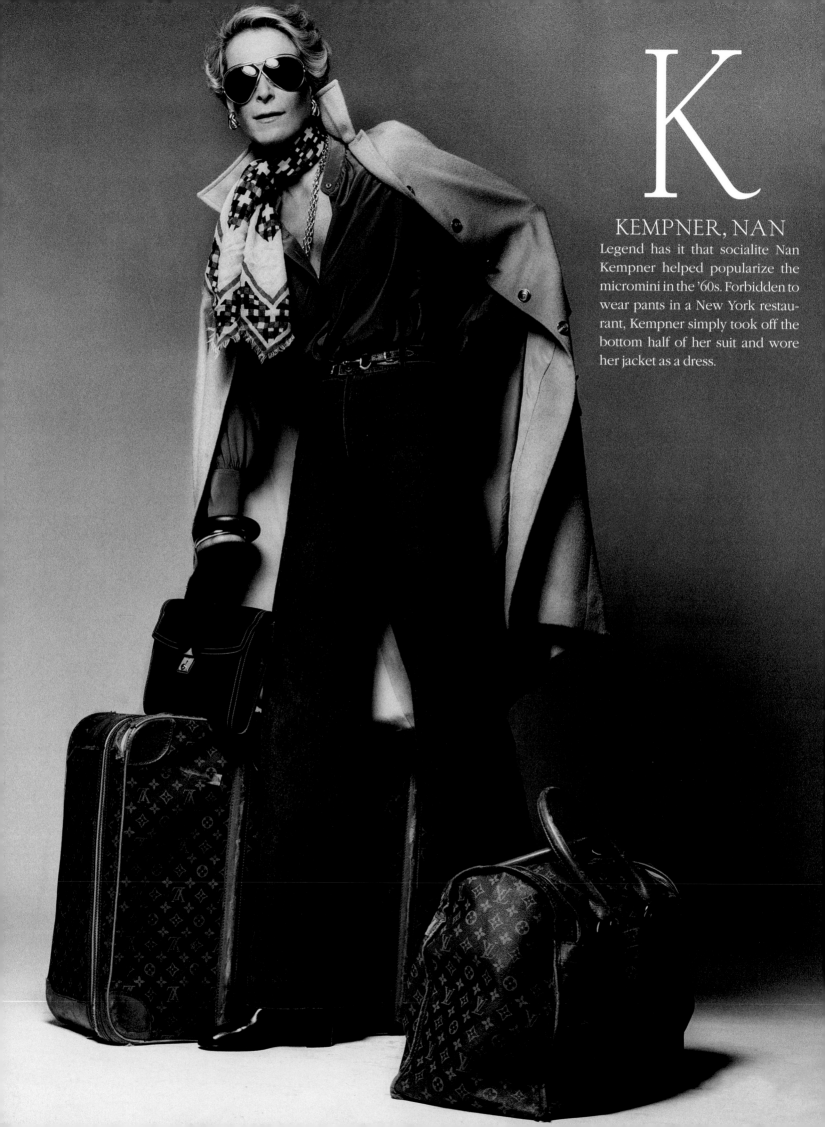

K

KEMPNER, NAN

Legend has it that socialite Nan Kempner helped popularize the micromini in the '60s. Forbidden to wear pants in a New York restaurant, Kempner simply took off the bottom half of her suit and wore her jacket as a dress.

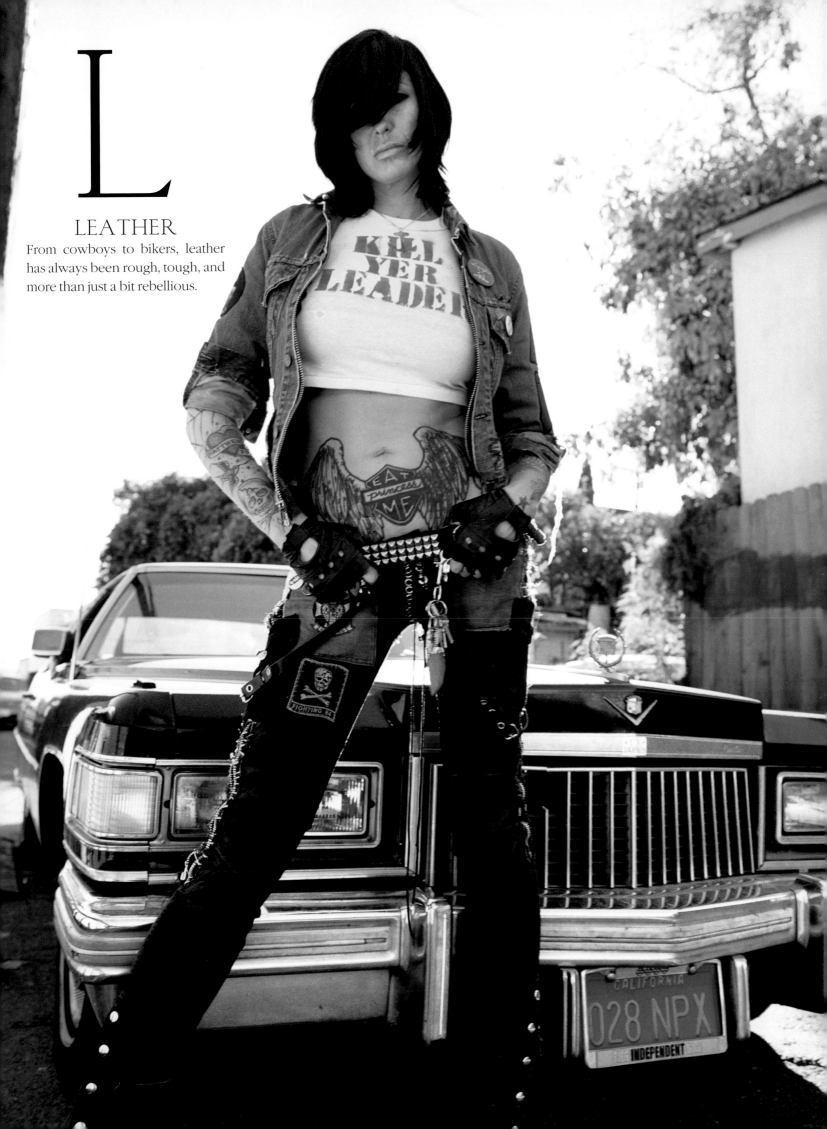

L
LEATHER
From cowboys to bikers, leather has always been rough, tough, and more than just a bit rebellious.

B

BASKETBALL

Canadian James Naismith may have created basketball in 1891 in Springfield, Massachusetts, but it was the Air Jordan sneaker and Nike ad campaigns—including "Real athletes wear Nike"—that made basketball chic into one of the biggest commercial successes to hit sports and the streets.

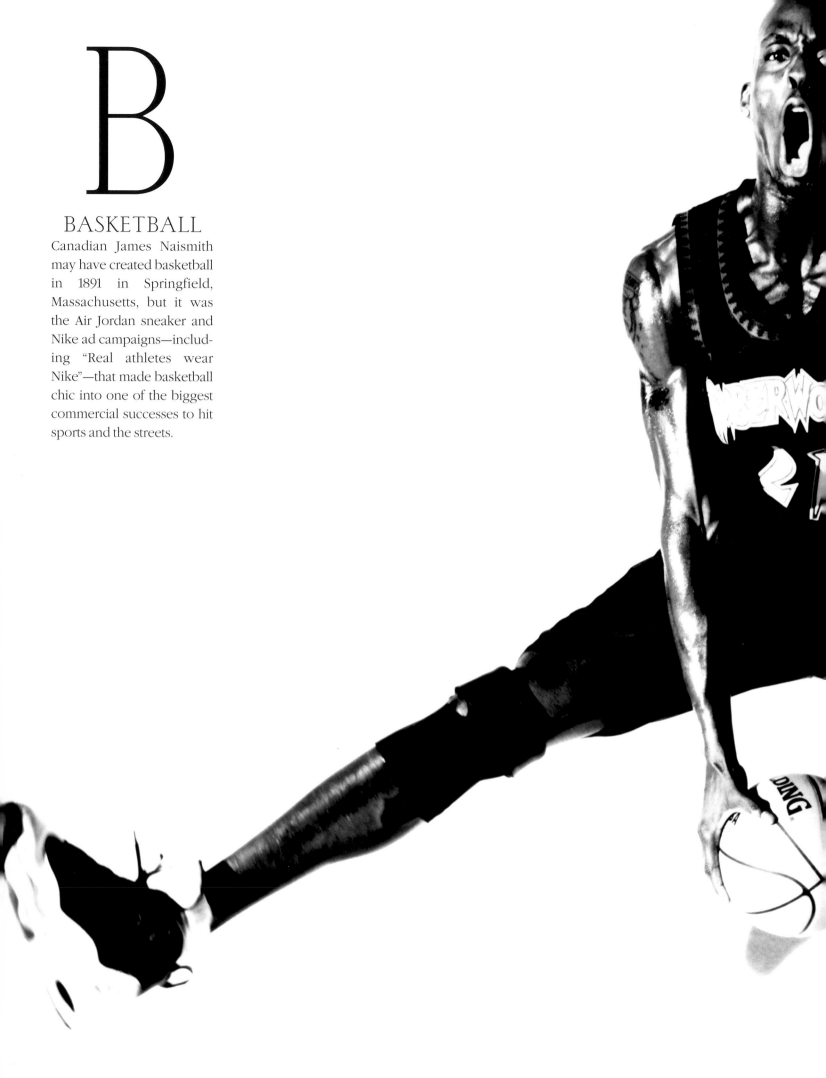

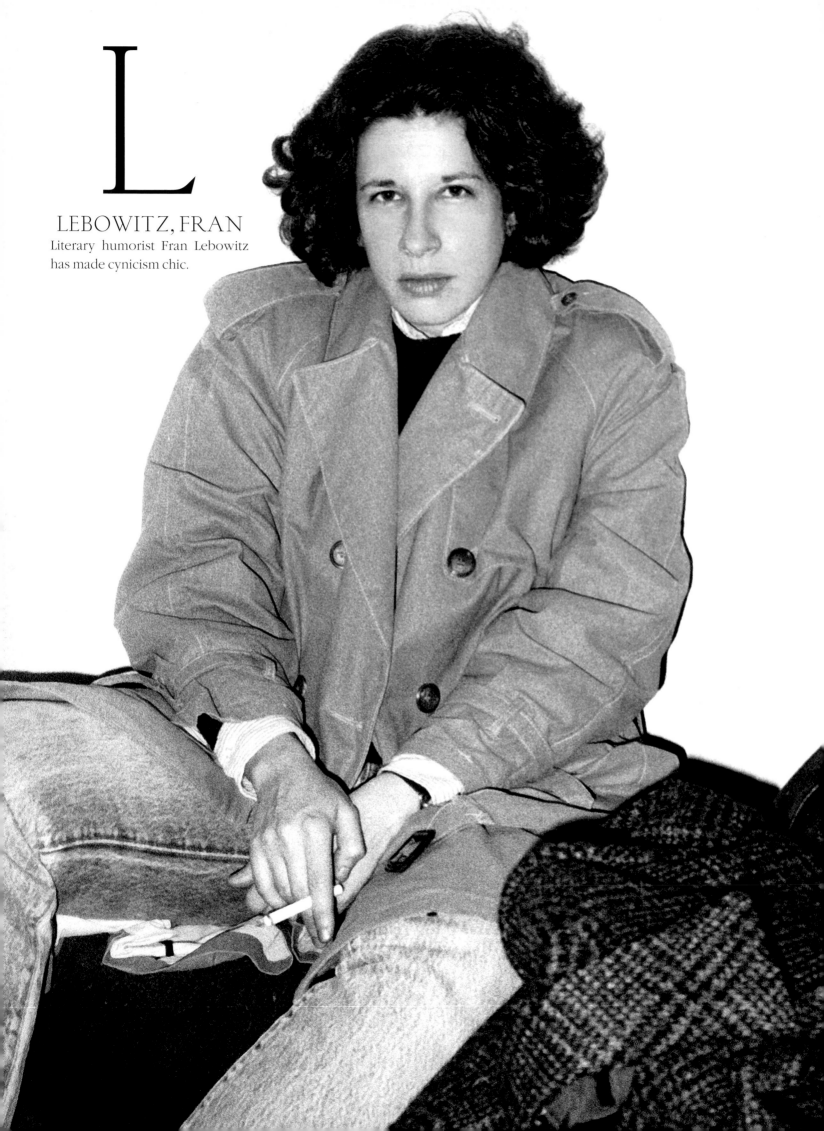

L

LEBOWITZ, FRAN
Literary humorist Fran Lebowitz has made cynicism chic.

The cover reads:

THE OFFICIAL
PREPPY HANDBOOK

$3.95

"Look, Muffy, a book for us."

The first guide to *The* Tradition. Mannerisms, Etiquette, Dress Codes, The Family. How to Be Really Top Drawer. *The Legacy of Good Taste, Proper Breeding & the Right Nickname.*

Winning with Ease and Losing with Grace. Lacrosse, Squash, Crew, and Field Hockey. The Sailing Scene. Flotillas, Regattas, Yachts and Yacht Clubs. The Sporting Life. Tally Ho! ... PAGE 100

MUMMY DADDY

The Schools. Boarding vs. Day, Coed vs. Single-Sex. Chapel, Lights-Out, Dining Halls and Study Halls. A Sampling of Mottoes and Memorabilia. The Importance of Getting Kicked Out PAGE 69

The Crucial Element. Top-Siders, Loafers, Tassels. *Cuffs a Must.* The Sock Controversy PAGE 138

Essays on:
THE VIRTUES OF PINK & GREEN
REGULATING THE CASH FLOW
ORIGINS OF THE PREP SCHOOL
THE OLD BOY NETWORK
CLUBS AT THE BIG THREE
BASIC BODY TYPES

EDITED BY LISA BIRNBACH

P

PREPPY

The Official Preppy Handbook, edited by Lisa Birnbach, was the bible for all argyle-sock, Fair Isle-sweater, grosgrain belt, and polo shirt-wearing teens in the 1980s. Even if you didn't go to boarding school, you could still look the part.

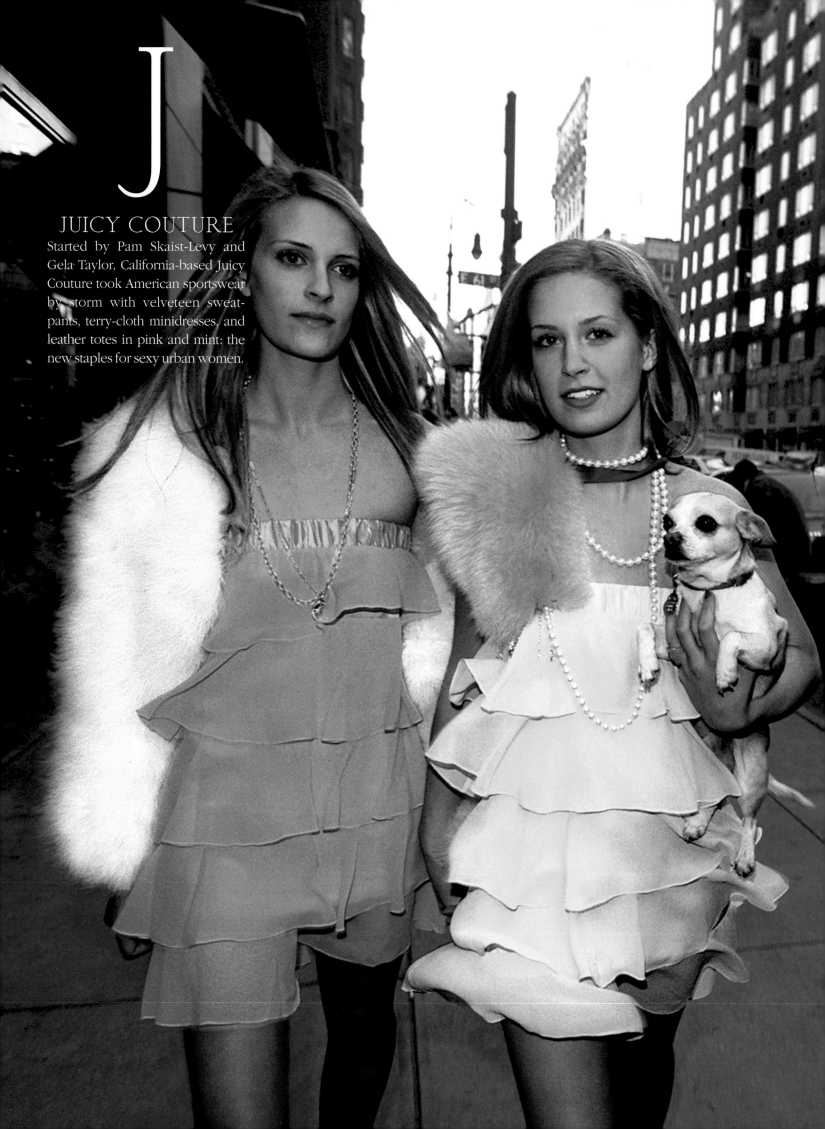

J

JUICY COUTURE

Started by Pam Skaist-Levy and Gela Taylor, California-based Juicy Couture took American sportswear by storm with velveteen sweat-pants, terry-cloth minidresses, and leather totes in pink and mint: the new staples for sexy urban women.

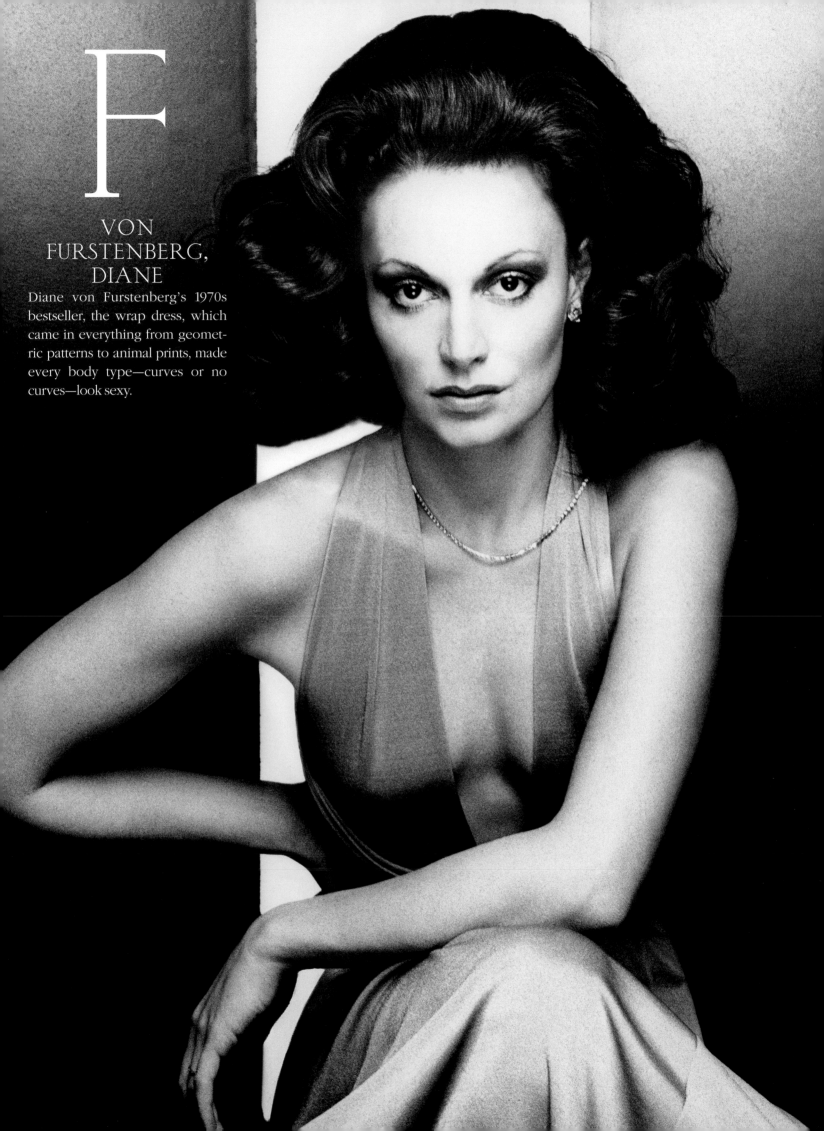

F

VON FURSTENBERG, DIANE

Diane von Furstenberg's 1970s bestseller, the wrap dress, which came in everything from geometric patterns to animal prints, made every body type—curves or no curves—look sexy.

H
HALLOWEEN

A 2,000-year-old Celtic tradition brought to the States by Irish immigrants, Halloween is now an essential part of American tradition.

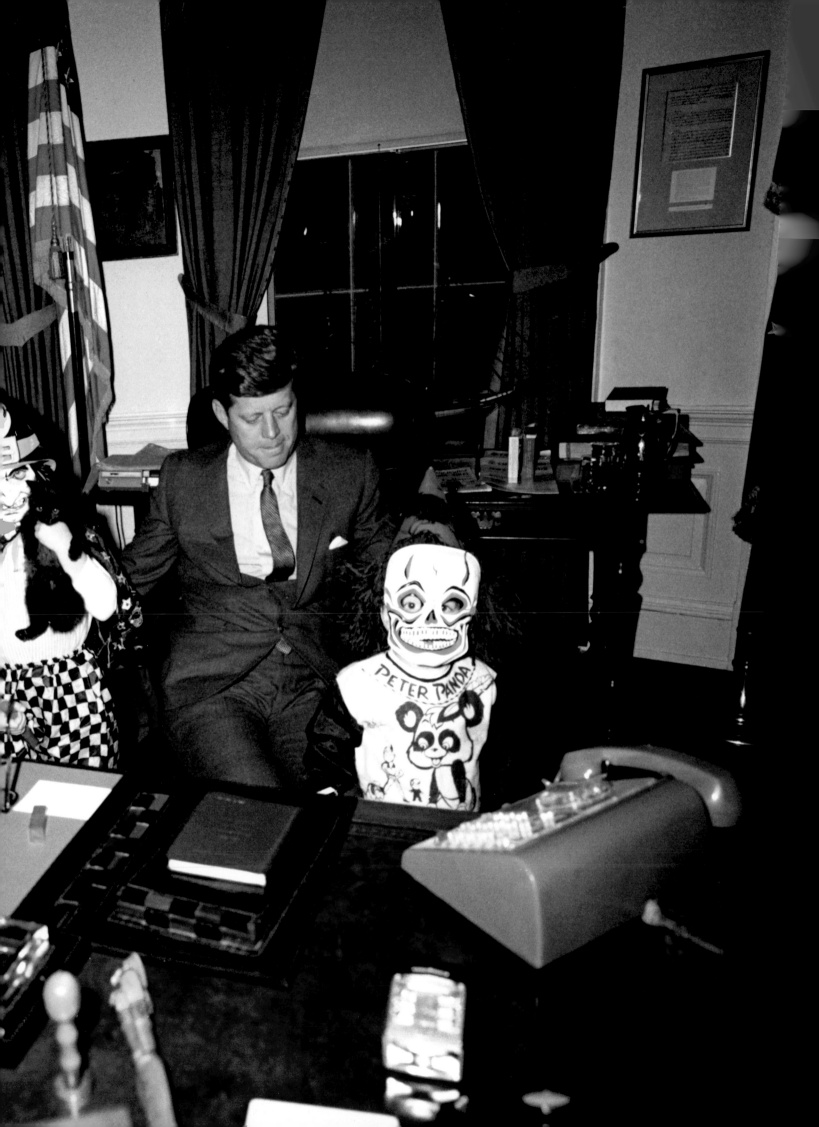

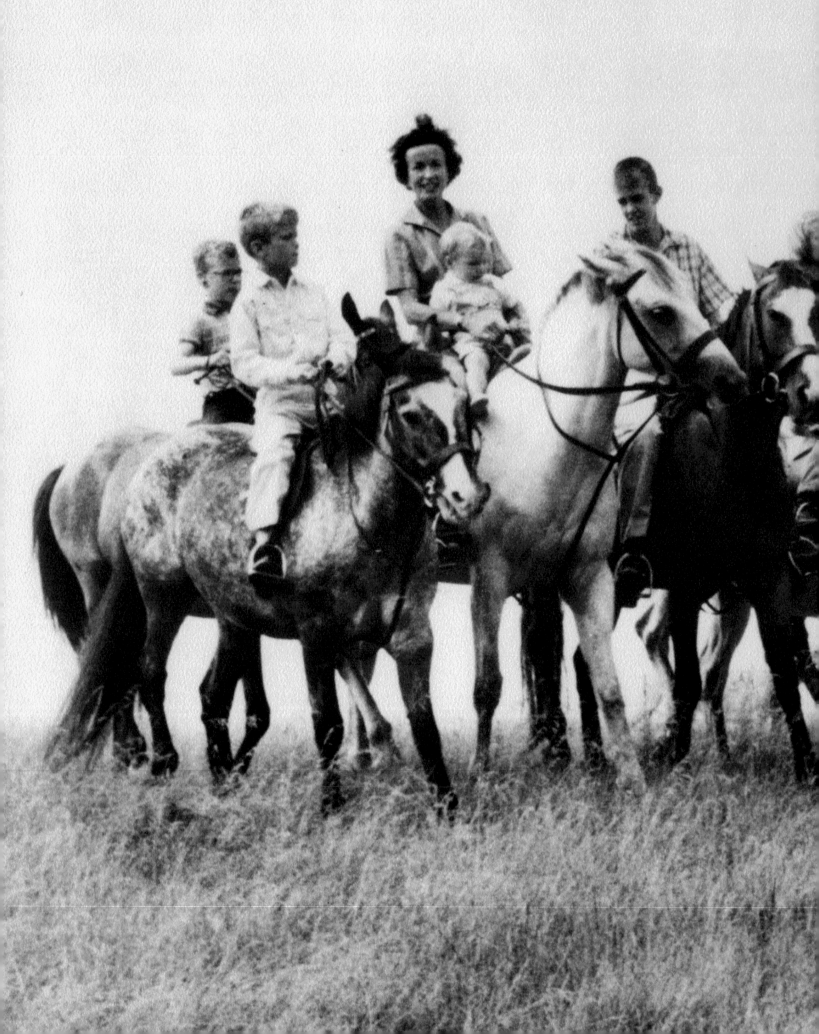

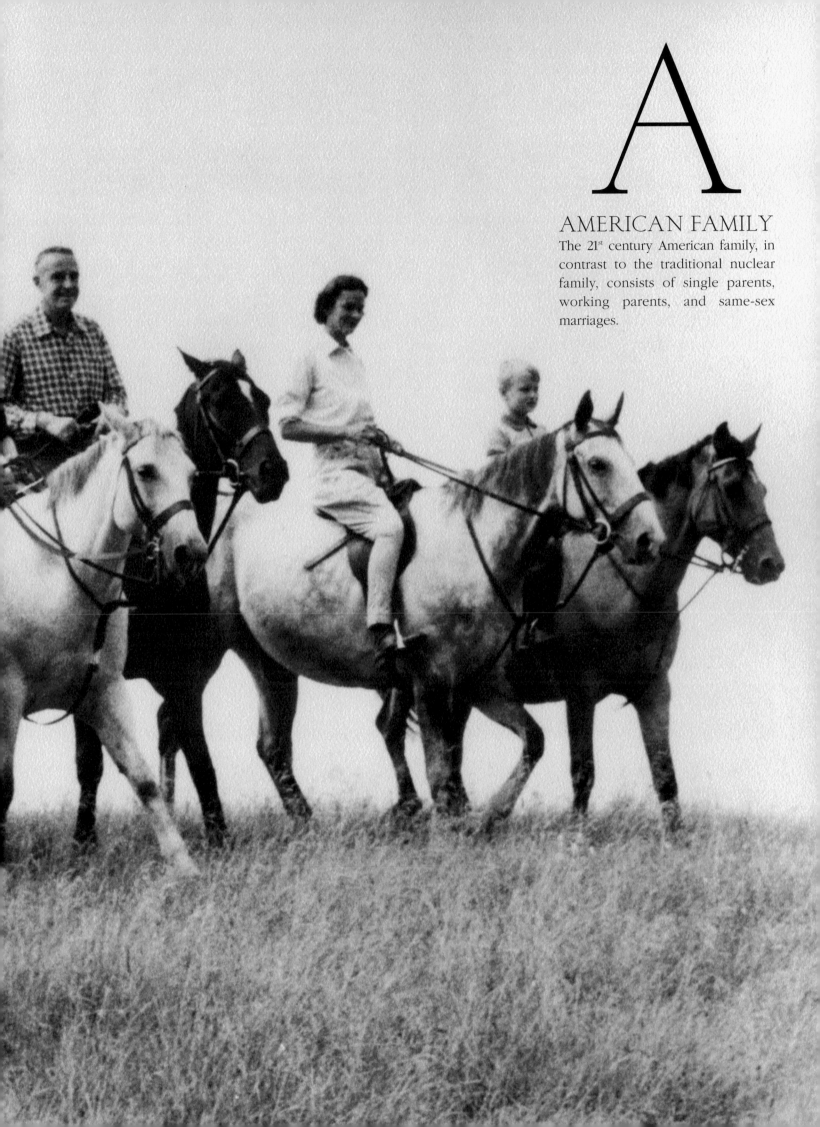

A
AMERICAN FAMILY

The 21st century American family, in contrast to the traditional nuclear family, consists of single parents, working parents, and same-sex marriages.

S

STETSON

In 1865, John B. Stetson made the "boss of the plains" hat with $10 worth of fur. Today the Stetson is the iconic Western hat.

D

DACHÉ, LILLY

Famed for her use of turbans, feathers, jewels, and furs, Lilly Daché was one of the great New York milliners of the '30s, '40s, and '50s. She is also credited with Carmen Miranda's elaborately concocted headdresses of fruits and birds.

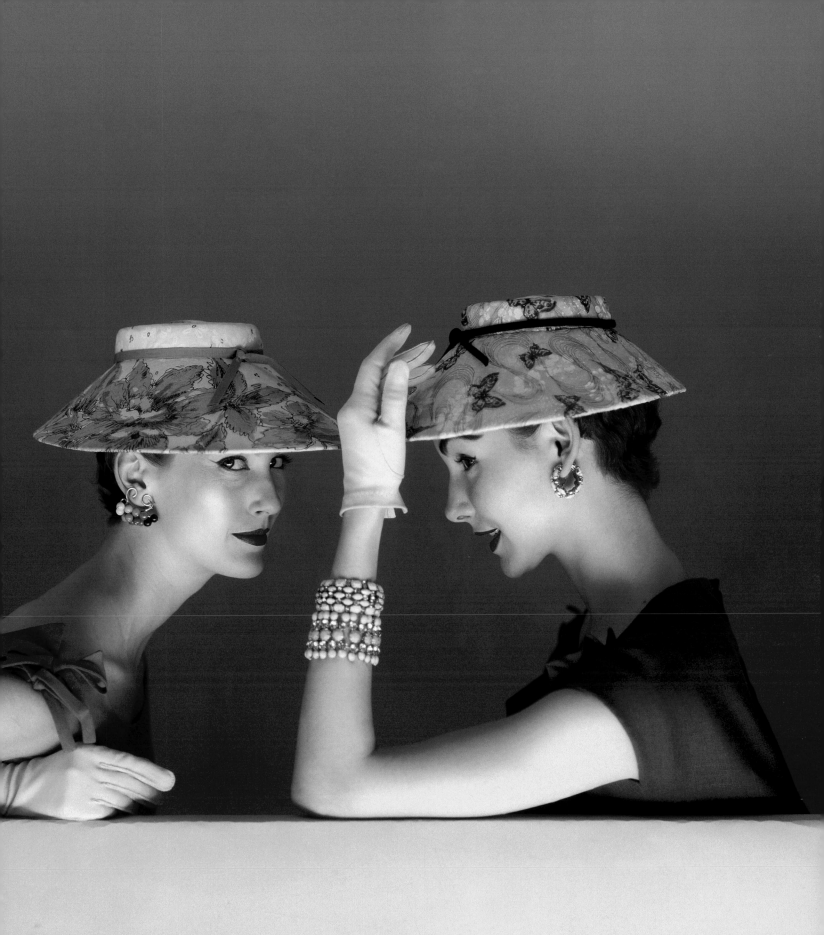

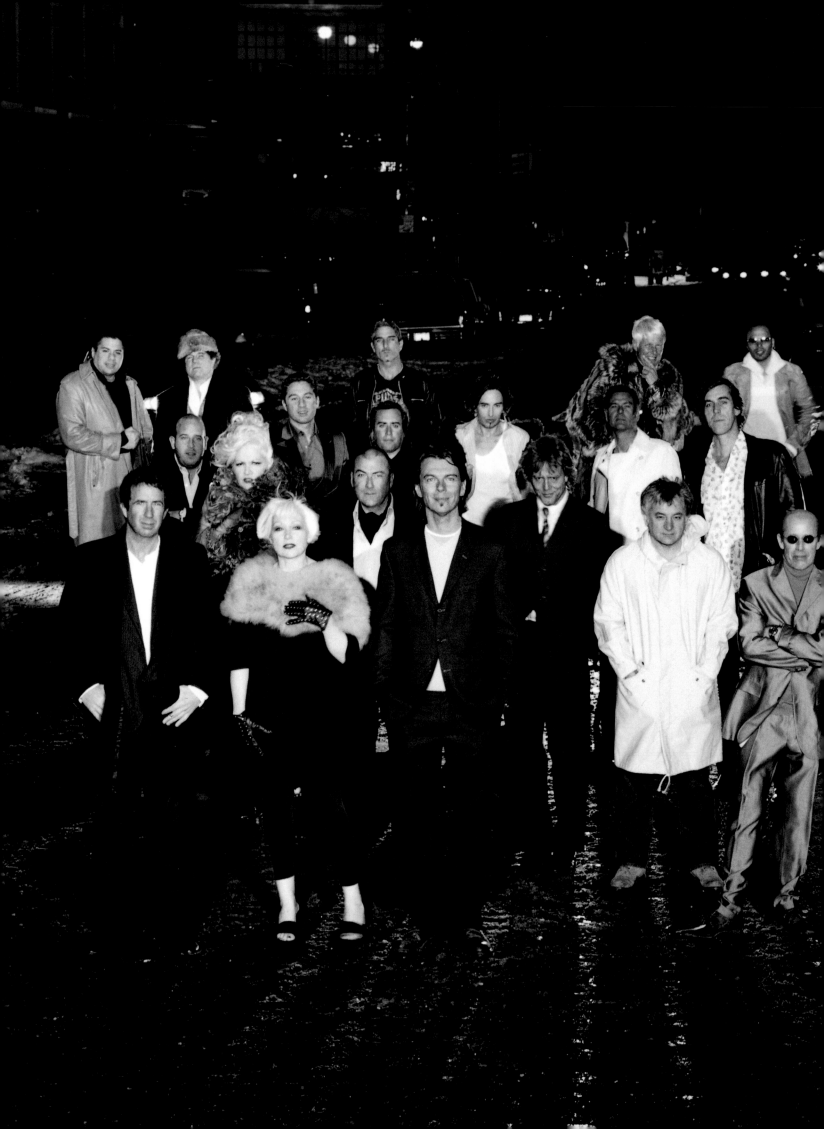

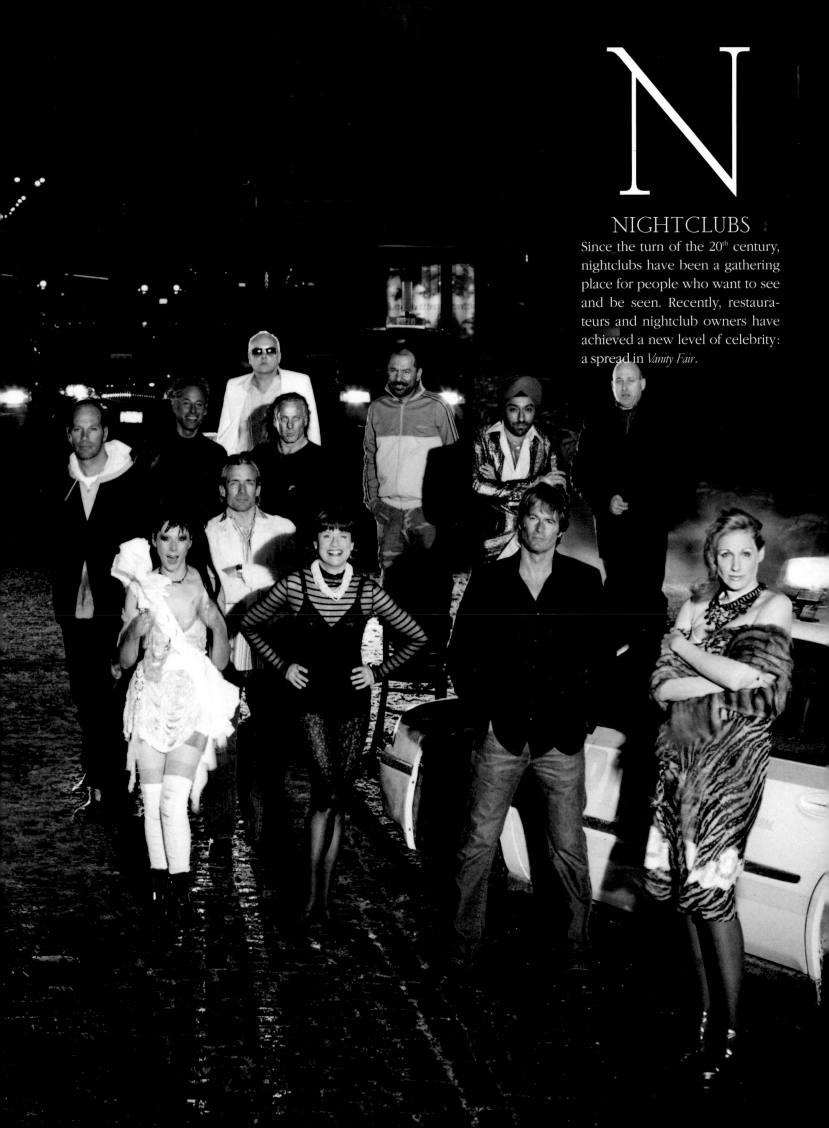

N

NIGHTCLUBS

Since the turn of the 20th century, nightclubs have been a gathering place for people who want to see and be seen. Recently, restaurateurs and nightclub owners have achieved a new level of celebrity: a spread in *Vanity Fair*.

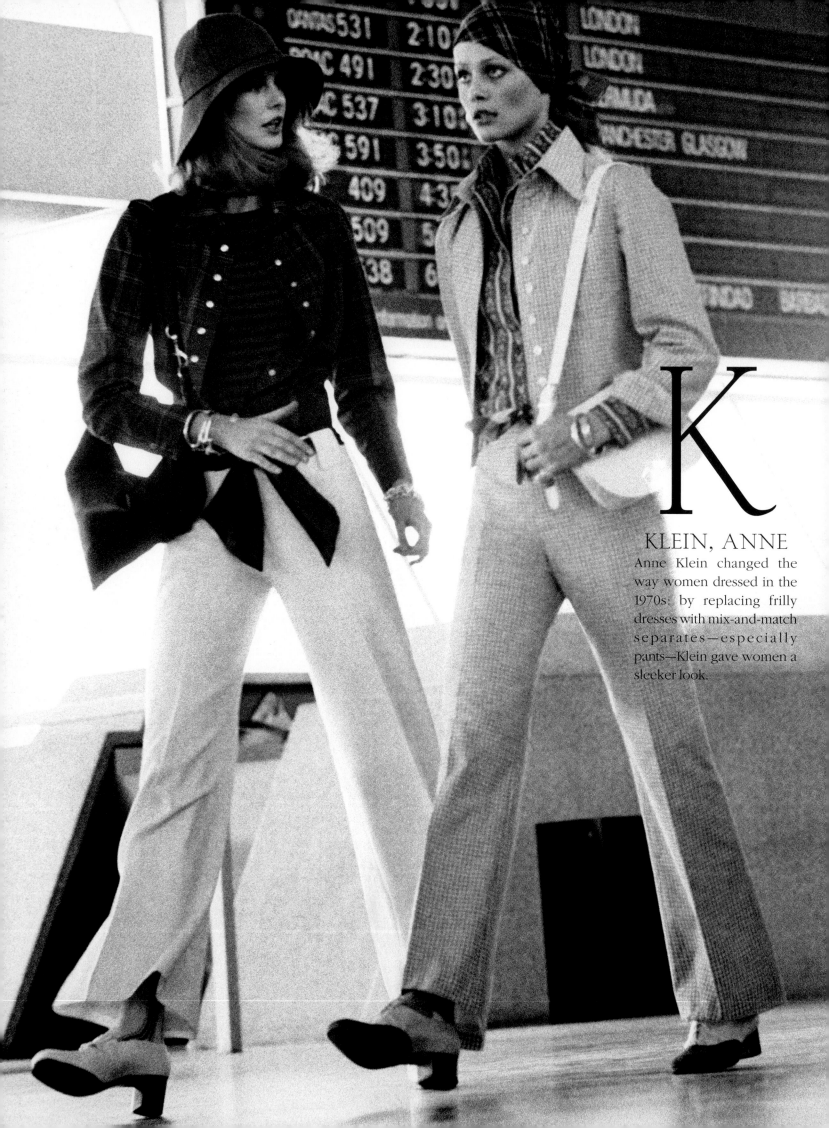

K

KLEIN, ANNE

Anne Klein changed the way women dressed in the 1970s: by replacing frilly dresses with mix-and-match separates—especially pants—Klein gave women a sleeker look.

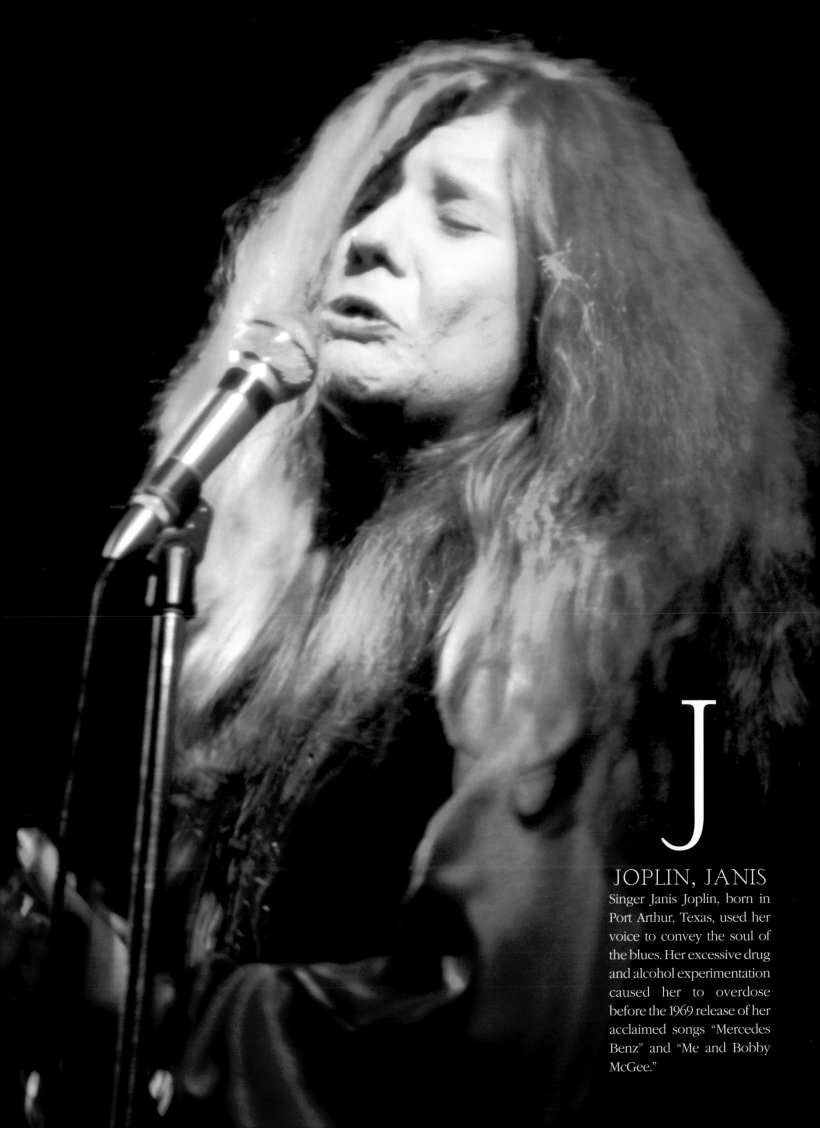

J

JOPLIN, JANIS

Singer Janis Joplin, born in Port Arthur, Texas, used her voice to convey the soul of the blues. Her excessive drug and alcohol experimentation caused her to overdose before the 1969 release of her acclaimed songs "Mercedes Benz" and "Me and Bobby McGee."

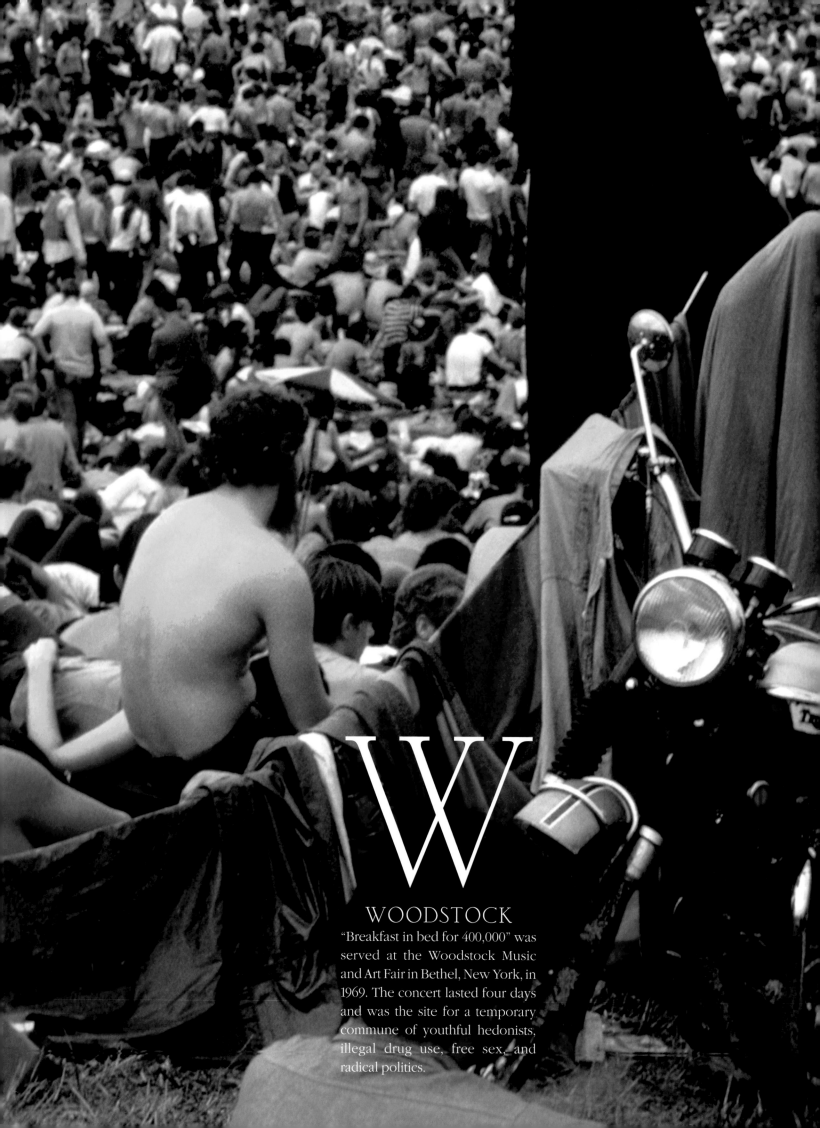

W

WOODSTOCK

"Breakfast in bed for 400,000" was served at the Woodstock Music and Art Fair in Bethel, New York, in 1969. The concert lasted four days and was the site for a temporary commune of youthful hedonists, illegal drug use, free sex, and radical politics.

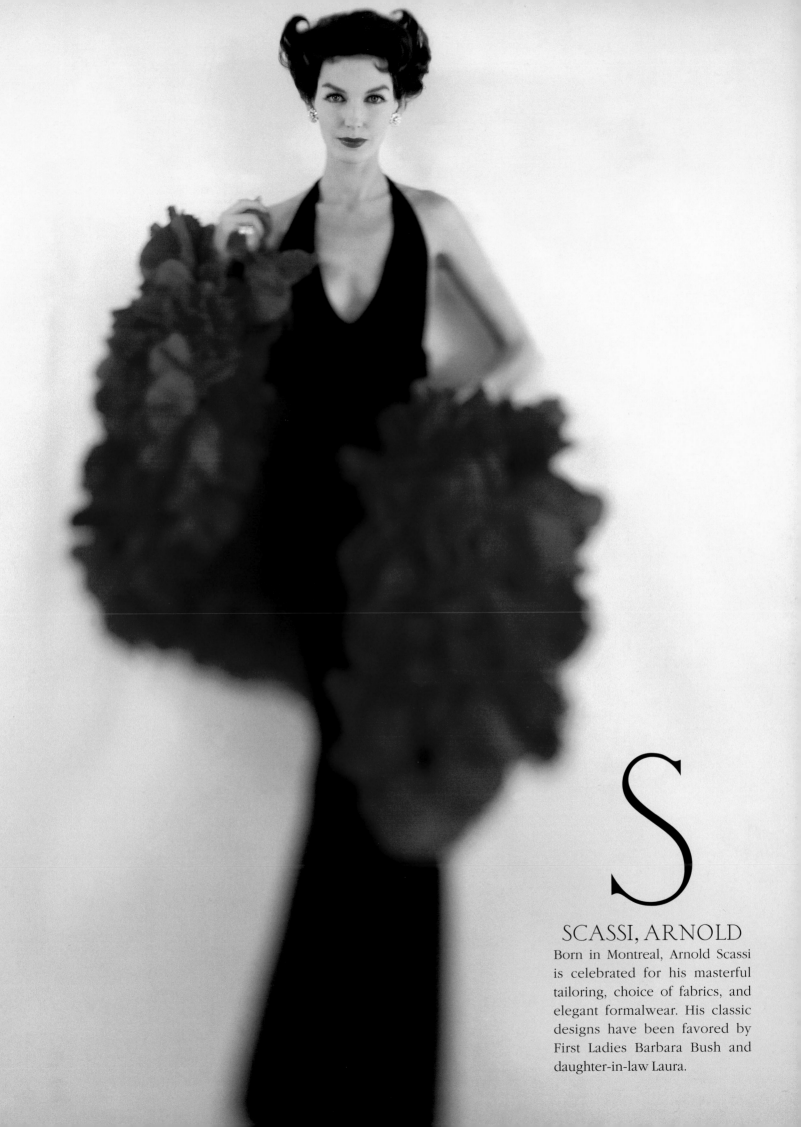

S

SCASSI, ARNOLD

Born in Montreal, Arnold Scassi is celebrated for his masterful tailoring, choice of fabrics, and elegant formalwear. His classic designs have been favored by First Ladies Barbara Bush and daughter-in-law Laura.

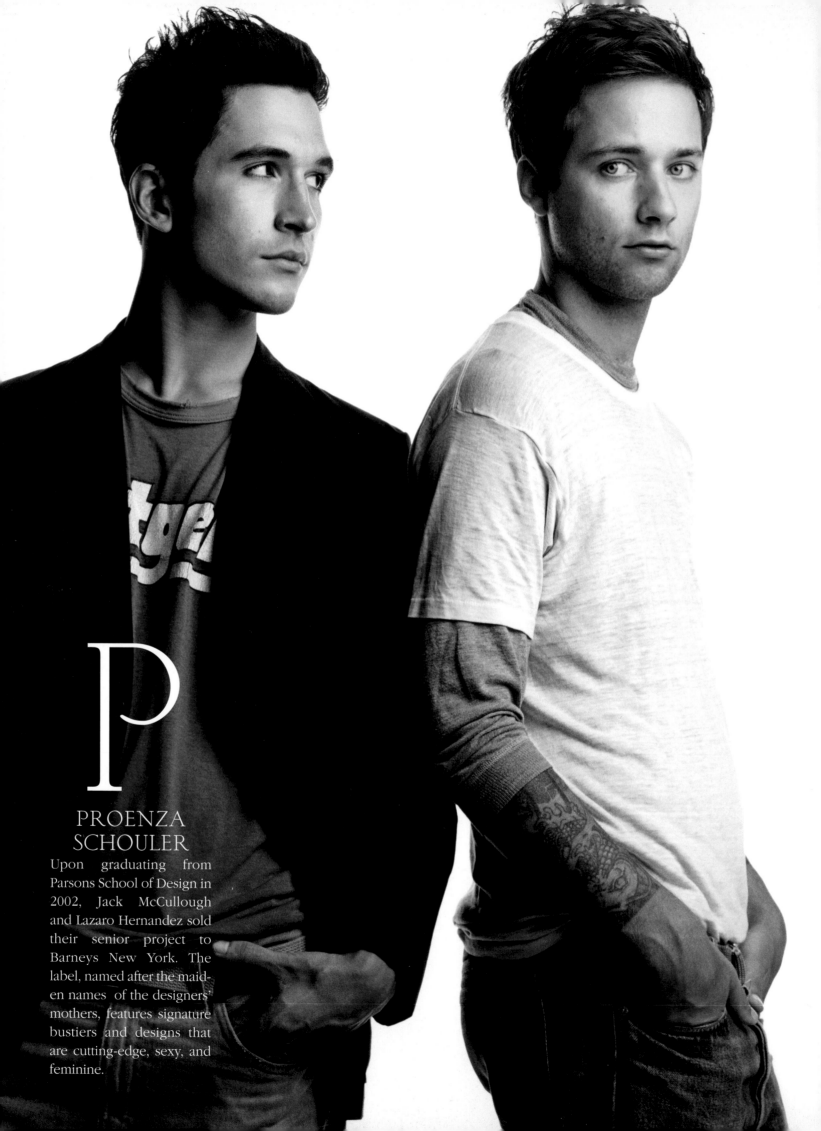

P

PROENZA SCHOULER

Upon graduating from Parsons School of Design in 2002, Jack McCullough and Lazaro Hernandez sold their senior project to Barneys New York. The label, named after the maiden names of the designers' mothers, features signature bustiers and designs that are cutting-edge, sexy, and feminine.

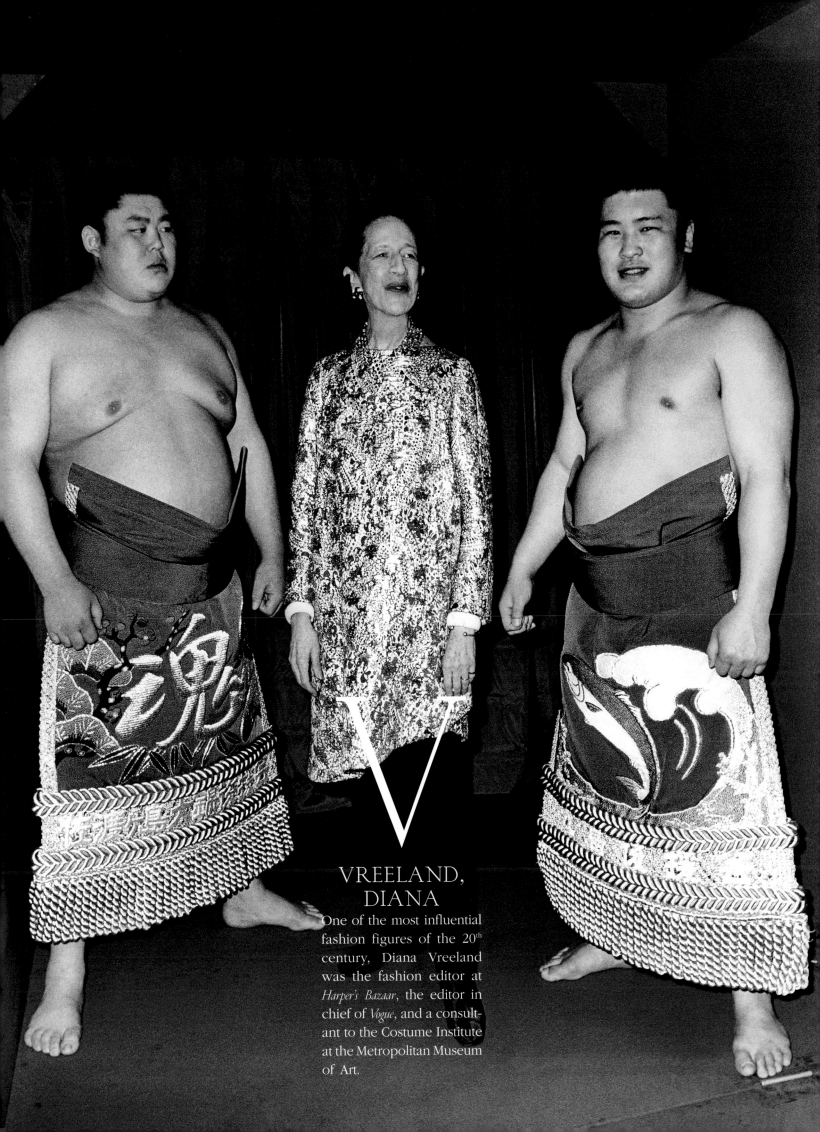

V

VREELAND, DIANA

One of the most influential fashion figures of the 20th century, Diana Vreeland was the fashion editor at *Harper's Bazaar*, the editor in chief of *Vogue*, and a consultant to the Costume Institute at the Metropolitan Museum of Art.

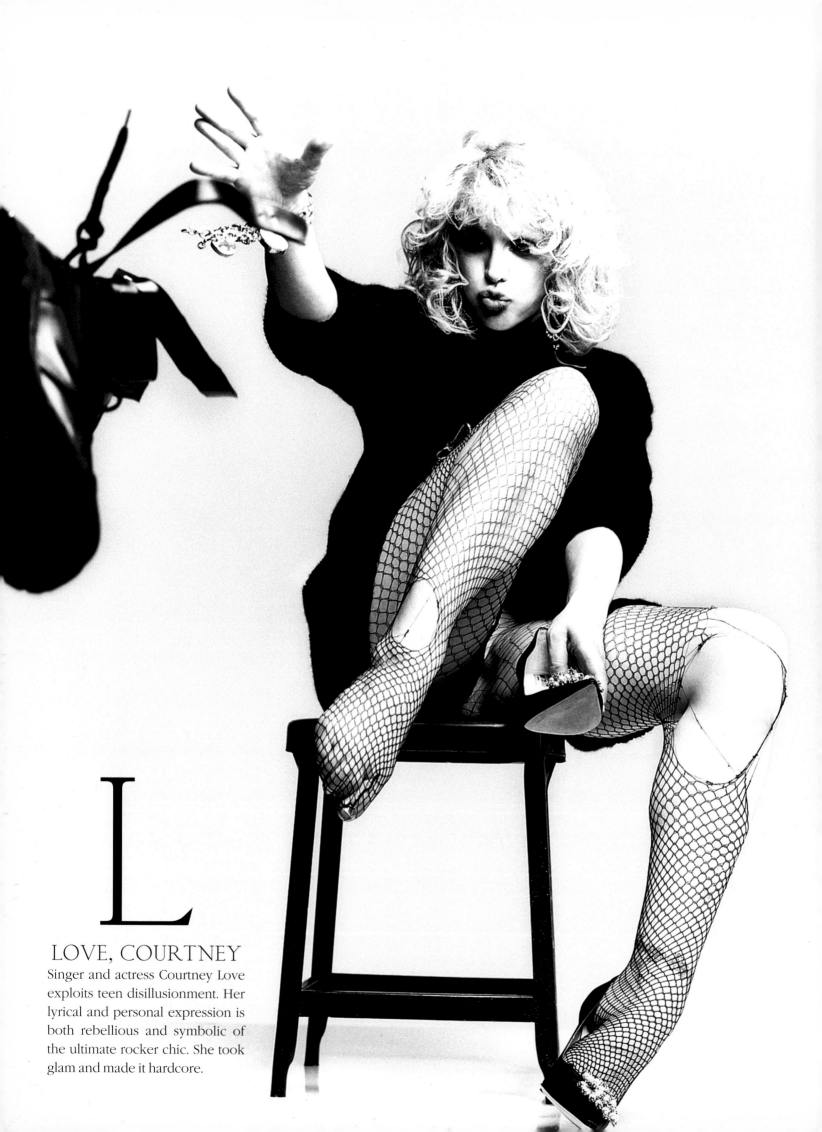

L

LOVE, COURTNEY

Singer and actress Courtney Love exploits teen disillusionment. Her lyrical and personal expression is both rebellious and symbolic of the ultimate rocker chic. She took glam and made it hardcore.

L

L-85

After the onset of America's involvement in World War II, the U.S. government issued a set of clothing restrictions known as L-85. Among the items regulated were skirt lengths (no longer than the knee), men's trousers (no cuffs or pleats), and fabrics: no silk (needed for parachutes) and no nylon (needed for rope).

WAR PRODUCTION BOARD

Commission, War Shipping Administration, and their auxiliaries, and cadet nurses of the Public Health Services.

(11) Apparel for feminine wear manufactured in foreign countries and received in customs in the United States prior to July 1, 1943

(e) *Equitable distribution* It is the policy of the War Production Board that the products described in this order or its schedules not required to fill rated orders shall be distributed equitably In making such distribution due regard should be given to essential civilian needs, and there should be no discrimination in the acceptance or filling of orders as between persons who meet the seller's regularly established prices and terms of sale or payment Under this policy every seller of such products, so far as practicable, should make available an equitable proportion of his merchandise to his customers periodically, without prejudice because of their size, location or relationship as affiliated outlets It is not the intention to interfere with established channels and methods of distribu-

filing a letter in triplicate, referring the particular provision appealed and stating fully the grounds of th peal

(h) *Communications to the Wa duction Board* All reports to t hereunder and all communicatio cerning this order shall, unless of directed, be addressed to War Pr Board, Textile, Clothing and Lea vision Washington 25, D C, Re

(i) *Violations* Any person fully violates any provision of t or who in connection with this fully conceals a material fact o false information to any d or agency of the United Stat of a crime, and upon convict punished by fine or impriso addition, any such person hibited from making or ob ther deliveries or from proc ing material under priorit may be deprived of priorit by the War Production Bo

Issued this 11th day of

WAR PRODUCT
By J JOSEPH W
Record

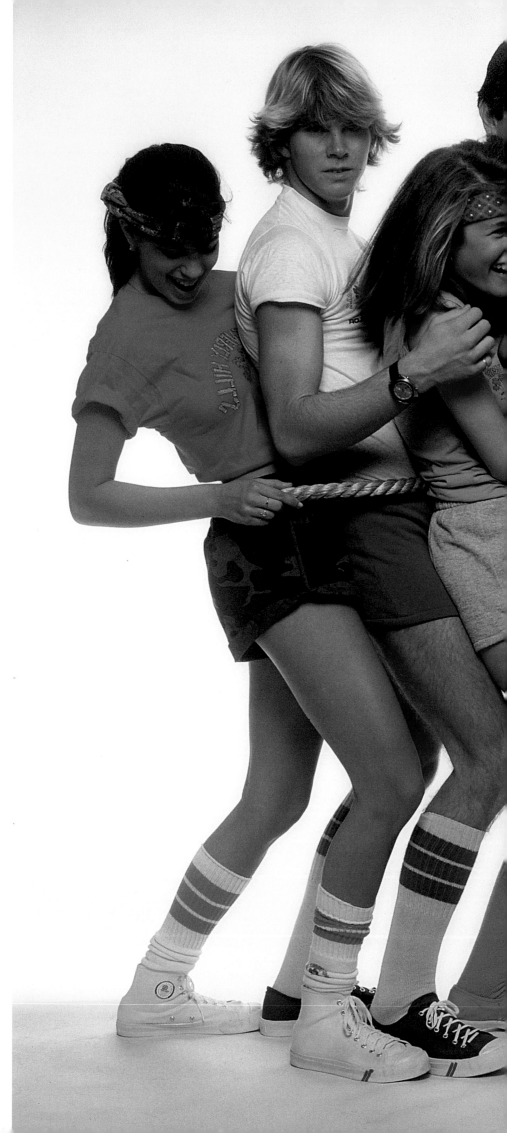

C
CAMP BEVERLY HILLS

In stark contrast to Giorgio's of Beverly Hills, which featured the '80s *Dallas* look, Camp Beverly Hills was a clothing store/hangout where you could listen to loud music or shop for vintage tuxedos and Hawaiian shirts.

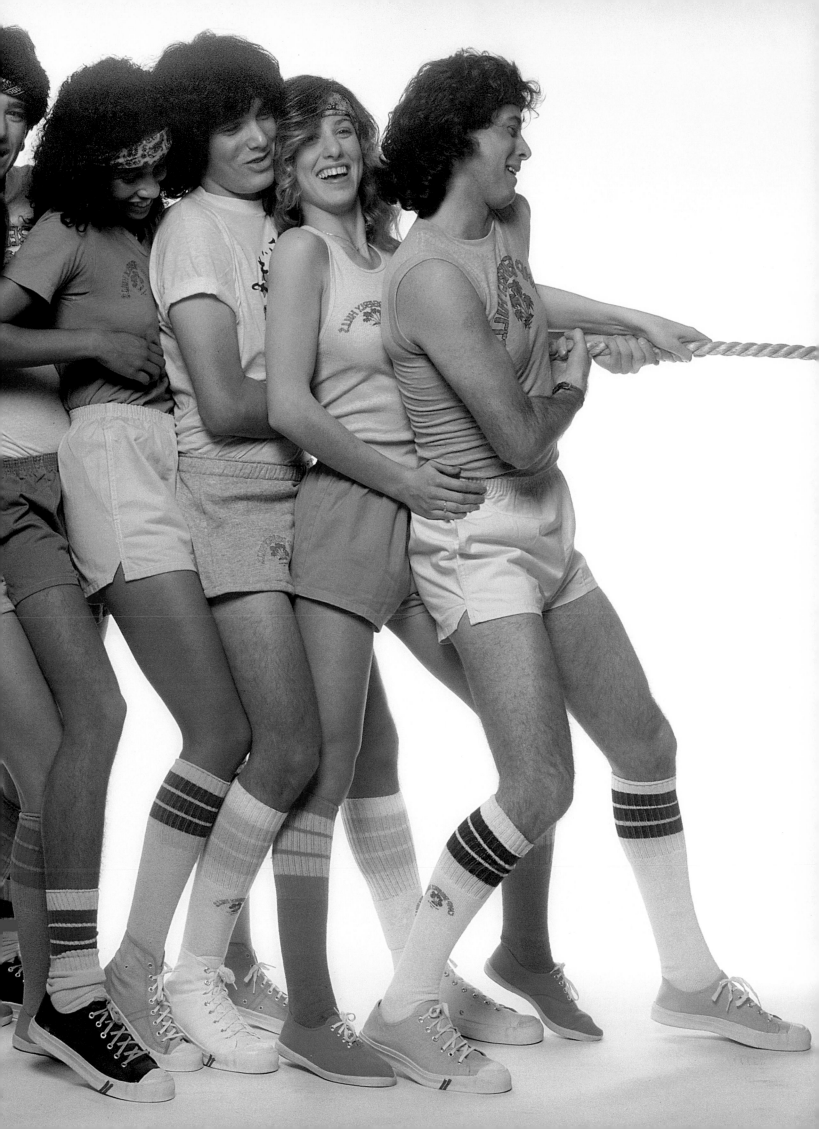

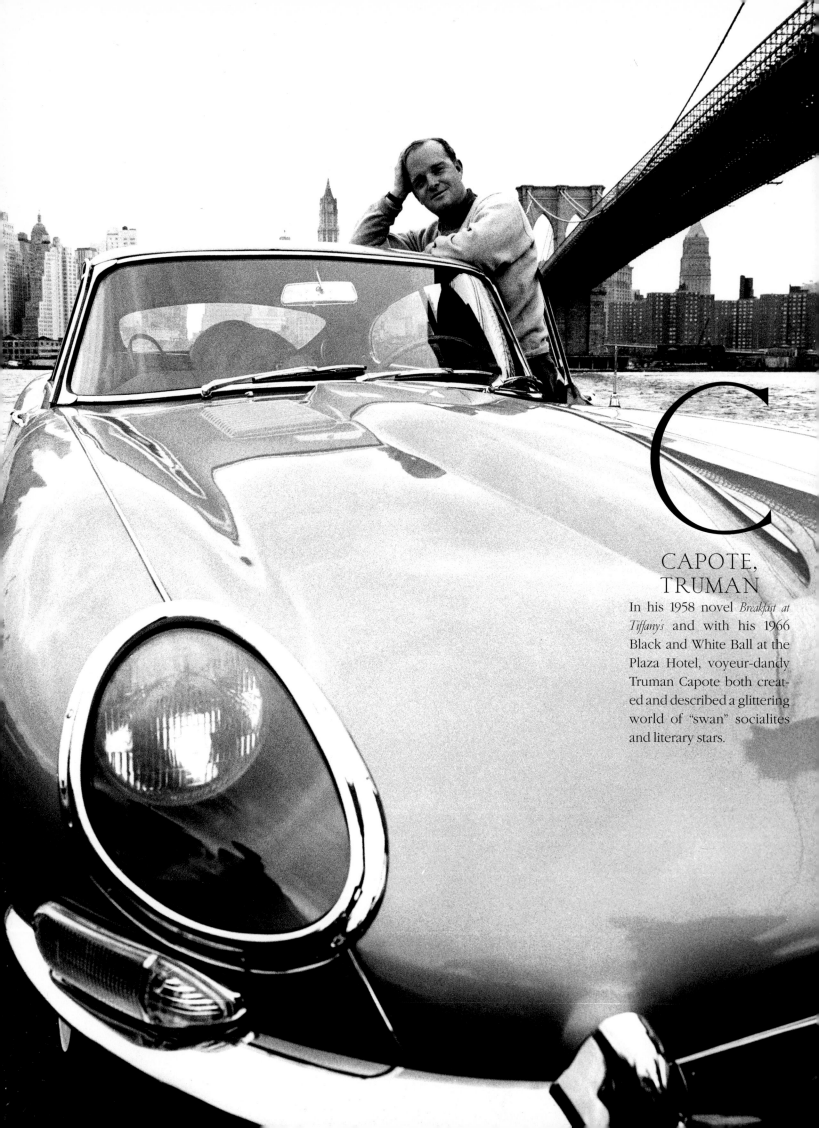

C

CAPOTE, TRUMAN

In his 1958 novel *Breakfast at Tiffany's* and with his 1966 Black and White Ball at the Plaza Hotel, voyeur-dandy Truman Capote both created and described a glittering world of "swan" socialites and literary stars.

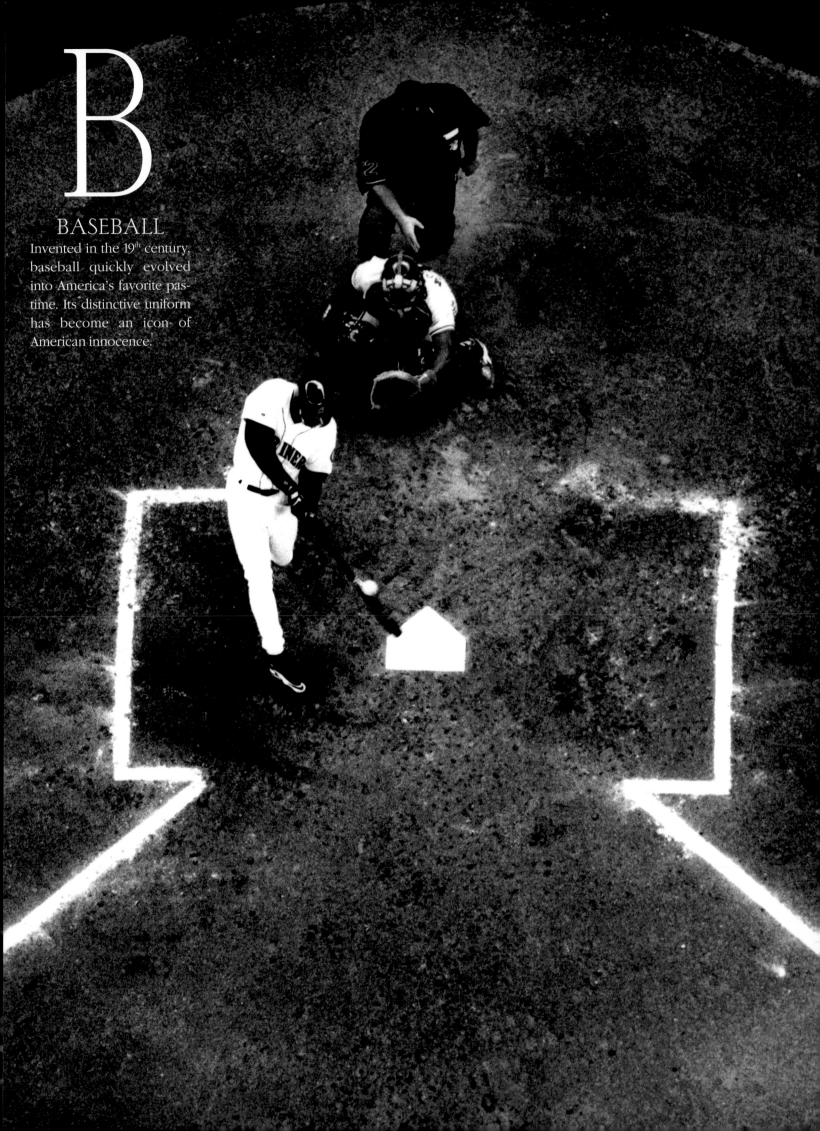

B

BASEBALL

Invented in the 19th century, baseball quickly evolved into America's favorite pastime. Its distinctive uniform has become an icon of American innocence.

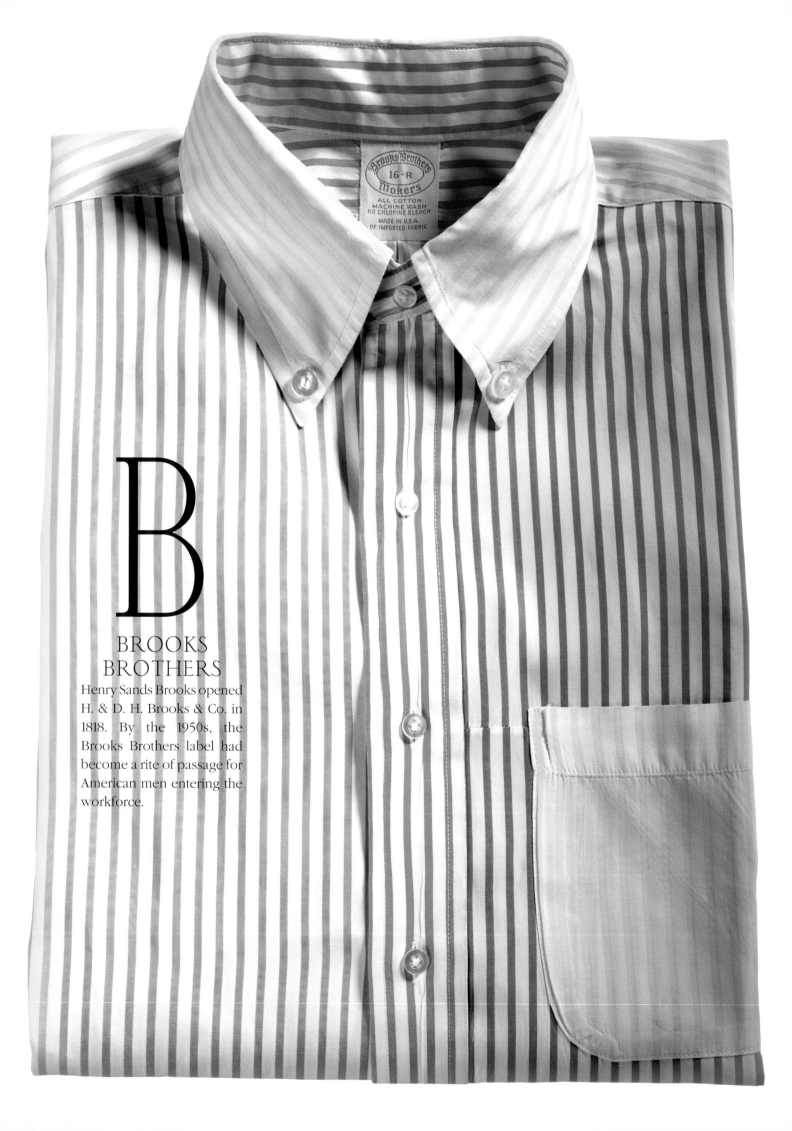

B

BROOKS BROTHERS

Henry Sands Brooks opened H. & D. H. Brooks & Co. in 1818. By the 1950s, the Brooks Brothers label had become a rite of passage for American men entering the workforce.

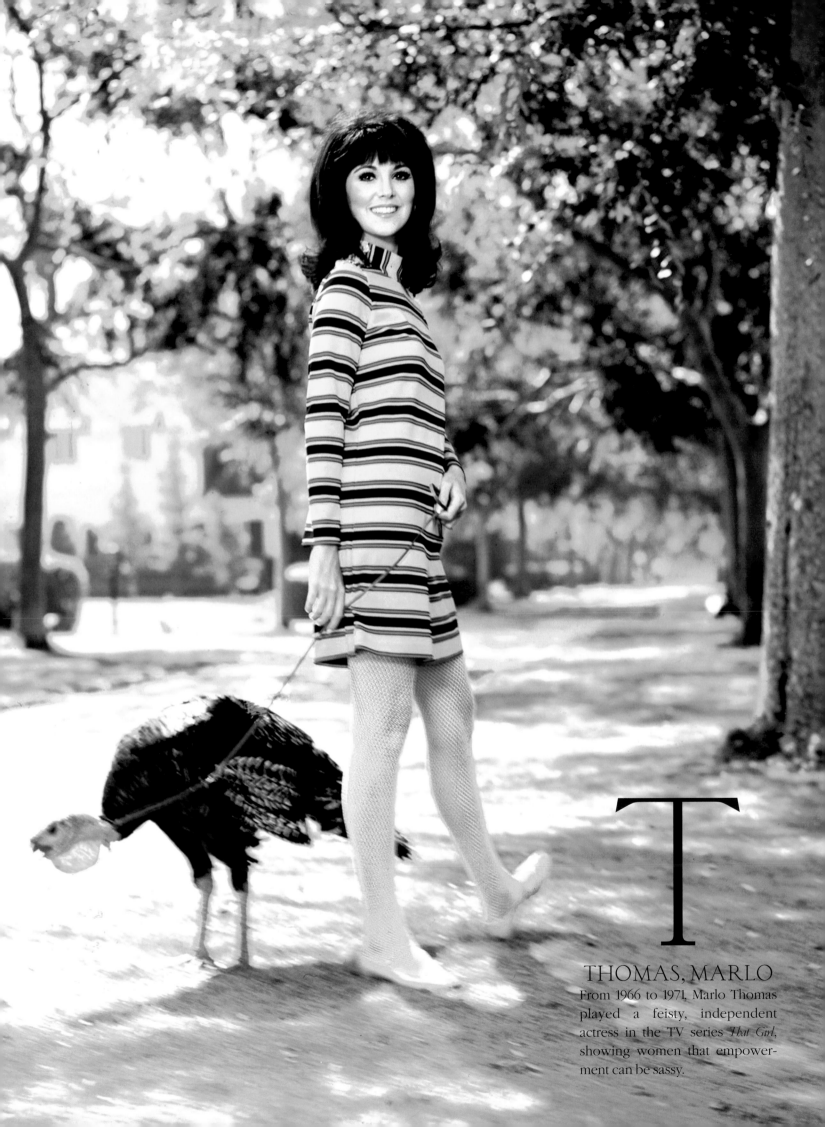

T

THOMAS, MARLO

From 1966 to 1971, Marlo Thomas played a feisty, independent actress in the TV series *That Girl*, showing women that empowerment can be sassy.

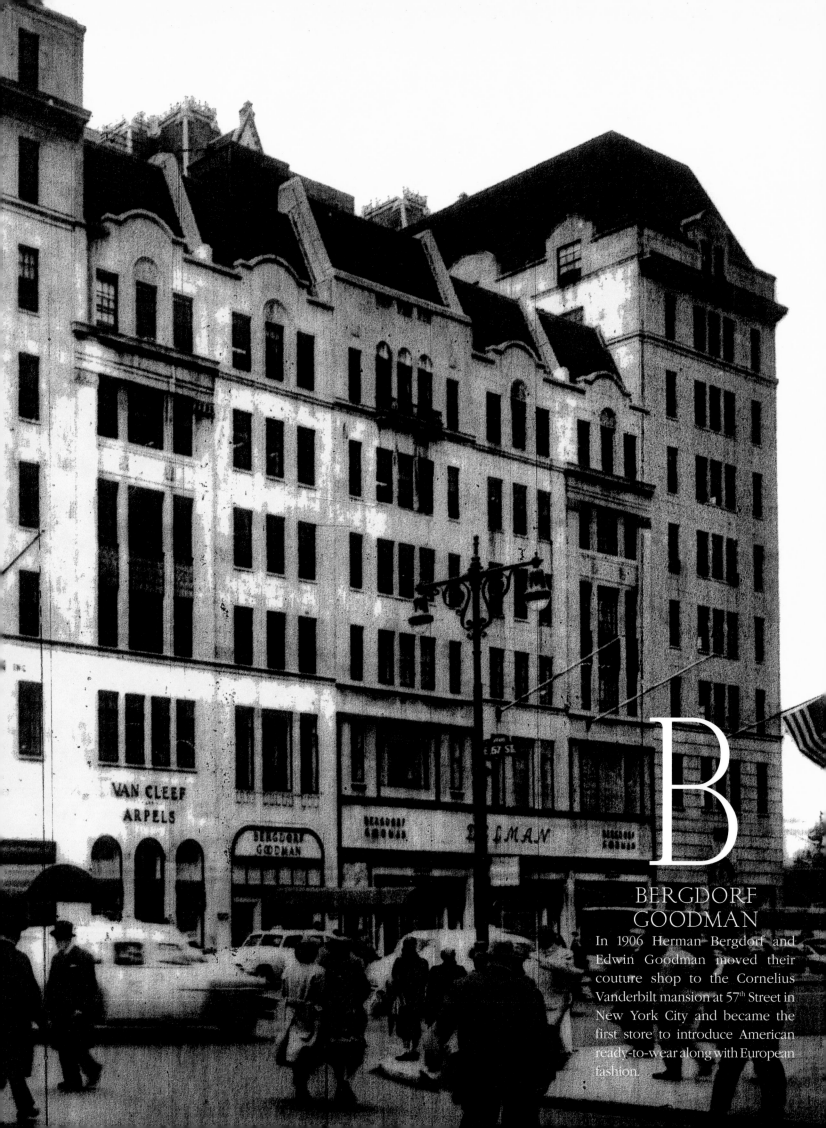

B
BERGDORF GOODMAN

In 1906 Herman Bergdorf and Edwin Goodman moved their couture shop to the Cornelius Vanderbilt mansion at 57th Street in New York City and became the first store to introduce American ready-to-wear along with European fashion.

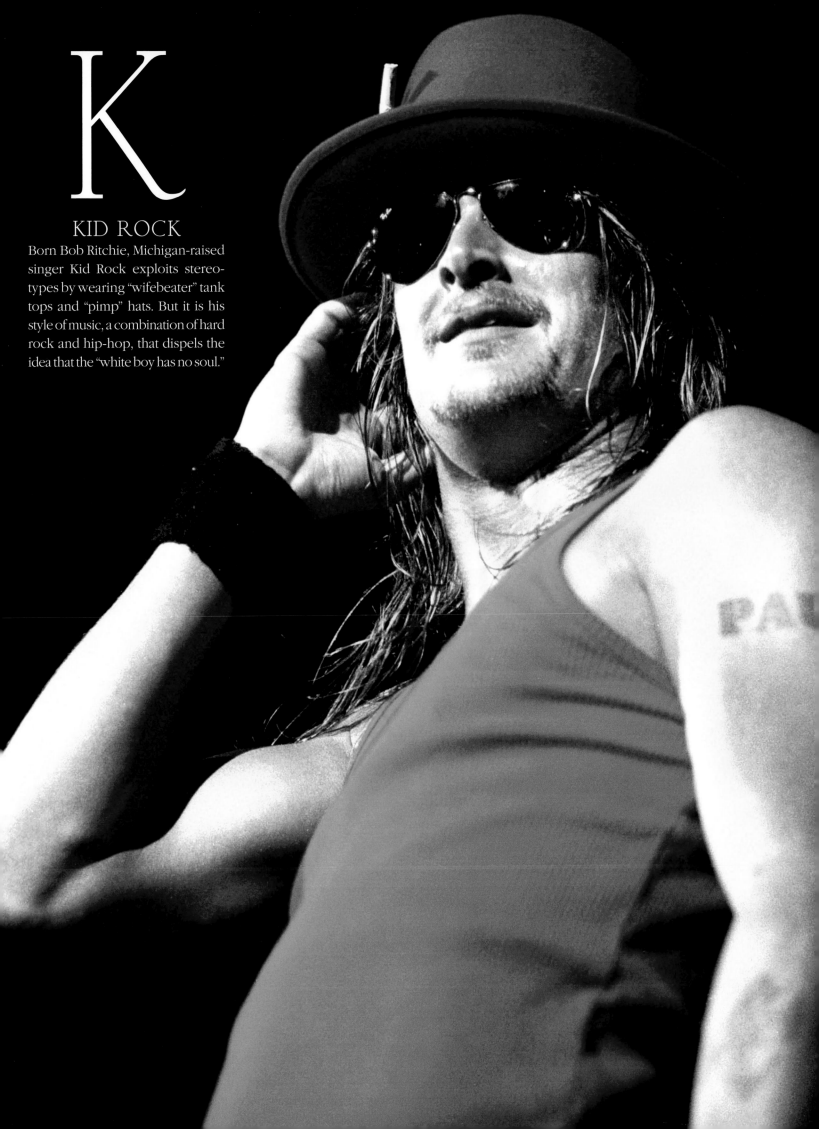

K

KID ROCK

Born Bob Ritchie, Michigan-raised singer Kid Rock exploits stereotypes by wearing "wifebeater" tank tops and "pimp" hats. But it is his style of music, a combination of hard rock and hip-hop, that dispels the idea that the "white boy has no soul."

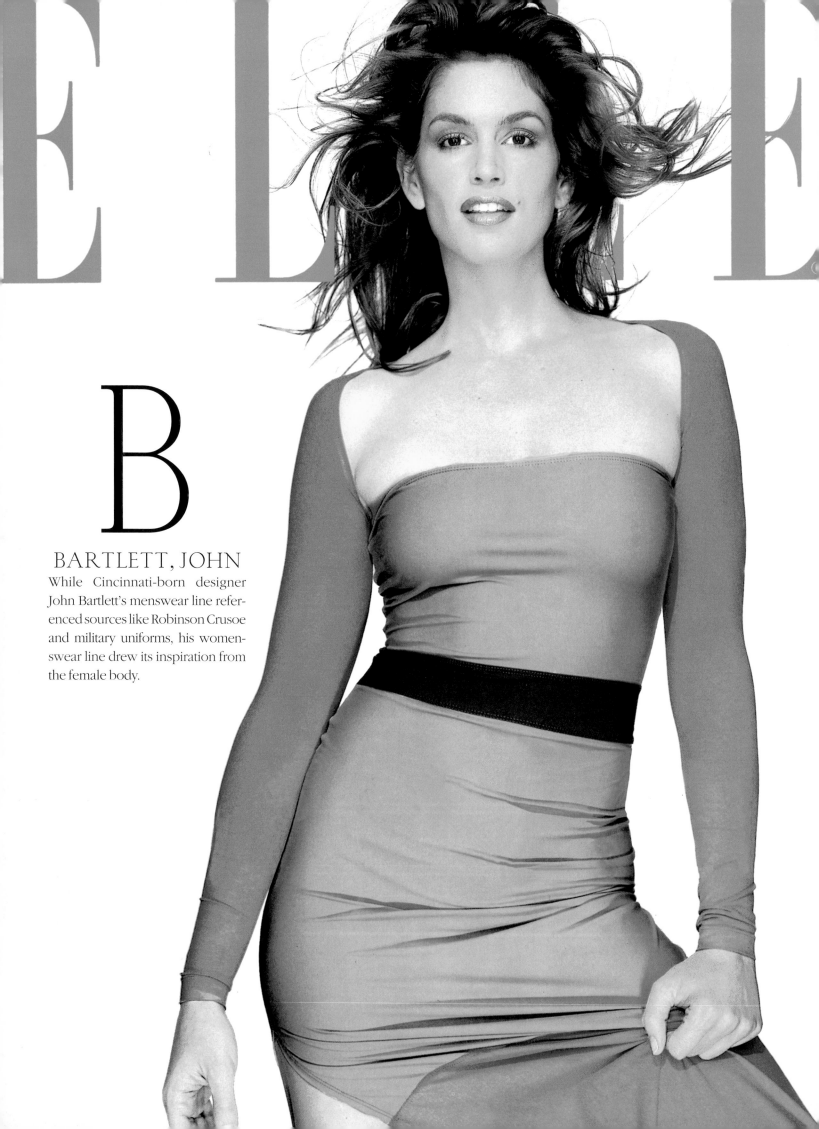

B

BARTLETT, JOHN

While Cincinnati-born designer John Bartlett's menswear line referenced sources like Robinson Crusoe and military uniforms, his womenswear line drew its inspiration from the female body.

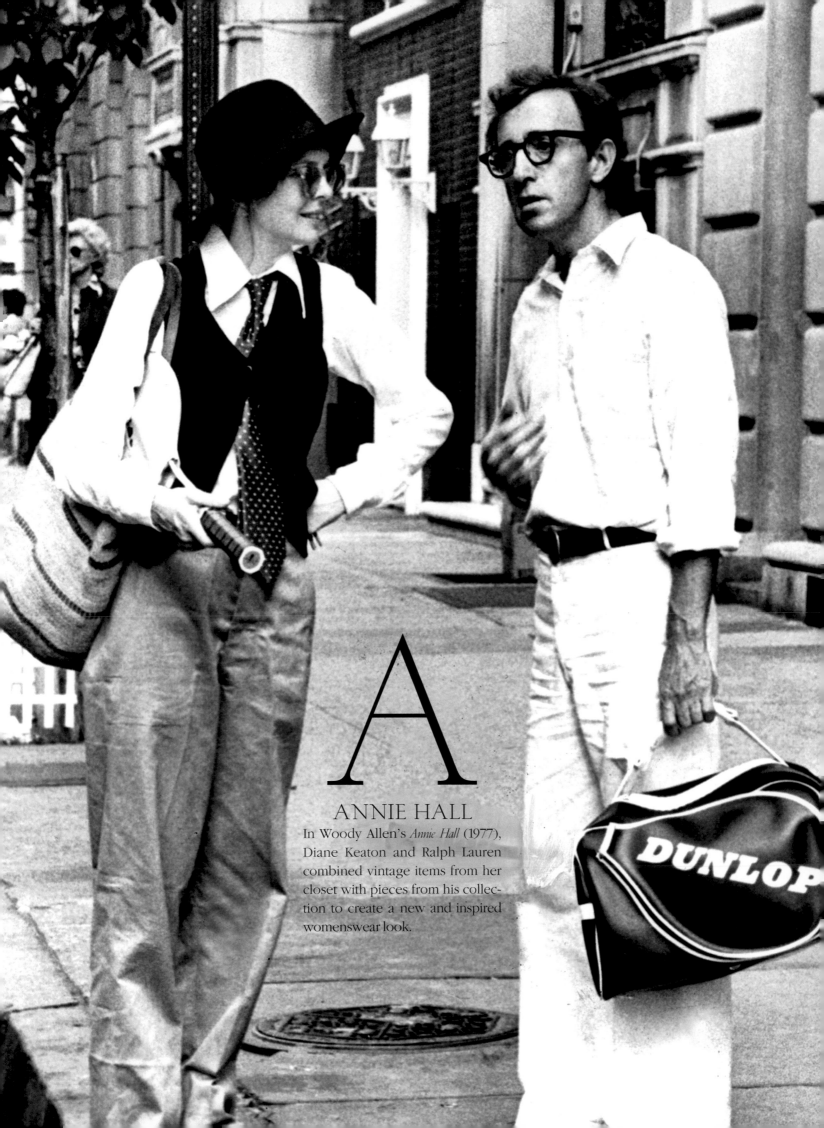

A
ANNIE HALL

In Woody Allen's *Annie Hall* (1977), Diane Keaton and Ralph Lauren combined vintage items from her closet with pieces from his collection to create a new and inspired womenswear look.

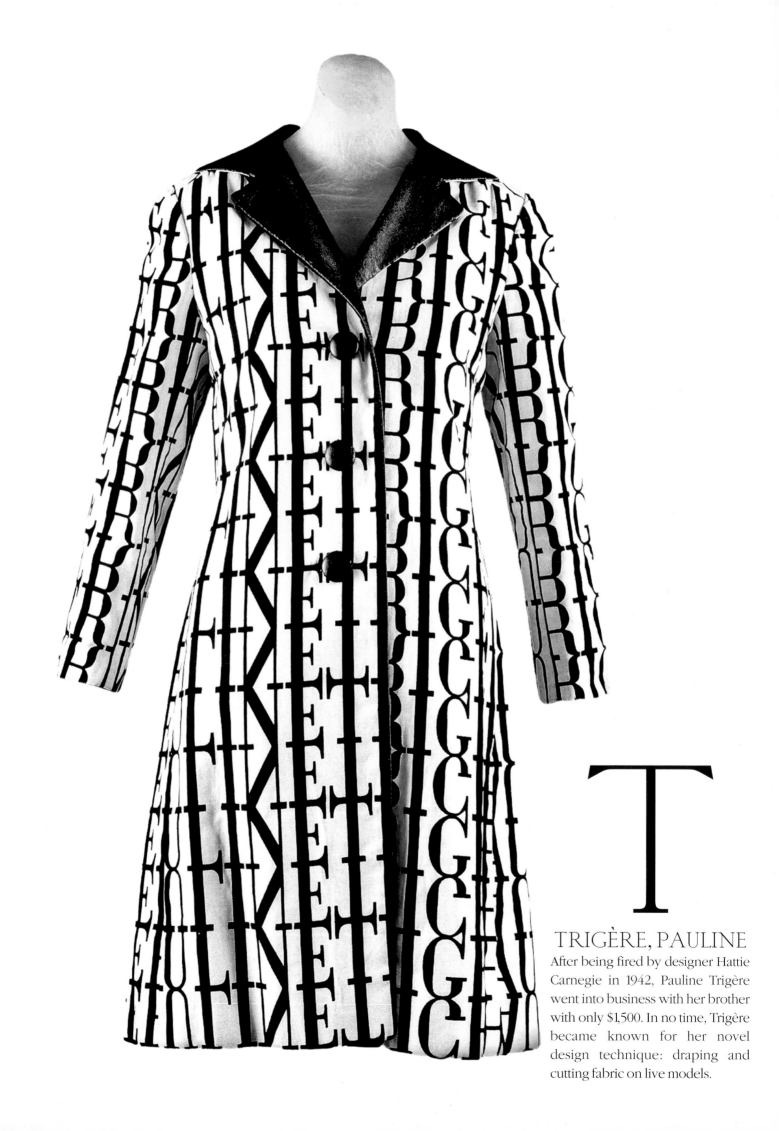

T

TRIGÈRE, PAULINE

After being fired by designer Hattie Carnegie in 1942, Pauline Trigère went into business with her brother with only $1,500. In no time, Trigère became known for her novel design technique: draping and cutting fabric on live models.

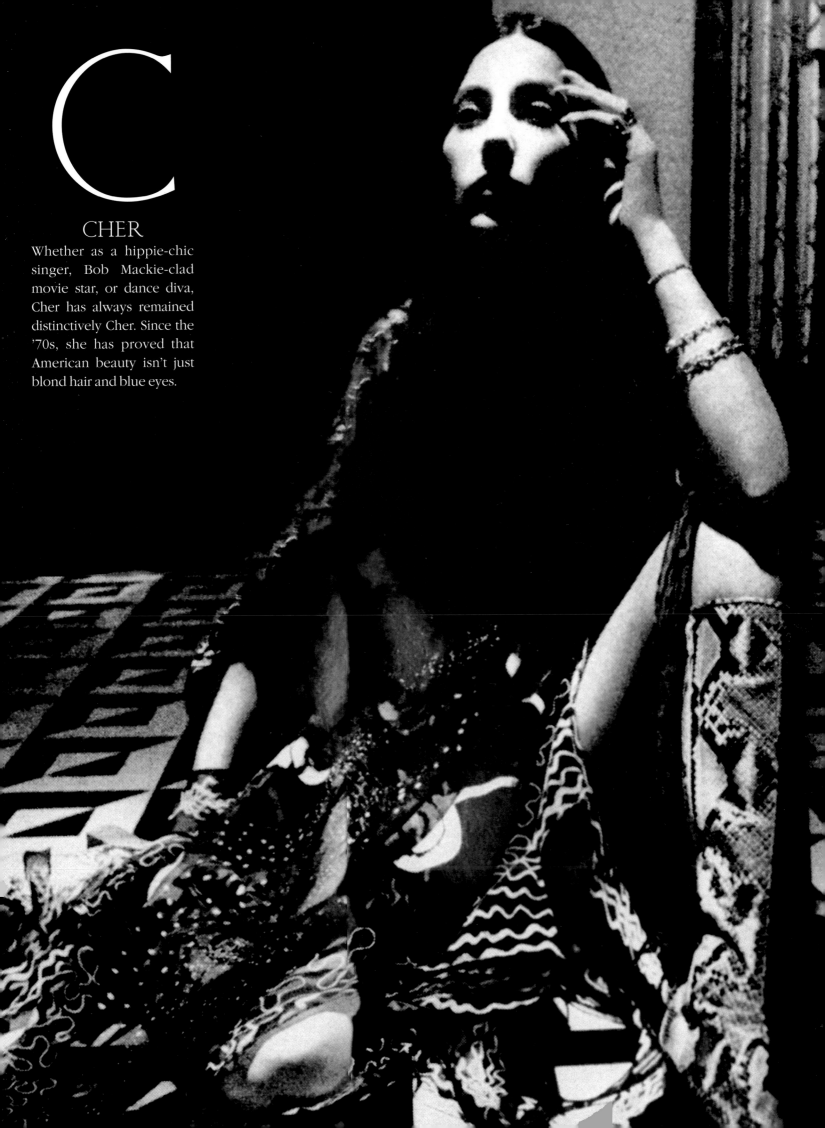

C

CHER

Whether as a hippie-chic singer, Bob Mackie-clad movie star, or dance diva, Cher has always remained distinctively Cher. Since the '70s, she has proved that American beauty isn't just blond hair and blue eyes.

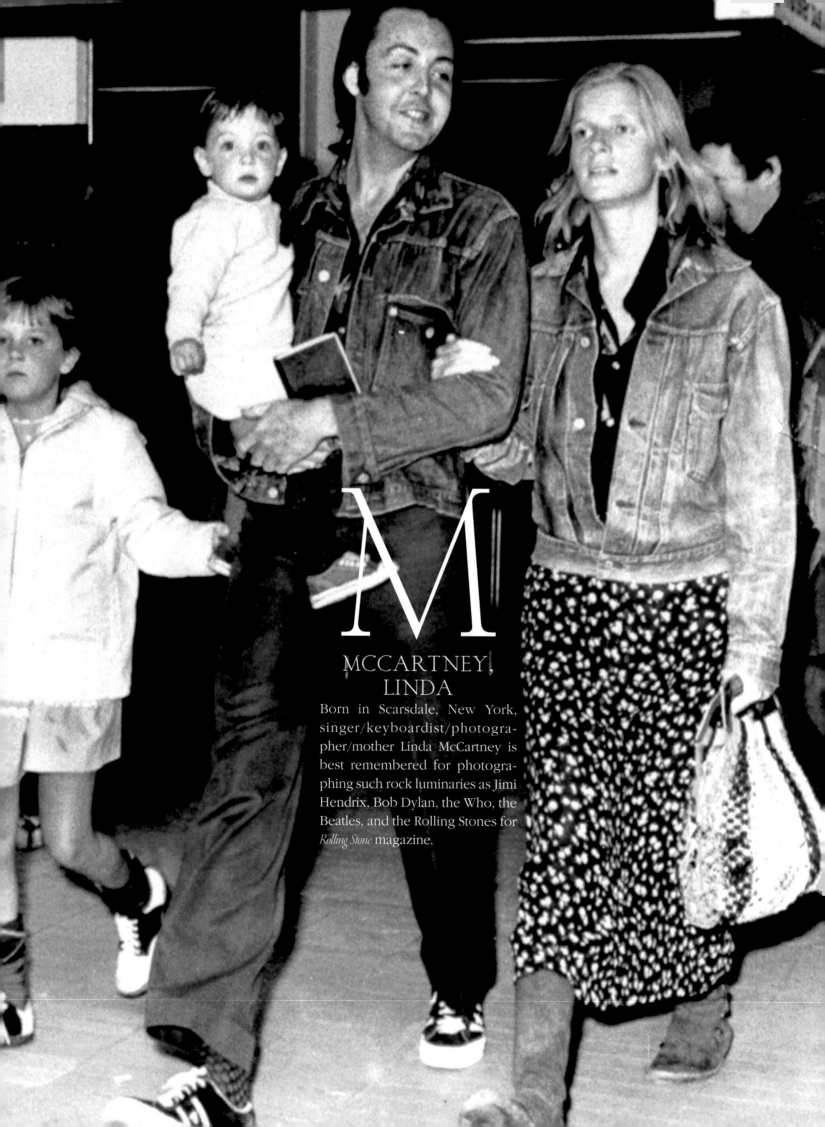

M
MCCARTNEY, LINDA

Born in Scarsdale, New York, singer/keyboardist/photographer/mother Linda McCartney is best remembered for photographing such rock luminaries as Jimi Hendrix, Bob Dylan, the Who, the Beatles, and the Rolling Stones for *Rolling Stone* magazine.

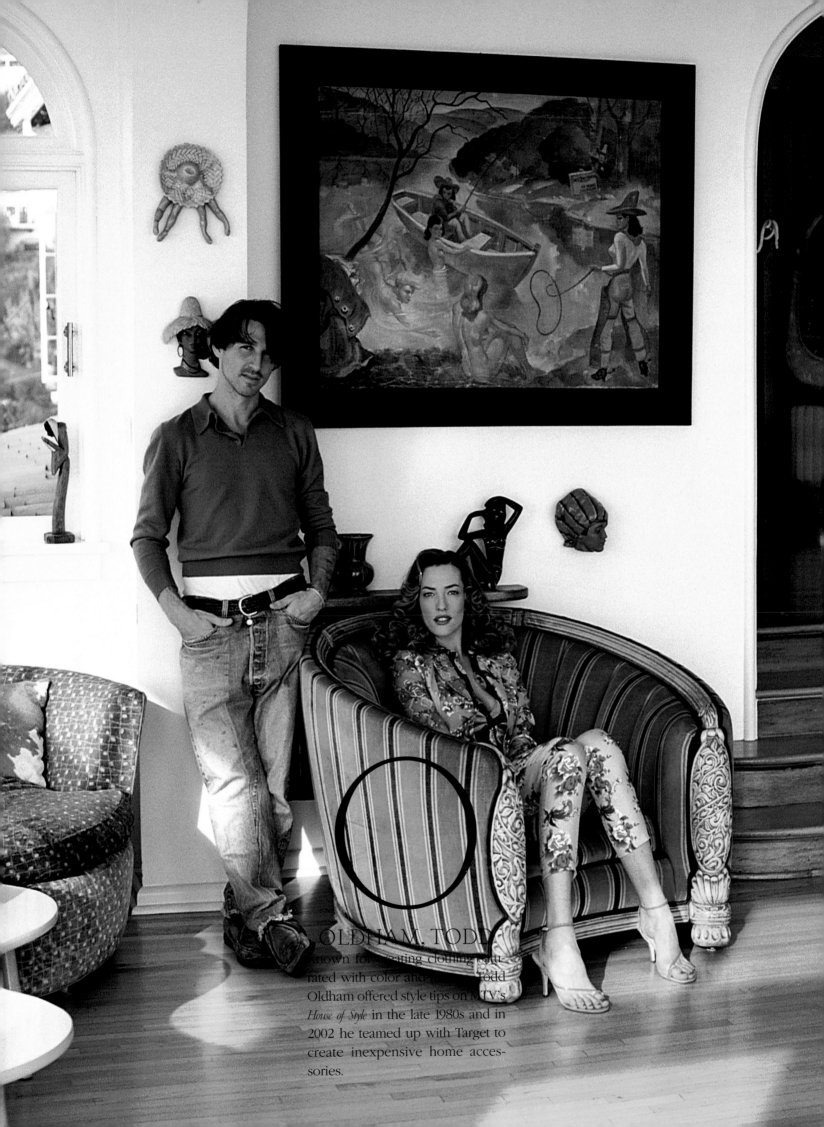

OLDHAM, TODD

known for creating clothing satu-
rated with color and *Todd
Oldham* offered style tips on MTV's
House of Style in the late 1980s and in
2002 he teamed up with Target to
create inexpensive home acces-
sories.

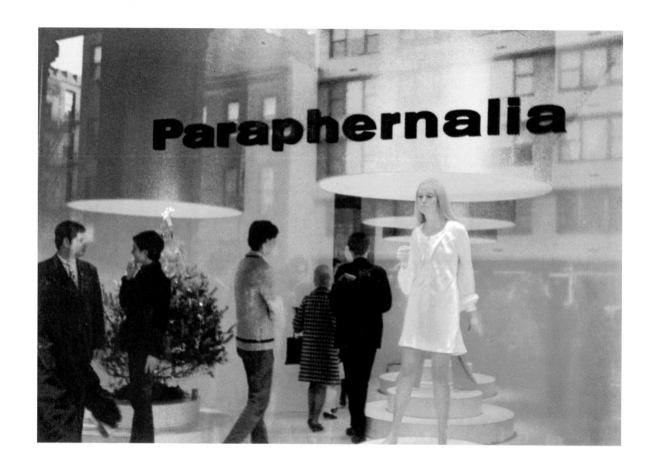

P

PARAPHERNALIA

In 1965, the tremors of London's youthquake reached Manhattan with the opening of Paraphernalia. The store sold pieces by recent design school graduates Betsy Johnson, Deanna Little, Joel Schumacher, and Carol Friedland.

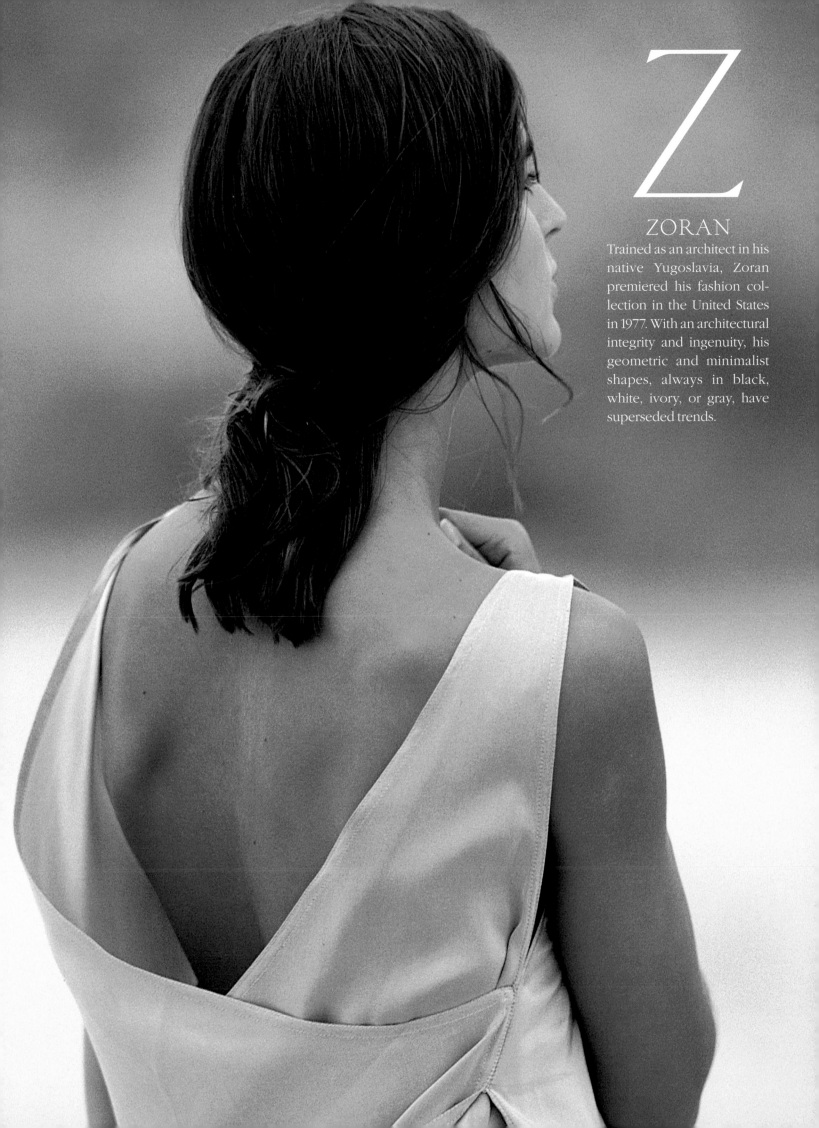

Z

ZORAN

Trained as an architect in his native Yugoslavia, Zoran premiered his fashion collection in the United States in 1977. With an architectural integrity and ingenuity, his geometric and minimalist shapes, always in black, white, ivory, or gray, have superseded trends.

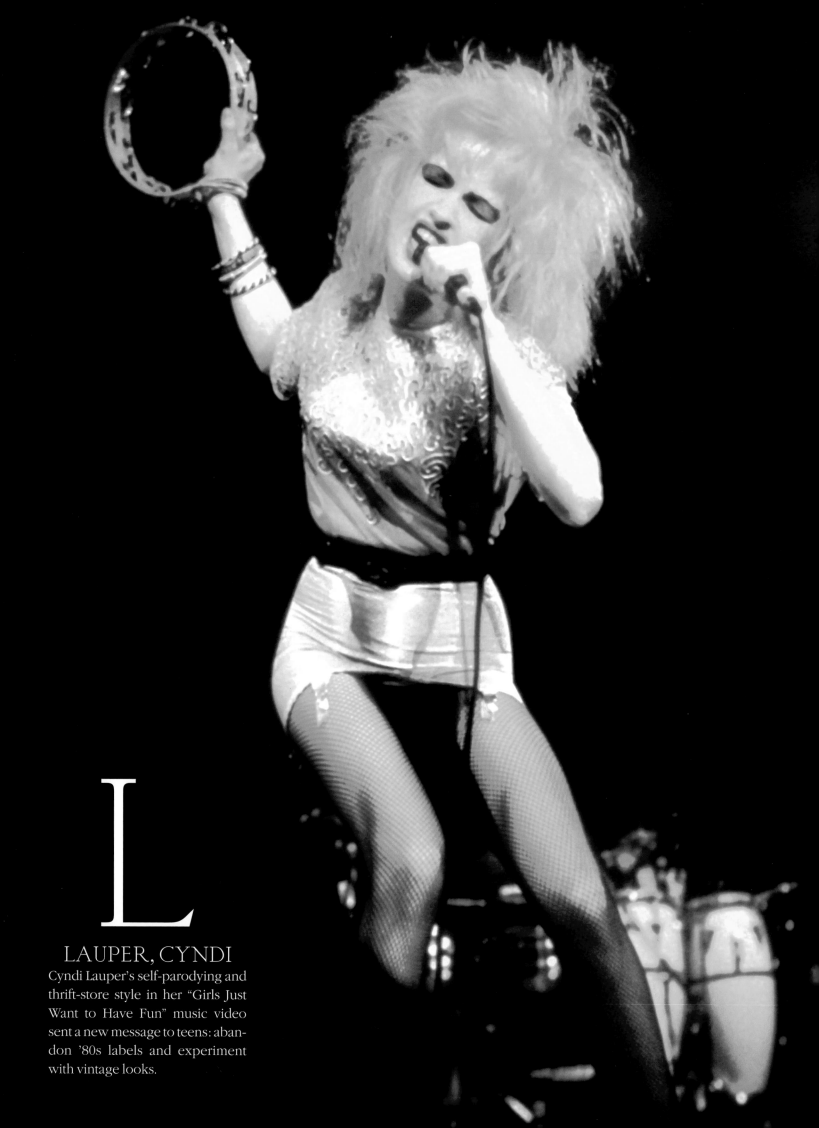

L

LAUPER, CYNDI

Cyndi Lauper's self-parodying and thrift-store style in her "Girls Just Want to Have Fun" music video sent a new message to teens: abandon '80s labels and experiment with vintage looks.

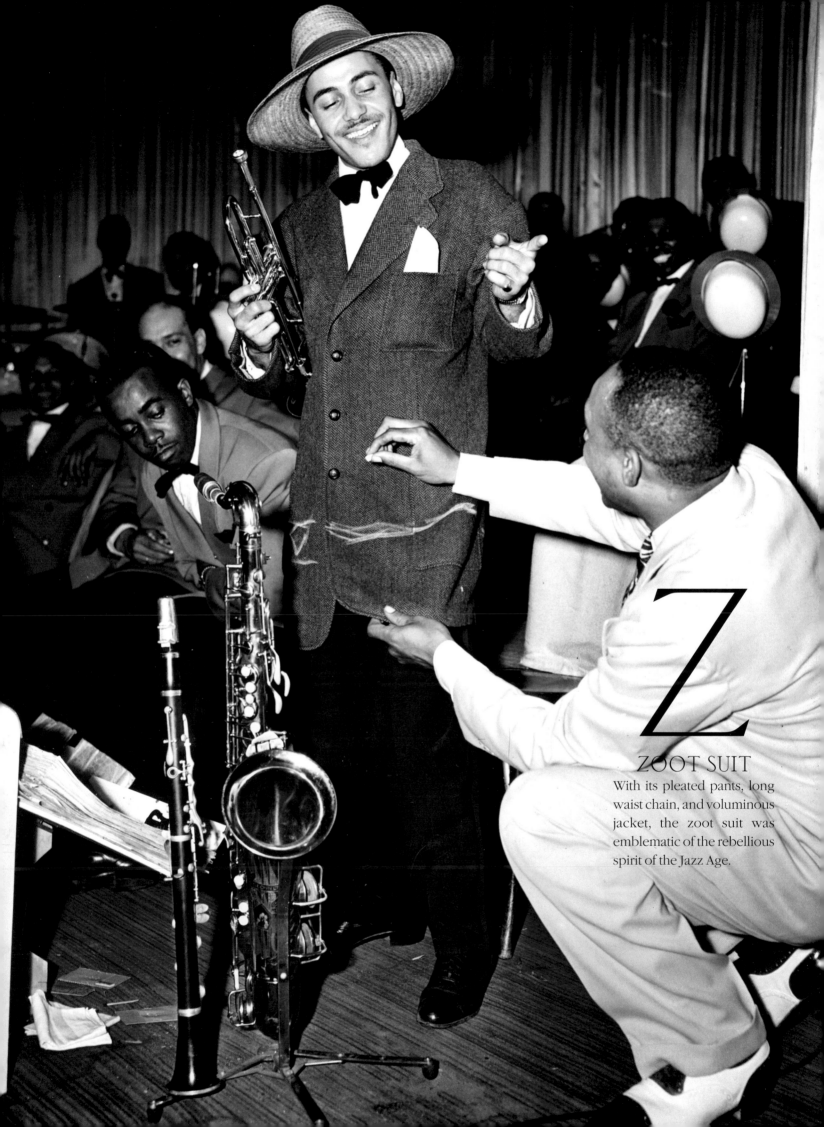

Z

ZOOT SUIT

With its pleated pants, long waist chain, and voluminous jacket, the zoot suit was emblematic of the rebellious spirit of the Jazz Age.

CHOW, TINA

Born in Cleveland, fashion model Tina Lutz became known as Tina Chow after her marriage to famed restaurateur Michael Chow. Her exotic looks led to premier ad campaigns during the 1980s, while her unique collection of vintage couture helped to establish a major trend.

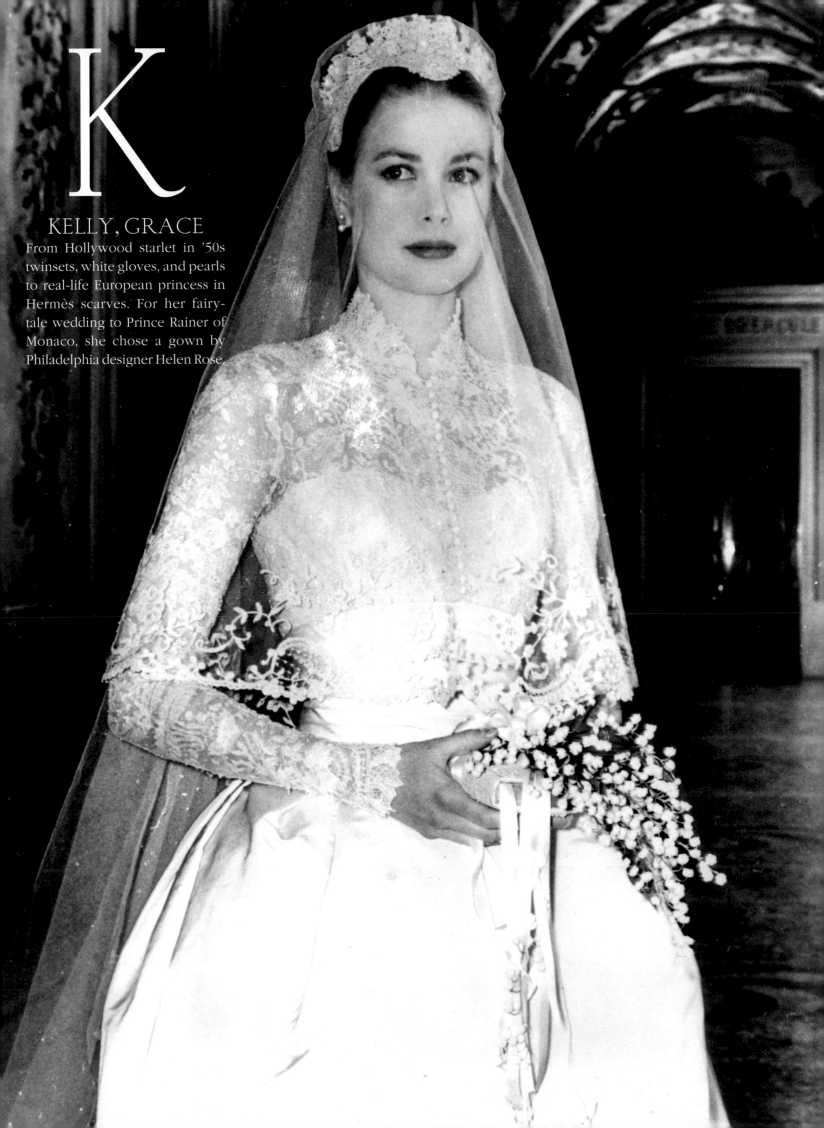

K

KELLY, GRACE

From Hollywood starlet in '50s twinsets, white gloves, and pearls to real-life European princess in Hermès scarves. For her fairy-tale wedding to Prince Rainer of Monaco, she chose a gown by Philadelphia designer Helen Rose.

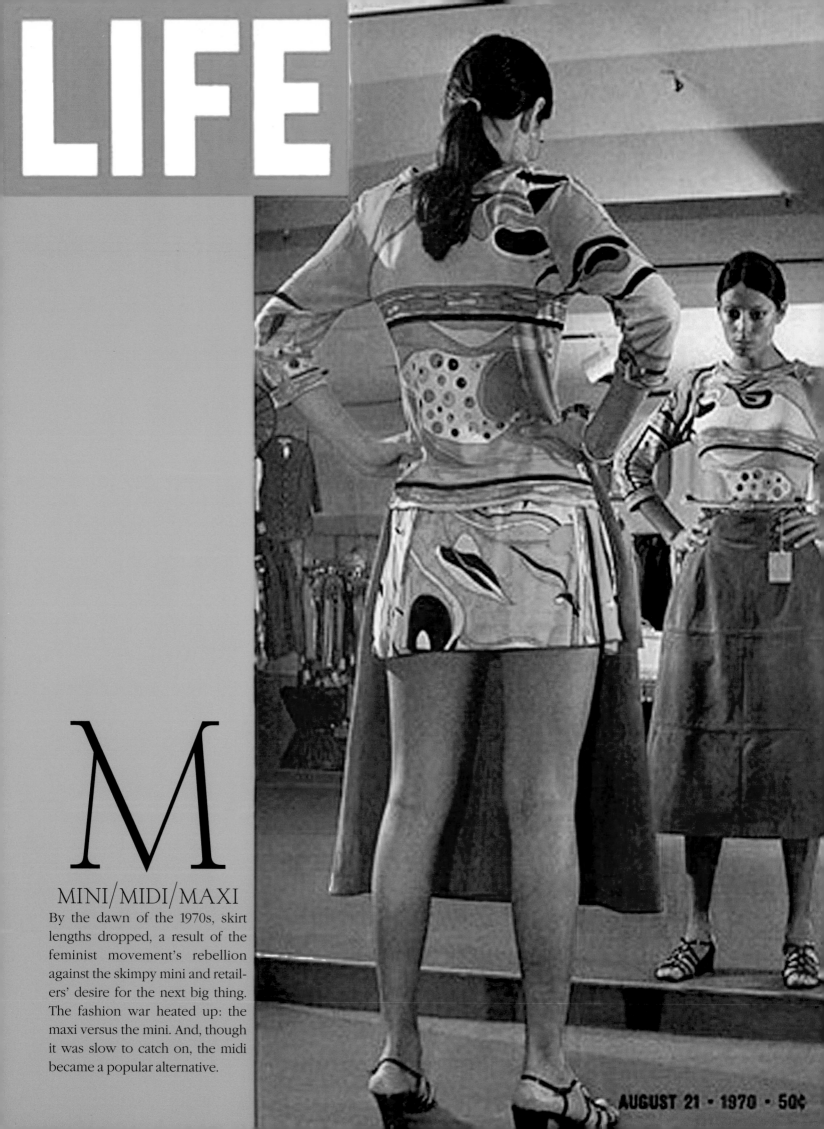

LIFE

M

MINI/MIDI/MAXI

By the dawn of the 1970s, skirt lengths dropped, a result of the feminist movement's rebellion against the skimpy mini and retailers' desire for the next big thing. The fashion war heated up: the maxi versus the mini. And, though it was slow to catch on, the midi became a popular alternative.

AUGUST 21 · 1970 · 50¢

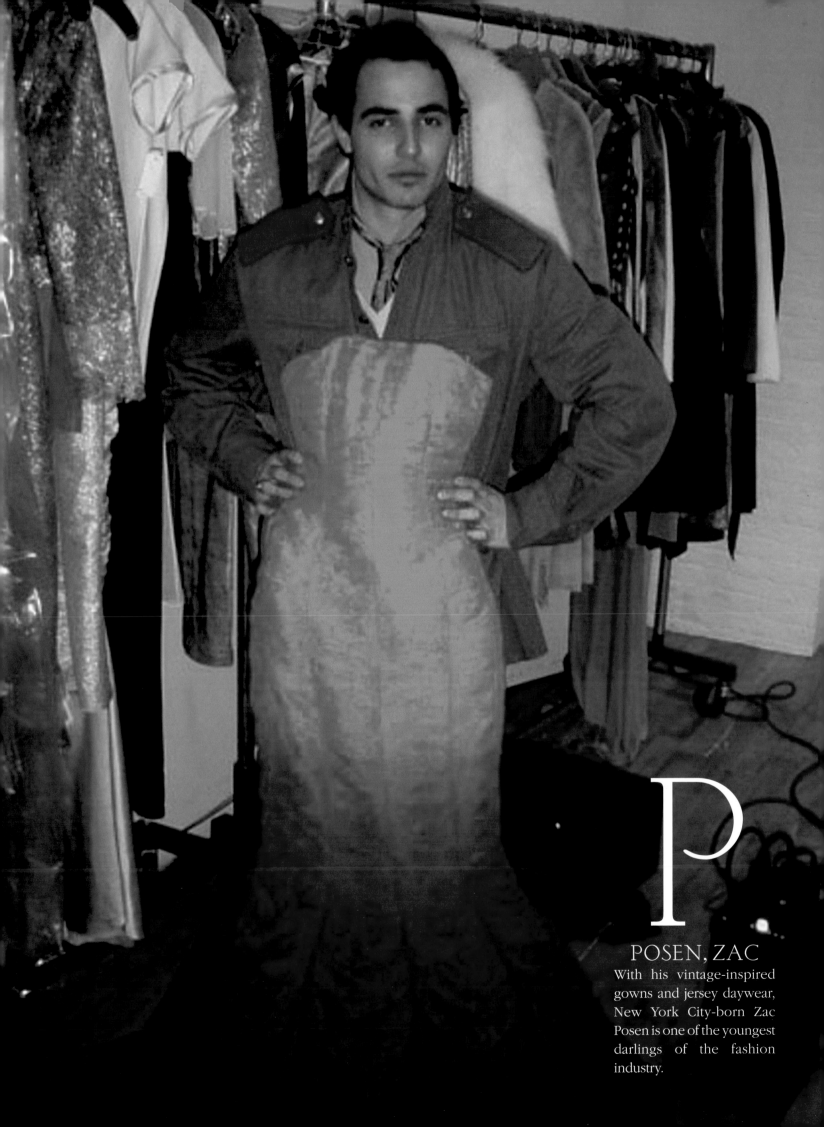

P

POSEN, ZAC
With his vintage-inspired gowns and jersey daywear, New York City-born Zac Posen is one of the youngest darlings of the fashion industry.

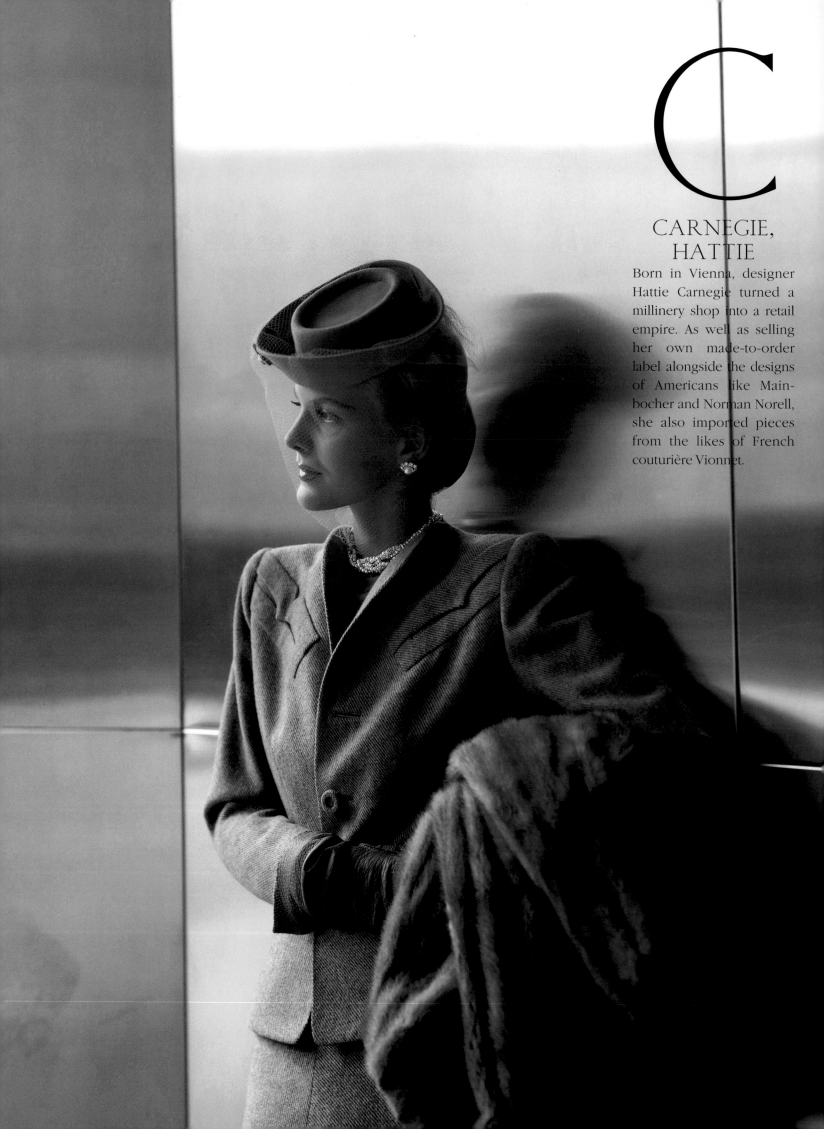

C

CARNEGIE, HATTIE

Born in Vienna, designer Hattie Carnegie turned a millinery shop into a retail empire. As well as selling her own made-to-order label alongside the designs of Americans like Mainbocher and Norman Norell, she also imported pieces from the likes of French couturière Vionnet.

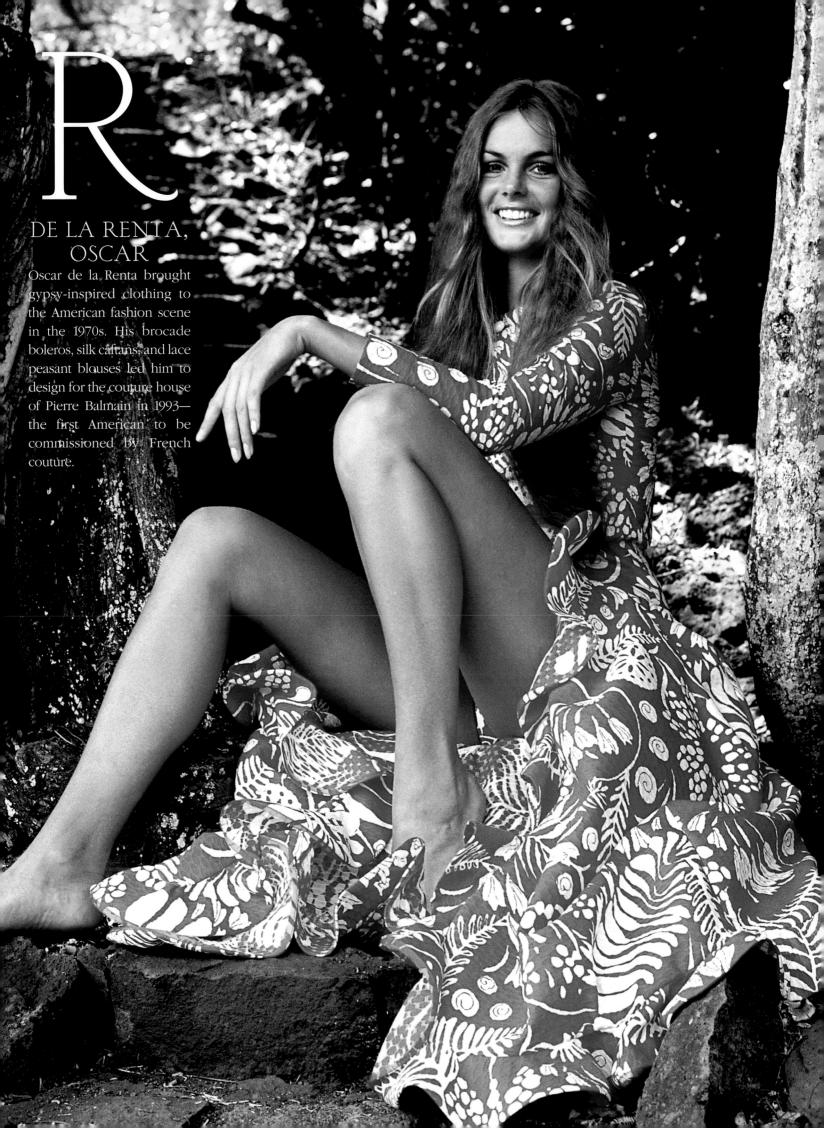

R

DE LA RENTA, OSCAR

Oscar de la Renta brought gypsy-inspired clothing to the American fashion scene in the 1970s. His brocade boleros, silk caftans, and lace peasant blouses led him to design for the couture house of Pierre Balmain in 1993—the first American to be commissioned by French couture.

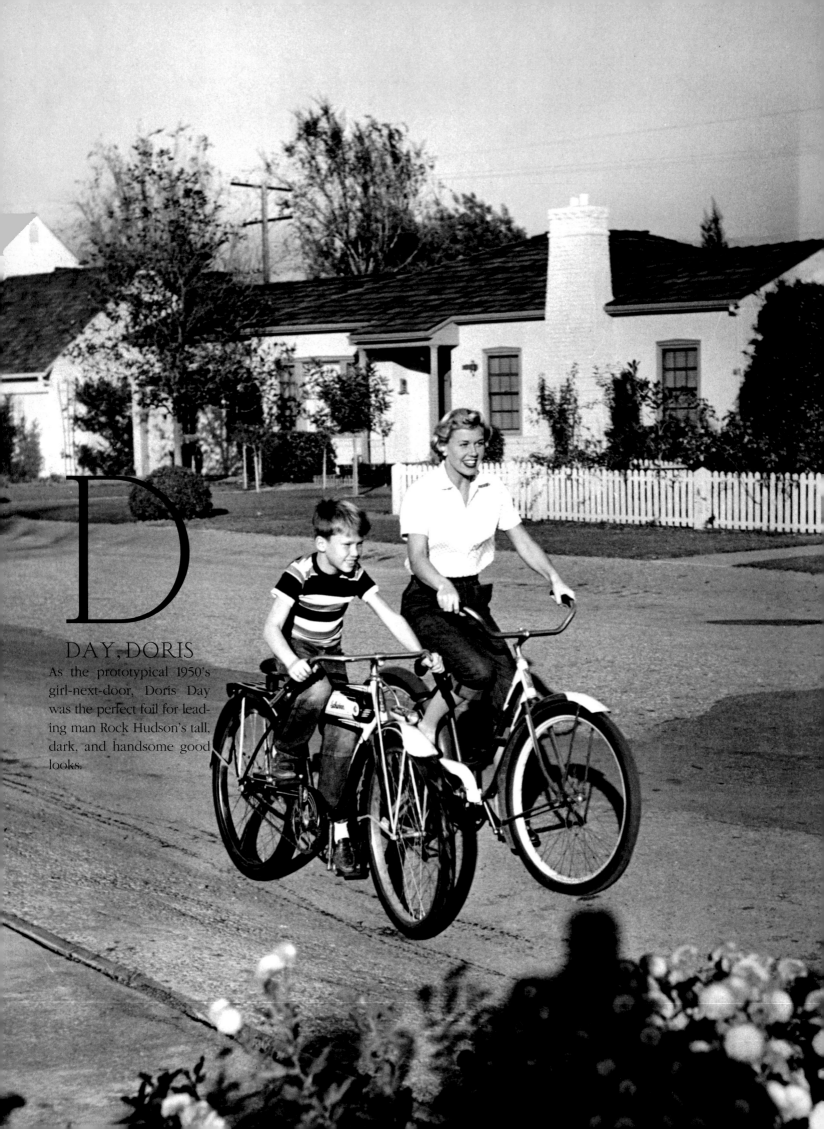

D

DAY, DORIS
As the prototypical 1950's girl-next-door, Doris Day was the perfect foil for leading man Rock Hudson's tall, dark, and handsome good looks.

M

MORRISON, JIM

On the eve of the Vietnam War, Florida-born singer Jim Morrison and his band the Doors verbalized antiwar sentiment with the song "The End." Morrison's black leather pants, untamed hair, and obsession with mysticism made him one of the most sought after rock poets.

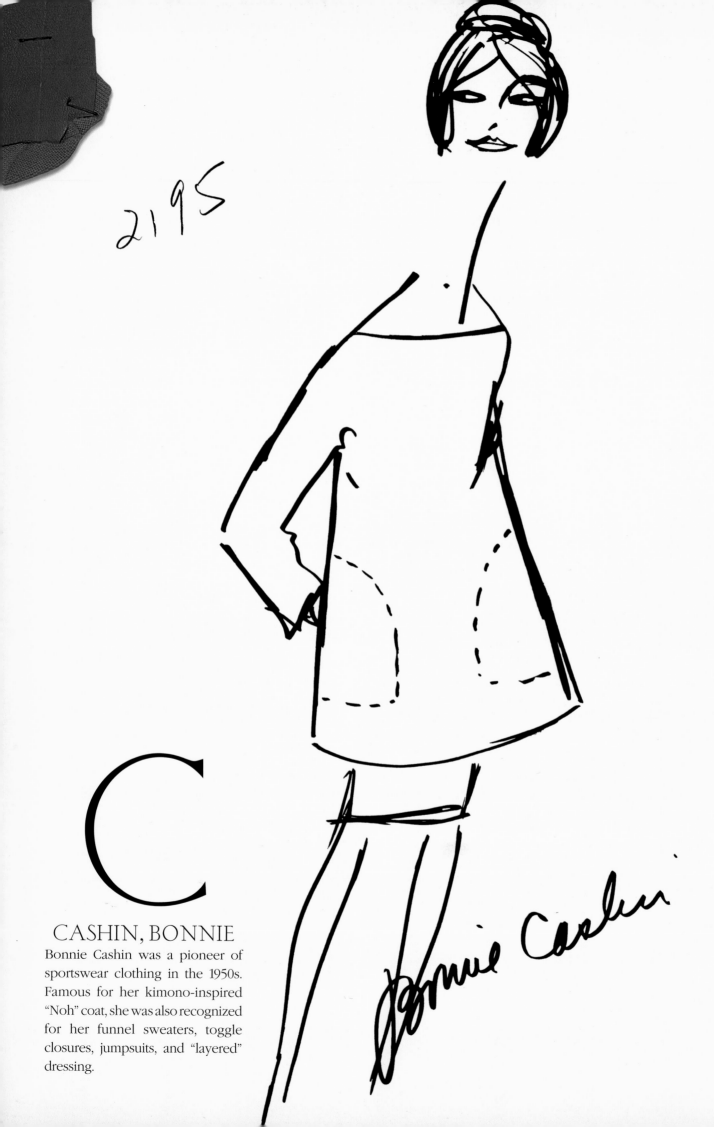

2195

CASHIN, BONNIE

Bonnie Cashin was a pioneer of sportswear clothing in the 1950s. Famous for her kimono-inspired "Noh" coat, she was also recognized for her funnel sweaters, toggle closures, jumpsuits, and "layered" dressing.

Bonnie Cashin

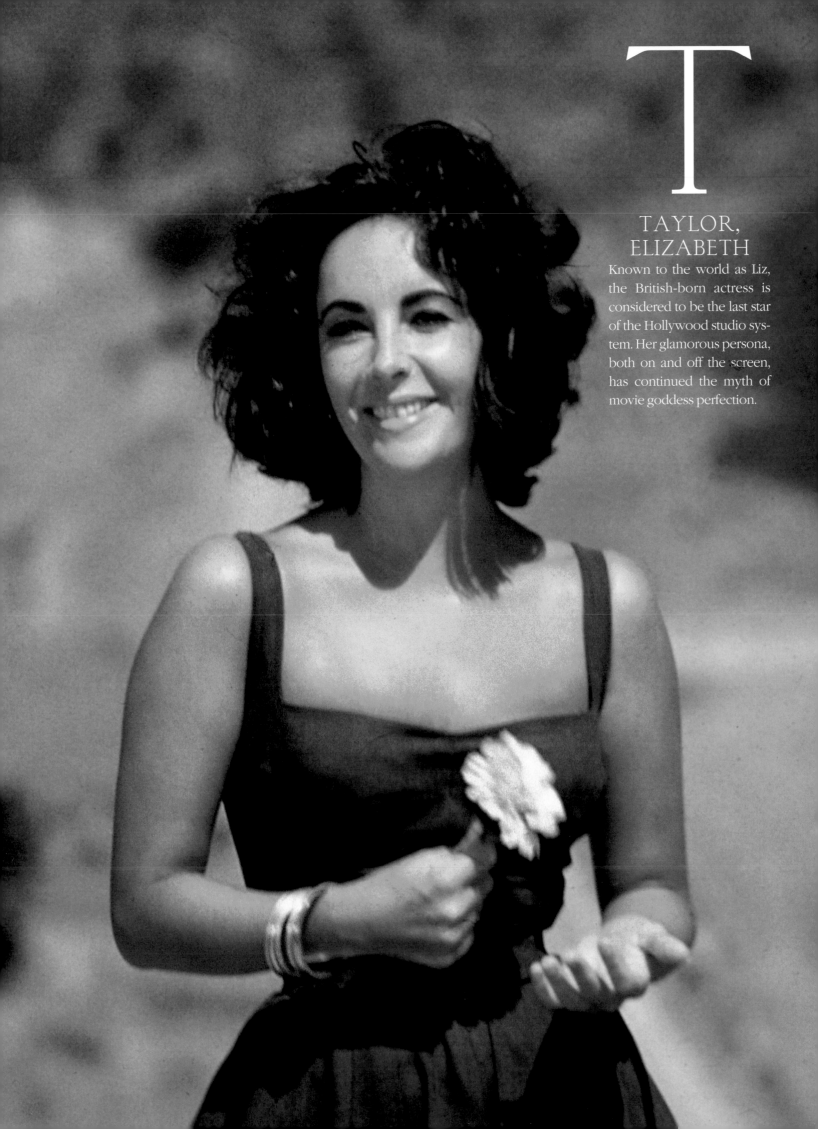

T

TAYLOR, ELIZABETH

Known to the world as Liz, the British-born actress is considered to be the last star of the Hollywood studio system. Her glamorous persona, both on and off the screen, has continued the myth of movie goddess perfection.

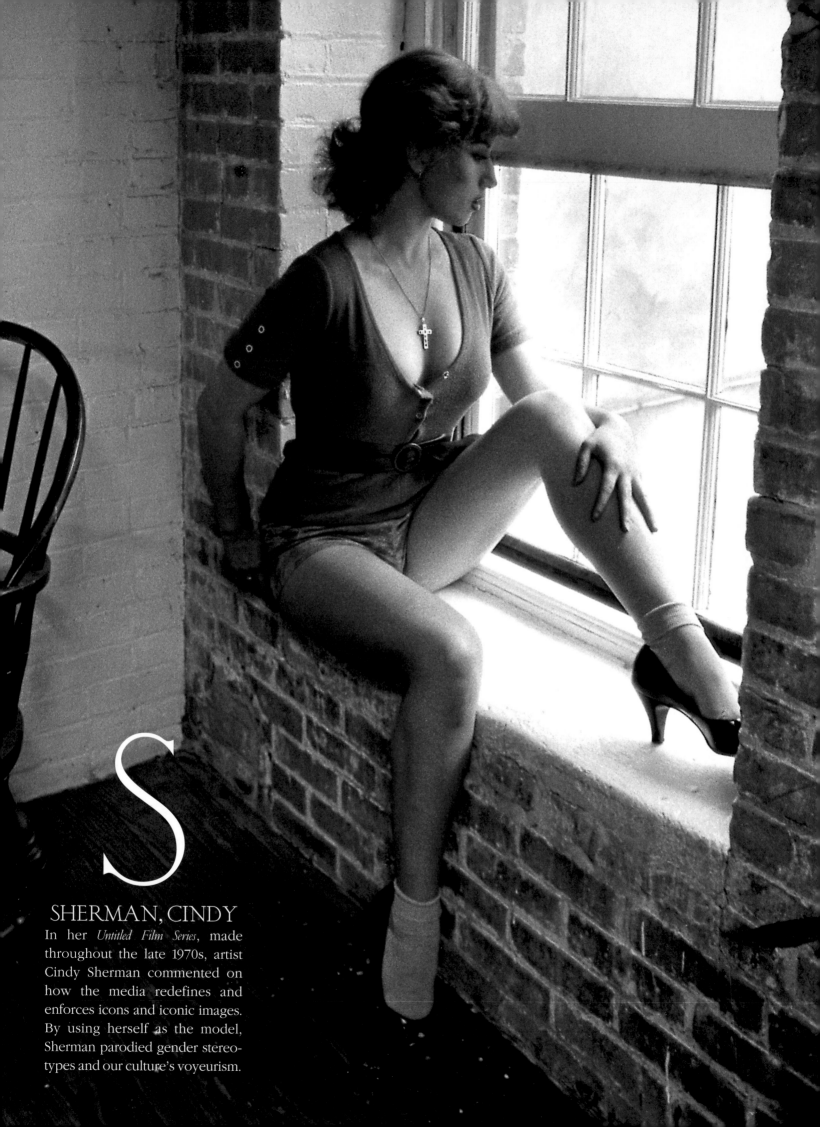

SHERMAN, CINDY

In her *Untitled Film Series*, made throughout the late 1970s, artist Cindy Sherman commented on how the media redefines and enforces icons and iconic images. By using herself as the model, Sherman parodied gender stereotypes and our culture's voyeurism.

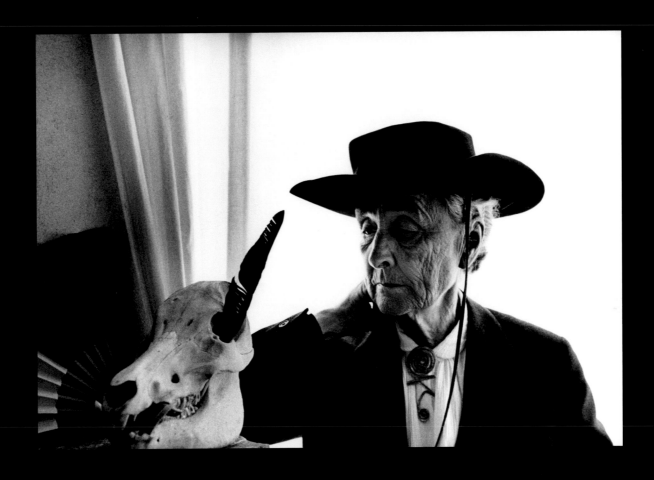

O'KEEFFE, GEORGIA

One of the leading avant-garde artists in the '20s and '30s. Georgia O'Keeffe's personal style—combining exotica with stark minimalism—reflected both her art and women's burgeoning independence.

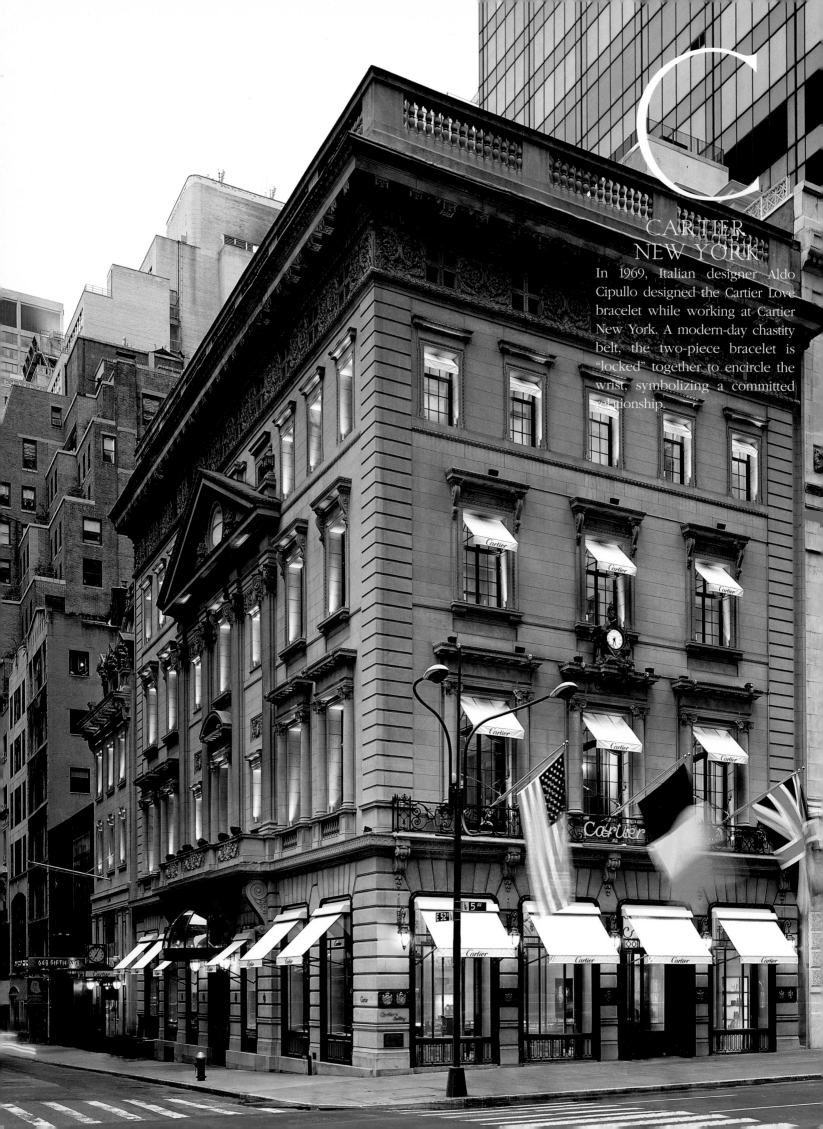

CARTIER
NEW YORK

In 1969, Italian designer Aldo Cipullo designed the Cartier Love bracelet while working at Cartier New York. A modern-day chastity belt, the two-piece bracelet is "locked" together to encircle the wrist, symbolizing a committed relationship.

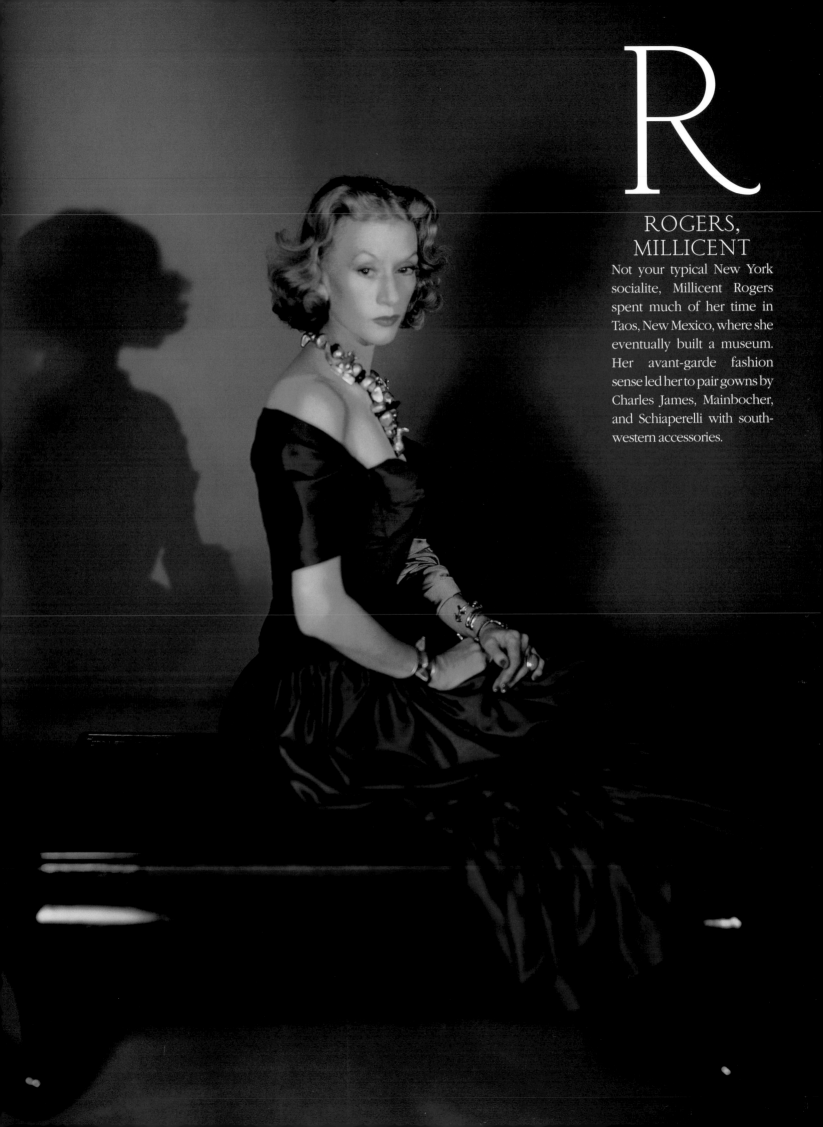

R

ROGERS, MILLICENT

Not your typical New York socialite, Millicent Rogers spent much of her time in Taos, New Mexico, where she eventually built a museum. Her avant-garde fashion sense led her to pair gowns by Charles James, Mainbocher, and Schiaperelli with south-western accessories.

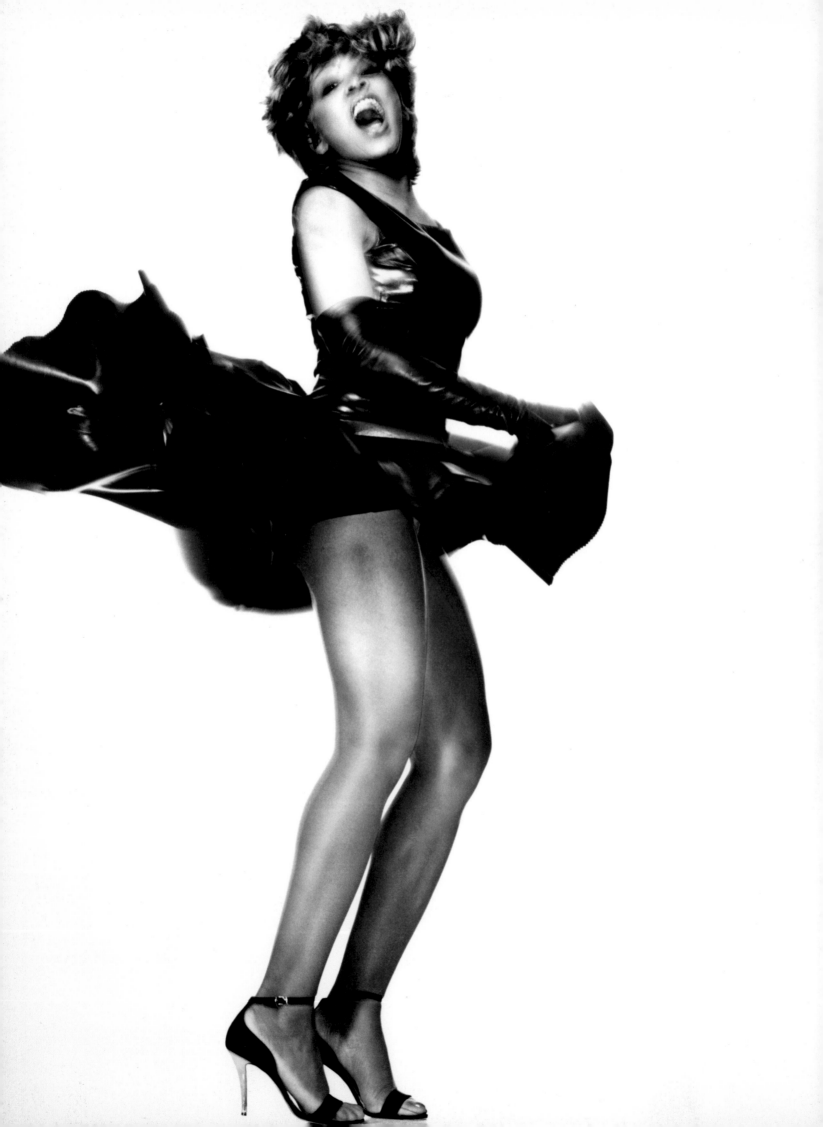

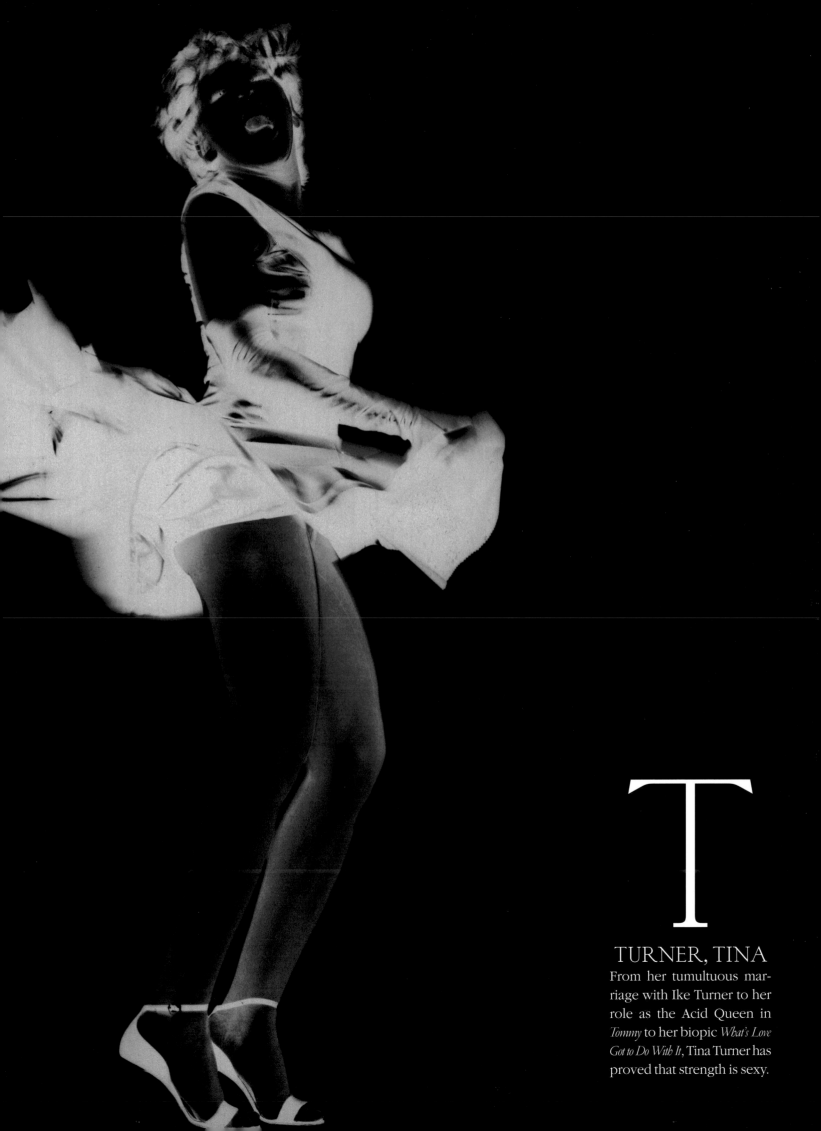

T

TURNER, TINA

From her tumultuous marriage with Ike Turner to her role as the Acid Queen in *Tommy* to her biopic *What's Love Got to Do With It*, Tina Turner has proved that strength is sexy.

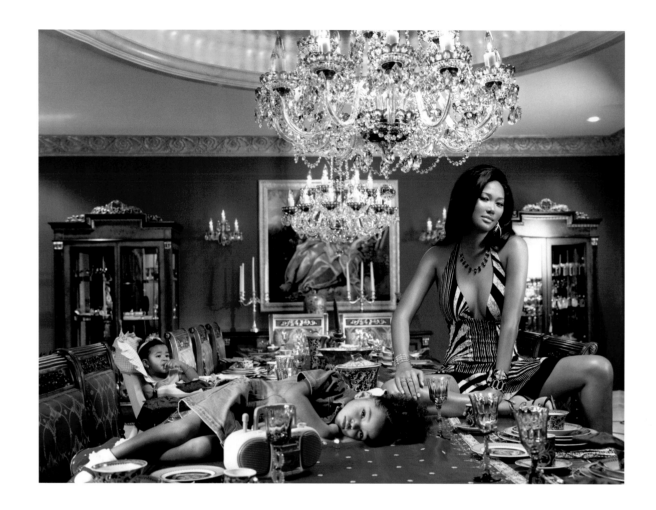

B

BABY PHAT

Launched by hip-hop entrepreneur Russell Simmons and headed by his wife, Kimora Lee Simmons, the clothing line Baby Phat (like its male counterpart, Phat Farm) has crossed over from an urban to a mainstream brand.

M

MAXWELL, VERA

In the 1930s, designer Vera Maxwell invented the "weekend wardrobe," consisting of two jackets, two skirts, and trousers made from durable wool. In 1971, Maxwell was the first to import Ultrasuede from Japan.

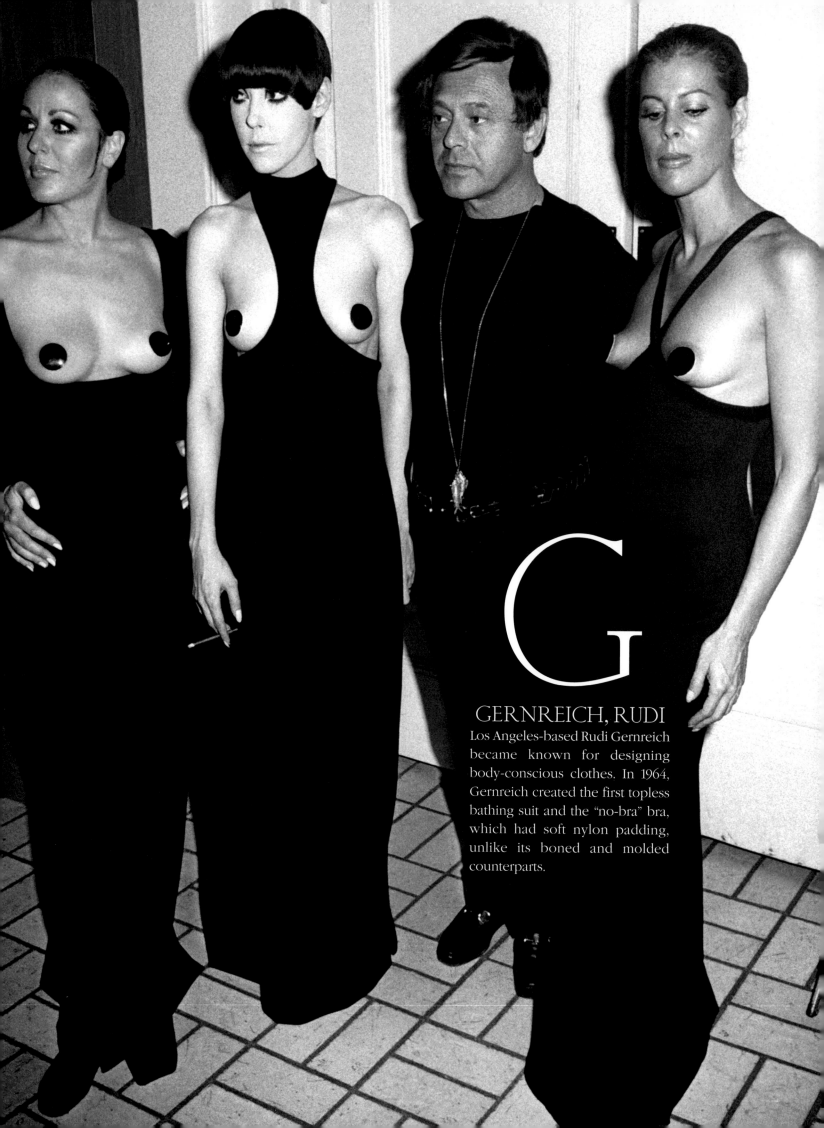

G

GERNREICH, RUDI

Los Angeles-based Rudi Gernreich became known for designing body-conscious clothes. In 1964, Gernreich created the first topless bathing suit and the "no-bra" bra, which had soft nylon padding, unlike its boned and molded counterparts.

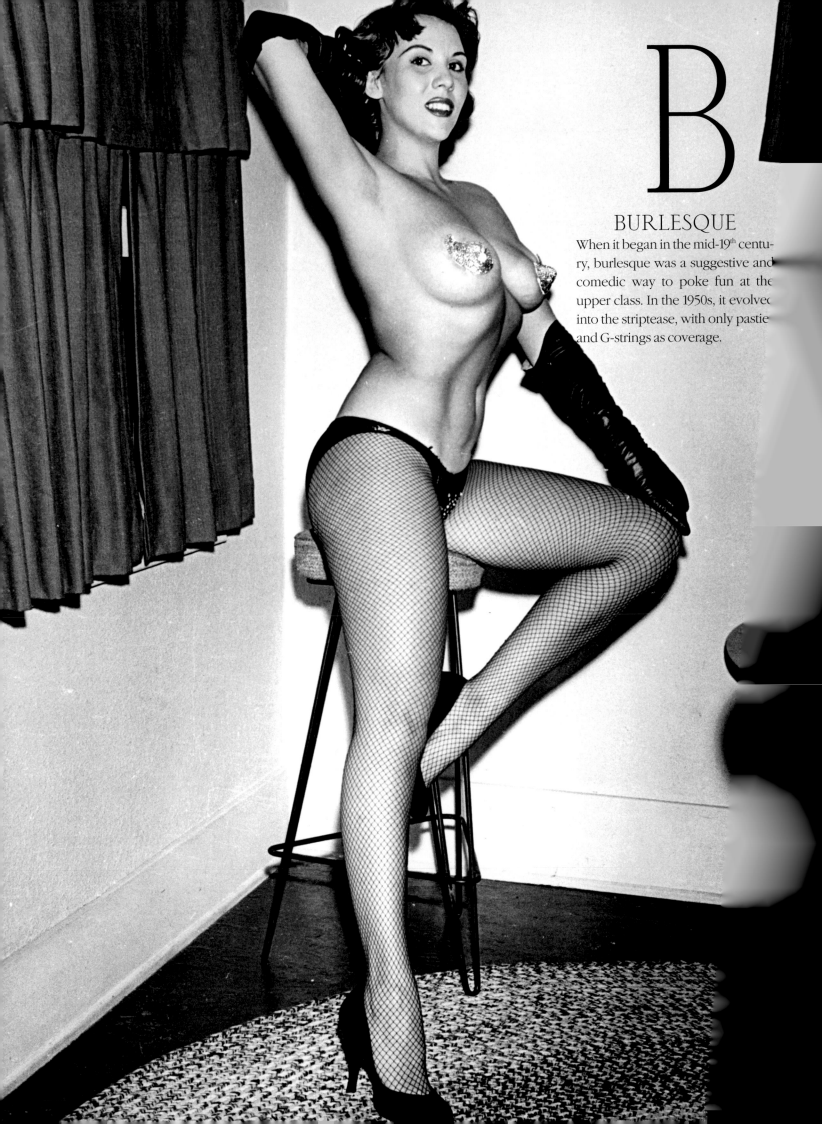

B

BURLESQUE

When it began in the mid-19th centu-
ry, burlesque was a suggestive and
comedic way to poke fun at the
upper class. In the 1950s, it evolved
into the striptease, with only pasties
and G-strings as coverage.

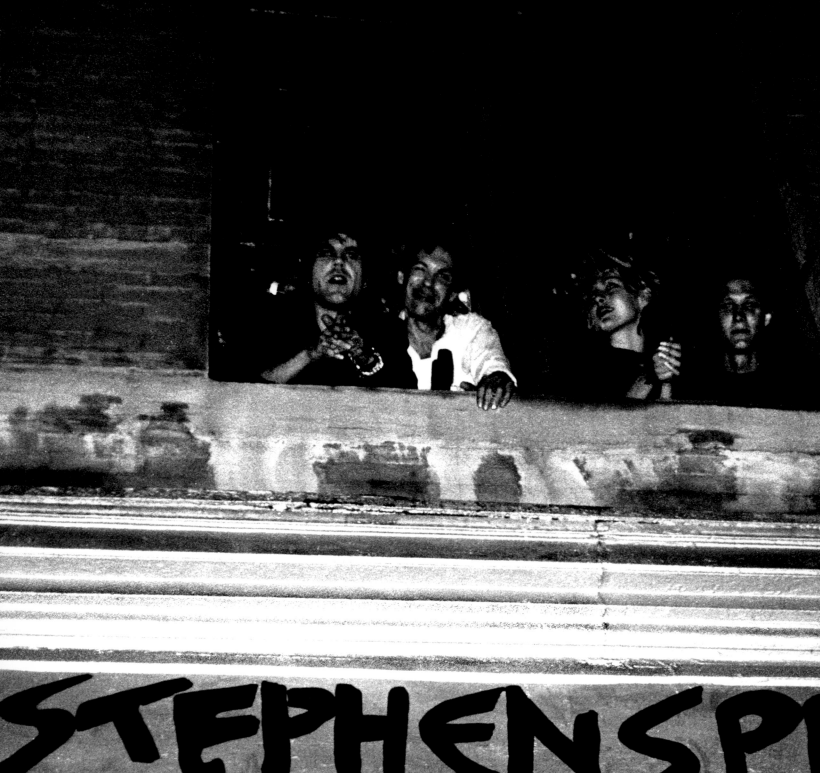

S
SPROUSE, STEPHEN

Ohio-born designer Stephen Sprouse started his career working for Halston and creating designs for Debbie Harry. But it was his Day-Glo colors, graffiti patterns, and punk style that made him appeal to the fashion world.

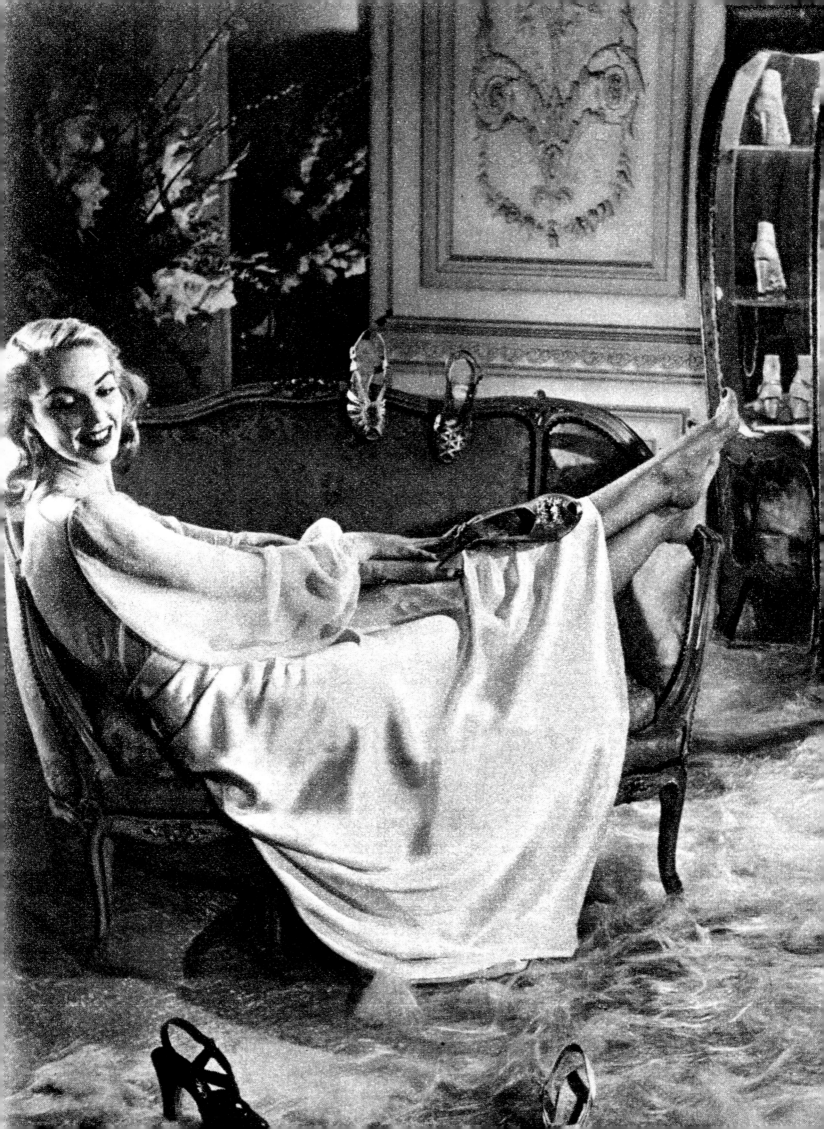

D

DELMAN

Established in 1919 by Herman Delman, Delman had close partnerships with Bergdorf Goodman and shoe designer Roger Vivier for Christian Dior. In the 1950s, the 5th Avenue shoe store saw such patrons as Marilyn Monroe, Marlene Dietrich, and Jackie Kennedy.

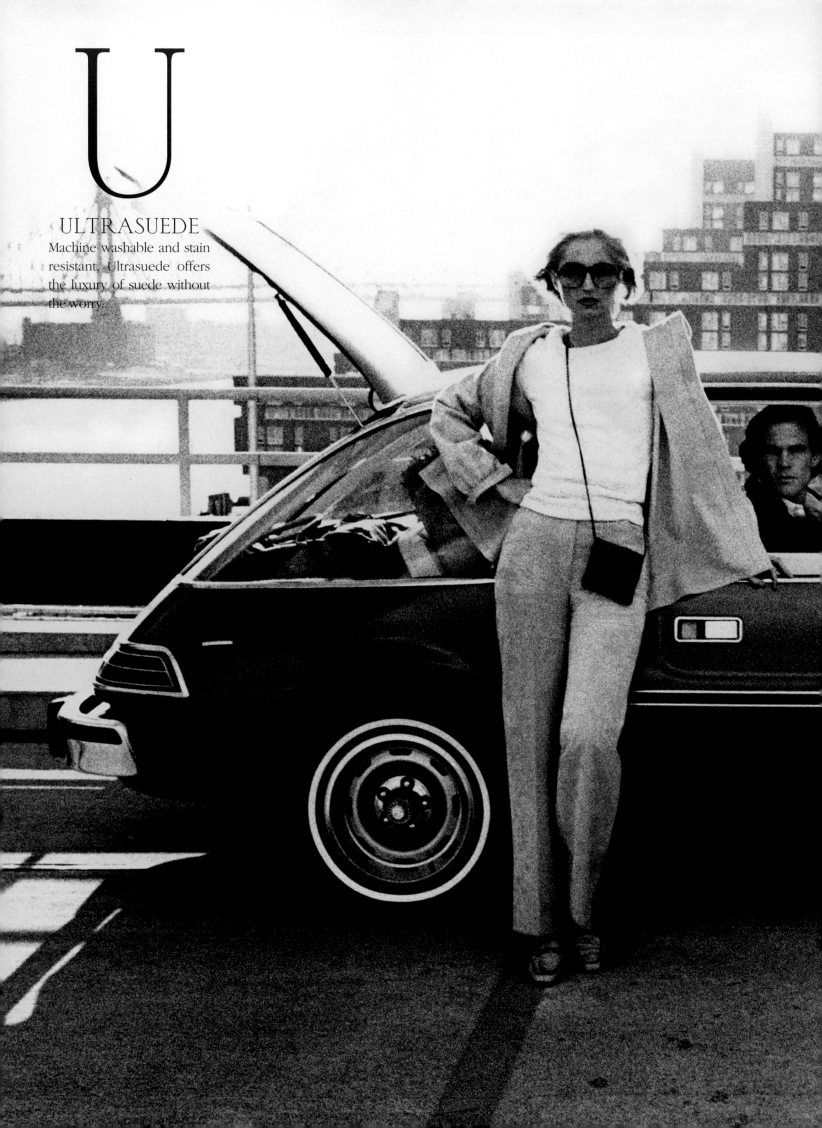

U

ULTRASUEDE

Machine washable and stain
resistant, Ultrasuede offers
the luxury of suede without
the worry.

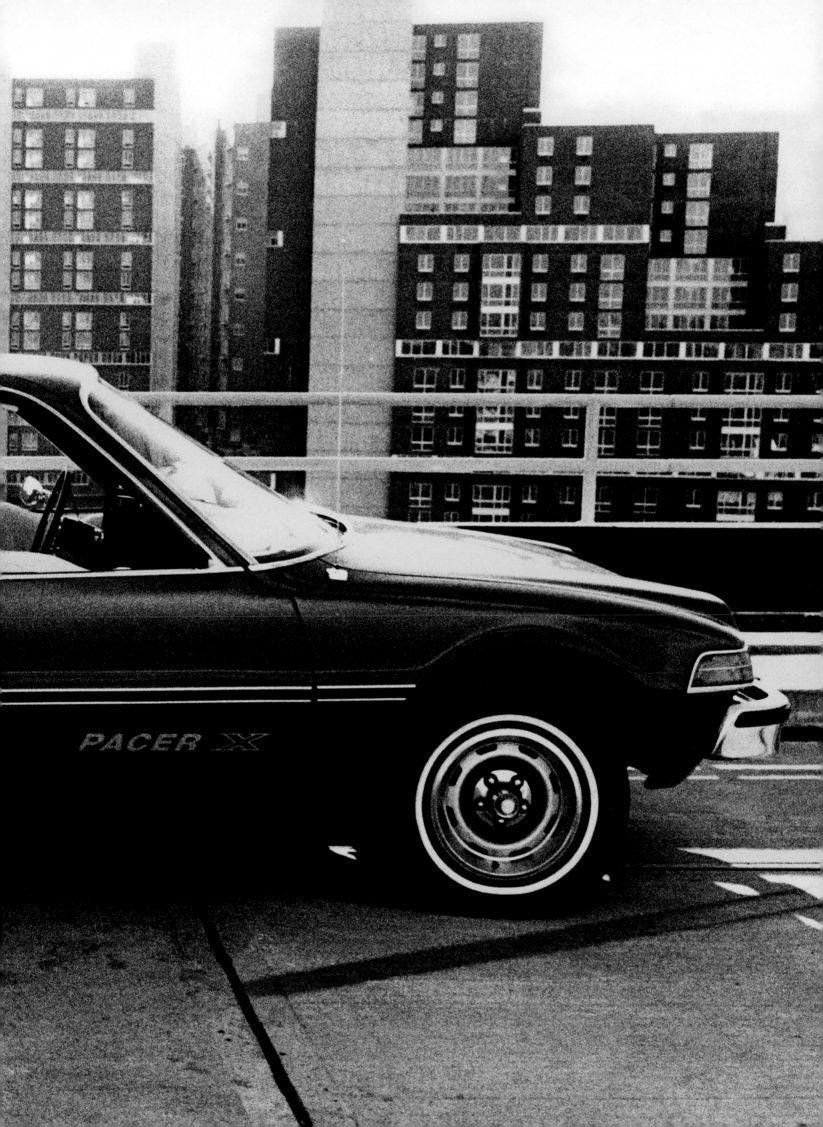

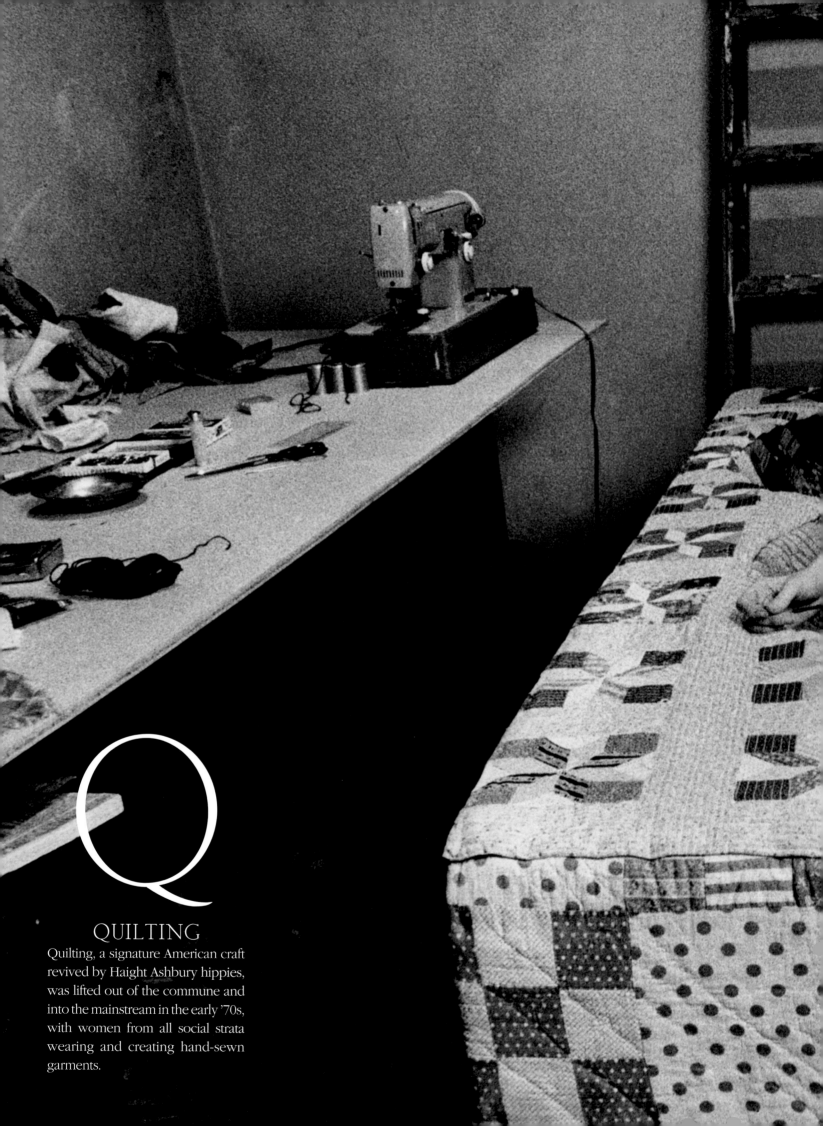

Q

QUILTING

Quilting, a signature American craft revived by Haight Ashbury hippies, was lifted out of the commune and into the mainstream in the early '70s, with women from all social strata wearing and creating hand-sewn garments.

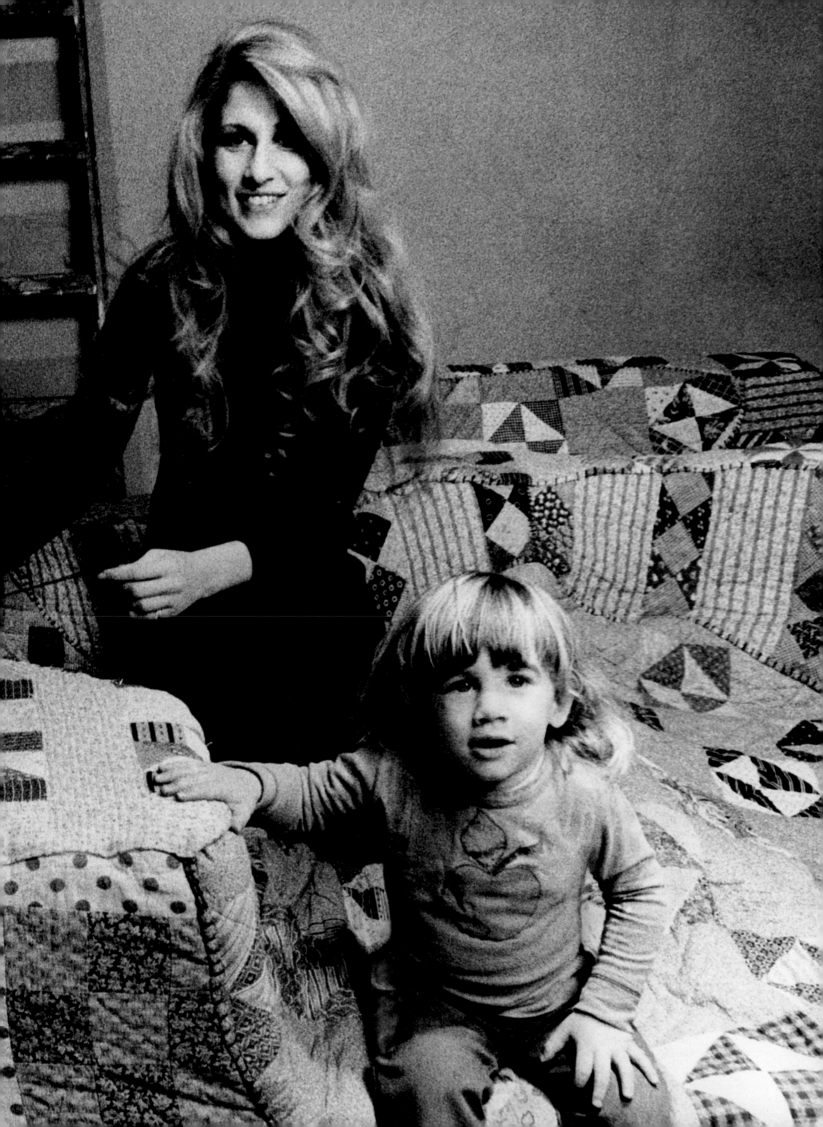

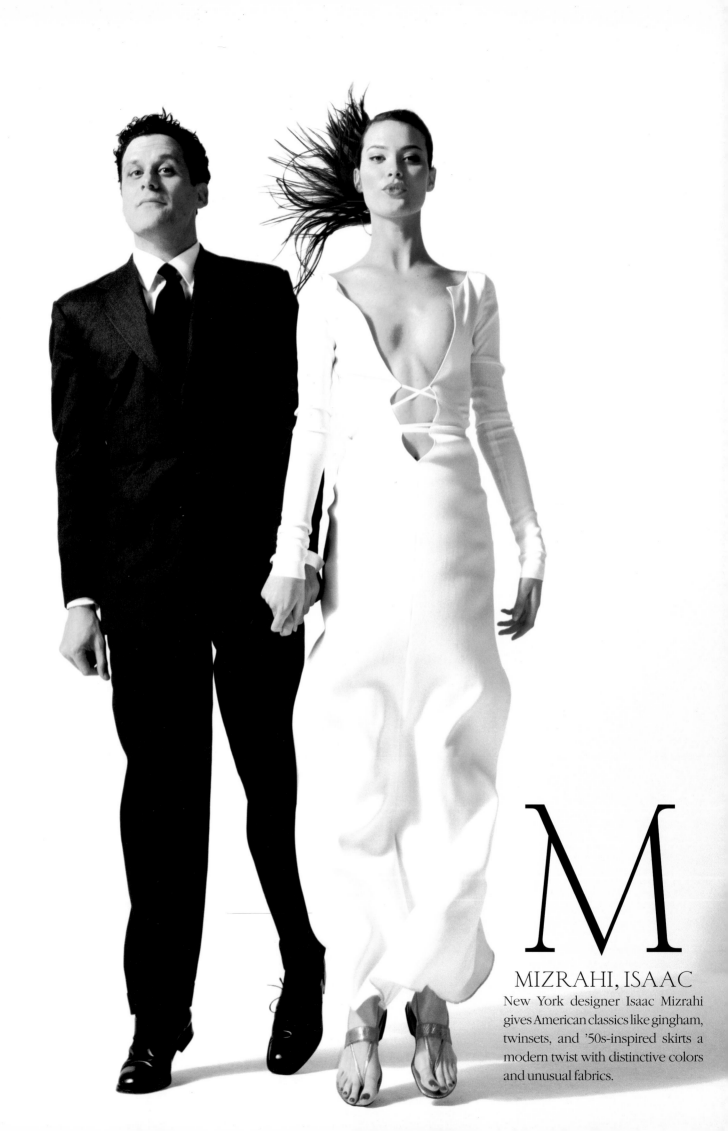

M

MIZRAHI, ISAAC

New York designer Isaac Mizrahi gives American classics like gingham, twinsets, and '50s-inspired skirts a modern twist with distinctive colors and unusual fabrics.

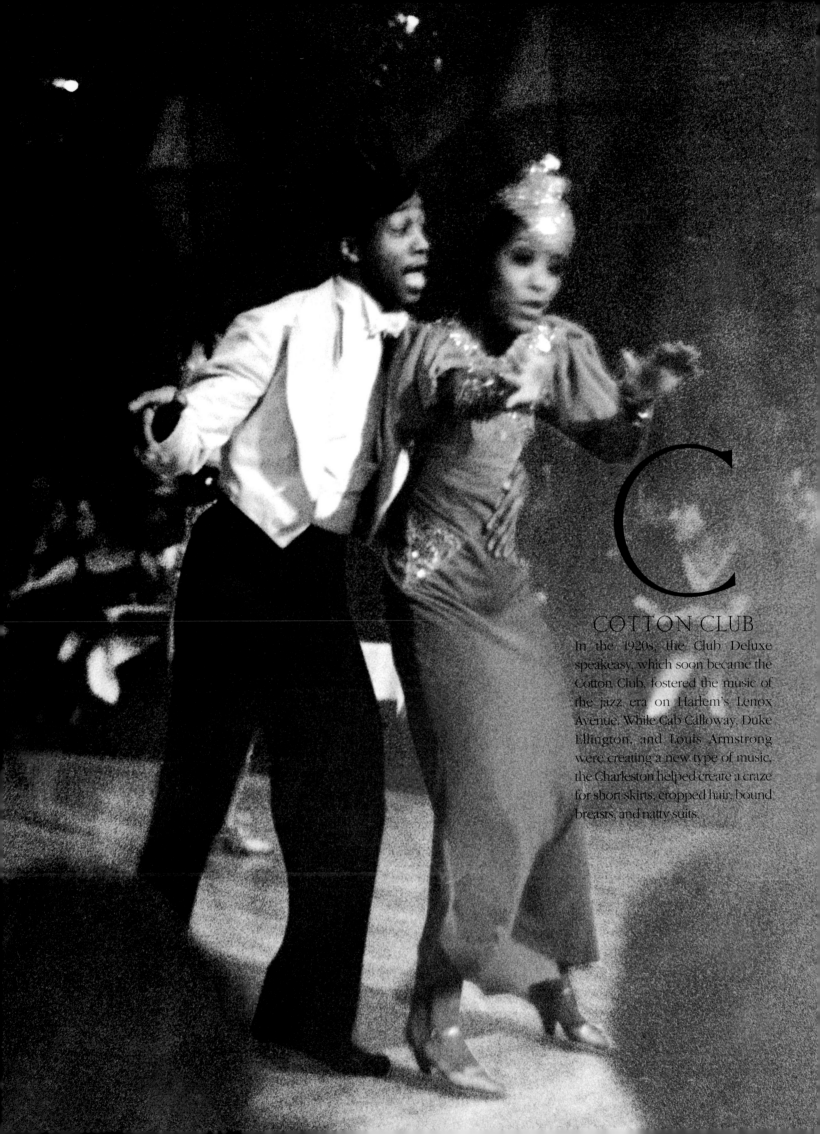

COTTON CLUB

In the 1920s, the Club Deluxe speakeasy, which soon became the Cotton Club, fostered the music of the jazz era on Harlem's Lenox Avenue. While Cab Calloway, Duke Ellington, and Louis Armstrong were creating a new type of music, the Charleston helped create a craze for short skirts, cropped hair, bound breasts, and natty suits.

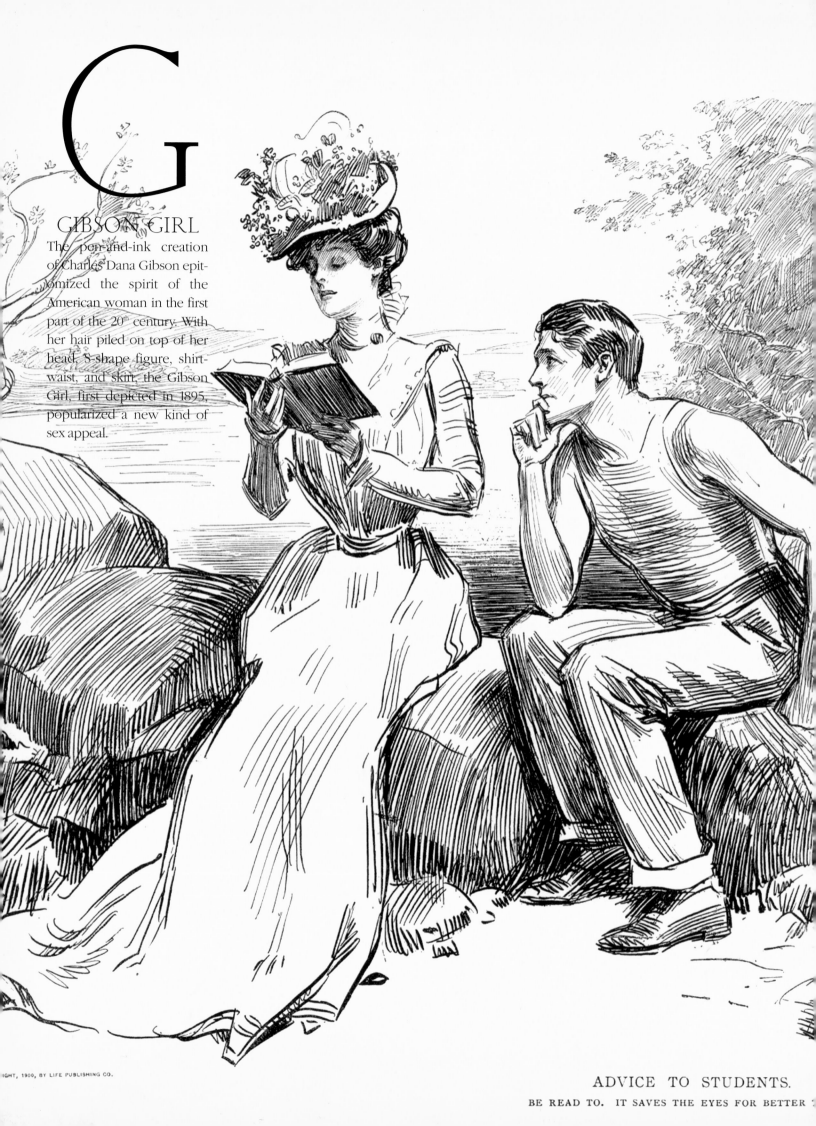

G

GIBSON GIRL

The pen-and-ink creation of Charles Dana Gibson epitomized the spirit of the American woman in the first part of the 20th century. With her hair piled on top of her head, S-shape figure, shirtwaist, and skirt, the Gibson Girl, first depicted in 1895, popularized a new kind of sex appeal.

ADVICE TO STUDENTS.

BE READ TO. IT SAVES THE EYES FOR BETTER

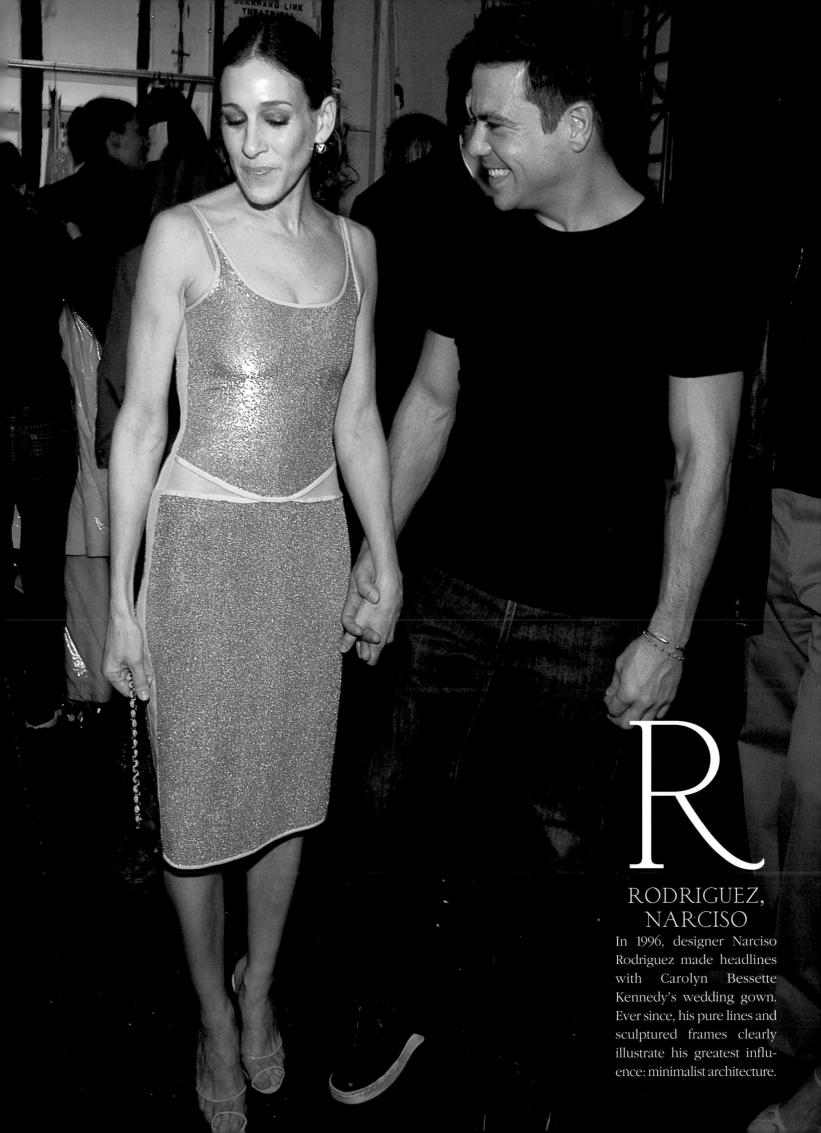

R

RODRIGUEZ, NARCISO

In 1996, designer Narciso Rodriguez made headlines with Carolyn Bessette Kennedy's wedding gown. Ever since, his pure lines and sculptured frames clearly illustrate his greatest influence: minimalist architecture.

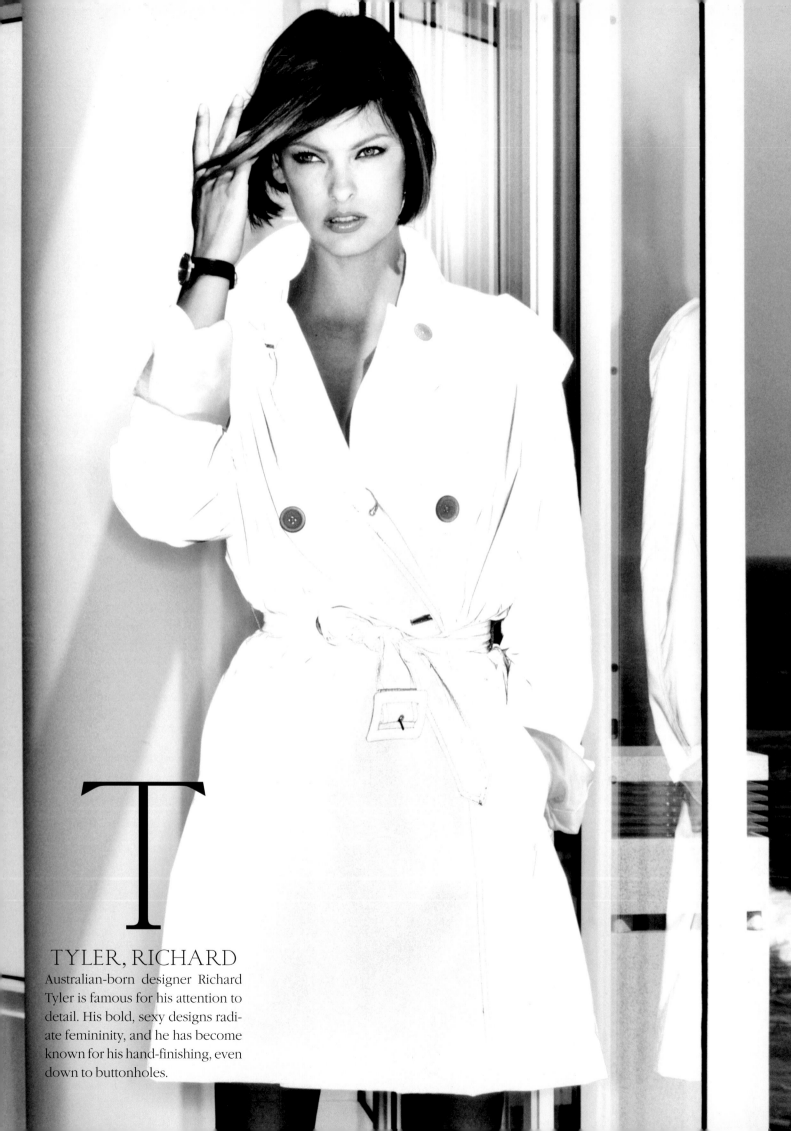

T

TYLER, RICHARD

Australian-born designer Richard Tyler is famous for his attention to detail. His bold, sexy designs radiate femininity, and he has become known for his hand-finishing, even down to buttonholes.

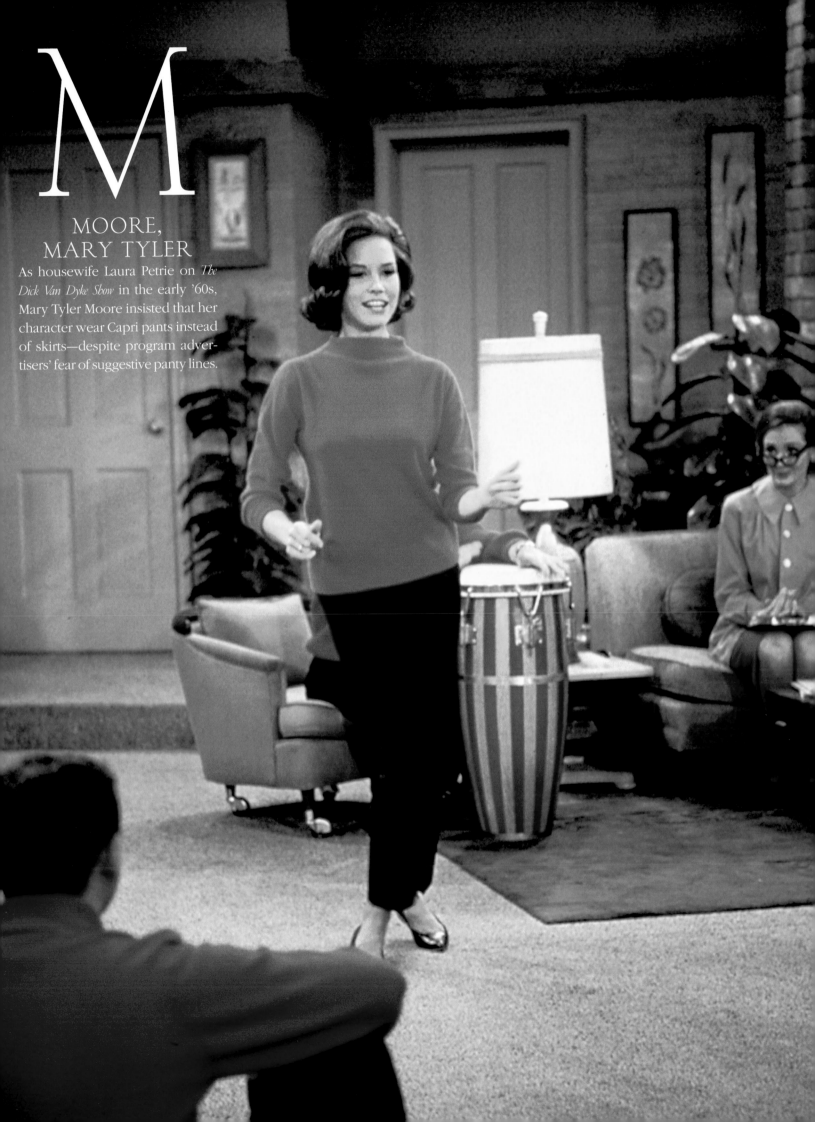

M
MOORE, MARY TYLER

As housewife Laura Petrie on *The Dick Van Dyke Show* in the early '60s, Mary Tyler Moore insisted that her character wear Capri pants instead of skirts—despite program advertisers' fear of suggestive panty lines.

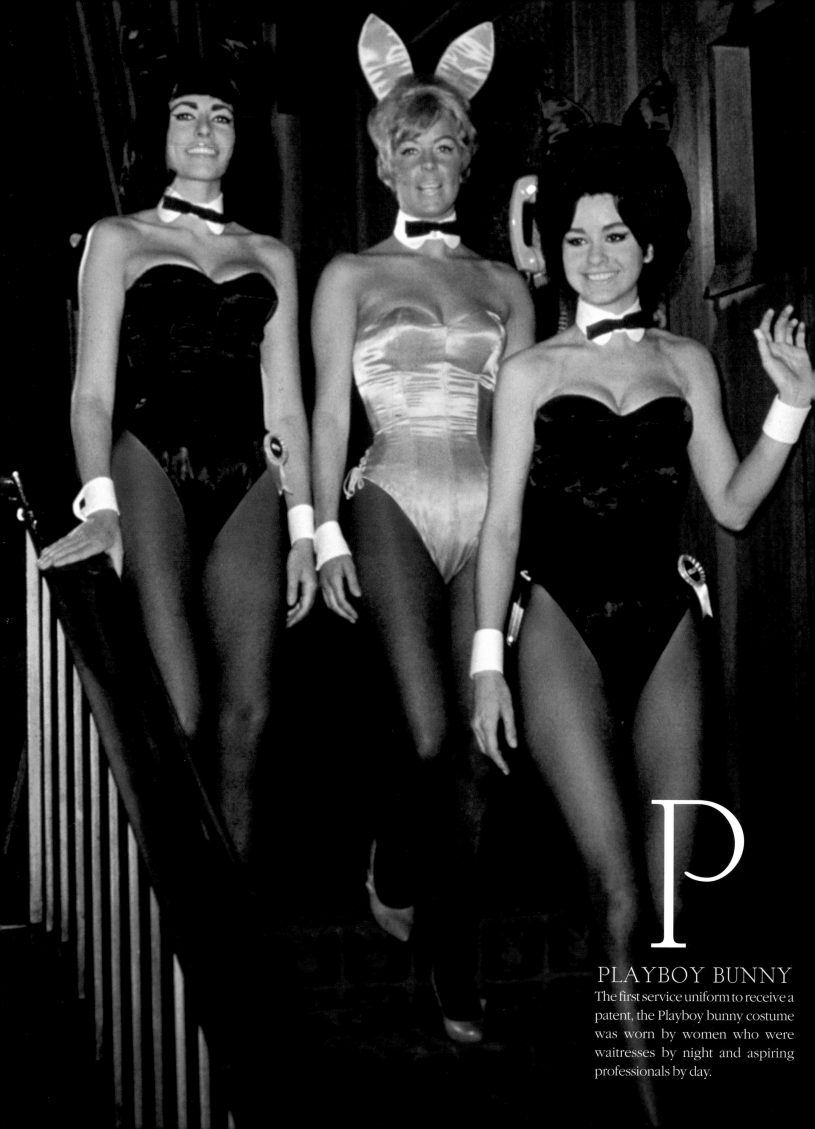

P

PLAYBOY BUNNY

The first service uniform to receive a patent, the Playboy bunny costume was worn by women who were waitresses by night and aspiring professionals by day.

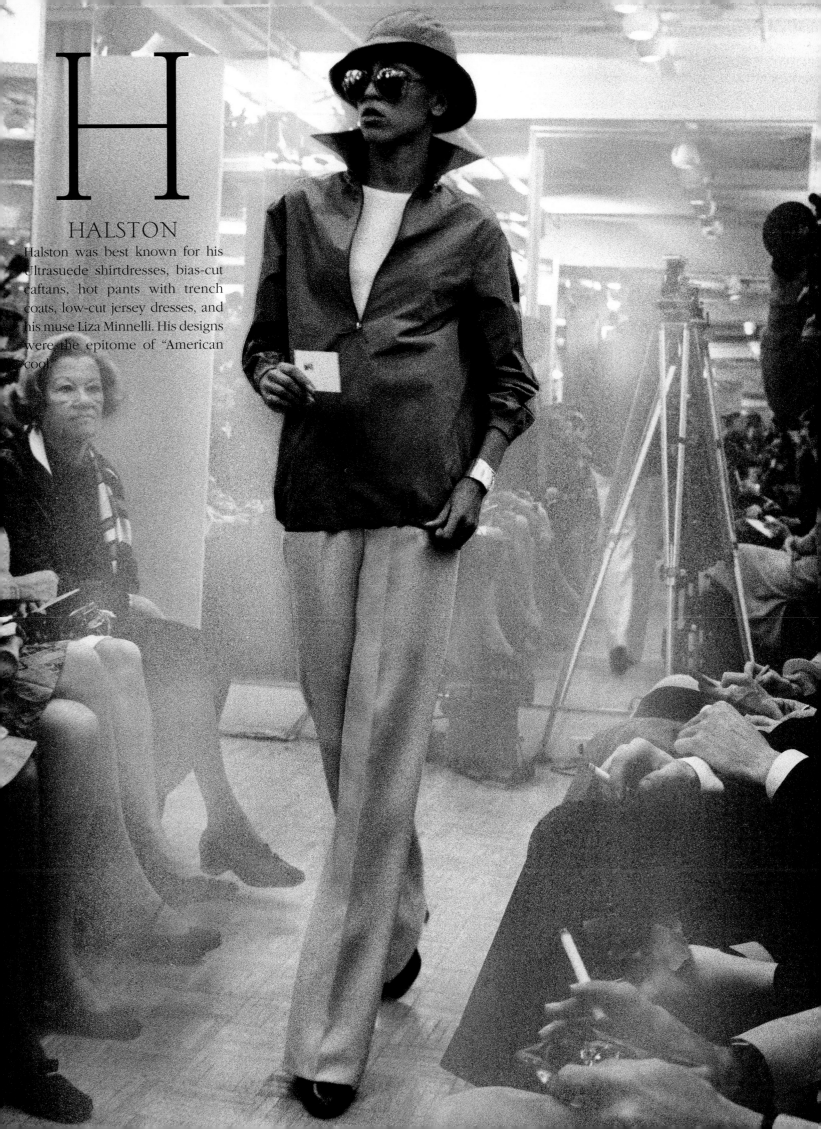

H
HALSTON

Halston was best known for his Ultrasuede shirtdresses, bias-cut caftans, hot pants with trench coats, low-cut jersey dresses, and his muse Liza Minnelli. His designs were the epitome of "American cool."

R

RED RIBBON

First used to encourage awareness and support for those afflicted with AIDS, ribbons have since inspired other groups to use ribbons of different colors for their own causes, such as the pink ribbon for breast cancer awareness.

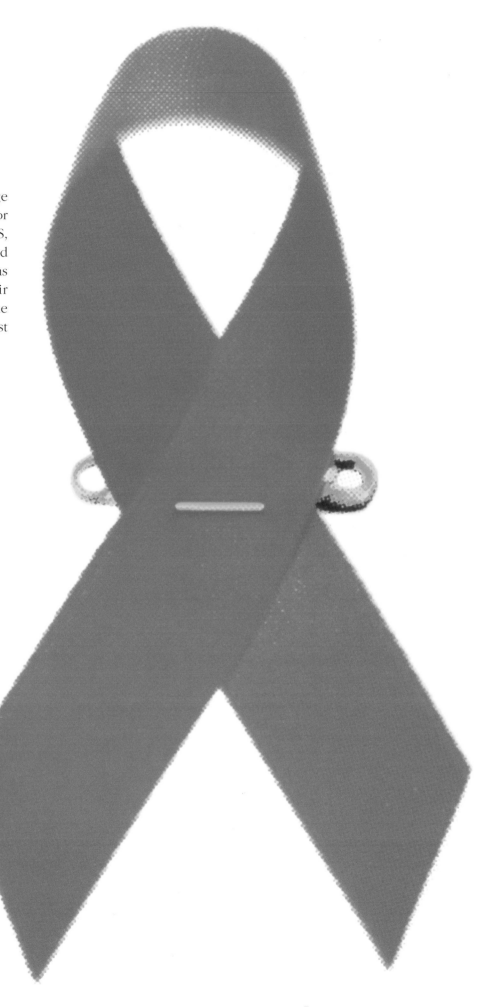

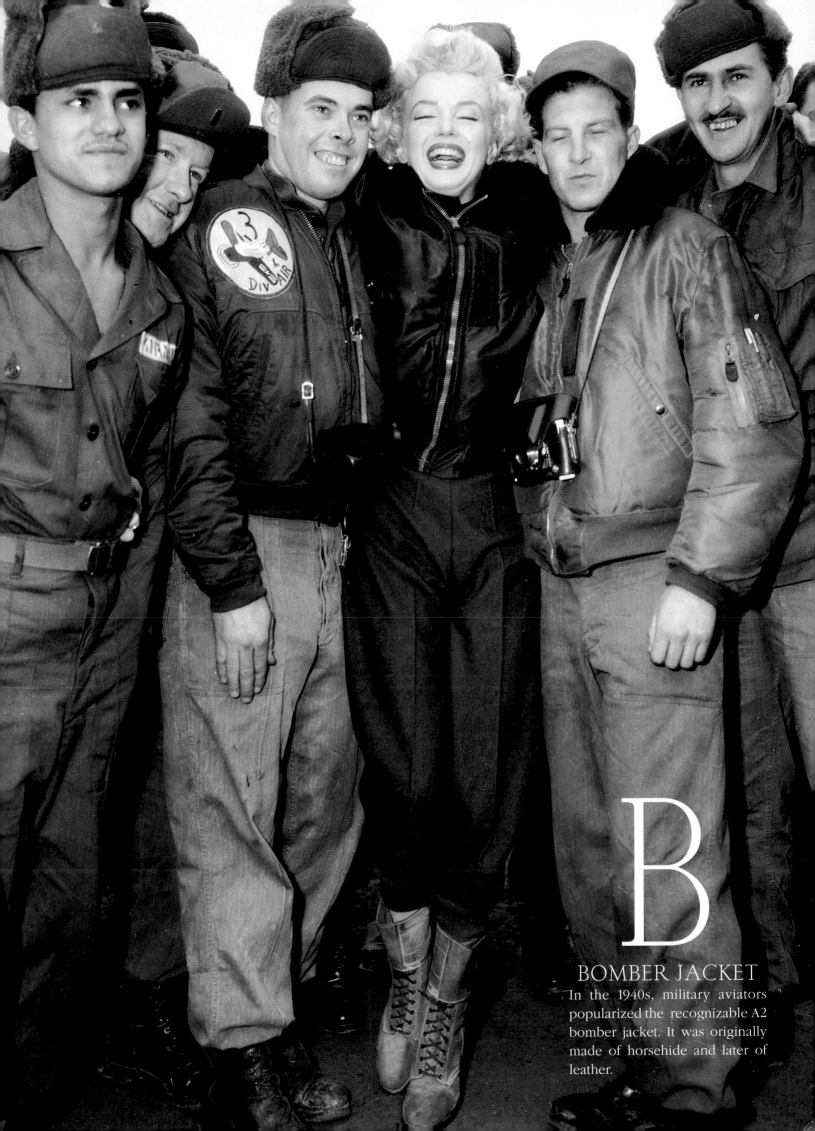

B

BOMBER JACKET

In the 1940s, military aviators popularized the recognizable A2 bomber jacket. It was originally made of horsehide and later of leather.

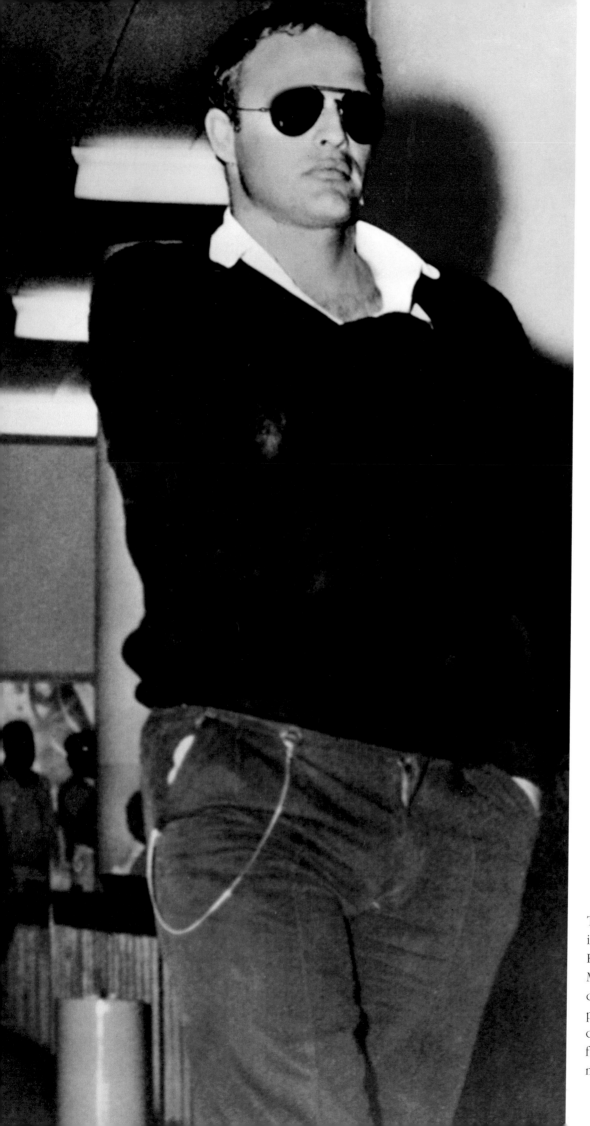

B

BRANDO, MARLON

The minute he walked onstage in 1947 as the brooding Stanley Kowalski in *A Streetcar Named Desire*, Marlon Brando not only forever changed the way actors would perform, but also created the non-conformist uniform in the 1953 film *The Wild One*: white T-shirt, motorcycle jacket, and blue jeans.

"Light a Lucky and you'll never miss sweets that make you fat"

Constance Talmadge

Constance Talmadge,
Charming Motion
Picture Star

INSTEAD of eating between meals . . . instead of fattening sweets . . . beautiful women keep youthful slenderness these days by smoking Luckies. The smartest and loveliest women of *the* modern stage take this means of keeping slender . . . when others nibble fattening sweets, they light a Lucky!

Lucky Strike is a delightful blend of the world's finest tobaccos. These tobaccos are toasted—a costly extra process which develops and improves the flavor. That's why Luckies are a delightful alternative for fattening sweets. That's why there's real health in Lucky Strike. That's why folks say: "It's good to smoke Luckies."

For years this has been no secret to those men who keep fit and trim. They know that Luckies steady their nerves and do not harm their physical condition. They know that Lucky Strike is the favorite cigarette of many prominent athletes, who must keep in good shape. They respect the opinions of 20,679 physicians who maintain that Luckies are less irritating to the throat than other cigarettes.

A reasonable proportion of sugar in the diet is recommended, but the authorities are overwhelming that too many fattening sweets are harmful and that too many such are eaten by the American people. So, for moderation's sake we say:—

"REACH FOR A LUCKY
INSTEAD OF A SWEET."

Constance Talmadge,
Charming Motion
Picture Star

"It's toasted"

No Throat Irritation-No Cough.

© 1929, The American Tobacco Co., Manufacturers

Coast to coast radio hook-up every Saturday night through the National Broadcasting Company's network. The Lucky Strike Dance Orchestra in "The Tunes that made Broadway, Broadway."

LUCKY STRIKE "IT'S TOASTED" CIGARETTES

Reach for a Lucky instead of a sweet.

C

CIGARETTES

In the late 19th century, America's first cigarette company opened its doors. Ever since, cigarettes have marked moments of liberation:

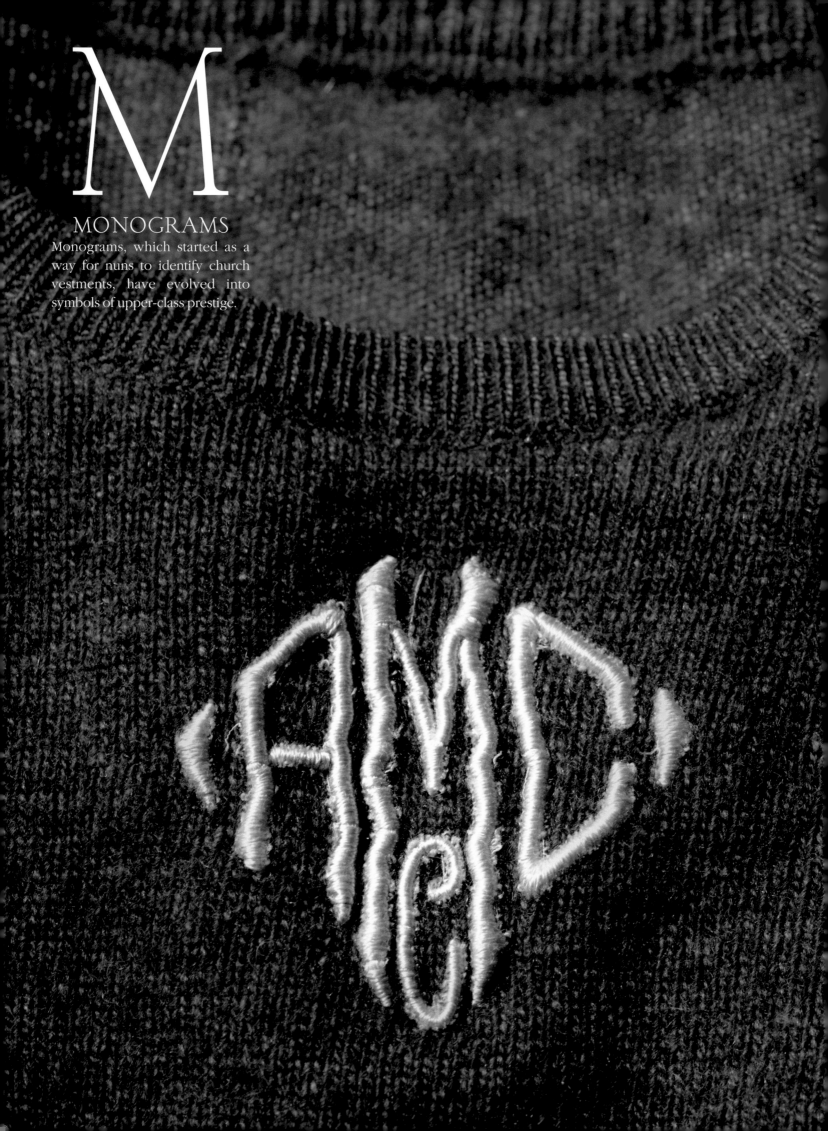

M

MONOGRAMS

Monograms, which started as a way for nuns to identify church vestments, have evolved into symbols of upper-class prestige.

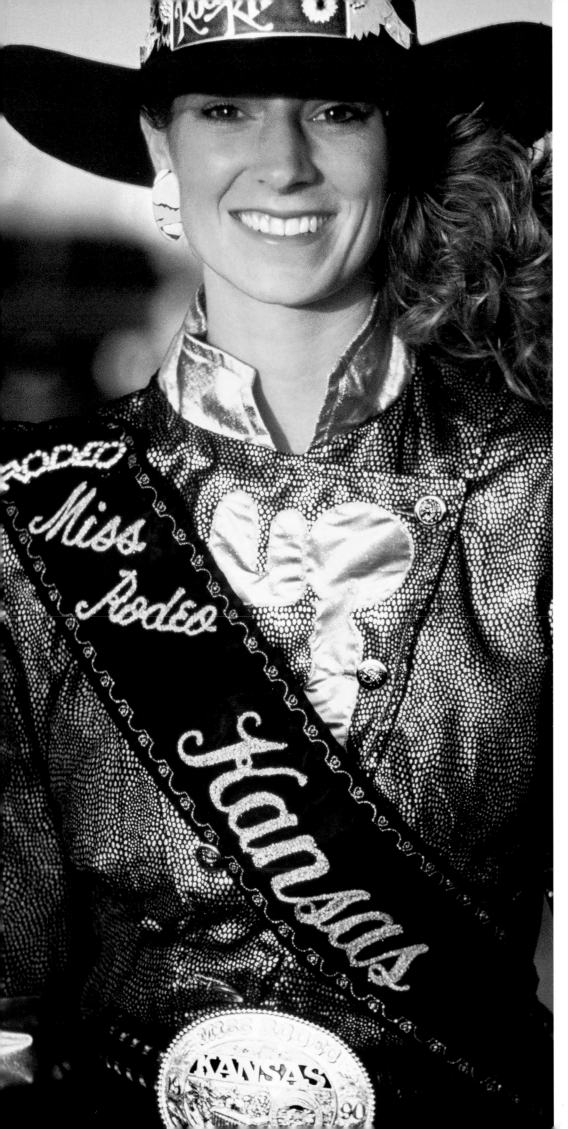

R

RODEO

Born in the early 20th century, the rodeo soon became more than just a cowboy showing off his riding skills. America's most beloved cowboy, Will Rogers, with his wide-brimmed hats, high-heeled boots, and flashy Western wear, conveyed the glamour of the Wild West.

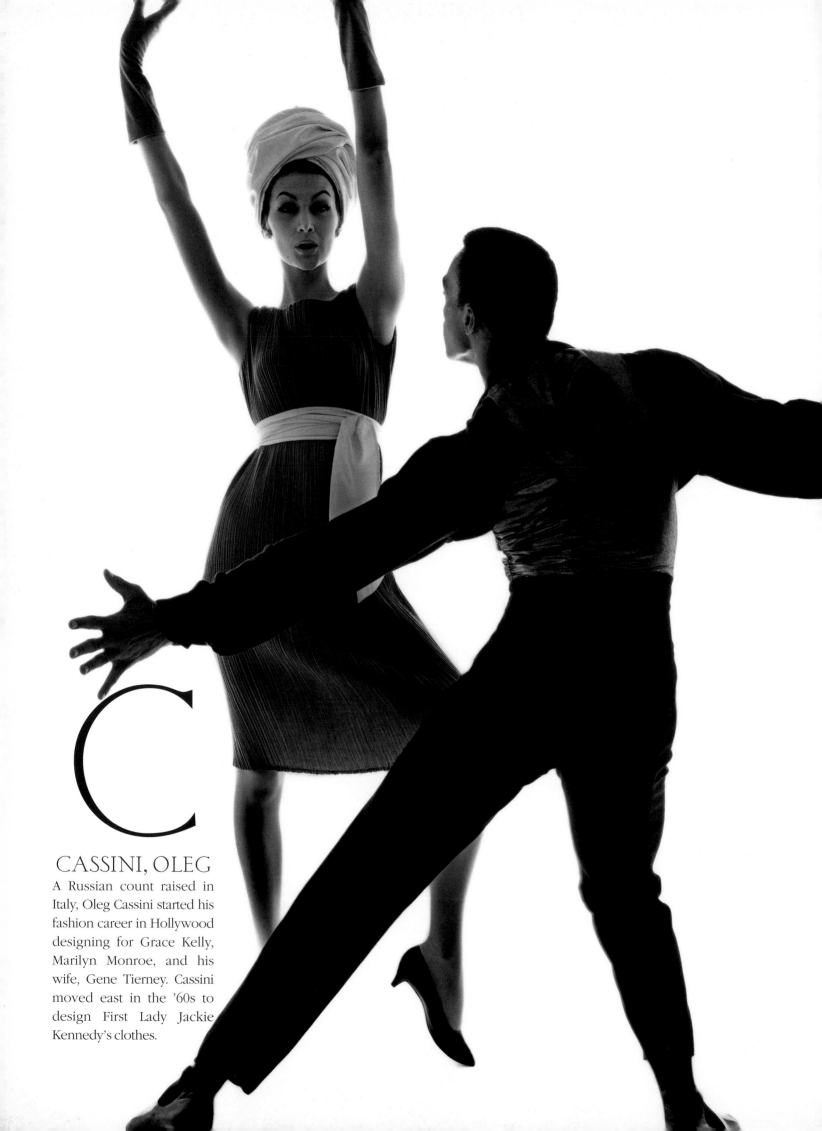

CASSINI, OLEG

A Russian count raised in Italy, Oleg Cassini started his fashion career in Hollywood designing for Grace Kelly, Marilyn Monroe, and his wife, Gene Tierney. Cassini moved east in the '60s to design First Lady Jackie Kennedy's clothes.

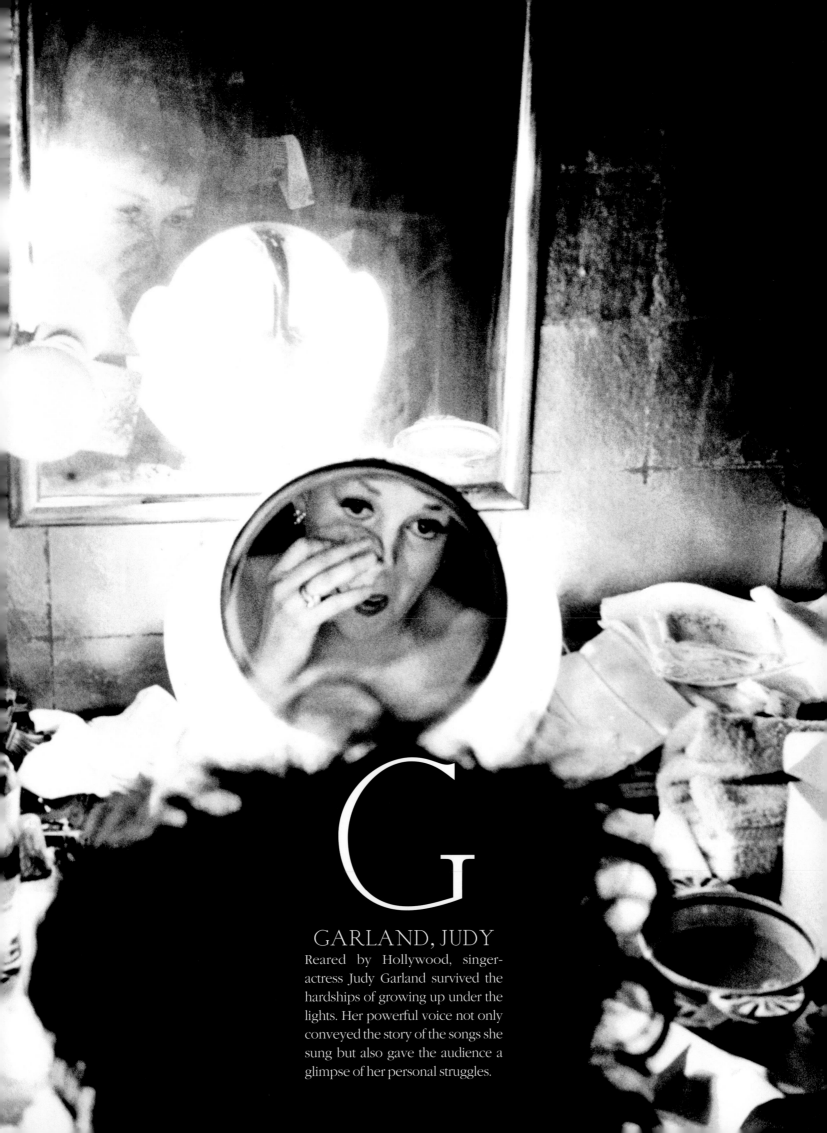

G

GARLAND, JUDY

Reared by Hollywood, singer-actress Judy Garland survived the hardships of growing up under the lights. Her powerful voice not only conveyed the story of the songs she sung but also gave the audience a glimpse of her personal struggles.

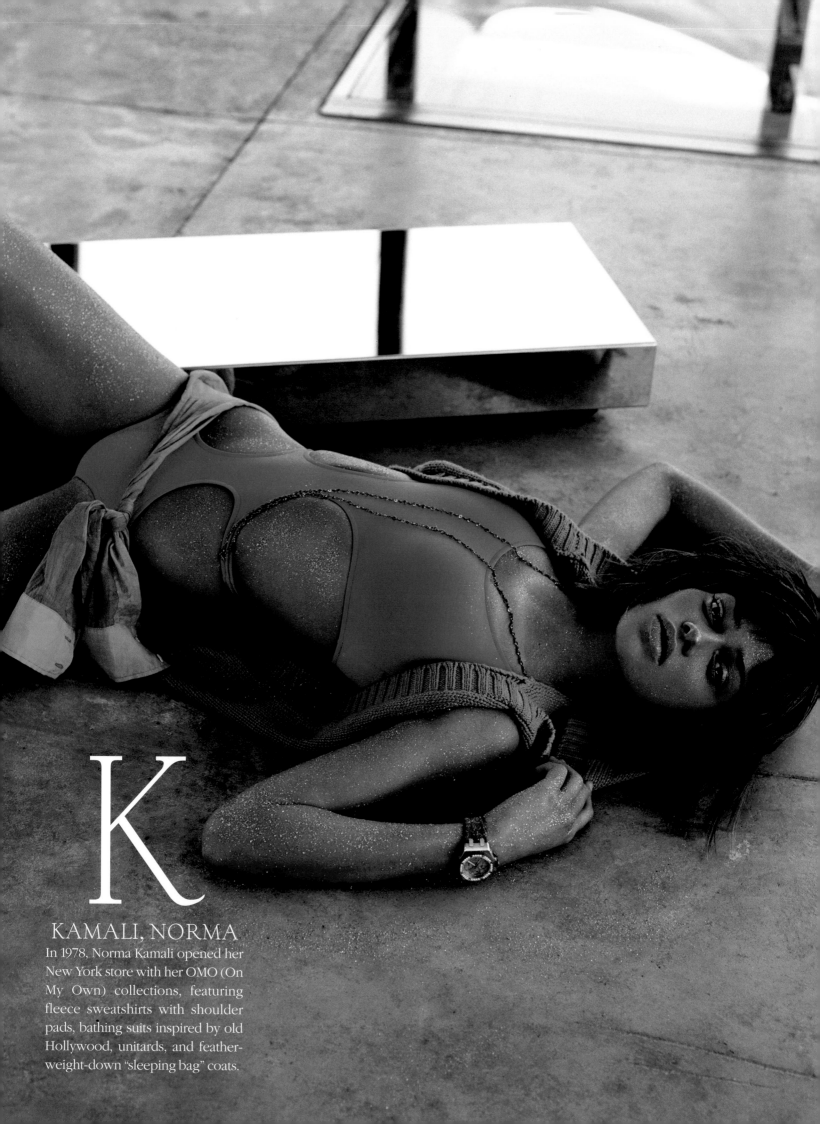

K

KAMALI, NORMA

In 1978, Norma Kamali opened her New York store with her OMO (On My Own) collections, featuring fleece sweatshirts with shoulder pads, bathing suits inspired by old Hollywood, unitards, and feather-weight-down "sleeping bag" coats.

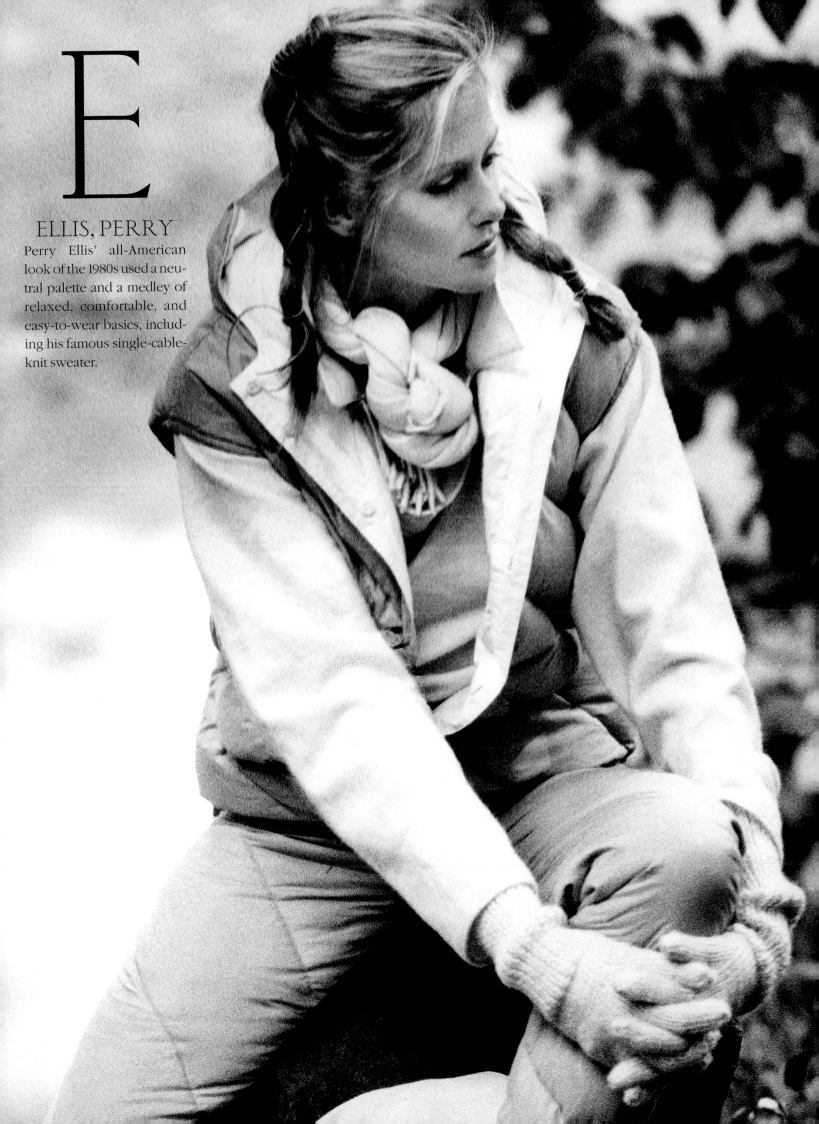

E

ELLIS, PERRY

Perry Ellis' all-American look of the 1980s used a neutral palette and a medley of relaxed, comfortable, and easy-to-wear basics, including his famous single-cable-knit sweater.

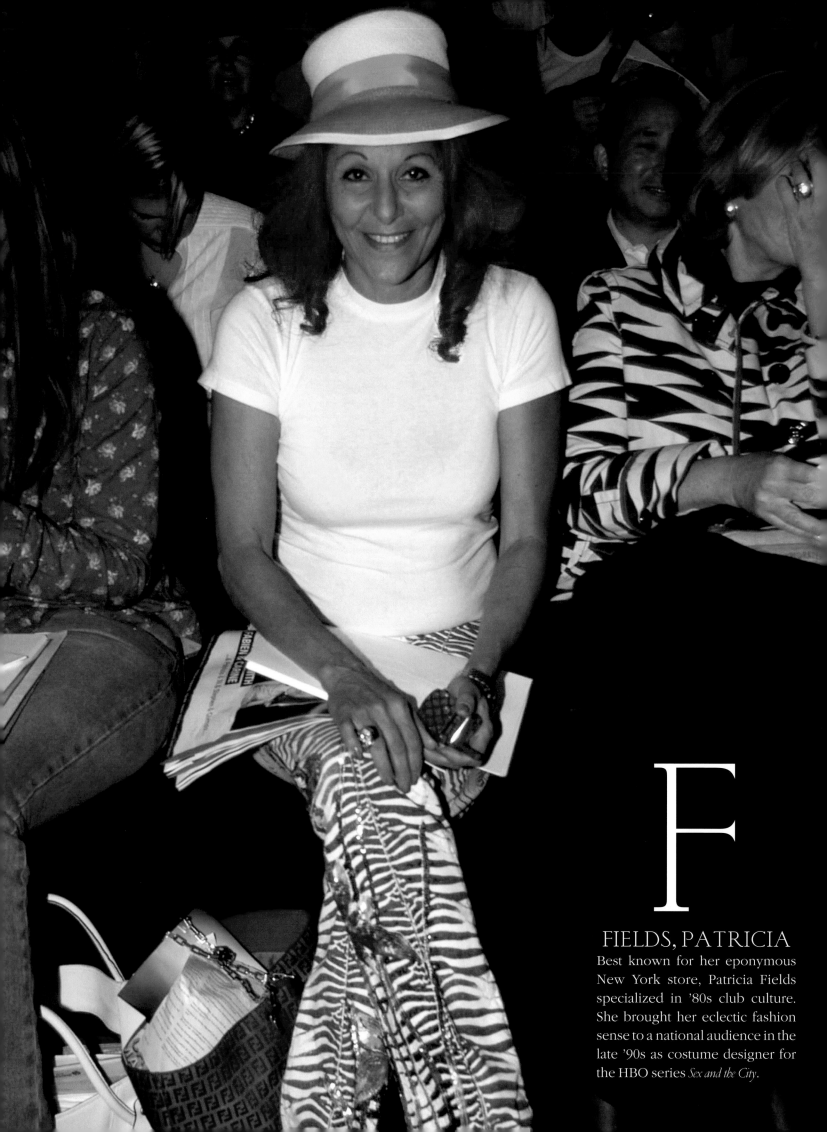

F

FIELDS, PATRICIA

Best known for her eponymous New York store, Patricia Fields specialized in '80s club culture. She brought her eclectic fashion sense to a national audience in the late '90s as costume designer for the HBO series *Sex and the City*.

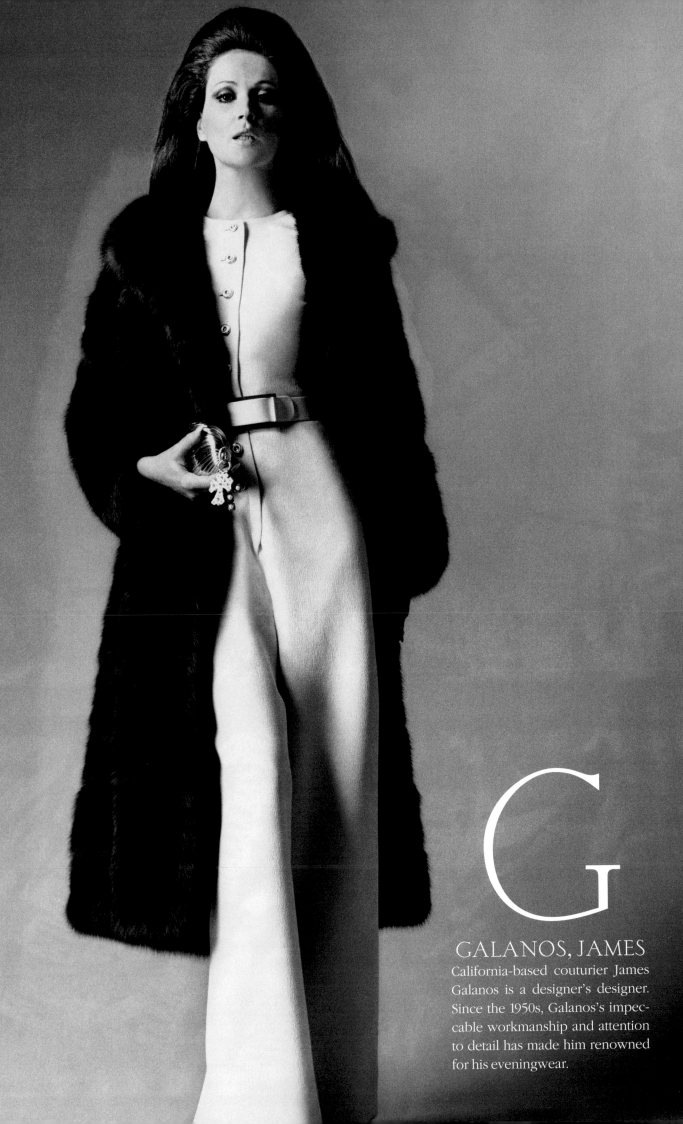

G

GALANOS, JAMES

California-based couturier James
Galanos is a designer's designer.
Since the 1950s, Galanos's impec-
cable workmanship and attention
to detail has made him renowned
for his eveningwear.

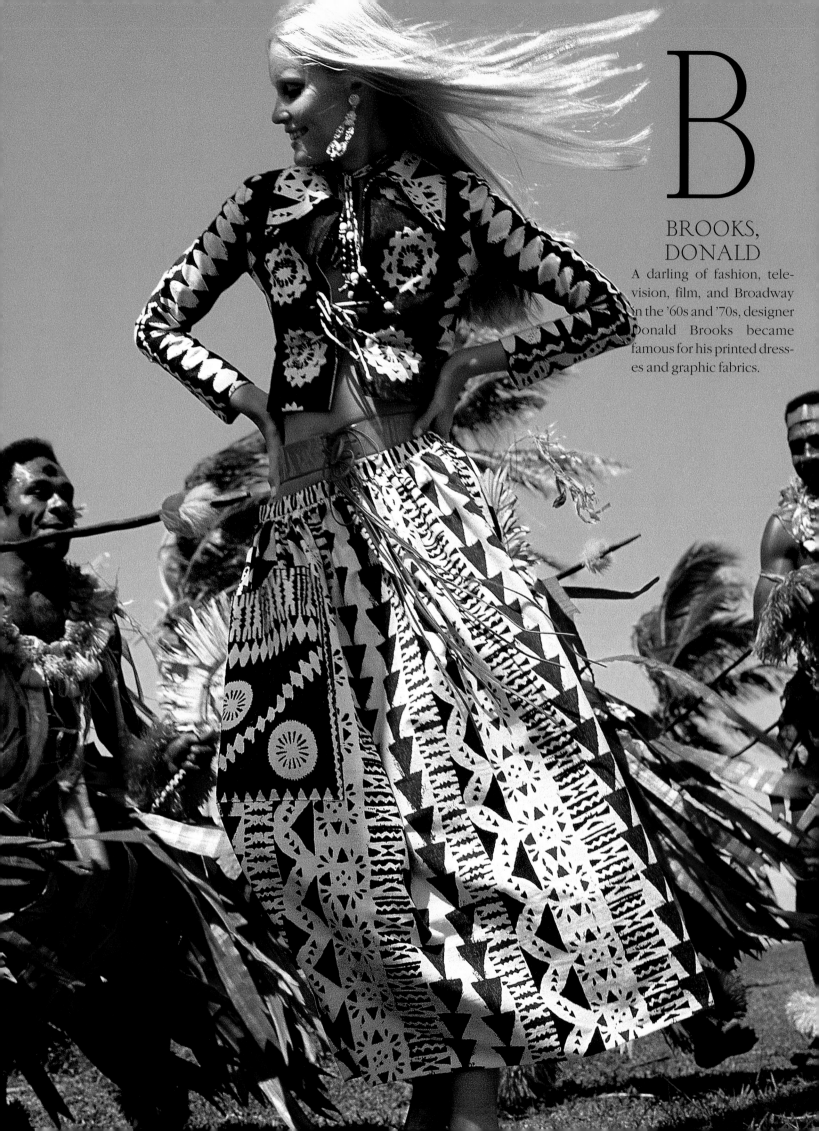

B

BROOKS, DONALD

A darling of fashion, television, film, and Broadway in the '60s and '70s, designer Donald Brooks became famous for his printed dresses and graphic fabrics.

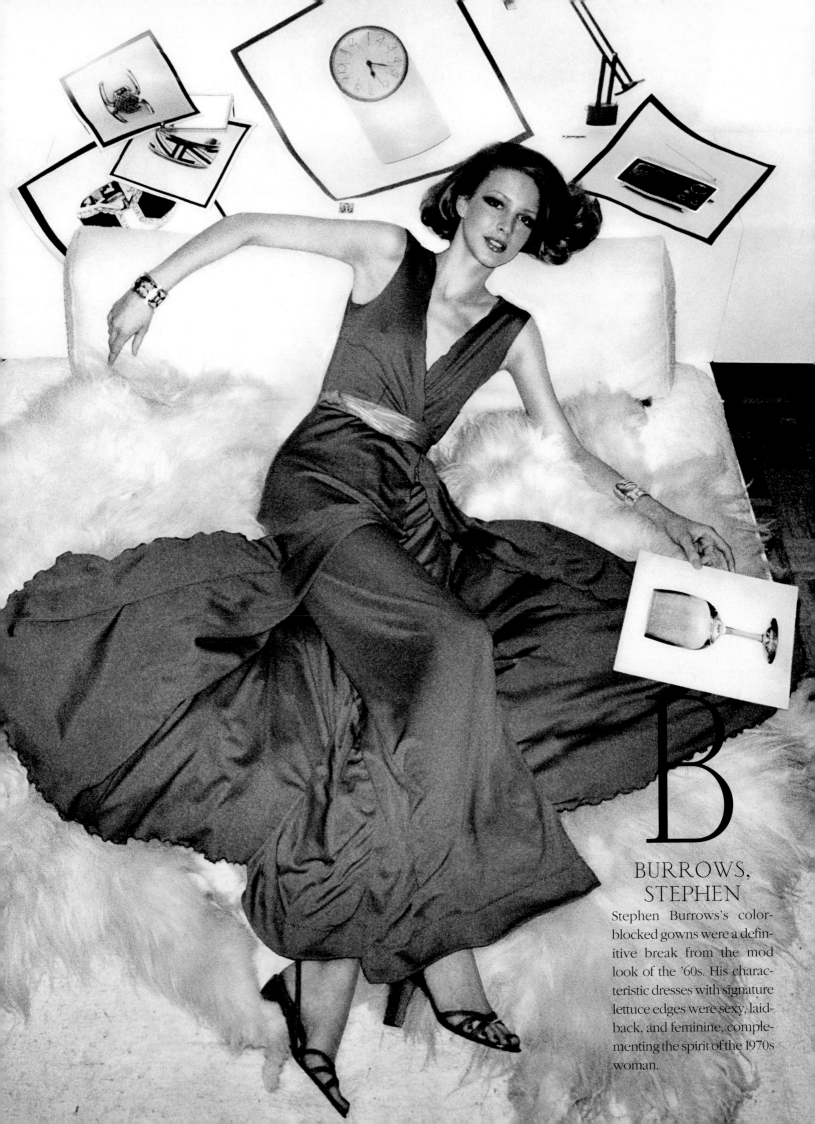

B

BURROWS, STEPHEN

Stephen Burrows's color-blocked gowns were a definitive break from the mod look of the '60s. His characteristic dresses with signature lettuce edges were sexy, laid-back, and feminine, complementing the spirit of the 1970s woman.

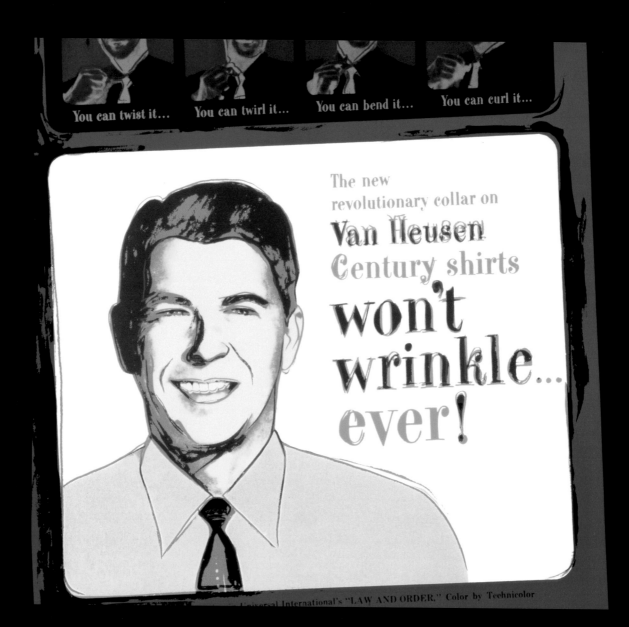

You can twist it… You can twirl it… You can bend it… You can curl it…

The new revolutionary collar on **Van Heusen** Century shirts **won't wrinkle... ever!**

Universal International's "LAW AND ORDER," Color by Technicolor

P

PHILLIPS VAN HEUSEN

In 1922, Seymour Phillips, whose parents had made shirts for coal miners, partnered with Dutch shirt maker John M. Van Heusen to create a collared shirt. Today, Phillips van Heusen, in addition to owning Calvin Klein, is still the number one bestselling dress-shirt maker in America.

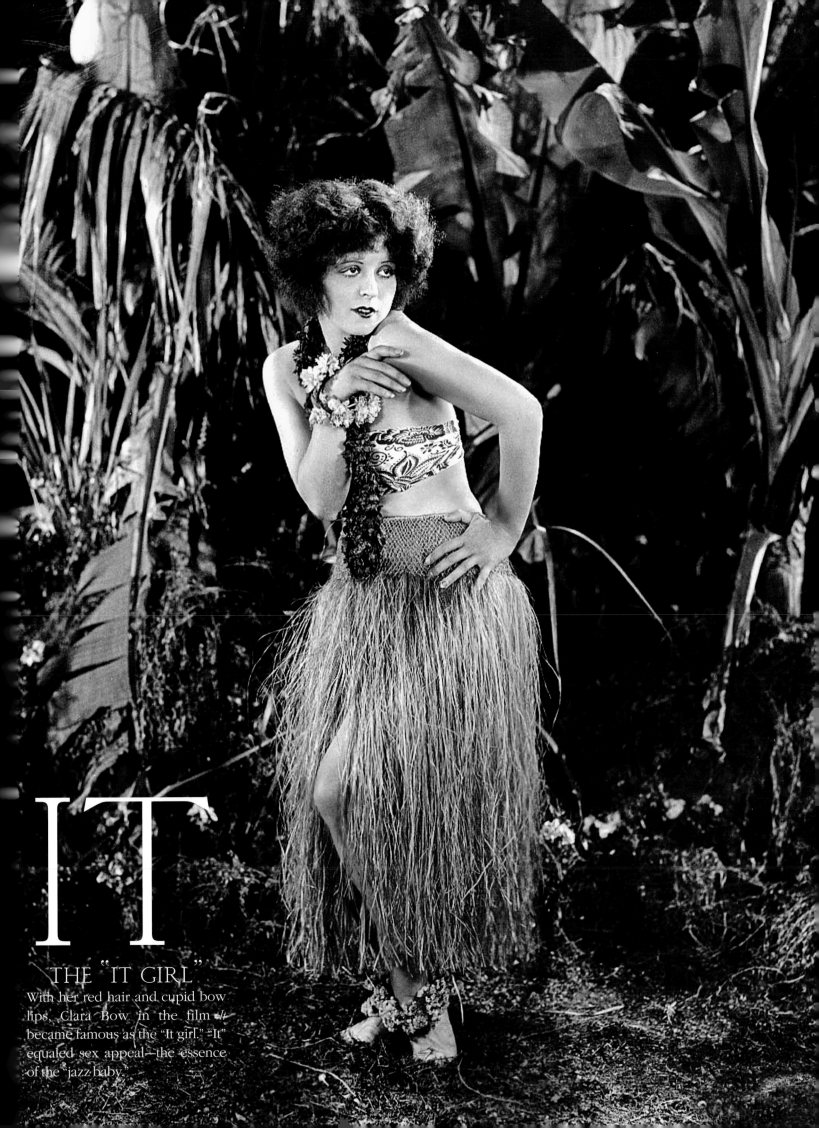

IT

THE "IT GIRL"

With her red hair and cupid bow lips, Clara Bow in the film *It* became famous as the "It girl." "It" equaled sex appeal—the essence of the "jazz baby."

I

ISAIA

Known simply for creating the ultimate little black Lycra dress in the 1980s, Isaia's clothes showcased the newly aerobicized body.

N

NORELL, NORMAN

Perhaps best remembered for his sequined "mermaid" evening sheaths, Indiana-born Norman Norell also helped to create a New York style and was a founder of the Council of Fashion Designers of America.

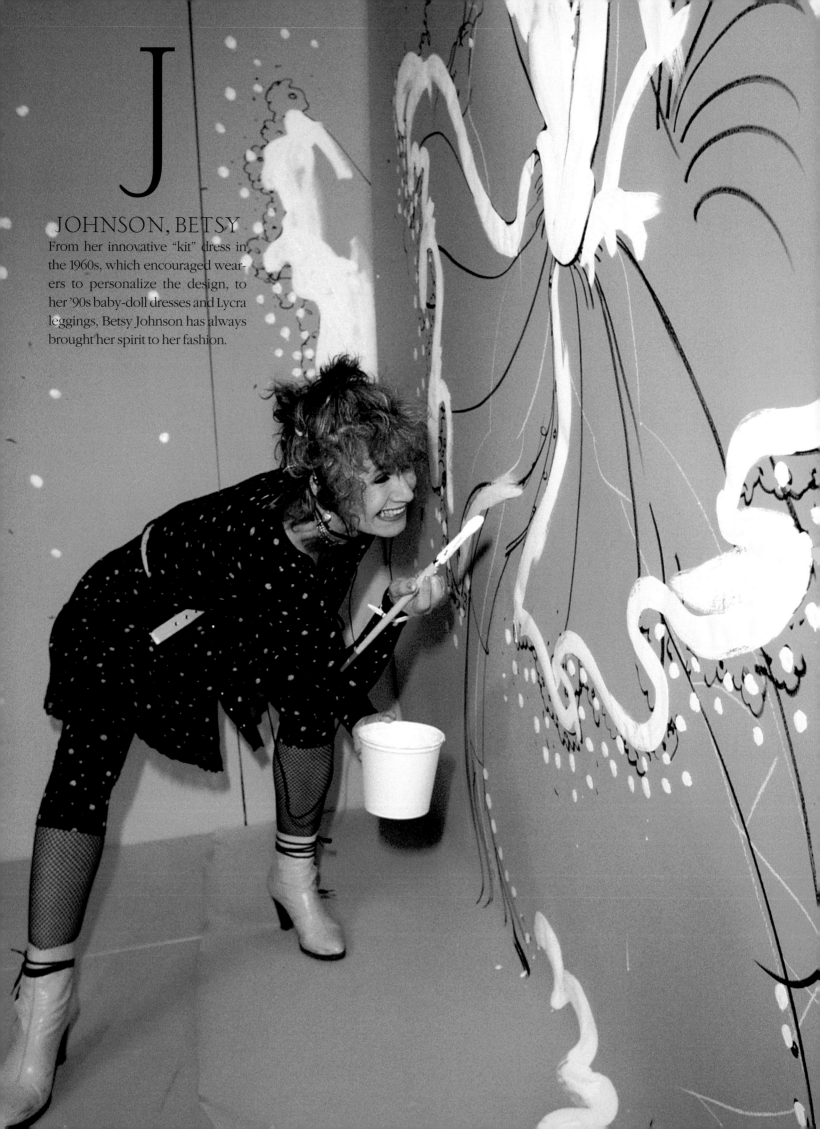

J

JOHNSON, BETSY

From her innovative "kit" dress in the 1960s, which encouraged wearers to personalize the design, to her '90s baby-doll dresses and Lycra leggings, Betsy Johnson has always brought her spirit to her fashion.

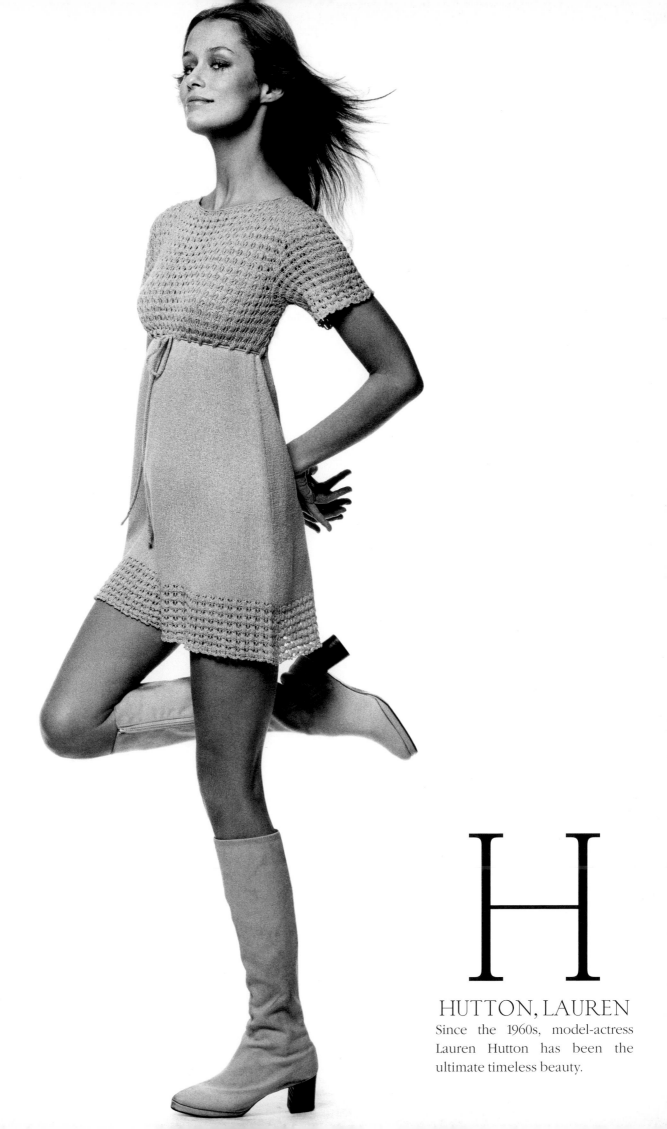

H

HUTTON, LAUREN
Since the 1960s, model-actress Lauren Hutton has been the ultimate timeless beauty.

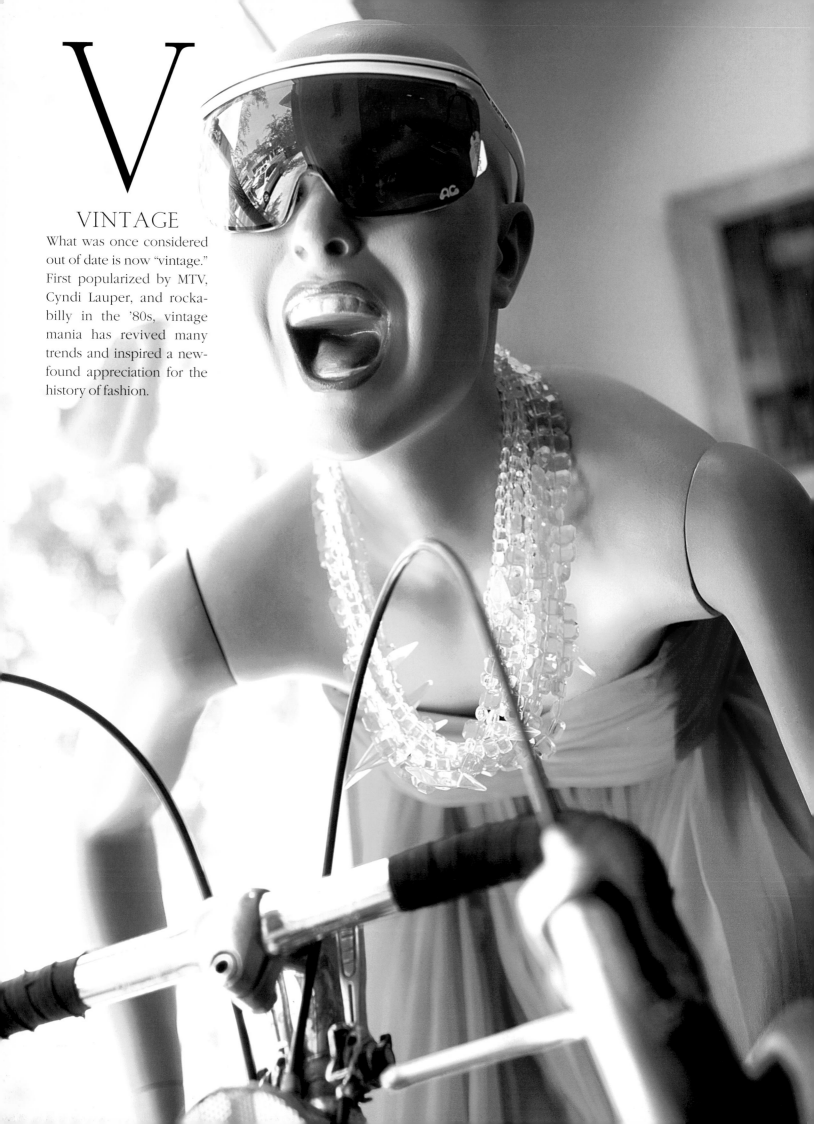

V

VINTAGE

What was once considered out of date is now "vintage." First popularized by MTV, Cyndi Lauper, and rockabilly in the '80s, vintage mania has revived many trends and inspired a new-found appreciation for the history of fashion.

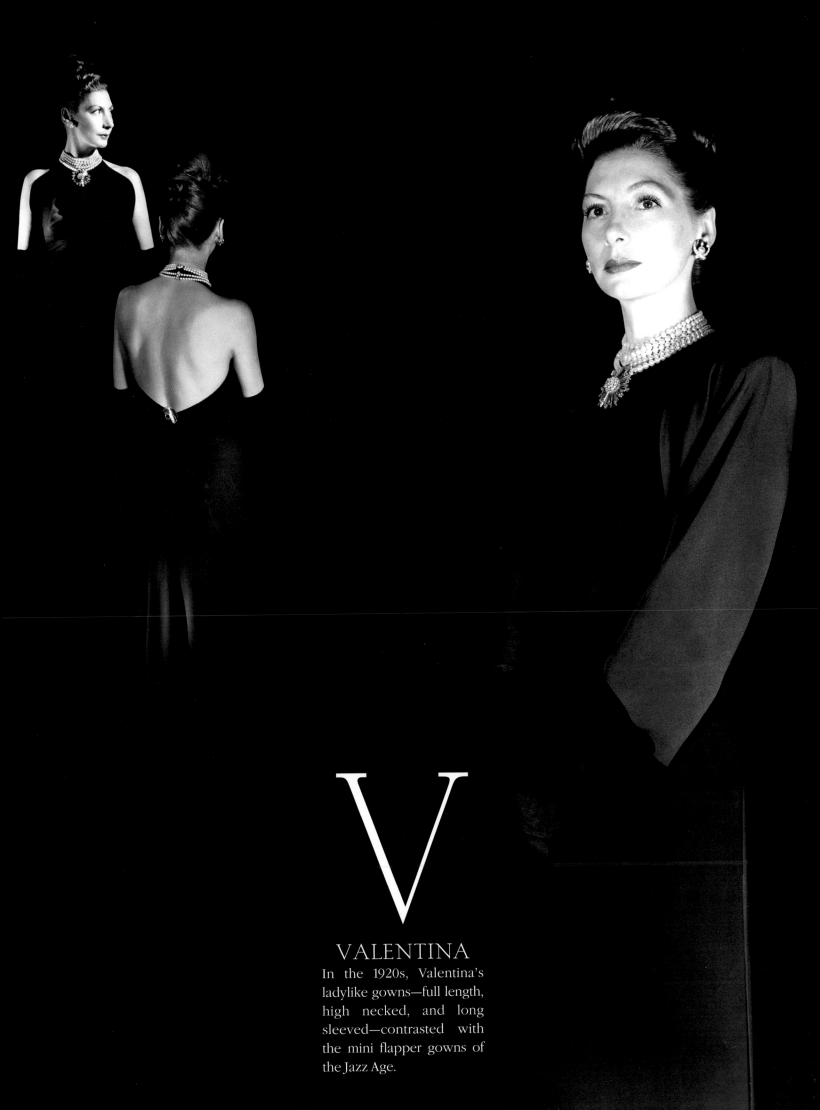

V

VALENTINA

In the 1920s, Valentina's ladylike gowns—full length, high necked, and long sleeved—contrasted with the mini flapper gowns of the Jazz Age.

P

PENDLETON

In the early 1900s, Pendleton Woolen Mills was known for plaid work shirts and Native American blankets. In 1949, Pendleton launched a women's collection with an unlined shirt-like jacket, the '49er.

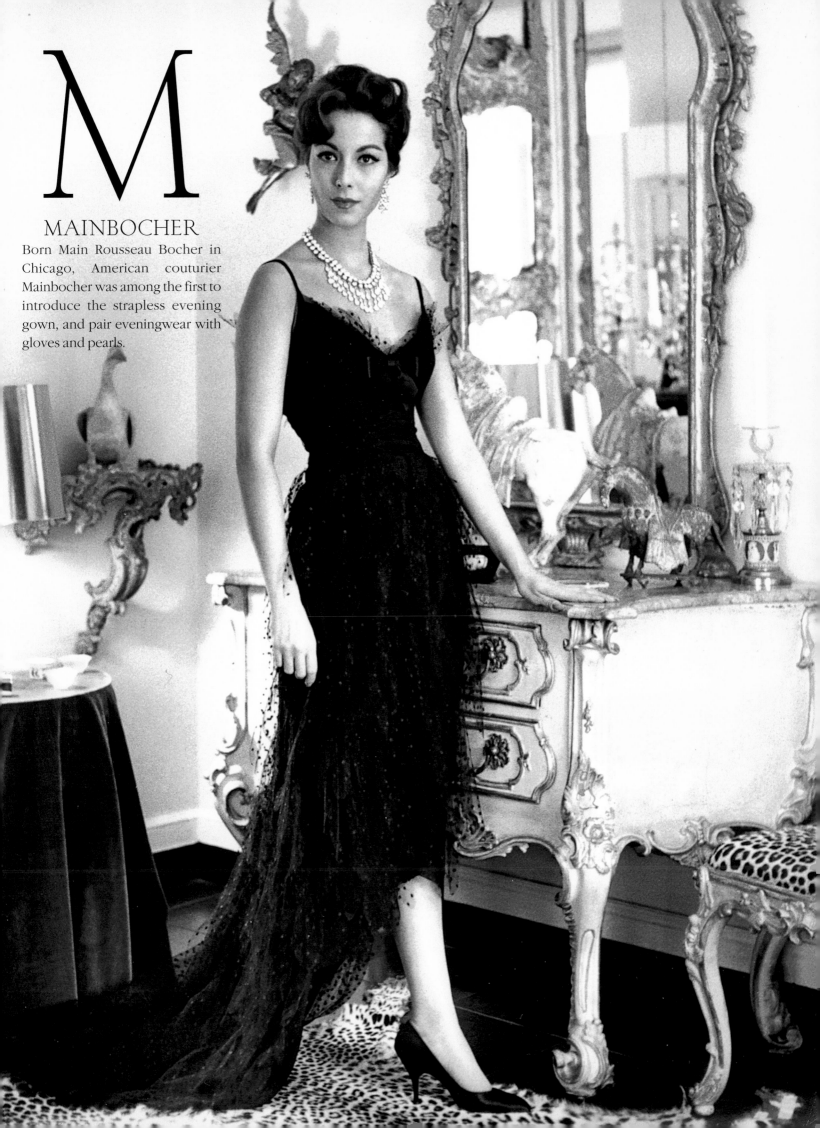

M
MAINBOCHER

Born Main Rousseau Bocher in Chicago, American couturier Mainbocher was among the first to introduce the strapless evening gown, and pair eveningwear with gloves and pearls.

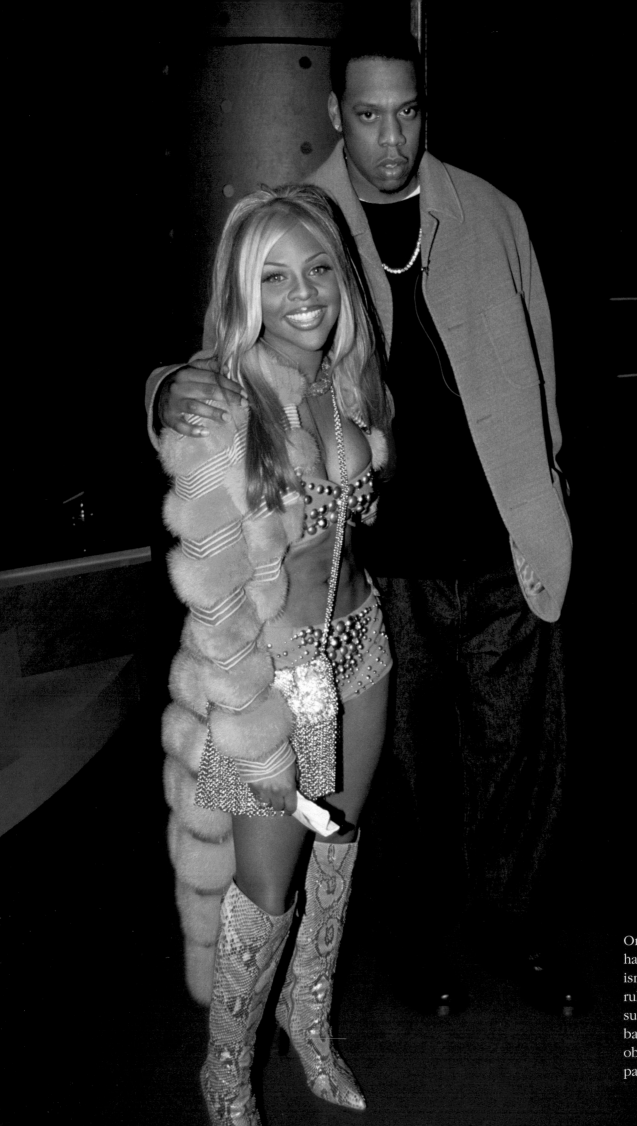

L

LI'L KIM

One of the queens of hardcore rap music, Li'l Kim isn't afraid to break the rules. The reasons for her success: explicit lyrics, a bad-girl image, and an obsession with fur. Clearly, it pays to be an original.

S

SIMPSON, WALLIS

The wedding of Baltimore's Bessie Wallis Warfield, who became Wallis Simpson and later the Duchess of Windsor, caused both King Edward VIII's abdication and the awakening of American couture. Her wedding ensembles were created by Mainbocher, putting him and American designers on the international map.

To Grace

Wallis Windsor
1947

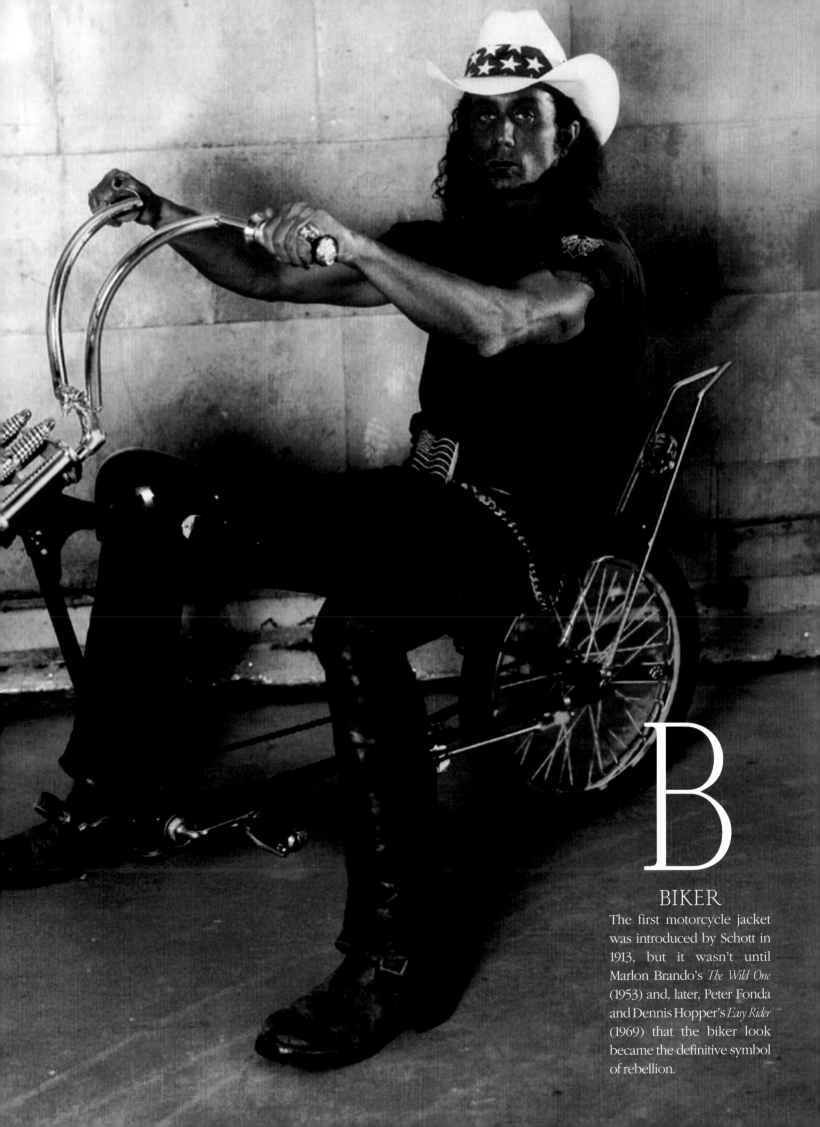

B

BIKER

The first motorcycle jacket was introduced by Schott in 1913, but it wasn't until Marlon Brando's *The Wild One* (1953) and, later, Peter Fonda and Dennis Hopper's *Easy Rider* (1969) that the biker look became the definitive symbol of rebellion.

COPYRIGHTS

ACKNOWLEDGMENTS

Special thanks:

American Style could never have occurred without the instrumental help of Condé Nast Publications and Anna Wintour.
To my husband, Gilles Bensimon, thank you for cooking, listening, loving, and reminding me that I can do it.
To my beautiful girls, thank you for your patience and love. Like Sea said, "Let's finish this book and get on with summer."
To my parents and family, thank you for always being there for me.
Thank you to Martine and Prosper Assouline, who have opened a new world of book publishing up to me. Without their help, support, and visual integrity, this book would just be another project on the " wish I could" shelf.
To the Costume Institute's Harold Koda, for showing me how fashion isn't just a dress but an art form, and a reflection of history.
Thank you to my assistant, Rene Ragan, for her unconditional support of this book, of me, and of my family. Without Rene this book would be filled with blank pages.
To Dyonne Venable, thank you so much for your incredible organizational skills and your last minute help. Your efficiency and professionalism never go unnoticed.
To Stephane Houy-Towner and Pamela Grimaud, for their vision, knowledge, and love of fashion.
Thank you to *ELLE*'s Guillaume Bruneau, who was there to help me synthesize thousands of images. His ability to outline the beauty of America is in itself an art form. His love for this land, and the images, inspired me to search harder for more evocative images. He is more than an art director who manipulates images and fonts; he is a master at creating order out of visual chaos.
Thank you to Assouline's editorial director, Karen Lehrman, who had to be my watchdog in terms of deadlines and text. She had to help me edit over 40,000 words that I had written about American Style. Not an easy feat for anyone; thank you for making it possible. And thanks as well to her assistant editor, Sarah Stein, for all of her help and efforts.
I would also like to extend a great thank-you to the Costume Institute's associate curator, Andrew Bolton, who gave me great insight on American designers, and who taught me how to look for the construction and the inspiration in all clothing.
To the Costume Institute, for all of their help in and out of the library.
To F.I.T., for allowing me access to such an incredible archive of work. I still cannot believe how well maintained the archives are.
To Pratt, for giving me access to their library. Their campus is an inspiration to all of us.
To Parsons, for their well-organized research archives. I found so many great articles on Joel Schumacher, Donald Brooks, and Paraphernalia there.
And to the graduates at Parsons, for motivating me to look beyond what is expected. Your craftsmanship and knowledge are an inspiration and very exciting.
To *ELLE* magazine, the art direction and the bridge you built between uptown and downtown style will be known as one of the biggest American style phenomenons ever. Thank you for all of your help.
To Michael Stier, from Condé Nast, who helped me and never laughed at my Excel files. Michael, thank you so much. This book would never be the caliber it is without the incredible resources from Condé Nast.
Thank you so much to all of the photographers, designers, celebrities, and contributors. You are the trailblazers that make the rest of the world think a little harder and dream.
Thank you also Ruven Afandor, Francesca Alongi, Pamela Anderson, Apostrophe, Bennett Ashley, Prosper Assouline, Martine Assouline, Alexander Assouline, Josef Astor, Richard Avedon, Barney's New York, John Bartlett, Anna Bartolini, Geoffrey Beene, Bergdorf Goodman, Gilles Bensimon, Gene Black, Bill Blass, Bloomingdale's, Christine Bobbish, Andrew Bolton, Guillaume Bruneau, Sean Byrnes, Camp Beverly Hills, Candie's, Paul Caranicas, Cartier, Oleg Cassini, Kenneth Cole, Niel Cole, Corbis, John Corins, Cindy Crawford, Jennifer Crawford, Elvis Cruz, Delman, Patrick Demarchelier, Catherine Deneuve, Lynn Downey, Mickey Drexler, Farrah Fawcett, Tracy Feith, Simon Fields, Thierry Freiberg, Joyce Fung, Betty Galella, Ron Galella, Getty Images, Bruce Glickman, Joshua Greene, Milton Greene, Stefani Greenfield, Lauren Greenfield, Pamela Grimaud, Guess Corp., Harrison & Shriftman, Debbie Harry, Ron Harvey, Christine Hefner, Wilson Henley, Carolina Herrera, Tommy Hilfiger, Dennis Hopper, Marin Hopper Goldstone, Stephane Houy-Towner, Lilly Hummell, Walter Iooss, Marc Jacobs, Betsey Johnson, Norma Kamali, Reed Karakoff, Donna Karan, Julie Kauss, KCD, Lesley Killoren, Tommy Killoren, Beyoncé Knowles, Harold Koda, Michael Kors, Stuart Kreisler, Tracy Kreisler, Jessica Krick, Elizabeth Kuhner, Marisa Laino, Liz Larson, Dan Lecca, Karen Lehrman, Levi's, Gideon Lewin, Peter Lindberg, Joel Lobenthal, Jennifer Lopez, Courtney Love, Malcolm Carfrae, Bob Mackie, Richard Martin, Charles Masters, Patrick McMullan, Miss America Corp., Isaac Mizrahi, Joan Moore, Greg Morris, Gigi Mortimer, Jeff Murray, National Geographic, Dewey Nicks, Corey Pails, Bill Parr, Anthony Petrillose, Nicole Phelps, Photofest, Zac Posen, Proenza Schouler, Lily Pulitzer, Stanislas de Quercize, Rene Ragan, Oscar de la Renta, Katy Rodriguez, Narciso Rodriguez, Peter Rogers, Roger-Viollet, Pierre Rougier, Joie Rucker, Jennifer Rush, Thibault de Saint Chamas, Arnold Scassi, Francesco Scaullo, Jason Schmidt, Allen Scott, Jessica Seinfeld, Ron Shamask, Brooke Shields, Lara Shriftman, Kimora Lee Simmons, Anne Slowey, Martin Snaric, Laurie Stark, Jeff Stein, Sarah Stein, Kristina Stewart, Michael Stier, Anna Sui, Thomas Tinervin, Tina Turner, Dyonne Venable, David Vincent, Courtney Wagner, Virginia Walker, Bruce Weber, Chris Winget, Anna Wintour, Robert Wyatt, Ken Wyse